BETWEEN EQUALIZATION AND MARGINALIZATION

Between Equalization and Marginalization

Women Working Part-Time in Europe and the United States of America

Edited by

HANS-PETER BLOSSFELD

and

CATHERINE HAKIM

OXFORD UNIVERSITY PRESS

OXFORD
UNIVERSITY PRESS

Great Clarendon Street, Oxford OX2 6DP

Oxford University Press is a department of the University of Oxford.
It furthers the University's objective of excellence in research, scholarship,
and education by publishing worldwide in

Oxford New York
Athens Auckland Bangkok Bogotá Buenos Aires Cape Town
Chennai Dar es Salaam Delhi Florence Hong Kong Istanbul Karachi
Kolkata Kuala Lumpur Madrid Melbourne Mexico City Mumbai Nairobi
Paris São Paulo Shanghai Singapore Taipei Tokyo Toronto Warsaw

and associated companies in Berlin Ibadan

Oxford is a registered trade mark of Oxford University Press
in the UK and in certain other countries

Published in the United States
by Oxford University Press Inc., New York

ISBN 0-19-828086-6

Printed in Great Britain
on acid-free paper by
Bookcraft (Bath) Short Run Books
Midsomer Norton

PREFACE

Family roles and the labour-market participation of women in Western industrial societies have changed more rapidly since the end of the Second World War than in any earlier period. This book presents a comparative study of the long-term development of women's part-time work in Europe and the United States of America. Our chief intention was to explore three contrasting, even conflicting perspectives on women's work: first, that women's increased labour-force participation—independently of its particular form—reduces their dependence on men and leads to greater equality between women and men in the labour market and the family; second, that the expansion of part-time work among women disadvantages and marginalizes women in the labour market and the family; and third, that within the context of the sexual division of labour in the family, part-time jobs and other low-paid or non-career jobs, including full-time jobs, can not only be tolerated but even enthusiastically appreciated by dependent wives and other secondary earners.

Using longitudinal and cross-sectional data on the labour force, we seek to disentangle these hypotheses both by exploring the longer-term historical development of diverse patterns of part-time work in modern societies and by identifying the common thread of the position of part-time work within women's life-courses. The key strength of the book is the cross-national comparative approach which illuminates the idiosyncrasies and historically specific developments within the countries studied. The project has been a collective effort and illustrates what can be achieved through collaborative research across Europe. Data on part-time work pose problems for comparative analysis. Each of the country case-studies was carried out by national experts—sociologists, economists, and labour-market experts—who were familiar with the data-sets available within each country and able to analyse them to fullest advantage. Our comparative perspective was developed through an international seminar held at the University of Bremen in late 1993. The papers were subsequently revised several times—to increase comparability, to explore the unique features of particular country contexts, to incorporate useful comments and suggestions from two anonymous Oxford University Press reviewers, and to underline theoretically significant findings. This process led to a fuller understanding of the place of part-time work in women's lives and of the multi-faceted character of part-time work.

The idea and initial support for this joint venture stemmed from the

Household Dynamics and Social Inequality project which was supported by the European University Institute in Florence, Italy from 1989 to 1992. The Sonderforschungsbereich 196, Statuspassagen und Risikolagen im Lebenslauf of the Deutsche Forschungsgemeinschaft (DFG) at the University of Bremen has been supporting our work since 1992. We are also grateful to the Commission of the European Communities, Directorate General for Employment, Industrial Relations and Social Affairs (DG V/C/1) in Brussels, particularly Dr Isabelle de Pourbaix, for the funding that made our workshop in Bremen possible in December 1993.

We wish to thank our colleagues at Bremen University for their superb collegial support. We also thank Julie Winkler-Vinjukova for ably assisting us at all stages of the book's gestation, particularly in helping to prepare the final typescript. We further wish to thank Cathleen Cramm, Teresa Lankuttis, and Jo Mowitz for their help in preparing the final version of the manuscript.

H.-P.B.
University of Bremen
C.H.
London School of Economics

CONTENTS

LIST OF TABLES

LIST OF FIGURES

LIST OF ABBREVIATIONS

EC	European Commission
EU	European Union
IDA	Danish Integrated Database for Labour Market Research
LFS	Labour Force Survey
MISEP	Mutual Information System on Employment Policies of the EU
OECD	Organisation for Economic Cooperation and Development

Abbreviations used in tables

*	less than 0.5%
FT	full-time
PT	part-time
LF	labour force
M	men/males
W	women/females

NOTES ON CONTRIBUTORS

TINDARA ADDABBO is a researcher in economics at the University of Modena in Italy. Her publications on women's employment include: 'Un modello dinamico di offerta di lavoro per le donne sposate, con applicazione al Regno Unito e alla Germania' (CLUEB, 1996) and 'L'offerta di lavoro delle donne tedesche e straniere in Germania Occidentale' (with Gianna Giannelli) in *Politiche del Lavoro* (1992).

HANS-PETER BLOSSFELD is Professor of Sociology and Social Statistics at the University of Bremen and external professor of sociology and political sciences at the European University Institute, Florence. Since 1990 he has been editor of the *European Sociological Review*. He is interested in youth, family, and educational sociology; studies of the labour market; and research in demography, as well as social stratification and mobility. He has written several books including *Techniques of Event History Modeling* (with Götz Rohwer, 1995); *Persistent Inequality: Changing Educational Attainment in Thirteen Countries* (edited with Yossi Shavit, 1993); and *The New Role of Women: Family Formation in Modern Societies* (edited, 1995).

BRENDAN J. BURCHELL is a lecturer in the Faculty of Social and Political Sciences at the University of Cambridge, and a fellow of Magdalene College. His publications and research interests include the psychological effects of unemployment, job insecurity and labour-market deprivation and self-employment, exploratory data analysis, and the analysis of work histories.

LAURENCE COUTROT is a research fellow at CNRS and a member of the laboratory of secondary analysis and methods applied to the social sciences (LASMAS) in Paris. She has a Ph.D. in sociology and is the co-editor (with C. Dubar) of *Cheminements professionnels et mobilités sociales* (1992). She is a specialist in mobility and training issues.

ANGELA DALE is Director of the Cathie Marsh Centre for Census and Survey Research (CCSR) at the University of Manchester. Her research interests include women's economic activity and occupational attainment in relation to family formation and ethnicity. CCSR is responsible for the support and dissemination of Samples of Anonymised Records from the 1991 Census and also has a research programme involving census and national survey data.

PAUL M. DE GRAAF is an associate professor of sociology at Nijmegen University, the Netherlands. He works on topics in social stratification, especially the effects of structural change on individual life chances. Recent articles by him have been published in the *Netherlands Journal of Social Sciences*, *Social Science Research*, and the *European Sociological Review*.

SONJA DROBNIČ is an assistant professor at the Institute for Empirical and Applied Sociology (EMPAS), University of Bremen. Her research interests include methods of empirical social research, life-course research, sociology of the family and labour markets, including research on labour markets in transition economies. Her publications include *Immigrants in a Welfare State* (Stockholm 1990); 'Social Networks and Organizational Dynamics' (with McPherson and Popielarz), *American Sociological Review* (1992); 'Unemployment in Transition Economies' (with Rus), in Jackson, Koltay, Biesbrouck (eds.), *Unemployment and Evolving Labor Markets in Central and Eastern Europe* (1995).

IRÈNE FOURNIER is a research fellow at CNRS and a member of LASMAS in Paris. She is a specialist in data analysis concerning employment and training issues. She has published with C. Marry and A. Kieffer 'Activité des jeunes femmes: héritages et transmissions', in *Economie et statistique* (1995).

CATHERINE HAKIM is Senior Research Fellow at the London School of Economics, Department of Sociology. She has published extensively on the sociology of the labour market, issues in women's employment, and on research design and research methods. Her latest book is *Key Issues in Women's Work* (1996).

HEATHER JOSHI is Deputy Director of the Social Statistics Research Unit and Professor of Economic Demography, at City University in London. She has previously worked in London and Oxford Universities and for the Government Economic Service. Her current responsibilities include the provision of academic access to the OPCS Longitudinal Study and several of her own research projects analysing this and data from national cohort studies. Her publications mainly concern women's employment and the family.

ANNICK KIEFFER is a research fellow at CNRS, and a member of LASMAS in Paris. Her interests focus on education, youth transition, and female employment in France and Germany. She has published with C. Marry and I. Fournier 'Activité des jeunes femmes: héritages et transmissions', *Economie et statistique* (1995).

EVA LELIÈVRE is a researcher at the French Institute of Demography (INED). She is a demographer who has published in the field of life-event

history analysis. She co-authored, with D. Courgeau, *Event History Analysis and Demography* (1992).

SØREN LETH-SØRENSEN is a sociologist employed as Senior Advisor at Statistics Denmark in Copenhagen. His responsibilities include management of the IDA database, established by the Bureau of Statistics. This longitudinal database includes information on labour-market status for the whole population as well as on all establishments with employees from 1980 to 1992.

GÖTZ ROHWER is Professor of Sociology at the Max Planck Institute for Human Development and Education in Berlin. He is interested in further development and application of statistical methods for longitudinal analysis. He has published several journal articles on social policy issues, demographic change, and labour-market processes and is co-author of *Techniques of Event History Modeling* (with Hans-Peter Blossfeld, 1995).

MARIANNE SUNDSTRÖM is Associate Professor of Economics at the Demography Unit of Stockholm University. She is the author of *A Study in the Growth of Part-time Work in Sweden* (1987) and has published several articles on part-time work, women's employment, and career breaks in connection with childbirth.

HARIS SYMEONIDOU is Head of Research in the National Centre of Social Research in Athens. She is a member of the EU Network on Women's Employment, a former member of the European Observatory on National Family Policies, and sits on a number of advisory committees to the Greek government. A demographer with a background in economics, she is a member of the board of directors of the Greek Society of Demographic Studies. She has published extensively on fertility patterns, women's employment, and family policy.

HEDWIG VERMEULEN works at the IVA, Institute for Labour Market Research, which is affiliated with Tilburg University, the Netherlands. She is engaged in comparative research on female labour-force participation, and has studied the labour markets for teachers and in the care sector. She recently published a paper on 'Tax Systems and Married Women's Labour Force Participation: A Seven Country Comparison' (with H. Vermeulen, S. Dex, and others) for the ESRC Research Centre on Micro-Social Change, Essex University.

IMMO WITTIG is a researcher at the University of Bremen, Institute for Empirical and Applied Sociology. He is working on the dependence of working behaviour on the interplay of demographic conditions, education, and the family cycle, and is especially interested in statistical methods for longitudinal data analysis.

1

Introduction: A Comparative Perspective on Part-Time Work

HANS-PETER BLOSSFELD AND CATHERINE HAKIM

Introduction

Part-time work seems to defy classification and explaining it presents a serious challenge to social scientists. Contradictions abound. High levels of part-time work are found both in relatively unregulated labour markets, such as Britain and the USA, and in highly regulated labour markets, such as Denmark, Sweden, and the Netherlands. The European Union (EU) Labour Force Survey consistently shows that voluntary and involuntary part-time work are both present, to varying degrees, in most countries. Employers in Italy, Greece, and France regard part-time workers as introducing an unattractive disruption of normal production processes and workplace discipline, while employers in Britain had created a large permanent part-time workforce long before economic recession stimulated deregulation and the casualization of labour contracts in most industrial economies in the 1980s and 1990s. The so-called 'part-time' workers of Sweden frequently work hours long enough to be classified as full-timers by the European Commission, while many part-time workers in the Netherlands, Britain, and West Germany work such short hours that the European Commission classifies them as marginal workers (European Commission, 1994: 103–13).

Within this great variation, there appear to be some common features. Where it exists, part-time work is dominated by women, and most part-time jobs are in the lower-grade and lower-paid occupations, in service-sector industries more often than in manufacturing industry. However these generalizations are immediately contradicted by the exceptions. Part-time workers in professional occupations are growing slowly, and they often return to full-time work after a few years (particularly in Sweden, West Germany, the Netherlands, and Denmark). Married women are a minority among part-timers in Italy and in most of the former socialist

countries of Central and Eastern Europe, whereas they form the majority in West Germany, Britain, the Netherlands, and France.

The female part-time workforce is almost as diverse as the female full-time workforce, and there is of course a fair degree of traffic between the two. This diversity, and the close links with the full-time workforce, underlie ambivalent, even contradictory theoretical approaches to date. One approach is to analyse labour supply as a whole, to focus on changes in (married) women's labour-force participation, and to treat hours worked as a continuous variable (Oppenheimer, 1970; Hakim, 1993a). In these labour-market analyses, full-time and part-time workers are treated as equivalent, and potential substitutes, and no qualitative differences between them are identified. In this approach, the key distinction is between full-time housewives and working women who are classified by their occupation, like men. The post-war growth of paid work among women, and among wives in particular, has produced the 'equalization thesis' that women's increased labour-force participation will reduce their dependence on men and ultimately lead to greater equality between men and women in the labour market and the family. There is now a substantial body of research on the effects of women's paid work on gender roles (Chafetz, 1990), family roles (Becker, 1981; Beck-Gernsheim, 1985; Thompson and Walker, 1989; Sørensen, 1990), family formation (Oppenheimer, 1988; Blossfeld and Huinink, 1991; Blossfeld, 1995), fertility (Ermisch, 1988; Bernhardt, 1993), divorce (Becker, Landes, and Michael, 1977; Becker, 1981; Booth, Johnson, and White, 1984; Sørensen, 1989; Blossfeld et al., 1995), occupational segregation (Blossfeld, 1987; Hakim, 1992; Hakim, 1993b), women's exits from the labour force after a birth and their subsequent re-entry into the labour market (Engelbrech, 1987; Joshi and Hinde, 1991; Krüger and Born, 1991; Lauterbach, 1993; Lauterbach, Huinink, and Becker, 1993), career and earnings opportunities (Blossfeld, 1989; Hannan, Schöman, and Blossfeld, 1990), as well as the social standing (Hammond, 1987) and the socioeconomic class of the family (Goldthorpe, 1983; Curtis, 1986; Osborn, 1987; Dex, 1990; McRae, 1990).

Another approach focuses on changes in the patterns of working time to compare full-time and part-time jobs in the labour market. Implicitly or explicitly, these researchers take full-time permanent jobs as the norm by which to assess part-time jobs and they assume that the welfare of part-time workers is determined solely by their own occupational status and earnings (Ellingsaeter, 1992). In effect, workers are studied as individuals, ignoring their family or household context, any income-sharing within the family, and any social security or other benefits enjoyed through family relationships. In most countries, part-time work is the dominant form of so-called 'atypical' or 'non-standard' employment contracts, a category

that includes fixed-term contracts, temporary jobs of all kinds (short-term, seasonal, and casual jobs), temporary workers hired through an agency, labour-only subcontracting, and homework. Part-time work is thus used to assess the implications of workforce flexibility more generally (Beechey and Perkins, 1987; Carley, 1990; Semlinger, 1991; Keller and Seifert, 1993). Most commonly, the conclusion drawn is that part-time work is problematic because of its inferior status in terms of statutory employment rights, social security coverage, and the terms and conditions of employment conferred by collective bargaining (Mückenberger, 1985; Rodgers and Rodgers, 1989; Hinrichs, 1990; Meulders, Plasman, and Plasman, 1994). Since part-time work is dominated by women, this stream of research has suggested the 'marginalization thesis' that part-time women are disadvantaged and marginalized in the labour market and the family (Möller, 1988; Büchtemann and Quack, 1990; Pfau-Effinger and Geissler, 1992; Marsh, 1991; Ebbing, 1992; Dale and Joshi, 1992; Bäcker and Stolz-Willig, 1993; Quack, 1993; Meulders, Plasman, and Plasman, 1994).

In between the equalization and marginalization theses, a third approach sets part-time workers (and others with non-standard contracts) within the context of the family and the sexual division of labour in the family to show how part-time jobs and other low-paid or non-career jobs, including full-time jobs, can be not merely tolerated but even enthusiastically appreciated by dependent wives and other secondary earners (Pahl, 1984; Becker, 1985; Hakim, 1991; Siltanen, 1994; Hakim, 1996a). This stream of research distinguishes between primary earners (breadwinners) and secondary earners, and recognizes that the work orientations and needs of the two groups differ qualitatively. Given the fashion for purely quantitative labour-market analysis, this approach has so far produced the smallest stream of empirical research.

All three of these contrasting, even conflicting perspectives are explored in this volume and, to varying degrees, find support in particular countries, among particular groups of (part-time) workers or particular types of part-time job. This book seeks to disentangle these contrasting, even conflicting theses by illuminating both the long-term historical development of diverse patterns of part-time work in various modern societies and the common thread of the place of part-time work within women's life-course. Within the country reports, we focus on six questions.

(1) What are the post-war trends in women's part-time and full-time work in Europe and the USA and how can we explain the changes?
(2) How do women's part-time and full-time work interrelate with the family cycle in different industrialized countries?
(3) To what extent have women's part-time and full-time employment changed across cohorts in different modern societies?

(4) How important is women's rising educational attainment to concomitant changes in female employment, and is it cause or consequence?

(5) Which contextual factors are most important in explaining cross-national variation in levels of part-time work: institutional and structural factors such as state employment policies, fiscal policies, state welfare systems, and employers' labour usage policies or social-cultural factors such as norms about sex-role differentiation and the sexual division of labour in the family?

(6) How useful are the three perspectives on part-time work in accounting for the full spectrum of part-time work across Western societies and former socialist countries in Central and Eastern Europe, and is any synthesis of them possible? And what new insights emerge from a broad assessment of the evidence and arguments?

The book as a whole employs three methods:

- analysis of long-term trends in female employment in each of the countries studied, so as to set (any growth in) part-time work in its wider labour-market, political, and ideological country context;
- cross-national comparisons between Western industrial societies aimed at identifying the relative importance of more specific government policies constraining or expanding women's choices to work full-time or part-time; and
- analysis of age-cohort, retrospective life-history, and panel data to examine the changing role of part-time work in women's lives and the link with full-time work or with inactivity over women's life-course.

Part-Time Work

Our focus is on part-time work, in all its forms. The following chapter reviews the key features of part-time work and examines more closely current issues and the theories developed to account for this post-war development in industrial labour markets. As Table 1.1 shows, part-time work varies hugely in importance—from 8 and 12 per cent of women's jobs in Greece and Italy to 66 per cent of women's jobs in the Netherlands, from a bare 1 and 2 per cent of men's jobs in Luxembourg and Austria to 16 per cent of men's jobs in the Netherlands and 10 per cent in Denmark. As the country chapters show, there are further differences and variation between and within countries in terms of the overlap between part-time and temporary jobs; in the huge range of hours worked by part-timers; in the extent to which part-time work is a recent innovation, which has yet to become fully established and accepted, or is already a permanent and somewhat separate part of the workforce; and in the relative import-

TABLE 1.1. *Key employment indicators, 1994*

	Working age population 15–64 (millions)	Total employment (millions)	Total employment as % of working-age population	Male employment as % of working-age population	Female employment as % of working-age population	Female part-timers as % of female employment	Male part-timers as % of male employment
USA	165.8	119.4	72	79	65	25	11
EU countries included in this analysis							
Netherlands	10.5	6.7	64	74	53	66	16
UK	38.1	25.1	66	72	60	44	7
Sweden	5.6	4.0	72	72	71	41	9
Denmark	3.5	2.5	71	76	66	34	10
Germany	55.8	34.9	63	71	54	33	3
France	37.9	22.1	58	65	52	28	5
Italy	39.4	19.9	51	66	36	12	3
Greece	7.0	3.8	53	69	38	8	3
EU countries excluded from this analysis							
Belgium	6.7	3.7	55	65	44	28	3
Ireland	2.3	1.2	52	66	38	21	5
Luxembourg	0.3	0.2	77	95	58	20	1
Austria	5.4	3.5	65	74	56	18	2
Spain	26.7	12.3	46	61	31	15	3
Portugal	6.7	4.5	67	77	58	12	5
Finland	3.4	1.9	57	58	56	11	6
Other European countries							
Poland	23.9	13.8	58	64	52	13	9
Slovenia	1.4	0.9	62	66	58	2	1
Hungary	6.9	4.0	58	61	56	2	1

Note: Figures for the USA relate to the population aged 16–64 instead of the population aged 15–64 and part-time jobs are slightly underestimated compared to European countries. USA CPS statistics define part-time workers as people whose weekly hours, in all jobs, total less than 35 hours, rather than people working part-time in their main job.

Sources: EU Force Survey data for 1994 and other sources reported in European Commission, *Employment in Europe 1995*, and estimates from other sources for Eastern Europe and for the USA.

ance of part-time work as a feature of women's working lives over the life-course.

Data and Analysis

There are few cross-national studies of part-time work. Most comparative studies address female labour-force participation more generally, with part-time work treated as one small facet of female employment (Layard and Mincer, 1985) or else compare countries at a single point in time (Meulders, Plasman, and Plasman, 1994). There are no studies that trace the diverse historical processes which have generated the great variation in part-time work in modern societies. The purpose of this volume is to complement point-in-time studies by a long-term comparative case-study approach. Using cross-sectional data for long stretches of time, typically the whole post-war period, from Population Censuses, Employment Censuses, annual Labour Force Surveys (LFS) and other *ad hoc* surveys of employers, workers and employment issues, we demonstrate the quite diverse and dynamic character of part-time work in different Western nations.

The former socialist countries of Central and Eastern Europe present a special case in this volume. In these societies, the standard employment contract was almost universal, in part because the demand for labour exceeded the supply, even with most women pulled into the workforce. Drobnič (in this volume) exploits the limited information available on part-time work before national Labour Force Surveys were instituted to show that these were often second jobs, or recruited supplementary labour among groups who were formally outside the labour force, such as the disabled and pensioners.

An important feature of our comparative study is the application of longitudinal analysis to work-history data to study the place of part-time work across time in women's lives. For Denmark we can utilize a panel data-set compiled from administrative records for the period 1980–9. For four countries (Britain, the USA, the Netherlands, and Greece), retrospective work and life-history data are available in varying degrees of detail and complexity. For West Germany, our data-set combines retrospective work- and life-history data for the post-war period up to 1984 extended by panel data for 1984–90. *Faute de mieux*, the annual Labour Force Survey (LFS) was used to construct synthetic cohort data for Sweden; was used to produce a short, three-year panel data-set on women's work histories for France; and provides the basis for detailed analyses by age for Italy.

The main advantage of retrospective life-history and longitudinal data is, of course, that they open the door to analyses that disentangle the relative effects of age, cohort, and period (Blossfeld and Rohwer, 1995). Age

effects are associated with growing older. Cohort effects are common to people who experience historical conditions and developments at particular points in their life and who are afterwards shaped in a specific way in their life-courses. For example, it has been shown that people starting their job careers under unfavourable (or favourable) labour-market conditions have been substantially handicapped (or advantaged) in their subsequent careers (Blossfeld, 1986; 1987). Period effects are due to the shared experience of particular historical events—such as the Second World War or the economic recession of the 1980s. Analyses of genuine panel data provide insights into the interplay between life histories, the economic cycle, and historical change. Cross-sectional surveys collecting retrospective work- and life-history data are not true longitudinal studies, but they have the advantage of covering longer spans of time; are often used as a cheaper alternative to true panel data, even for recent decades; and can provide a good substitute for genuine longitudinal data for research topics where social attitudes and motivations are not important, as this type of information cannot reliably be collected retrospectively and are the most important variables regularly omitted from research analyses (Hakim, 1987: 87–100; 1996a: 119; 1996c). But much depends on the size of the sample, the degree of detail in the data, and the skill of the research analyst. As the country reports for the USA, West Germany, Britain, the Netherlands, and Greece demonstrate, there is huge variation between surveys collecting work-history data. In Greece, for example, the information is limited to synoptic accounts of the main features of women's employment profiles (see Tables 4.9 and 4.10), but this can also be the final result of analyses of far more complex work-history data (Hakim, 1996b: Table 14). New panel studies of adult populations, such as the German Socio-economic Panel Study initiated in 1984, are obliged to supplement a prospective panel design with an initial survey collecting retrospective work- and life-history data for adults in the sample.

A Theoretical Perspective on the Cross-National Comparisons

There are three overlapping and related groups of potential explanations for the complex patterns of change in women's part-time employment: (1a) overall historical demand-factors for labour could be working as well as (1b) differences in the structure of occupations and industries; (2) supply-side factors could be important working through educational expansion, and changes in fertility and household structure; and (3) the broader political and ideological country contexts could be important parts of the explanation leading to various packages of family, employment, and welfare policies.

Women's Labour-Force Participation and Historical Changes in the Overall Demand for Labour

With regard to the effects of the overall demand for labour on the change in women's part-time and full-time work two partly contradictory hypotheses have been discussed in the social sciences. On the one hand, the 'reserve army' hypothesis suggests that married women (with children) serve as a key 'reserve army' of labour so that changes in their employment generally and their part-time work in particular can be explained by changes in the overall demand for labour. According to this thesis, steep economic growth (or decline) will lead to increases (or decreases) of married women's part-time and full-time employment over historical time. For example, the rapid economic growth in Northern Europe and the USA between the late 1950s and mid-1970s should have led to an increased demand for married women's labour, while married women's employment in Southern Europe should have been fairly relatively unaffected during the same period because these countries had not experienced an economic boom, but on the contrary, an emigration of male workers to Northern Europe. A modified version of the 'reserve army' thesis might be applied to former socialist countries of Central and Eastern Europe, where there was a chronic shortage of workers and women were continuously being stimulated to participate in paid work.

The 'labour flexibility' hypothesis on the other hand contends that part-time work as the dominant form of 'atypical' or 'non-standard' employment is to a large extent the result of employment shortages. Unemployment makes unions weak and employers powerful, leading to deregulation of hiring and lay-off practices and to more flexible work arrangements of all kinds. Low levels of overall demand for labour should therefore increase the level of part-time work in all countries. This should be the case in Southern European countries after the end of the Second World War up to the early 1970s, and in all Western European countries and in the USA during the economic crisis of the 1980s and early 1990s. Similarly, the former socialist countries in Central and Eastern Europe are expected to produce more part-time work in their transition from socialism to capitalism. This is because these countries are experiencing a steep increase in unemployment and an unprecedented 'deregulation' of employment conditions, affecting the possibilities for part-time work of all types of workers.

So far, we have two explanations for an increase in women's part-time employment in the post-war period: too little or too much labour relative to jobs (Rosenfeld and Birkelund, 1995). However, the implication of the 'reserve army' thesis is that full-time and part-time work should gain importance primarily for married women (with children) who try to recon-

cile market work with family roles; while the implication of the labour flexibility thesis is that part-time work should generally be a more widespread phenomenon in the labour market, affecting all different kinds of workers in more or less the same way, men and women, and people of all ages. Of course, part-time work will always be particularly attractive for certain groups of men and women who give priority to some other non-market activity (for example students, pensioners, or mothers) and therefore constitute a qualitatively different workforce (as argued by Hakim in Chapter 2). But according to the labour flexibility thesis, part-time work should not be particularly related to the family cycle and married women with small children should not be a very special group among the part-time employed.

Women's Labour-Force Participation and Changes in the Structure of Occupations and Industries

Many researchers stress that changes in women's (part-time) work are not only a matter of increases or decreases in the overall level of employment, but more importantly, a consequence of the expansion of certain types of jobs in modern societies. Official statistics for Western European countries and the USA in recent decades display an impressive similarity in three trends of change in the occupational structure (Erikson and Goldthorpe 1992):

(1) there has been an impressive shift away from manual and productive jobs to non-manual service and administrative jobs;
(2) the greatest drop in manual employment has been for semi-skilled and unskilled workers and less for skilled workers; and
(3) the greatest increase in non-manual employment has not been in unskilled jobs,[1] but in skilled commercial and administrative positions, skilled services, the semi-professions, and professions.

Both the upward shift in the skill structure of jobs and the specific nature of administrative and service jobs make it increasingly less likely that mechanization or the use of unqualified foreign workers can be used to solve labour demand problems in modern service societies. The 'post-industrial society' hypothesis states therefore that more and more jobs within the service industries can or must be provided by part-time workers (Rosenfeld and Birkelund, 1995). Given a high level of sex segregation in the labour market in modern societies, part-time jobs seem to be a unique solution to employment for (married) women (with children) (Hakim,

[1] There has been no growth in the total volume of work at the unskilled level end of the labour market, although the increase in part-time jobs at this level gives that impression.

1992; 1993*b*), particularly during periods of economic boom, when women might function as a 'reserve army'. One can therefore presume that in Northern European countries high levels of part-time work have been the result and have resulted in increasing levels of occupational segregation particularly during times of strong economic growth (Blossfeld, 1987; Hakim, 1993*b*). Furthermore, according to the 'public-sector' hypothesis (Esping-Andersen, 1990; 1993), this trend should have been reinforced during the 1960s and 1970s by the growth of the welfare state in all Northern European capitalistic countries, especially in Scandinavia, because the public sector provides an attractive labour market for female part-time work. Conversely, employment stagnation in the welfare states of Northern Europe (Becker and Blossfeld, 1991), starting in the early 1980s, should have had a depressing impact on the incidence of female part-time work in these societies.

In terms of part-time work, this development in Northern Europe should contrast sharply with long-term trends in most Southern European countries and former socialist countries of Central and Eastern Europe. Most Southern European countries did not have a steep economic boom in the 1960s and 1970s and therefore could only experience a much weaker, delayed, and then less intensive trend towards a post-industrial society in general and in public-sector employment in particular. Thus, in these countries there has not only been a lower overall demand for women's labour in the 1960s and 1970s but also, and partly as its consequence, a far slower change in the occupational structure. Compared to Northern European countries, female part-time work should therefore be less important in Southern Europe; and we expect it to be much more related to women's traditional role as (unpaid) family workers in agriculture and other small businesses.

Finally, the former socialist countries of Central and Eastern Europe present a special case. In these countries, the trend towards post-industrial society has been comparatively weak until the end of the 1980s because of strict regulation of hiring and lay-off practices resulting in high job security and a remarkable occupational stability. However, after the breakdown in socialist regimes there has been a massive restructuring of occupations in these countries so that one can expect these countries to gradually catch up in their occupational structure with Western capitalistic economies. Drobnič (in this volume) therefore predicts that part-time work in these countries will further increase in the late 1990s based on a swiftly expanding service sector.

Changes in the Supply of Women's Labour in Modern Societies during the Post-War Period

There also have been important changes in female labour supply in the post-war period. In all European countries and in the USA, women have

experienced major increases in the average educational attainment level across cohorts (Shavit and Blossfeld, 1993), shifts in the process of family formation, dramatic changes in fertility as well as household structure over the life-course (Blossfeld, 1995), and significant declines in retirement age.

According to the 'thesis of educational investments', better qualified women are more likely to be continuously full-time employed over the life-course, and if they interrupt their employment career because of family events (marriage or childbirth), they will re-enter part-time and full-time employment more quickly. Thus, educational expansion is expected to increase the supply of female full-time and part-time workers over all phases of the family cycle, across cohorts, and in all modern societies. However, the longer women remain in school, the more they will also delay their entry into first full-time work over the life-course. Thus, the 'thesis of extended educational participation' (Blossfeld, 1995) contends that across birth cohorts, the proportion of younger (single) women working full-time declines, while the proportion of younger men and women working part-time increases because part-time work is much more compatible with the activities of a student.

Since women continue to have primary family responsibilities in modern societies, changes in family events are important determinants of women's labour-force participation. In Europe and the USA, the trend towards early marriage observed for the first two-thirds of the century has been reversed, with age at first marriage now rising much faster than it fell during the previous period (Blossfeld, 1995). Most of these countries are also faced with low levels of fertility and an increasing age at entry into first motherhood across age cohorts (Blossfeld, 1995). Increasing divorce rates (Blossfeld *et al.*, 1995) and a rise of consensual unions before marriage (Blossfeld, Manting, and Rohwer, 1994), made previously rare family types such as female-headed families and *de facto* unions increasingly common in Europe and the USA. These developments lead to a continuous re-evaluation of the role of women in modern society and to an increasing supply of women's part-time and full-time work in all phases of the family cycle, that is, the 'thesis of the declining importance of the family cycle'. However, there are marked differences between Western European countries in terms of the distribution of household types, the age when children leave the parental home, the proportion and significance of consensual unions, the fertility rate, the stability of marriage, and the rate of entry into remarriage. An international comparison (Blossfeld, 1995) of changes in family systems shows that Sweden has led the way in terms of marriage and first motherhood age, the level of fertility (which was first declining and then has been rising again since the mid-1980s), the incidence of consensual unions (which have become more or less universal), as well as

divorce rates (which are falling slightly today after a steep and continuous rise over 30 years); the other Northern European capitalist countries and the USA appear to follow this trend with a delay of about fifteen years. In the Southern European countries, however, the family system is still fairly 'conventional' or 'traditional': consensual unions and divorce rates are comparatively low and marriage is still an important event. However, during the 1980s, the fertility rate fell sharply in these countries and non-marital unions as well as divorces are continuously rising, especially among the younger age groups. This may be an indication that Southern European countries might also experience an important transformation of the family system—albeit at a lower differentiation level and with a delay of about two decades compared to the North (Blossfeld, 1995). These results suggest a 'North-South lag' hypothesis in the importance of family cycle events influencing employment–family linkages and conserving a greater sexual division of labour which still leads most wives to concentrate their activities on the home and family.

Finally, in all modern Western societies, retirement ages for men and women have fallen over time, increasing the number of healthy elderly people who can seek to supplement their pensions through income based on part-time work ('the thesis of the increasing importance of pensioners').

Women's Employment and Broader Political and Ideological Country Contexts

In this volume, the most important insights with regard to the development of female part-time work in the post-war period result from our case-study approach, showing how common trends in labour demand and female labour supply have been suppressed or sustained by broader political and ideological country contexts and hence have produced quite diverse tempos and hetero-geneous patterns of female (part-time) employment over time. Although each country studied in this book has a specific pattern of female part-time work, it is possible to formulate general statements about how various packages of family, employment, and welfare policies increase or decrease the costs of women's part-time work as compared to full-time work or non-employment. Partly following Esping-Andersen (1990; 1993), we distinguish six main clus-ters of societies that are supposed to produce quite different developments of women's (part-time) employment in the post-war period.

First, there are the Scandinavian social democratic welfare-state regimes, which emphasize the principle of egalitarianism and seek to reduce class and gender inequalities (Esping-Andersen, 1990). Government policies pro-actively seek to integrate women into the labour force, utilizing employ-ment policy, fiscal policy, and regulations within the social welfare system to radically alter women's choices in favour of employment and against

economic dependence on a husband, as noted in Chapter 11 on Sweden by Sundström and in Chapter 10 by Rohwer and Leth-Sørensen on Denmark. Social democratic welfare states require and advocate greater state expenditure which increases the public-sector workforce (Esping-Andersen, 1990). The organizational power of labour is a major force behind the development of these regimes, which could explain why part-time work shows fewer signs of being a marginal employment relationship (Ellingsaeter, 1992). We thus expect that this political-institutional framework supports women's work, and perhaps full-time work in particular.

Second, there are the 'liberal' welfare-state regimes in Britain and the USA, emphasizing the principle of individual freedom. They accept the distributional consequences of market forces in terms of class and gender inequalities and do little to stimulate married women's labour supply in particular (Esping-Andersen, 1990). The relatively unregulated labour market tends to create a high proportion of low grade, semi-skilled, and unskilled (part-time) jobs with low pay, poor employment benefits and prospects. The proportion of the workforce in the public sector is much lower than in social democratic welfare states. We would thus expect that the framework of 'liberal' welfare states encourages employers to create more precarious forms of part-time work. In addition, government policies are dominated by means-tested assistance, modest universal transfers, and modest social-insurance plans. Beyond such major similarities in the institutional structure, there are also well-known differences in the ways that women are able to combine paid employment and child-bearing in Britain and the USA (Dex and Shaw, 1986). As Chapter 9 by Burchell, Dale, and Joshi shows, British society has seen women's primary task much more in the family, stimulating more the combination of paid employment and non-market activities than full-time employment of mothers. In Britain, many mothers actively seek jobs in the educational sector, whether part-time or full-time, to benefit automatically from term-time working arrangements that allow them to spend time at home with their children during the school holidays. Chapter 12 by Drobnič and Wittig notes that in the USA most employers pay for health insurance for full-time workers, but only few provide insurance for part-time employees. Given the escalating costs of health care in modern societies, this might constitute a major part of American women's greater preference for full-time work. To British women, health care is not an incentive to work full-time as they receive it free (Dex and Shaw, 1986). Another reason to expect more American mothers to work full-time than British mothers is that they are able to offset at least some of any childcare expenses against tax (Dex and Shaw, 1986).

Third, the Netherlands and West Germany may be considered conservative welfare states, supporting wives and mothers who give priority to family activities (Esping-Andersen, 1990). National policies generally

favour wives' economic dependence on their husbands, and stimulate mother's choices for non-employment against part-time work, and part-time work against full-time employment. Conservative welfare states typically provide low levels of childcare and daycare services for older children. For example, in Germany the school day finishes in time for children to go home for lunch, so that jobs with only very short daily hours in the mornings become attractive to mothers. As noted in Chapter 7 by Blossfeld and Rohwer, German dual full-time earner marriages are also punished by the tax system which privileges wives' non-work or part-time work. In conservative welfare states the labour market is, however, far more regulated than in 'liberal' ones; and also the proportion of the public-sector workforce is much higher. Thus, in conservative welfare states many part-time jobs tend to be better protected and the proportions of marginal jobs should be lower. An interesting difference between Germany and the Netherlands in the expansion of women's part-time work is discussed in Chapter 8 by De Graaf and Vermeulen. They note that there has been a delay of about a decade in the expansion of women's part-time work in the Netherlands because of the ideological system of pillarization in the 1950s and 1960s. During this period the public discourse of conflicting religious and political groups resulted in an enforcement of traditional family roles with high levels of fertility. Since the early 1970s the influence of churches and of religion has declined rapidly, opening the way to more tolerant public attitudes to the labour-market participation of wives and mothers.

Fourth, in France the country context has a special influence on the employment–family linkage (Kempeneers and Lelièvre, 1991). In France, public discourse has been concerned with the population question and the government seeks pro-actively to increase fertility. While in many other countries like Britain, West Germany, or the Netherlands the dominant ideology has been that the mother's place is at home, in France an opposite attitude has been adopted (Gauthier, 1992). French national policies have not sought to dissuade women from joining the labour force as full-time workers, but to reduce the obstacles to fertility for working women. France has developed one of the most sophisticated provisions of childcare services in Europe: daycare centres and home-based nannies (government-licensed workers who take care of other working mother's children in their own homes) enable mothers to work full-time. France also provides evidence that the organization of weekly school hours and the school year can have an enormous impact on the types of full-time and part-time job that are attractive to mothers in facilitating the combination of employment and family responsibilities. Coutrot, Fournier, Kieffer, and Lelièvre note in Chapter 6 that in France reduced hours at 80 per cent of a normal working week are attractive, given that children do not attend school on Wednesdays and many mothers prefer to be at home on this day of the

week. However, one would expect that in the French context, where ideo-
logy supports full-time work for wives and mothers, part-time work might
more often be involuntary.

Fifth, the countries of Southern Europe also share common features.
The most important characteristics seem to be that these countries had a
'lagged position' in the transition from an agricultural to an industrial
economy and that most of these countries missed the steep economic
growth from the late 1950s until the mid-1970s. This unprecedented eco-
nomic growth in Northern Europe transformed the agricultural-industrial
labour markets into service economies, the 'traditional' or 'conventional'
family systems into 'highly differentiated and modernized' ones and the
democratic states into different types of welfare states. Thus, in Southern
European countries, labour-market structures, family systems, and the
(welfare) state lag behind the developments in the North of Europe. For
long periods, national policies in Greece (see Chapter 4 by Symeonidou)
and Italy (see Chapter 5 by Addabbo) continued to support the existing
sexual division of labour which led most wives to concentrate their ener-
gies on the home and family. We would thus expect these countries to have
preserved traditional forms of family life and encouraged wife's non-work
over part-time work and full-time work. Only in the 1980s did government
policies gradually start to influence women's work patterns in a different
direction. For example, Italy introduced a law to legitimate part-time work
(see Chapter 5) and childcare leave periods have been extended in Greece
(see Chapter 4).

Sixth and finally, the political and ideological country context in the for-
mer socialist countries of Central and Eastern Europe differed profoundly
from Western capitalist economies. A far-reaching redistribution of
resources, egalitarian policy with regard to class and gender, and the ideo-
logy of equality of conditions were the main principles explicitly pursued
by state socialist countries. As shown by Drobnič in Chapter 3, work
arrangements in these countries can tentatively be described as standard
forms of employment, with life-long, secure, permanent, full-time jobs.
Part-time work was not considered a typically female phenomenon. It was
used to increase labour input, or to keep in the labour force persons who
otherwise were normally excluded from the labour market, such as pen-
sioners and disabled persons. These countries set up a comprehensive and
relatively generous system of family benefits, including lengthy periods of
paid maternity and childcare leaves. The common employment pattern was
based on a two full-time earner family model, and full-time re-employment
of women after childbirth. Thus, part-time work was not considered to be
a typically female phenomenon. After the breakdown of the socialist
economies in Central and Eastern Europe, legal possibilities for fixed-term
employment and part-time work have been broadened considerably in

these countries. We would thus expect that precarious, less-protected or even non-protected forms of employment will rapidly increase in these transition countries (see Chapter 3).

Variations in the country-specific organization of women's (part-time) work are rarely captured by national surveys, which typically simply record the hours worked per week or even rely on simple self-classification as a full-time or part-time worker; such data are therefore never analysed in cross-national comparative studies. Research surveys are only slowly being modified to collect appropriate information on the diverse features of non-standard forms of employment as well as on the conventional full-time permanent employee job. This means that cross-national variations in the character of part-time work, and in female employment more generally, often remain hidden or implicit, or have to be assumed, in the country analyses which follow.

Table 1.1 presents key employment indicators for the USA, for the European countries included in the analysis, and for other European Union (EU) countries excluded from this study, ranked by the percentage of part-timers in the female workforce. The analysis covers the four largest countries within the European Union: Germany, Britain, France, and Italy together account for 102 million workers or 70 per cent of the EU workforce. Between them, they also provide a good cross-section of Northern and Southern European societies, of highly regulated and relatively unregulated labour markets, of countries with a long tradition of female employment and those where the dependent housewife and breadwinner husband model of the family still meets with wide support. Female employment rates range from a low of 36 per cent in Italy to 60 per cent in the UK, almost double the lower rate. The incidence of part-time work similarly varies from only 12 per cent in Italy to 44 per cent in the UK, although the incidence of male part-time work is more constant in this group of countries, within the range 3 to 7 per cent. The features of the part-time workforce in these four largest EU countries are analysed by Addabbo in Chapter 5, showing that the contrasts are greatest in the service sector but much smaller in agriculture and manufacturing industry. In the service sector, part-time workers' share of employee jobs remains at a low of 5 per cent in Italy, rises to 16 per cent in France, 22 per cent in West Germany, and to 30 per cent of the employee workforce in Britain. These contrasts are repeated in the female workforce (see Table 5.9).

Four of the smaller EU countries are included, in particular those with the highest and lowest levels of part-time working in Western Europe. In this group of smaller countries, we again have a good cross-section of Northern and Southern European societies, of countries with high and low female employment, and of labour markets which offer very few or a great many part-time jobs to women and men (Table 1.1). In the Netherlands,

fully 66 per cent of all working women are in part-time jobs, along with 16 per cent of male workers. In Sweden, 41 per cent of working women classify themselves as part-timers (some working only slightly reduced hours) as do 9 per cent of working men. Denmark has only a moderate level of part-time work among women, along with Germany, but one of the highest levels of part-time work among men, at 10 per cent of the total. Finally Greece rounds off the group with the lowest level of part-time working among women in the EU.

To put these Western European countries in perspective, Table 1.1 presents data for the seven EU countries excluded from the analysis. Apart from Spain and Luxembourg, with exceptionally low and high overall employment rates, the excluded countries generally fall within the range of employment characteristics illustrated by the eight countries selected for the analysis. Similarly, employment rates and part-time work in the USA, Poland, Slovenia, and Hungary do not present any special characteristics, being well within the range for Western Europe, but they are otherwise very different labour markets.

Plan of the Book

Chapter 2 examines part-time work, and the explanations offered for it, in relation to Europe and Western industrial society generally, drawing on the country reports in this volume as well as other sources. Chapters 3 to 12 then present country reports, starting with a single chapter on Eastern European countries, moving north and eastwards to finish with the USA. Chapter 13 synthesizes the results, paying particular attention to the issue of women's part-time employment across the life-cycle, the findings from longitudinal analyses, and the impact of national labour-market, social, and economic policies.

Given disparities in the data available for each country, only broader contrasts can be drawn between societies, and the effects of particular factors cannot be isolated and proven conclusively. None the less, comparisons of part-time work across these dozen labour markets contribute a new understanding of how part-time work can take qualitatively different forms in different countries, leading to conflicting accounts for employment practices that share an umbrella label, but often little else.

REFERENCES

Bäcker, G. and Stolz-Willig, B. (1993), 'Teilzeit—Probleme und Gestaltungschancen' ('Problems of Part-Time Work and Opportunities for Change'), *WSI* (1993–9), 545–53.

Beck-Gernsheim, E. (1985), 'Vom "Dasein für andere" zum Anspruch auf ein Stück "eigenes Leben": Individualisierungsprozesse im weiblichen Lebenszusammenhang' (' From "Being there for Others" to Having a Right to One's Own Life'), *Soziale Welt*, 36: 307–40.

Becker, G. S. (1981), *A Treatise on the Family* (Cambridge, Mass.: Harvard University Press).

—— (1985), 'Human Capital, Effort and the Sexual Division of Labour', *Journal of Labor Economics*, 3: S33-S58; reprinted in id, *A Treatise on the Family—Enlarged Edition* (Cambridge Mass.: Harvard University Press), pp. 54–79.

—— Landes, E. M. and Michael, R. T. (1977), 'An Economic Analysis of Marital Instability', *Journal of Political Economy*, 85: 1141–87.

Becker, R. and Blossfeld, H.-P. (1991), 'Cohort-Specific Effects of the Expansion of the Welfare State on Job Opportunities: A Longitudinal Analysis of Three Birth Cohorts in the Federal Republic of Germany', *Sociologische Gids* (1991–4), 261–84.

Beechey, V. and Perkins, T. (1987), *A Matter of Hours: Women's Part-Time Work, and the Labor Market* (Cambridge: Polity Press).

Bernhardt, E. M. (1993), 'Fertility and Employment', *European Sociological Review*, 9: 25–42.

Blossfeld, H.-P. (1986), 'Career Opportunities in the Federal Republic of Germany: A Dynamic Approach to the Study of Life-Course, Cohort, and Period Effects', *European Sociological Review*, 2: 208–25.

—— (1987), 'Labor Market Entry and the Sexual Segregation of Careers in the Federal Republic of Germany', *American Journal of Sociology*, 93: 89–118.

—— (1989), *Kohortendifferenzierung und Karriereprozeß—Eine Längsschnittanalyse über die Veränderung der Bildungs- und Berufschancen im Lebenslauf* ('Differences between Cohorts and the Career Process'), (Frankfurt a. M. and New York: Campus Verlag).

—— (1995) (ed.), *The New Role of Women: Family Formation in Modern Societies* (Boulder, Colo.: Westview Press).

—— and Huinink, J. (1991), 'Human Capital Investments or Norms of Role Transition? How Women's Schooling and Career Affect the Process of Family Formation', *American Journal of Sociology*, 97: 143–68.

—— and Rohwer, G. (1995), *Techniques of Event History Modeling: New Approaches to Causal Analysis* (Mahwah, NJ: Lawrence Erlbaum).

—— Manting, D., and Rohwer, G. (1994), 'Patterns of Change in Family Formation in the FRG and the NL: Some Consequences for Solidarity between Generations', in H. Becker and P. L. J. Hermkens (eds.), *Demographic, Economic and Social Change, and Its Consequences* (Amsterdam: Thesis Publisher), pp. 175–96.

—— De Rose, A., Hoem, J., and Rohwer, G. (1995), 'Education, Modernization, and the Risk of Marriage Disruption in Sweden, West Germany, and Italy', in K. O. Mason and A.-M. Jensen (eds.), *Gender and Family Change in Industrialized Countries* (Oxford: Clarendon Press), pp. 200–22.

Booth, A. S., Johnson, D. R., and White, L. (1984), 'Women's Outside Employment, and Marital Instability', *American Journal of Sociology*, 90: 567–83.

Büchtemann, C. F. and Quack, S. (1990), 'How Precarious is "Non-Standard" Employment? Evidence for West Germany', *Cambridge Journal of Economics*, 14: 315–29.

Carley, M. (ed.) (1990), *Non-Standard Forms of Employment in Europe*, European Industrial Relations Review Report No. 3 (London: EIRR).

Chafetz, J. (1990), *Gender Equity: An Integrated Theory of Stability and Change* (Newbury Park, Calif.: Sage).

Curtis, R. F. (1986), 'Household and Family in Theory on Inequality', *American Sociological Review*, 51: 168–83.

Dale, A. and Joshi, H. (1992), 'The Economic and Social Status of British Women', in K. Schwarz (ed.), *Frauenerwerbstätigkeit—Demographische, soziologische, ökonomische und familienpolitische Aspekte*, Materialien zur Bevölkerungswissenschaft, vol. 77 (Wiesbaden), pp. 97–122.

Dex, S. (1990), 'Goldthorpe on Class and Gender: The Case Against', in J. Clark *et al.* (eds.), *John H. Goldthorpe: Consensus and Controversy* (London: Falmer Press), pp. 135–52.

—— and Shaw, L. B. (1986), *British and American Women at Work: Do Equal Opportunities Policies Matter?* (London: Macmillan).

Ebbing, U. (ed.) (1992), *Aspects of Part-Time Working in Different Countries*, SAMF-Arbeitspapier 1992–7 (Gelsenkirchen).

Ellingsaeter, A. L. (1992), *Part-Time Work in European Welfare States: Denmark, Germany, Norway and the United Kingdom Compared*, Institute for Social Research, Oslo, Report 92:10.

Engelbrech, G. (1987), 'Erwerbsverhalten und Berufsverlauf von Frauen: Ergebnisse neuerer Untersuchungen im Überblick' ('Employment Behaviour and Job Careers of Women'), *Mitteilungen aus der Arbeitsmarkt- und Berufsforschung*, 20: 181–96.

Erikson, R. and Goldthorpe, J. H. (1992), *The Constant Flux: A Study of Class Mobility in Industrial Societies* (Oxford: Oxford University Press).

Ermisch, J. F. (1988), *Economic Influences on Birth Rates* (London: National Institute for Economic and Social Research).

Esping-Andersen, G. (1990), *The Three Worlds of Welfare Capitalism* (Cambridge: Polity Press/Princeton, NJ: Princeton University Press).

—— (ed.) (1993), *Changing Classes* (London and Newbury Park, Calif.: Sage).

European Commission (1994), *Employment in Europe 1994* (Luxembourg: Office for Official Publications of the European Communities).

Gauthier, A. H. (1992), 'The Western European Governments' Attitudes and Responses to the Demographic and Family Questions', paper presented at the European Science Foundation Conference, St Martin (Germany), November 1992.

Goldthorpe, J. H. (1983), 'Women and Class Analysis: in Defence of the Conventional View', *Sociology*, 17: 465–88.

Hakim, C. (1987), *Research Design: Strategies and Choices in the Design of Social Research* (London: Allen & Unwin/Routledge).

—— (1991), 'Grateful Slaves and Self-Made Women: Fact and Fantasy in Women's Work Orientations', *European Sociological Review*, 7: 101–21.

Hakim, C. (1992), 'Explaining Trends in Occupational Segregation: The Measure-

ment, Causes and Consequences of the Sexual Division of Labour', *European Sociological Review*, 8: 127–52.

—— (1993a) 'The Myth of Rising Female Employment', *Work, Employment and Society*, 7: 97–120.

—— (1993b) 'Segregated and Integrated Occupations: A New Framework for Analysing Social Change', *European Sociological Review*, 9: 289–314.

—— (1996a) *Key Issues in Women's Work: Female Heterogeneity and the Polarisation of Women's Employment* (London: Athlone Press).

—— (1996b) 'Labour Mobility and Employment Stability: Rhetoric and Reality on the Sex Differential in Labour-Market Behaviour', *European Sociological Review*, 12: 1–31.

—— (1996c) 'The Sexual Division of Labour and Female Heterogeneity', *British Journal of Sociology*, 47: 178–88.

Hammond, J. H. (1987), 'Wife's Status and Family Social Standing', *Sociological Perspectives*, 30: 71–92.

Hannan, M. T., Schömann, K., and Blossfeld, H.-P. (1990), 'Sex and Sector Differences in the Dynamics of Wage Growth in the Federal Republic of Germany', *American Sociological Review*, 55: 694–713.

Hinrichs, K. (1990), *Irregular Employment and the Loose Net of Social Security: Some Findings on the West German Development*, Centre for Social Policy Research, Bremen, working paper no. 7/90.

Joshi, H. and Hinde, P. R. A. (1991), 'Employment after Child-bearing: Cohort Study Evidence', NCDS Discussion Paper 35, Social Statistics Research Unit, City University, London.

Keller, B. and Seifert, H. (1993), 'Regulierung atypischer Beschäftigungs-verhältnisse' ('Regulation of Atypical Work'), *Wirtschafts- und Sozialwissenschaftliches Institut des Deutschen Gewertschaftsbundes*, 11: 538–45.

Kempeneers, M. and Lelièvre, E. (1991), 'Employment and Family within the Twelve', *Eurobarometer*, no. 34, DGV (Brussels: European Commission).

Krüger, H. and Born, C. (1991), 'Unterbrochene Erwerbskarrieren und Berufsspezifik: Zum Arbeitsmarkt und Familienpuzzle im weiblichen Lebensverlauf' ('Interrupted Employment Careers and Occupations'), in K. U. Mayer, J. Allmendinger, and J. Huinink (eds.), *Vom Regen in die Traufe: Frauen zwischen Beruf und Familie* ('Women between Employment and Family') (Frankfurt a. M. and New York: Campus Verlag), pp. 142–62.

Lauterbach, W. (1993), *Erwerbsverläufe von Frauen* ('Employment Careers of Women'), (Ph.D. thesis, Berlin: Free University).

—— Huinink, J., and Becker, R. (1993), *Erwerbsbeteiligung und Berufschancen von Frauen. Theoretische Ansätze, methodische Verfahren und empirische Ergebnisse aus der Lebensverlaufsperspektive* ('Employment Participation and Job Opportunities of Women') (mimeo; University of Konstanz; University of Dresden).

Layard, R. and Mincer, J. (eds.) (1985), *Trends in Women's Work, Education and Family Building*, Supplement to the *Journal of Labour Economics*, 3: S1–S390.

McRae, S. (1990), 'Women and Class Analysis', in J. Clark *et al.* (eds.) *John H Goldthorpe: Consensus and Controversy* (London: Falmer Press), pp. 117–33.

Marsh, C. (1991), *Hours of Work of Women and Men in Britain* (London: HMSO).

Meulders, D., Plasman, O., and Plasman, R. (1994), *Atypical Employment in the EC* (Aldershot, Hants: Dartmouth).

Möller, C. (1988), 'Flexibilisierung—Eine Talfahrt in die Armut: Prekäre Arbeitsverhältnisse im Dienstleistungssektor' ('Increasing Flexibility: A Road to Poverty'), *Wirtschafts- und Sozialwissenschaftliches Institut des Deutschen Gewerkschaftsbundes*, 8: 466–75.

Mückenberger, U. (1985), 'Die Krise des Normalarbeitsverhältnisses' ('The Crisis of the Standard Working Relationship'), *Zeitschrift für Sozialreform*, (1984–7), 415–33 and (1985–8), 457–74.

Oppenheimer, V. K. (1970), *The Female Labor Force in the United States: Demographic and Economic Factors Governing Its Growth and Changing Composition*, Population Monograph Series, Department of Demography, University of California, Berkeley.

—— (1988), 'A Theory of Marriage Timing', *American Journal of Sociology*, 94: 563–91.

Osborn, A. F. (1987), 'Assessing the Socio-Economic Status of Families', *Sociology*, 21: 429–48.

Pahl, R. E. (1984), *Divisions of Labour* (Oxford: Basil Blackwell).

Pfau-Effinger, B. and Geissler, B. (1992), 'Institutionelle und sozio-kulturelle Kontextbedingungen der Entscheidung verheirateter Frauen für Teilzeitarbeit' ('Institutional and Sociocultural Contexts of Married Women's Decisions to Work Part-Time'), *Mitteilungen aus der Arbeitsmarkt- und Bernfsforschung*, 25: 358–70.

Quack, S. (1993), *Dynamik der Teilzeitarbeit* ('Dynamics of Part-Time Work') (Berlin: Edition Sigma).

Rodgers, G. and Rodgers, J. (eds.) (1989), *Precarious Jobs in Labor Market Regulation: The Growth of Atypical Employment in Western Europe* (Geneva: International Labour Office).

Rosenfeld, R. A. and Birkelund, G. E. (1995), 'Women's Part-Time Employment: A Cross-National Comparison', *European Sociological Review*, 11: 111–34.

Semlinger, K. (ed.) (1991), *Flexibilisierung des Arbeitsmarktes: Interessen, Wirkungen, Perspektiven* ('Increasing the Flexibility of the Labour Market: Interests, Outcomes, and Perspectives') (Frankfurt a. M. and New York: Campus Verlag).

Shavit, Y. and Blossfeld, H.-P. (1993), *Persistent Inequality: Changing Educational Attainment in Thirteen Countries* (Boulder, Colo.: Westview Press).

Siltanen, J. (1994), *Locating Gender: Occupational Segregation, Wages and Domestic Responsibilities* (London: UCL Press).

Sørensen, A. (1989), *Economic Independence, Economic Equality and Divorce*, Harvard University, Cambridge, Mass. and Max-Planck-Institut für Bildungsforschung, Berlin (mimeo).

—— (1990), *Gender and the Life Course*, Harvard University, Cambridge, Mass. and Max-Planck-Institut für Bildungsforschung, Berlin (mimeo).

Thomson, L. and Walker, A. J. (1989), 'Gender in Families: Women and Men in Marriage, Work, and Parenthood', *Journal of Marriage and the Family*, 51: 845–71.

2

A Sociological Perspective on Part-Time Work

CATHERINE HAKIM

Throughout Europe, and in most OECD countries, part-time work has been expanding, along with other types of non-standard employment. There are large differences between countries in national levels of part-time work at the start of the increase, and in the size and longevity of the increase. In Sweden and Denmark, where high female economic activity rates have reached saturation levels, there is little or no further growth in part-time work and even some switching back to full-time jobs instead. In Greece, Italy, and Spain, women's employment remains at relatively low levels, irrespective of hours worked, as shown in Table 1.1. But in most countries the common experience is of growth in what has until recently been regarded as a somewhat uninteresting or irrelevant labour-market minority group. There are three features of the new part-time jobs that are now attracting closer attention: part-time jobs are growing faster than and sometimes replacing full-time jobs in the workforce; they are part of a broader trend towards diverse forms of non-standard or atypical employment contract and working hours; and they are most commonly taken up by women (Dahrendorf, Kohler, and Piotet, 1986; Beechey and Perkins, 1987; Jenson, Hagen, and Reddy, 1988; Boyer, 1989; Lane, 1989; ILO, 1989; Rodgers and Rodgers, 1989; Dale and Glover, 1990; Hakim, 1990a; 1990b; Hepple, 1990; OECD, 1990; 1994; 1995; Duffy and Pupo, 1992; Gladstone, 1992; Meulders, Plasman, and Vander Stricht, 1993; Bosch, Dawkins, and Michon, 1994; Meulders, Plasman, and Plasman, 1994;

I thank OPCS for allowing me to use the OPCS 1% Longitudinal Study and members of the LS Support Programme at the Social Statistics Research Unit (SSRU), City University, in particular Simon Gleave, for assistance with accessing the data used for Tables 2.4 and 2.5. I am indebted to Søren Leth-Sørensen in Danmarks Statistik for making available a quantity of unpublished data on labour mobility in Denmark, including the analyses which formed the basis for Table 2.6 of this chapter. I thank Sheila Jacobs for making available tables from her unpublished D.Phil. thesis, including the analyses which formed the basis for Table 2.7 of this chapter. I thank the European Commission and the OECD for permission to reproduce Figs. 2.1 and 2.2 from their publications.

McRae, 1995; Nätti, 1995; Rosenfeld and Birkelund, 1995; Wedderburn, 1995; Rojot and Blanpain, 1997).

In the European Community as a whole one-third of all jobs are non-standard in some way; however almost half of all working women are in non-standard jobs compared to less than a third of men (Table 2.1). This is in marked contrast to the exclusive emphasis on permanent full-time jobs for men and women in centrally planned economies, as noted by Drobnič in Chapter 3. Part-time work is the most widespread and important of the new varieties of atypical work. In part, this is because the term applies to many different work arrangements that require less than the 'standard' working week of about 40 hours, including vertical and horizontal part-time work described by Addabbo in the report on Italy in Chapter 5 (see also Wedderburn, 1995; Hepple and Hakim, 1996).

Three Types of Part-Time Job

Legal definitions of part-time work display endless variation—between countries, between industries, and between occupations (Rojot and Blanpain, 1997), going well beyond the variation in statistical definitions (OECD, 1995: 211). For example, in Germany a person is classified as a part-time worker if the contractual working time is less than that of full-time workers, which is generally specified in collective agreements, and in the mid-1990s varied from 35 to 40 hours a week. However, only people working more than 18 hours a week have the benefit of all social insurances in Germany. In France, part-time workers are those working one-fifth shorter hours than the normal working time or the legally allowed maximum of 39 hours or any lesser number of hours specified in collective agreements. Such definitions can be important for interpreting national statistics correctly, especially if they are supplied by employers. But they are also misleadingly narrow: new forms of employment contract allow part-time work without the term being applied. For example zero-hours contracts and annual hours contracts can lead to part-time hours being worked at particular times of the year or throughout the year, producing some overlap with seasonal work. For a social scientific analysis we need a conceptual framework which differentiates the main types of part-time work and helps us to understand the attractions of part-time work to employer and to worker. As I have argued elsewhere (Hakim, 1993*b*: 291; forthcoming), ideally we should distinguish three distinct types of part-time work, which exhibit differential rates of growth and do not exist in all countries, as is evident from the distributions of working hours across Europe shown in Fig. 2.1.

TABLE 2.1. *Standard and non-standard jobs in the European Community, 1987*

	Men in employment		Women in employment		All in employment	
	Full-time permanent employees	All other workers	Full-time permanent employees	All other workers	Full-time permanent employees	All other workers
Luxembourg	87	13	71	29	81	19
West Germany	77	23	53	47	68	32
Netherlands	77	23	40	60	64	36
Belgium	77	23	57	43	70	30
United Kingdom	76	24	48	52	64	36
France	74	26	62	38	69	31
Denmark	69	31	45	55	59	41
Italy	66	34	65	35	65	35
Ireland	63	37	71	29	66	34
Spain	60	40	49	51	57	43
Portugal	58	42	50	50	55	45
Greece	42	58	38	62	41	59
European Community	71	29	54	46	64	36

Source: Extracted from Hakim, 1990*a*: Table 2, based on Eurostat LFS data.

1. Reduced hours work, with weekly hours a little shorter than usual, such as 30–6 or 30–9, is often organized in response to an employee's request. It is thus more of a personal choice, involves no change of occupation or employer, and is expected to be of limited duration, with the worker returning to full-time hours, when children have reached a certain age, for example. Tilly (1991: 11) calls these jobs 'retention jobs', noting that they are still rare in the USA. However, reduced hours work is the dominant form in Sweden, as Sundström notes in Chapter 11, and it is treated as a distinct category in France, as Coutrot *et al.* note in Chapter 6. Many so-called 'part-timers' in Sweden and Denmark are working 30 hours a week (6 instead of 8 hours a day, for example) and would be classified as full-time workers in Finland, Britain, and other countries. In Norway, the def-inition of part-time work was changed in 1989: part-time employees are those working less than 37 hours a week, with the exception of those work-ing 30–6 hours a week who classify themselves as full-timers (Nätti, 1995: 355).

2. Half-time jobs of around 15–29 hours a week are a dominant type in Britain, Germany, France, and Belgium (Fig. 2.1). Half-time jobs are more likely to be organized by the employer on a permanent basis, with people recruited directly and specifically for these long-term jobs.

3. Marginal work involves very few hours a week, such as less than 10 or less than 15, is often exempted from income tax and social security contri-butions, and is sometimes excluded from statutory employment rights or employer benefits (Schoer, 1987; Hakim, 1989*a*; 1989*b*; Meulders *et al.*, 1993: 82–5; Meulders *et al.*, 1994: 30–1). In Germany, people working less than 15 hours a week and with low earnings are excluded from social insur-ance: 2 million women and 1 million men fell into this category in 1992; in Britain, estimates range from 2 to 4 million marginal workers with earn-ings below the social insurance threshold (Hakim, 1989*b*: 488; European Commission, 1995*b*: 140). In the USA, unpaid family workers working less than 15 hours a week are not considered employed and are excluded from employment statistics. Similarly, jobs with less than 8 hours a week have been excluded from EC proposed directives on atypical workers which aim to improve the rights of part-timers (Wedderburn, 1995: 68). In December 1995 the European Court of Justice ruled in *Nolte* v. *Landesversicherungs-anstalt Hannover* that the exclusion of low-paid marginal workers (work-ing less than 15 hours a week) from the German statutory social security scheme was permissible, even though considerably more women than men are affected. Marginal workers in Germany are not subject to contribu-tions and are also excluded from sickness benefits and the national pension scheme. This landmark judgment established the legality of treating mar-ginal workers differently from part-time workers working over 15 hours a week.

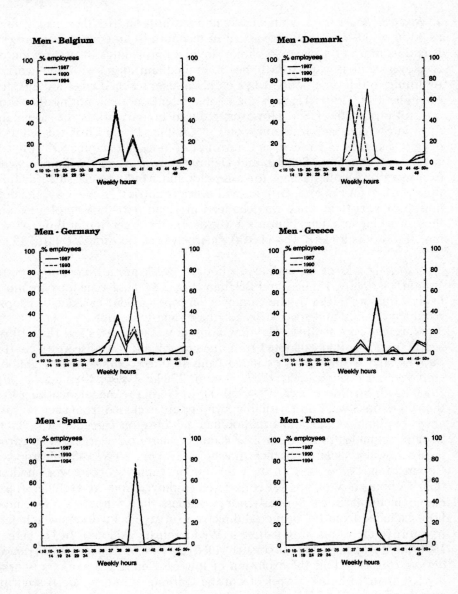

F<small>IG</small>. 2.1. The distribution of usual hours worked per week by employees in industry and services in EU member states, 1987, 1990, and 1994
Source: European Commission, *Employment in Europe 1995*, pp. 183–6.

cont. pp. 27–9

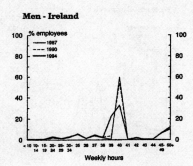

Men - Ireland

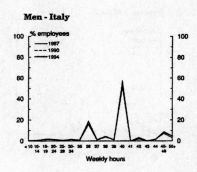

Men - Italy

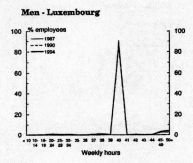

Men - Luxembourg

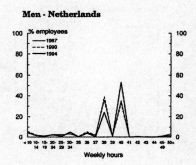

Men - Netherlands

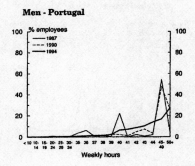

Men - Portugal

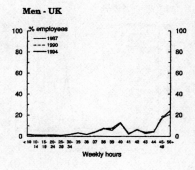

Men - UK

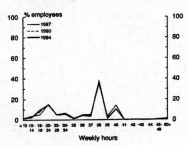

Women - Belgium

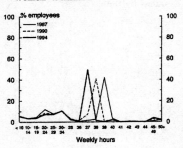

Women - Denmark

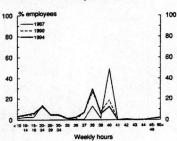

Women - Germany

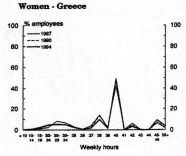

Women - Greece

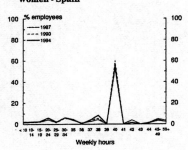

Women - Spain

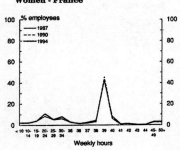

Women - France

Women - Ireland

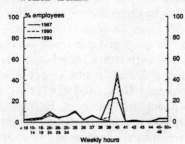

Women - Italy

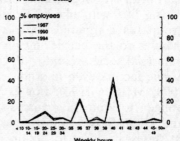

Women - Luxembourg

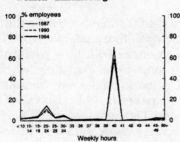

Women - Netherlands

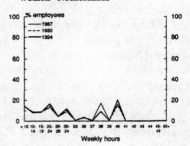

Women - Portugal

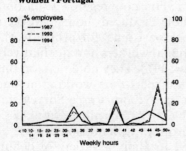

Women - UK

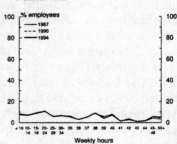

Given that part-time work means such different things even within European labour markets, cross-national comparisons are often not comparing like with like.[1] The different size and importance of these three groups as compared with the full-time workforce in any country contributes to the perplexing diversity of patterns of part-time work across industrial societies and to the weak correlations with other social and economic factors even in studies limited to Europe (Bruegel and Hegewisch, 1994; McRae, 1995). For example Rosenfeld and Birkelund (1995) were obliged to limit their analysis to a narrow group of Northern European and Anglo-Saxon countries, excluding Japan, Southern Europe, and socialist states, in order to obtain reasonable correlations between the proportion of female employees in part-time jobs and other socio-economic indicators; even then, the most important correlate was simply the industrial structure, as measured by the proportion of women working in the public sector.

OECD and EC reports have recently started to distinguish between the three types of part-time work to show, for example, that marginal work of under 10 hours a week is important both in countries with little part-time work, such as Spain, and in countries with substantial part-time workforces, such as the Netherlands, Britain, Denmark, and even Germany (European Commission, 1994: 108–12; Meulders *et al.*, 1994: 16; OECD, 1994: 78–82). In the Netherlands, Britain, and Denmark marginal work grew over the decade 1983–92, so it is becoming more rather than less important, in part due to the growth of one-day-a-week jobs held by students in full-time education (Hakim, 1996*d*). In the European Community as a whole, most women working 30–4 hours a week regard themselves as full-time workers, and the European Commission now regards a full-time classification as most appropriate for these 'reduced hours' workers (rightly, in my view), thus reserving the label 'part-time' for people working 10–29 hours a week, and classifying marginal workers as a qualitatively different group (European Commission, 1994: 116). They note that, on this basis, there is much less variation in levels of part-time working among women across Europe than is indicated by the Labour Force Survey statistics routinely reported each year (see Table 1.1). This alternative classification has not yet been adopted within European Commission reports or in research analyses, which continue, as yet, to apply a variety of definitions of part-time work, thus magnifying the cross-national differences to be explained in this study.

In contrast, male part-time work seems to be relatively homogeneous: across Europe, the USA, and other industrialized countries, male part-

[1] Another implication is that the diversity of labour forces even within the European Union is great enough to lend further support to the proposal that flexible integration is the only realistic way forward (Centre for Economic Policy Research, 1995).

timers tend to be the very young and students or else older people approaching retirement (see Fig. 2.2, below). For men, part-time work functions as a transition into or out of the workforce (Meulders *et al.*, 1994: 17; OECD, 1994: 84–6; Hakim, 1995*b*: 578–80; 1996*d*; Nätti, 1995).

So far, academic discussion of this development has been dominated by two perspectives that differ in emphasis but are in agreement that part-time jobs offer sub-standard rather than non-standard employment, and constitute a social problem which calls for policy initiatives and new legislation from policy-makers, both nationally and in the European Commission. What can loosely be termed the 'feminist' perspective and the 'trade union' perspective on part-time work have both painted a gloomy picture of part-time jobs, routinely concluding that they are an inadequate alternative to 'standard' full-time permanent jobs. Both perspectives are reflected in chapters of this volume.

This chapter, and the book as a whole, develops an alternative sociological perspective on part-time work, one which differs sharply from the two previous dominant perspectives, is informed by recent empirical research on part-time work, and sets part-time work in the context of work histories and the family life-cycle.[2] This sociological perspective takes account of the fact that part-time work is typically taken up voluntarily and offers higher levels of job satisfaction than full-time work. It follows that part-time work can be analysed in a neutral or even positive light rather than from the purely negative perspective that has so far dominated debate and clouded understanding of this new development in the workforce. It appears that in the rush to contribute to policy debates and support the case for the EC Social Charter, academic sociologists have lost sight of theoretically important distinctions to be drawn between various types of labour-market participation. The principal argument of this chapter is that part-time employment constitutes a qualitatively different type of workforce involvement from full-time employment, one which gives priority to some other non-market activity around which the part-time job must be fitted. Other types of non-standard work may be taken up for the same reason, in particular temporary work in all its forms, but long-term part-time employment exhibits most clearly the key features of this new and distinctive work orientation. Women are the largest and most visible group using part-time work in this way, but certain groups of men, especially students, also use part-time employment and other types of non-standard work as an alternative form of labour-force attachment.

[2] Strictly speaking Goldthorpe (1984) has already offered a third, sociologically informed perspective. However, his 1984 paper, reprinted in 1985, has never been taken up as an alternative approach, even by academic sociologists, perhaps because it is presented within the framework of the political economy of the labour market and industrial relations.

This new sociological perspective is developed in the following sections of this chapter, which reviews and synthesizes recent research on the characteristics of part-time jobs and part-time workers across Europe and the USA. The final section draws the themes together into a summary statement of the sociological significance of part-time work within labour-market analysis. In Chapter 13, Blossfeld shows how part-time work has a qualitatively different place in life and work histories from continuous full-time employment, and that national policies and cultures regarding the sexual division of labour play a major role in shaping women's employment across the life-cycle.

In the remainder of this chapter the term part-time work refers to half-time jobs and marginal jobs. Reduced hours workers are regarded as equivalent to full-timers, in line with EC practice and, as it happens, in line with the definition of part-time work that has long been used in British labour statistics. However, a variety of definitions of part-time work are applied in interview surveys and national statistics (OECD, 1995: 211), and hence in the country reports in Chapters 3 to 12: jobs with less than 37 hours a week (West Germany); jobs with less than 35 hours a week (USA, Sweden, Netherlands); jobs with less than 30 hours a week (Denmark, Britain, and France); jobs with hours shorter than 'usual' for the occupation (Italy and Greece); and self-classification as a part-time worker (France, West Germany, Greece, and most European LFS surveys). The higher the hours threshold, the larger the number of part-time workers identified. However the distribution of hours worked by men and women in each country (Figure 2.1) is perhaps more useful than definitional limits in clarifying the types of part-time work that appear in each country.

The Rise in Part-Time Employment

The post-war increase in female employment is usually interpreted as an indicator of women's rising work attachment. With the singular exception of the USA, this is questionable, as higher female work rates are due to the introduction of part-time jobs, sometimes at the expense of full-time jobs. Across the European Community, most of the additional jobs created over the 1980s were part-time. However there was a major difference between the North and South of the Community. In Italy, Portugal, Spain, and Greece, numbers of part-time jobs declined over much of the 1980s, in contrast to the pattern elsewhere. In Germany, France, and Belgium, part-timers accounted for a significant proportion of the additional jobs created in the 1980s. In the Netherlands, two-thirds of the net addition to jobs in this period were part-time rather than full-time (European Commission, 1993: 32).

The Netherlands provides a sharply defined case. As de Graaf and Vermeulen show in Chapter 8, there has been no change at all in women's 20 per cent full-time work rate in the post-war decades in the Netherlands. All the increase in female employment is due to the creation of a new part-time workforce, roughly double the size of the female full-time workforce, drawing previously inactive women into the labour market. Similarly in Britain, the full-time work rate for women remained at an almost unvarying level of one-third of women of working age from 1851, and possibly before that, up to the mid-1990s (Hakim, 1996a: 63).

Compared to other European countries, the British labour market has always been relatively unregulated and part-time work has never been prohibited (unlike in some European countries) either by statute law or by collective bargaining (Hepple and Hakim, 1996; Rojot and Blanpain, 1997). So there was no obstacle to the steady expansion of part-time work after the marriage bar was abolished around the time of the Second World War.[3] It was the only source of apparent employment increase up to the late 1980s (Joshi, Layard, and Owen, 1985). However, employment growth was illusory up to 1988, with a 15 per cent decline in full-time employment being concealed and cancelled by a five-fold increase in part-time employment. Only from 1988 onwards was there any genuine increase in the volume of employment in Britain, measured in full-time equivalent jobs (Hakim, 1993a: 102). Similarly, the much discussed continuous rise in female employment since the Second World War consisted entirely of the substitution of part-time for full-time jobs from 1951 to the late 1980s. Only in the late 1980s was there any expansion in the volume of female employment, measured in full-time equivalent jobs, as women's full-time

[3] The marriage bar was the formal rule, jointly enforced by employers and trade unions, that women had to leave paid employment on marriage. This rule effectively excluded all married women from the labour market, so that working women were necessarily single, widowed or, rarely, divorced. The marriage bar became widespread in the second half of the nineteenth century in Britain, and was abolished from the 1940s onwards, after a long campaign by women's organizations against employers and trade unions. For example, the marriage bar was abolished in the British Civil Service in 1946, but the Union of Post Office Workers maintained the marriage bar for its own employees until 1963. Abolition of the marriage bar constituted a fundamental change in women's workforce participation, and was a key factor in the rise of part-time work after the Second World War, yet it is only rarely mentioned by social historians, sociologists, and economists in Britain (Lewenhak, 1977: 41, 94, 215, 225–6, 265–6, 292; Walby, 1986: 57, 171–2, 204–7, 240). In the USA and other countries the marriage bar consisted of social and cultural norms dictating that wives should not engage in paid employment, which did not go as far as a legally enforceable rule, but had equally profound effects on patterns of female employment and earnings (Goldin, 1990). Pott-Buter (1993) reviews the very different pace of change in equal opportunities legislation and related attitudes across Western Europe, demonstrating their impact on female employment.

work-rates began climbing at the same time as numbers in part-time work (Hakim, 1993a: 98–104). It is notable that the incidence of part-time work among married women actually fell in the 1980s, from 55 per cent of married women in employment in 1984 to 50 per cent in 1991; conversely the proportion of non-married women working part-time rose from 23 per cent in 1984 to 29 per cent in 1991 (OPCS, 1992: 15). Similarly, there was a decline in the proportion of part-timers among working women in the 1980s across the Nordic countries (Nätti, 1995).

Conventional measures of economic activity and employment can hide as much as they reveal on female employment, and need to be supplemented by new measures, especially for cross-national comparisons (Hakim, 1993a: 107–13). The Dutch and British labour forces represent two extreme cases, but other European countries are discovering that the rise in female employment in recent decades consists of the creation of a part-time workforce, sometimes with the substitution of part-time jobs for full-time jobs, with women switching from a full-time involvement in the workforce to a part-time involvement instead, and on a permanent basis (OECD, 1988: 139). The substitution of part-time for full-time jobs in OECD countries was first explored by de Neubourg (1985), who found that over the decade 1973–83, in France, West Germany, the Netherlands, Sweden, and Britain the number of full-time workers had declined while there was substantial growth in the number of part-timers. A review of developments in women's employment in the USA, Britain, Germany, France, Holland, Sweden, Italy, Spain, Israel, Australia, and Japan noted that the rise of part-time work produced some convergence in women's employment across widely differing societies (Mincer, 1985). The European Commission has found the headcount measure of employment sufficiently misleading for cross-national comparisons that it now looks at the 'volume of employment', which is simply full-time equivalent figures of employment (European Commission, 1989: 19; 1993: 33). More recently, the dramatic post-war increase in female employment in Sweden has also been revealed as largely illusory, with calls for sharper measures of hours actually spent in market work (Jonung and Persson, 1993; Pott-Buter, 1993: 203–8; Hakim, 1996a: 32–4). Long periods of parental leave are in practice spent outside the workforce and in domestic activities, even if job rights are preserved. These long spells of non-work show up in national statistical surveys of absences from work, revealing Sweden to be a dramatic outlier on these measures (OECD, 1991). It appears that survey classifications must be amended in future to differentiate between people with job rights and those actually engaged in market work, and to reweight the contribution of part-timers with more realistic measures of actual market hours (Zighera, 1996). Recent OECD (1994: 77, 1995: 16) and EC reports (Meulders *et al.*, 1994: 3; European Commission, 1995a: 17) confirm that

the substitution of part-time for full-time jobs and the increasing share of part-time work in total employment continued throughout the 1980s, albeit to varying degrees, so that the issue is of some consequence.

Post-war trends in female employment and the rise in part-time work should perhaps be read as a substantive change in the nature of women's involvement in the labour market rather than as a simple increase in attachment to work. At the very least, two processes are displayed in recent trends, differing in weight between countries and at particular points in time. One dominant development well into the 1980s was the substitution of part-time for full-time jobs, in the workforce as a whole and among working women in particular. In some countries the 1980s and 1990s were characterized by a parallel process of a genuine rise in female full-time work rates and in absolute levels of full-time work, alongside the continued expansion of part-time jobs among men and women. The growth of part-time work is due to rising workforce participation of groups that have a high propensity to work part-time or not at all, but there is also evidence of substantive change in women's work orientations more generally, producing a polarization of women's employment (Hakim, 1996*a*).

The Sex-Role Preferences and Work Orientations of Part-Time Workers

In most countries, part-time work tends to be concentrated among the least skilled, lowest grade, and lowest paid jobs, with the poorest employment benefits and prospects. One notable exception is Sweden, where part-time work typically consists of reduced hours jobs, which would be classified as full-time jobs elsewhere in Europe. Denmark also illustrates the point that part-time work may expand even when part-timers have employment rights equal to those of full-timers. Perhaps the more universal feature is that the majority of part-timers are wives and mothers who are not primary earners within their households (though Italy is one exception, as Addabbo points out in Chapter 5). Part-time jobs are generally heavily segregated. Occupational segregation is increasing in the part-time workforce, in contrast with the trend towards the desegregation of full-time jobs (Hakim, 1992; 1993*b*; Rubery and Fagan, 1993; Jacobs, 1995: 167). It is thus all the more remarkable that part-time workers, and working women generally, report high levels of satisfaction with their jobs, often greater satisfaction than is reported by full-time workers, or by men, with their objectively more rewarding, higher status, and better paid jobs (Hakim, 1991), a finding that has been replicated across Europe and in other industrial societies (Nerb, 1986: 19, 50–8; Curtice, 1993).

The 1980 Women and Employment Survey for Great Britain found that

women working part-time expressed more overall satisfaction with their jobs, and in particular were happier with their working hours than were women working full-time. In fact the main complaint of women working full-time was that they would prefer jobs with shorter working hours—one-third said this compared with only 11 per cent of part-timers preferring longer work hours (Martin and Roberts, 1984: 41, 74). In West Germany, half of all women in full-time employment would prefer part-time hours (Pfau-Effinger, 1993: 394). In the Nordic countries, 20 to 30 per cent of female full-time employees would prefer shorter working hours (Nätti, 1995: 351). Contrary to received opinion, forced choices are more common among full-timers than among part-timers. A national survey carried out in spring 1989 for the British Equal Opportunities Commission found that 74 per cent of male workers, 84 per cent of women working full-time, and 96 per cent of women working part-time found their working hours convenient. One-half to two-thirds of the part-timers were extremely satisfied with the amount of time they have available to spend with their family and on leisure, compared with less than 30 per cent of men and women working full-time (Marsh, 1991: 66–8, 75). Many part-timers feel that their combination of employment and non-market activities gives them 'the best of both worlds' and continue with part-time work long after their children have left home or their husband has retired (Marsh, 1991: 27; Watson and Fothergill, 1993). Part-time work is thus more common among women beyond child-rearing age: 27 per cent of women aged 20–5, 54 per cent of women aged 26–45, and 66 per cent of women aged 46–55 years work part-time (Marsh, 1991: 27). Commentators are starting to conclude that part-timers' compromise between market and non-market activities differs qualitatively from that chosen by full-time workers (Marsh, 1991: 69; Hakim, 1991; 1993a: 106; Watson and Fothergill, 1993). The country reports presented in this book demonstrate further that active demand for part-time work is widespread, even if often hidden.

The EC Labour Force Survey shows that throughout the 1980s, among both men and women, voluntary part-time work was far more important than involuntary part-time work in all countries, with the single exception of Irish men (Hakim, 1990a; Meulders *et al.*, 1994: 30; OECD, 1995: 80). The LFS question on reasons for working part-time is designed to measure involuntary part-time work, a topic that greatly exercised the European Commission throughout the 1980s (1989: 75, 89; 1990: 91, see also OECD, 1990; 1995: 43–97). Involuntary part-time work consists of people who have taken a part-time job because they could not find a full-time job, and the LFS only classifies people as voluntary part-time workers if they insist they do not want a full-time job (Hakim, 1990a). However, LFS results are clouded by the inclusion of people working short-time hours for economic reasons among involuntary part-time workers; this category can include

full-timers whose usual overtime hours have been suspended and is qualitatively different, given that short-time working for economic reasons is typically of short duration and often attracts wage replacement benefits (MISEP, 1995: 19–27; OECD, 1995: 79). Across the European Community, the incidence of involuntary part-time work first rose slightly (Hakim, 1990*a*: 196) then fell during the 1980s, from 21 to 16 per cent of male part-time workers, and from 10 to 9 per cent of female part-time workers in 1983 and 1990 respectively (Meulders *et al.*, 1994: 30)—leaving the relative importance of voluntary and involuntary part-time work virtually unaltered. Countries where part-time work is still unusual, such as Italy and Greece, display very mixed attitudes to part-time work. All of the above results exclude France, where LFS results on involuntary part-time work (termed under-employment in France) are never reported. Most French women regard a full-time job as the norm, leading to the widespread view that involuntary part-time work is dominant in France, even among women, unlike Britain, Denmark, and the Netherlands, where part-time jobs are popular among women. In fact, as Chapter 6 by Coutrot *et al.* shows, part-time work is typically taken voluntarily in France as well: a two-thirds majority of men and women working part-time in 1994 reported that they did not want a full-time job. Involuntary part-time work is higher in France than in other countries with substantial part-time workforces, and it rose steadily from one-quarter to one-third of the part-time workforce in the 1990s, but it is still not the dominant feature of part-time work, as is frequently claimed, despite the long tradition of full-time work among women in France. The similarity of male and female work orientations in France is illustrated by the level of involuntary part-time work being identical for men and women, but it had not reached 40 per cent even by the mid-1990s.

The positive interest in part-time work extends beyond those who already have part-time jobs. As the European Commission recognized in the 1980s, there is also a hidden demand among people (mainly women) in full-time jobs as well as among women outside the labour market, and this demand seems to be different from the general interest in reductions in working hours routinely expressed by both men and women (Nerb, 1986: 15, 19). Special surveys of employees in all twelve member states organized by the European Commission in 1985–6 revealed a large untapped potential for part-time jobs, annual hours contracts, and other innovations in working hours. One-quarter of full-time employees said they would accept a drop in earnings to achieve shorter working hours; over half of European workers would accept annual hours contracts, or the monthly equivalent, so long as the variable hours could be jointly agreed with their employer. Among both men and women, one-third said they would choose shorter working time in preference to an increase in pay for the same working

hours, if the choice were offered in the next wage round, and the proportion rose to half of all employees in Denmark and the Netherlands. However, full-time women were twice as likely as full-time men to be interested in shorter working hours, and working women generally expressed a marked preference for part-time hours as the ideal to aim for (Nerb, 1986: 19, 52). After excluding non-respondents, 38 per cent of working women preferred to work less than 30 hours a week compared to only 7 per cent of men; 19 per cent of women compared to 2 per cent of men preferred to work less than 20 hours a week (Nerb, 1986: 52). Not surprisingly, almost half of employees working long full-time hours (41 hours or more per week) sought a reduction in working hours, and this was just as true of men as of women. However, among those already working reduced hours (30–4 hours a week), one-third (34 per cent) of working women compared to one-quarter (24 per cent) of working men preferred less than 30 hours a week as the ideal, despite a corresponding loss of income (Nerb, 1986: 54). Similar results are reported in country surveys. For example, in West Germany the demand for part-time jobs of 18–30 hours a week is far greater than the number of such jobs created by employers: 47 per cent of all women in full-time jobs would prefer part-time work if this were available in the company they work for (Pfau-Effinger, 1993: 394). In the Netherlands, a 1993 survey of all people aged 16 and over (whether working or not) asked about work hours preferences in an ideal world where all practical obstacles (including childcare) were resolved, and found that wives chose ideal hours substantially different from husbands' ideal hours. The majority of husbands preferred a full-time job, including some 30 per cent choosing long full-time hours even in an ideal world. In contrast, 14–20 per cent of wives chose not to work at all as the ideal; another 10–20 per cent only wanted a marginal job of less than 15 hours a week; and 40–50 per cent preferred half-time jobs of around 20 hours a week. In effect, the great majority of wives actively prefer to be secondary earners, retaining the homemaker role as their primary identity (Plantenga, 1995: 284–7).

Part-time jobs are attractive to many women in part because of prevailing norms about the sexual division of labour in the family, or what is sometimes labelled the 'gender contract' (Pfau-Effinger, 1993: 389). Few wives regard themselves as principal or co-equal earners with their husbands. Recent research demonstrates that, across Europe and industrial society generally, the majority of women (as well as men) still accept and even prefer the sexual division of labour that allocates domestic responsibilities to the wife and the income-earning role to the husband (Hakim, 1996a: 84–98). Not surprisingly, there is a strong correlation between the acceptance of sex-role differentiation, work commitment, attitudes to the mother's child-rearing role, and a mother's decision to work full-time, part-

time, or not at all (Hakim, 1995*a*; Thomson, 1995: 80–3; Hakim, 1996*a*: 88–91). In general, women working part-time hold more traditional attitudes towards women's role in the home and at work, attitudes that are closer to those of men and non-working women than to those of women working full-time (Warr, 1982; Martin and Roberts, 1984: 169–84; Dex, 1988: 124; Hakim, 1991; Alwin, Braun, and Scott, 1992; Vogler, 1994; Hakim, 1995*a*).

Social attitude survey data are regarded with deep suspicion by many sociologists, and many reject broadly Weberian theories that treat norms, values, and preferences as having causal power, alongside social structural and economic factors, in favour of broadly Marxian theories that give primacy to economic and social structural explanations—in part because much research has found attitudes to be poor predictors of actual behaviour due to the failure to distinguish between approval and choice in most studies (Hakim, 1996*a*: 84–5). However, personal preferences about the appropriate roles of men and women, the roles of husbands and wives, and family relations, are deeply held and change relatively slowly, quite unlike the highly volatile political attitudes reported by public opinion polls (Hakim, 1996*a*; 1996*b*). Some sociologists argue that the gender contract is a key socio-cultural feature of societies, embedded in the institutional system and continually reproduced by women themselves (Pfau-Effinger, 1993: 389–90). The International Social Survey Programme (ISSP) has for some years collected data on sex-role ideology, through responses to the statement 'A husband's job is to earn the money; a wife's job is to look after the home and family', an item that is often treated as a measure of 'modernity' in attitudes. Throughout the 1980s and into the 1990s this statement (or equivalents) attracted roughly 50 per cent of men and women disagreeing and 50 per cent agreeing or indifferent, in the USA, Britain, Germany, and other European countries, with responses fluctuating slightly over time but remaining broadly balanced between acceptance and rejection (Witherspoon, 1988: 189; Scott, 1990: 57; Kiernan, 1992: 97–9; Scott, Braun, and Alwin, 1993: 34; Haller and Hoellinger, 1994: 102). However, the complete separation of roles has been updated in the post-war decades to accept wives going out to work as a secondary activity. An unusual academic survey carried out in the mid-1980s in Britain showed that there are qualitative differences between the sex-role preferences and work orientations of women in full-time employment and women with part-time jobs. Interestingly, women working part-time and women without any paid employment held almost identical views, accepting the 'bourgeois' model of family roles, with a clearly defined sexual division of labour, as the ideal to aim for. The majority of female part-timers regard breadwinning as the primary (but not exclusive) responsibility of men and see wives as secondary earners whose primary (but not exclusive) responsibility is for the home.

The majority of women working full-time reject this division of labour in favour of symmetrical roles for spouses (Vogler, 1994: 45, 55; Hakim, 1996a: 86–9).

One of the European Commission's Eurobarometer surveys provides unique evidence on the diversity of sex-role preferences within European countries as well as across Europe as a whole (Table 2.2). The EU survey shows that one-third of European adults still support the complete separation of roles in the family, with the wife financially dependent on her hus-

TABLE 2.2. *The diversity of sex-role preferences in Europe: percentage of adults supporting each of three models of the sexual division of labour*

| | Model | | | |
	Egalitarian	Compromise	Separate roles	Total
Greece	53	23	25	100
Denmark	50	33	17	100
Italy	42	28	30	100
France	42	27	31	100
Netherlands	41	27	32	100
United Kingdom	39	37	24	100
Belgium	35	25	40	100
Ireland	32	26	42	100
West Germany	29	38	33	100
Luxembourg	27	23	50	100
Men				
15–24 years	49	33	18	100
25–39	40	38	22	100
40–54	28	36	36	100
55 and over	26	28	46	100
Women				
15–24 years	60	25	15	100
25–39	45	32	23	100
40–54	36	34	30	100
55 and over	31	29	40	100
Total for EC of 10	38	32	30	100

Notes: The question asked: 'People talk about the changing roles of husband and wife in the family. Here are three kinds of family. Which of them corresponds most with your ideas about the family?'

A family where the two partners each have an equally absorbing job and where housework and the care of the children are shared equally between them.

A family where the wife has a less demanding job than her husband and where she does the larger share of housework and caring for the children.

A family where only the husband has a job and the wife runs the home.

None of these three cases

Percentages have been adjusted to exclude the 3% not responding to the question and the 3% choosing the last response.

Source: Derived from Eurobarometer report *European Women and Men 1983* (1984).

band. Rejection of this model does not necessarily mean that people move to acceptance of completely equal sharing of income-earning and domestic functions: one-third only support a compromise arrangement in which the wife may do some paid work—a part-time job would be typical. Roughly one-third of the EC population supported each of the three family models. The egalitarian model attracted most support in Greece, Denmark, Italy, and France, followed closely by the Netherlands and the UK. The complete separation of roles attracted most support in Luxembourg, Ireland, and Belgium. But in all countries there was a wide spread of support for all three models of the family, none receiving majority support, with the single exception of Greece's majority support for the egalitarian model. This suggests that the 'modern' egalitarian family is really a reversion to a pre-industrial model. Overall, a two-thirds majority of European men and women favour the idea of the working wife, but a two-thirds majority also favour the wife retaining all or the major part of the domestic role. Within countries, differences by sex are negligible except in Greece, Italy, and France where men are distinctly less favourable than women towards the egalitarian marriage (European Commission, 1984: 9). Age has a strong influence on attitudes (Table 2.2). In part, these results reflect generational differences, and in part a genuine change in attitudes over the life-cycle as women can adopt more 'traditional' sex-role norms after they have children. In some countries, such as Britain, social class is also strongly associated with sex-role ideology, as Vogler (1994: 45, 55) has shown, with working-class men and women far more likely to support the complete separation of roles than do service-class couples.

Clearly, values and sex-role preferences are only one factor among the many that determine employment behaviour. However, new research in the 1990s suggests that sex-role preferences and values are becoming more influential in women's employment choices than they were in the past, when employment was driven primarily by economic necessity. For example, Thomson's analysis of the 1994 British Social Attitudes Survey indicated that women's employment decisions were informed primarily by their conceptions of women's role at home and at work and only secondarily by practical factors such as childcare problems or financial need. Careful checks indicated that attitudes to the mother's 'proper' role in the family were not just a form of self-justification or *post-hoc* rationalization (Thomson, 1995: 80–3).

The continuing and even increasing impact of sex-role norms is pointed up by research on women who have invested in higher education qualifications and thus have access to better paid jobs. Analyses of the 1991 British Household Panel Study data show that sex-role ideology continues to influence employment decisions among the highly qualified, as these women can afford to choose between competing lifestyles, given

homogamy (Table 2.3). A two-thirds majority of women, whatever their level of education, hold ambivalent (or adaptive) sex-role norms, with minorities firmly accepting or rejecting the sexual division of labour. It is well established that higher education qualifications are associated with higher work rates—a 'mark up' of 17 percentage points in Table 2.2 (82 versus 65 per cent). But the impact of sex-role norms is greater, and it is largest among the highly qualified women, producing a 'mark up' of 28 percentage points in employment rates when modern and traditional women are compared (92 versus 64 per cent). Of course, the influence of traditional attitudes to women's role in the home will only become apparent after a woman has got married and had children. The expression of traditional attitudes is crucially dependent on others, on achieving marriage to a partner able to support a family and on child-bearing, and in that sense the influence of traditional attitudes is moderated by (and can be conflated with) 'contextual' socio-economic factors, especially in data-sets with no information on values and sex-role preferences. A very detailed historical and comparative analysis of women's employment in seven northern European countries led Pott-Buter to conclude that preference theory offers the only explanation for the continuing exceptionally low female employment rates (measured on a full-time equivalent basis) in the Netherlands as compared with Belgium, France, Denmark, Germany, Sweden, and Britain (Pott-Buter, 1993: 203–8, 322).

TABLE 2.3. *The impact of sex role norms on employment rates*

Sex-role norms	Percentage of each group in employment		Distribution of sample	
	Highly qualified women	Other women	Highly qualified women	Other women
Modern	92	76	23	14
Ambivalent	84	66	63	67
Traditional	64	54	15	20
All women aged 20–59	82	65	100	100
Base=100%	746	2700	746	2700

Notes: Highly qualified women have tertiary level qualifications, beyond A-level (that is, above the level of the *Baccalaureat* or the *Abitur*). Other women have no qualifications or only secondary school qualifications (up to A-level).

Sex-role norms were scored by Corti *et al.* on the basis of nine attitude statements, including the ISSP item 'A husband's job is to earn the money, a wife's job is to look after the home and family' discussed in this chapter. Of the other eight attitude statements, six concerned the role of a mother and two concerned the role of wives and adult women more generally.

Source: Calculated from Tables 6.21 and 6.22 in Corti *et al.* (1995: 69) reporting 1991 survey results from the British Household Panel Study.

The heterogeneity of women's sex-role preferences and hence their work orientations and employment behaviour is still not fully recognized as an important additional factor that needs to be incorporated into research analyses. Working women are a strongly self-selected group and are unrepresentative of all women of working age (Fiorentine, 1987; Hakim, 1991; 1995*b*; 1996*c*), and there are further qualitative differences in work orientations between women choosing long-term full-time employment or long-term part-time employment. The first group of women are committed to careers in the labour market and therefore invest in training and qualifications, and generally achieve higher grade occupations and higher paid jobs. Some remain voluntarily childless. The second group of women give priority to their domestic role and activities, do not invest in what economists term 'human capital' even if they acquire educational qualifications, transfer quickly and permanently to part-time work as soon as a breadwinner husband permits it, choose undemanding jobs 'with no worries or responsibilities' when they do work, and are hence found concentrated in lower grade and lower paid jobs which offer convenient working hours with which they say they are satisfied. Women working part-time or not at all express the most traditional sex-role preferences, and typically choose to marry men with even more traditional views of women's roles (Martin and Roberts, 1984: 176; Hakim, 1991: 105, 110, 114; 1996*a*: 86–91). In West Germany, Britain, and the United States, part-timers are twice as conservative as full-timers in their emphasis on a wife's domestic responsibilities taking priority over market work, even when there are no children of any age at home, that is, before there are children or when they have left home (Alwin, Braun, and Scott, 1992). Chapters 7 and 8 on West Germany and the Netherlands in this book show that marriage itself, independently of motherhood, can be an important turning point in many women's employment histories. There is a tendency to forget that the marriage career, with its emphasis on an exclusively domestic role, remains the ideal for large sections of the female population, especially working-class women, even if it is no longer the only role model available to women, even if it owes much to brainwashing by male-dominated institutions, even if it sometimes fails to deliver the expected benefits (Pollert, 1983; Rose, 1992; Hakim, 1996*a*; 1996*c*; 1996*e*). The marriage career remains the dominant role model for women in many countries, including Germany, Greece, and until recently also the Netherlands. In Germany, fiscal policy and employment policy have supported the complete sexual division of labour in marriage or, at most, marginal part-time jobs for wives (Pfau-Effinger, 1993: 391). As Symeonidou demonstrates (see Table 4.9 in this volume), one-quarter of prime-age Greek women have never done any paid work and another quarter stopped work permanently before or soon after marriage, so that half of all Greek women still follow the classic marriage career which treats

domestic work and employment as mutually exclusive activities. Sundström's report on Sweden in Chapter 11 indicates that part-time work has grown mainly in this group, among women who will not work at all if their market work cannot be fitted around their domestic responsibilities, among women for whom market work is a secondary, conditional, and contingent activity. This group is highly responsive to national policies and employer policies which lower or raise the barriers to paid work, such as the fiscal policies and social welfare regulations employed in Sweden to control women's employment. Similarly, in East Germany, government policies forced high female employment rates on couples, without necessarily changing women's gender ideology and work orientations (Braun, Scott, and Alwin, 1994). Female heterogeneity and the polarization of women's employment is demonstrated clearly in Coutrot *et al.*'s report on France in this book, showing sharp contrasts between the subgroup of women who switch between full-time and part-time work and the subgroup of women who switch between part-time work and being out of the labour force.

The division of women into two (or three) qualitatively different groups is not fixed and immutable but in constant flux. The relative size of the groups will differ between countries, and over time, and some women will switch between groups over their lifetime. But the key point is that the existence of two diverse groups polarizes women's experiences in the labour market, as Goldin (1990), Humphries and Rubery (1992), Coleman and Pencavel (1993), and Burgess and Rees (1994) demonstrate for the USA and Britain, and the 'average' or 'typical' working woman becomes a fictitious and misleading illusion. This polarization is illustrated most sharply by the French case. Within Europe, French women, along with Finnish and Portuguese women, are distinctive in their commitment to continuous full-time employment in preference to unpaid child-rearing activities. For reasons not fully explained in Chapter 6, nor elsewhere, their work commitment has been consistent enough to force the French government to maintain generous pro-natalist policies, including reliable childcare services for working women. At the same time, a minority of women continue to give priority to family and non-market work over employment. Between these two groups there has been little scope for part-time work to grow, despite active encouragement through government policies in recent years—in marked contrast with the Netherlands, where new government policies had immediate effects, as Chapter 8 shows.

The Feminist Perspective: Problems of Childcare

The conclusion so far is that part-time work is typically chosen voluntarily by women who prefer to give priority to non-market activities and

hence work not at all or only part-time. This contradicts the dominant feminist view which insists that part-time work is an unwilling 'choice' forced on women by the need to cope with childcare responsibilities, a compromise taken up *faute de mieux* rather than a positive preference. Even taken at face value, the argument is unpersuasive. It fails to take account of part-timers' high levels of job satisfaction despite being restricted to the least attractive jobs, and of the fact that childcare problems do not prevent large numbers of women from working full-time, while others insist childcare must be a full-time activity.[4] The argument is contradicted also by the fact that there were increases in female full-time work in the 1980s in Britain and other countries without any improvements in childcare services (Humphries and Rubery, 1992: 253), mainly because women paid for private childcare and partly due to the increase in voluntary childlessness (Hakim, 1996a: 124–6).

Cross-national comparisons are often used to demonstrate the importance of childcare services over and beyond all other causal factors, whether structural or personal. A fairly typical example is the comparative study of women's employment in the USA and Britain carried out by Dex and Shaw (1986). In their conclusions, Dex and Shaw underline the importance of childcare tax allowances in facilitating women's full-time work in the USA and explaining the much lower incidence of part-time work in the USA as compared with Britain. However, the authors also noted that most families recover no more than 20 per cent of their childcare costs through the allowance and lower income families much less than 20 per cent (Dex and Shaw, 1986: 8, 126). The authors acknowledge a series of other causal factors, such as the fact that employers pay for health insurance for full-time employees but not for part-time employees in the USA, whereas Britain's free health care services are not dependent on working status or contributions; that British women have a greater preference for part-time work; and that the British fiscal and social welfare systems make part-time work more attractive to both employers and workers than in the USA (Dex and Shaw, 1986: 126–7). The conclusions to be drawn from their careful study are, first, that women in Britain make 'free' choices that are not constrained by fiscal, social security, and, most important of all, national health service policies that shape or even dictate the labour-market behaviour of women in the USA and second, that, given the choice, a large proportion of women choose part-time work, despite the fact that in both

[4] All women face social structural and cultural barriers to working outside the home, and to achieving higher status jobs within the workforce. However, there is no evidence that such barriers are greater for part-time workers than for full-timers, so issues of sex discrimination do not need to be addressed here. Indeed, the expectation is that these barriers would be most important for full-time workers, who are seeking promotion up career ladders, and lowest for part-time workers.

countries part-time jobs are concentrated towards the bottom end of the occupational hierarchy.

Comparisons across Europe show that the age of the youngest child, if any, often has little or no effect on wives' full-time and part-time work rates, which exhibit distinctive national patterns (European Commission, 1995*b*: 142, Chart 73). One European Commission study has now noted that part-time work is most prevalent in all member states except for Belgium, not among women of child-bearing age between 25 and 49, but among older women of 50 and over (European Commission, 1993: 159). In 1991, one third (36 per cent) of women in employment aged between 50 and 64 worked part-time in the Community as a whole, while for those over 64, the figure was 52 per cent. By contrast, only 29 per cent of women aged 25 to 49 were employed on a part-time rather than full-time basis. In a number of countries—Denmark, France, Italy, and Greece—the lowest proportion of women working part-time was in this age group. As the Commission notes, this fact is not wholly consistent with the argument that the major reason for women working part-time is to enable them to reconcile employment with family responsibilities (European Commission, 1993: 159–60). The report acknowledges that childcare responsibilities are a factor in the rise of part-time work, but not the only factor nor necessarily the most important factor. In 1991, significant proportions of working women in the 25 to 49 age group chose to work part-time only: 63 per cent in the Netherlands, 45 per cent in the United Kingdom, almost 40 per cent in Germany, and almost a third in Denmark. However, 30 per cent of working wives with no childcare responsibilities also chose to work part-time rather than full-time, and the proportion rose to as high as 66 per cent in the Netherlands, as compared with only 36 per cent of single women without children. In Germany and Denmark, over 40 per cent of married women without children chose part-time work in preference to full-time work, with similar contrasts in other countries. Only in Greece does the incidence of part-time work remain at a low and unvarying level for both single and married women without children (European Commission, 1993: 160). Earlier Commission reports have acknowledged that childcare services, while important, are clearly not a crucial factor when a comparative perspective is adopted. For example, Portugal has a very high female employment rate that consists almost exclusively of full-time work (see Table 1.1), even though childcare services are non-existent (European Commission, 1990: 92–8), whereas Greece has low female work rates and little part-time work. Dutch women took up part-time jobs with enthusiasm as soon as laws were loosened to permit it, whereas French women continue to strongly resist government attempts to 'impose' part-time work on them, as demonstrated in Chapters 6 and 8 of this book. These sharp contrasts can be explained by national 'cultural' and institutional differ-

ences, but another key factor seems to be norms about the sexual division of labour. Sex-role preferences and work orientations are the 'hidden' factors that are measured by attitude surveys, including the Eurobarometer, but not (yet) by the LFS (Hakim, 1996a: 83–98). Childcare services may still be important at the margin in particular countries, for example in explaining whether mothers who regard themselves as secondary earners return to work, and the timing of their return to work.

Despite all this evidence, including the evidence on part-timers' active preference for part-time jobs, many European social scientists continue to insist that no one can meaningfully 'choose' to do a part-time job (Meulders *et al.*, 1994: 29). This objection of principle is often linked to the trade-union view of part-time work.

The Trade-Union Perspective:
Part-Time Work as a Threat to Standard Jobs

Historically, the trade-union view of part-time jobs, throughout Europe, was that they could not be regarded as 'proper jobs' since they were of no interest to men and primary breadwinners (Cordova, 1986; Meulders *et al.*, 1994: 28–31). Trade-union antagonism to part-time work (and to all types of non-standard contract, including temporary jobs) has two equally powerful causes—one conscious and explicit, the other unstated and implicit. First, trade unions' patriarchal and sexist attitudes led unions to give unthinking priority to the interests of male members over the concerns of any female members. Second, the trade unions' long campaign to establish and maintain the 'standard' full-time permanent job as the norm meant that they were always explicitly opposed to other types of employment contract, seeking to prevent their growth if not abolish them altogether.

In principle, trade unions support equal opportunities policies, but in practice priority has always been given to the concerns of male trade-union members. In Britain, for example, the Trades Union Congress (TUC) officially supported the principle of equal pay for men and women from 1888 onwards, but trade unions were content to allow men to be paid twice as much as women for their work right up to the mid-1970s, when a woman minister in a Labour government pushed through equal pay and sex discrimination legislation (Grint, 1988: 101–5; Castle, 1993: 409–12, 427). Male-dominated trade unions colluded with employers to maintain earnings differences between men and women over a century of considerable change in the pattern of women's employment and in occupational segregation (Hakim, 1994; 1996a: 9–13, 60–82, 176). Twenty years after the introduction of equal opportunities legislation, there is little evidence that traditional trade-union policies and procedures have been altered to

incorporate women's somewhat different concerns and preferences into collective bargaining.

Beechey and Perkins found trade unions and employers in agreement in their perception of part-time jobs as only marginal and of female part-time workers as not proper wage earners and not committed to work. This perspective underlay trade-union collusion with employers in selecting part-timers first for redundancies and in minimizing the impact of equal pay laws by classifying male jobs as skilled and hence better paid (Beechey and Perkins, 1987: 53, 127, 145). Dickens and Colling found that equal opportunities issues rarely feature in collective bargaining. One reason is that male trade unionists are blind to the way existing structures favour men over women and they remain unaware of the sexist nature of their concerns: male interests are presented as general members' interests whereas women's concerns are seen as sectional, even frivolous or divisive (Colling and Dickens, 1989: 34, 37, 38, 40; Dickens and Colling, 1990). Trade-union negotiators may also argue that they represent the interests of their most forceful and active members. As a result, trade-union negotiators focus on pay and accord low priority to other issues of greater concern to women. Surveys routinely find that for many women, especially part-time workers, convenience factors in a job take priority over the pay and promotion factors of most concern to men (Hakim, 1991: 108). Trade-union negotiators even resent joint equal opportunities committees as a threat to their own negotiating role and bargaining power (Colling and Dickens, 1989: 40; Dickens and Colling, 1990: 53).

At best, trade unions have a mixed record regarding discrimination against disadvantaged groups in employment, and examples can be found of trade unions themselves discriminating against women or condoning employment discrimination (Dickens *et al.*, 1988: 65). Some studies find that employers are more likely to be sensitive to equal opportunities issues, more aware of injustices and (indirectly) discriminatory practices because a substantial proportion of personnel managers are women whereas few trade-union negotiators are women (Dickens and Colling, 1990: 49–50; Cockburn, 1996: 42–3). Gender blindness and myopia extend to industrial relations experts as well (Rubery and Fagan, 1995). Reviews of the issues confronting trade unions today regularly omit any mention of women's different concerns or of equal opportunities issues in a more heterogeneous workforce, even while recognizing in the abstract that the challenges for trade unions internationally are interest aggregation, employee loyalty, and representativeness (Müller-Jentsch, 1988; Hyman, 1991: 636).

The lack of attention to gender issues in collective bargaining across Europe in the 1990s led the European Commission to commission a study of the problem. The report concluded with twelve recommendations for trade-union action and two recommendations for employer action

(Cockburn, 1996: 3–5). It noted that women are less fully defined by their employee role, have broken work histories, and have historically played a lesser role in the trade-union movement—but argues that this must now change. The report concluded that male trade unionists impede women, do not represent women's interests well, and assume they are speaking for both sexes when they are only speaking for men. Most men are blind to the gender dimension in trade-union agendas, and men give women's issues low priority. Over the centuries, men have established the trade-union movement as a male space, with a male culture, and resent women's intrusion; men are reluctant to relinquish the male property they have historically built in trade unionism (Cockburn, 1996: 59–60). As a result, women's concerns are still not being adequately represented in collective bargaining and the social dialogue process (Cockburn, 1996: 64). The report underlined that women often have a different perspective from men even on 'neutral' issues, such as mobility or working time; on issues of special concern to women, such as part-time jobs, women held diverse positions (Cockburn, 1996: 3). What Cockburn does not address is the fact that the heterogeneity of working women, and their differences from men, seriously complicate the trade-union bargaining position.

With their long-standing focus on the interests of main breadwinners (typically men) and hence on 'standard' full-time permanent jobs, it is understandable that trade unions have always viewed part-time (and temporary) work as an inadequate alternative. For decades, part-time jobs have been labelled as not 'real jobs' and thus unacceptable to any serious worker. The traditional trade-union perspective on part-time jobs continues to dominate the debate on part-time work in many countries (Epstein, 1986: 72–4; Kravaritou-Manitakis, 1988; Rodgers and Rodgers, 1989: 12, 97–9, 101–3, 194, 254–5; Hörning *et al.*, 1995: 29–31), as illustrated here by Chapter 6 on France. However, the fullest exploration of this objection is found in the German literature. Following Mückenberger's seminal article in 1985, there was intensive debate on whether the highly regulated German labour market impeded growth and change and whether deregulation was needed to achieve greater flexibility and to reduce unemployment (Mückenberger, 1985; 1989; Hinrichs, 1990). Mückenberger pointed out that the standard employment contract for full-time permanent work became the crucial reference point for all trade-union bargaining; any development which weakened this norm was perceived to erode trade-union bargaining power and even the trade-union movement itself. This led to multiple and cross-cutting objections to all forms of non-standard work and especially to part-time jobs which are the most common type (Hörning *et al.*, 1995). The traditional trade-union policy has been to seek a reduction in full-time working hours for everyone, and the creation of part-time jobs is perceived to undermine this objective. It is argued that part-time

jobs will be created by splitting full-time jobs, and by imposing part-time jobs on people against their will. Since few part-timers are trade-union members, expansion of the part-time workforce is seen to further weaken trade-union representation and control. There are fears that any flexibility in working time would lead to rationalization, increased productivity, and the intensification of work. All forms of non-standard work create divisions within the workforce and would undermine collective health and safety regulations. Reduced hours jobs would constitute unpaid short-time working. Short hours part-time jobs have lower levels of social security provision and would impose strain on the social welfare net. It was even argued that trade unions would find it impossible to negotiate for flexible working time and part-time jobs in collective agreements, and that any individually negotiated shorter working hours would weaken the collective bargaining position (Hörning *et al.*, 1995: 29–31, 171). Closely linked to these objections is the one that is never explicitly addressed: part-time workers are typically students or married women secondary earners, and they expose the trade-union focus on (male) breadwinners and standard jobs as particular rather than universal; part-time jobs expose the sexual division of labour in the family as contingent rather than necessary.[5]

Trade-union opposition to part-time jobs has been most intransigent in Greece and Italy, where government proposals to expand part-time work were rejected (Kravaritou-Manitakis, 1988: 33, 46–59) and the part-time workforce remained small in both countries, as shown in Chapters 4 and 5. But everywhere trade unions have been hostile, slowing the growth of part-time jobs (Kravaritou-Manitakis, 1988: 138–46; Rodgers and Rodgers, 1989: 12, 194; Pfau-Effinger, 1993: 394). From 1984 onwards there was a sea change in attitudes to labour flexibility, with a series of legislative changes across Europe and elsewhere which were gradually accepted by trade unions (ILO, 1987: 1–2; Kravaritou-Manitakis, 1988: 32). In any event, trade-union opposition lost force during recessions.

Given this history, it is not surprising that part-time workers, casual workers, homeworkers, and freelance workers have remained outside the trade-union movement. In Britain, about 40 per cent of men and women in full-time permanent jobs are trade-union members compared to 20 per cent of people in non-standard jobs: 30 per cent of people in fixed-term contracts, 22 per cent of people in part-time jobs, 10 per cent of people in seasonal and casual jobs, and about 8–10 per cent of the self-employed (Beatson and Butcher, 1993: 676; Dex and McCulloch, 1995: 77). Part-time

[5] The German debate did address this issue because the German concept of the standard employment contract went well beyond the basic definition of full-time permanent employment to include entitlement to all statutory and other employment benefits plus a family wage sufficient to maintain a husband, dependant wife, and one child (see Mückenberger, 1985).

workers, including homeworkers, generally display little interest in union-
ization as a solution to their problems because trade unions are perceived
as defending the interests of male workers and primary breadwinners
rather than the different interests of women and secondary earners
(Hakim, 1987*a*: 171–5). The opposition of trade unions helped to ensure
that part-time jobs remained a separate, low status, and marginal element
in the workforce, excluded from the employment benefits obtained by full-
time workers.[6] A 1980 national survey of working women in Britain found
that half of full-timers compared to one-third of part-timers were offered
opportunities for further training; 41 per cent of full-timers as against 16
per cent of part-timers had opportunities for promotion; 96 per cent of full-
timers and 77 per cent of part-timers received paid holidays; 80 and 51 per
cent respectively were entitled to sick pay. Among employers who ran a
pension scheme, 74 per cent of full-timers and 22 per cent of part-timers
belonged to the scheme (Martin and Roberts, 1984: 46–53). By 1991,
among people whose employer had a pension scheme, 61 per cent of full-
time men, 55 per cent of full-time women but only 17 per cent of part-time
women were members of the pension scheme (OPCS, 1993: 118).
Fortuitously, the social partners' collusion on marginalizing part-time
workers fitted well with the fact that the work most readily organized as
part-time jobs by employers is typically lower grade and low skill work
with low earnings, usually in service industries (Rubery, Horrell, and
Burchell, 1994: 213). In most countries, part-time work tends to be located
towards the bottom end of the occupational hierarchy. However, employ-
ers perceive most part-timers as not seeking demanding work with oppor-
tunities for training and promotion (Hunt, 1975; Beechey and Perkins,
1987: 118; McRae, 1995: 51).

In some countries the volume of part-time work has now risen to levels
where marginalization ceases to be a viable policy. Added to this, the fall
in the volume of full-time permanent 'standard' jobs has eroded trade-
union membership levels to the point where trade unions have been forced
to reposition themselves (Duffy and Pupo, 1992). None the less, across
Europe, the majority of employee representatives in companies remain
lukewarm in their support for part-time work schemes or else remain
actively opposed to them (McRae, 1995: 54–5). However, some trade
unions have formally adopted new policies, actively seeking members
among workers in non-standard jobs, in particular among part-timers. The

[6] On the face of it, the collusion between (male) trade unionists and (male) employ-
ers to wholly exclude married women from the workforce, through the marriage bar
(see n. 2 above), was replaced by a new policy of marginalizing part-time workers (most
of whom are women) and excluding them from mainstream employment rights and
benefits. Thus women's economic dependency and male patriarchal control were main-
tained in a new form for a large proportion of women.

new line is that part-time workers are no different from full-time workers, and need the same degree of employment protection, rights, and benefits; however, part-time jobs have been constructed by employers to be the worst jobs in the workforce and need to be upgraded. Behaviour which was seen as a characteristic of part-time workers, such as low work commitment, high labour turnover, absenteeism, or lack of interest in training and promotion, is now argued to be a characteristic of part-time jobs (Beechey and Perkins, 1987). The implicit argument is that part-time workers will behave just like full-time workers, if only the quality of the jobs can be improved.

Until 1994, when a series of legal decisions gave part-time workers in Britain the right to join employers' pension schemes and the same statutory employment rights as full-time workers, an extensive debate focused on the extent and importance of part-timers' statutory employment rights (Hakim, 1995*a*). Some commentators argued that this had been the key barrier preventing part-timers from fulfilling their true potential and preventing their full integration into the workforce. This seems unlikely. According part-time workers rights to job security, or the right to join employers' pension schemes does not change their basic sex-role preferences and work orientations, the nature of the work they do, the skills they bring to it, and the wage rate for the job. The change in law was significant in forcing employers to treat all workers the same, whatever their work hours, but produces no automatic stimulus to wider social and economic change. Indeed, there is already the contrary evidence of Sweden and Denmark. Mother-friendly and egalitarian social policies in Sweden have not had any major impact on patterns of occupational segregation and women's concentration in the lower grades of the occupational structure (Hakim, 1996*a*: 150). The equalization of legal rights for all workers in Denmark has not eliminated sharp differences in labour turnover between full-time and part-time workers (Hakim, 1996*c*). In sum, improving the legal rights of part-timers does just that, but no more. There is no reason to expect a spillover effect on occupational segregation and on labour mobility.

Labour Mobility and Labour Turnover

Closely related to the trade-union perspective on part-time work is the question of the employment stability, or instability, of part-time workers (or jobs) compared with full-time workers (or jobs). Time and again social scientists compare the two groups and conclude that there is no evidence that women in general, and women working part-time in particular, show a lesser degree of attachment to work in terms of loyalty to a particular

employer (Marsh, 1991: 57), that part-time workers do not appear to be necessarily more unstable than full-time workers (Dex, 1987: 115), or that the evidence that part-time jobs are high-turnover jobs should not be taken at face value (Elias and White, 1991: 32–6, 58). When differences are noted, they are attributed to the occupations in question rather than to the incumbents, to labour-market segmentation (Blossfeld and Mayer, 1988: 129), or to age effects (Elias and White, 1991). However, new analyses of national data for Britain and the USA reveal large and continuing sex differentials in job tenure and labour turnover (Hakim, 1995b; 1996c). The sex differential is constant across age groups and types of occupation. Women collectively, and part-time workers in particular, do not offer the same employment stability as male workers, as employers have always known. Even in Finland and France, two countries with a long tradition of continuous full-time employment among women, labour turnover is twice as high among part-timers as among full-timers (Nätti, 1995: 353–4; and Table 6.6 in this volume).

In countries where part-time work is a new development, part-time jobs may in practice be of short duration—as illustrated by Chapter 5 on Italy in this volume. But in countries with large and stable part-time workforces, employers organize the great majority of part-time jobs as permanent jobs. In Britain about 20 per cent of part-time jobs are designated as temporary jobs compared to about 10 per cent of full-time jobs (Hakim, 1987b: 551; 1990a: 174; Rubery, Horrell, and Burchell, 1994: 214). Thus employers' policies cannot account for the job tenure differential between part-timers and full-timers, a differential which becomes more noticeable in the longer tenure groups, and which is increasing as part-time work expands (Hakim, 1996c: 8). Two other independent analyses of job tenure over the last two decades in Britain also show that sex differentials have been maintained, across occupational and age groups, with only a small narrowing of the gap over two decades (Burgess and Rees, 1994; 1996; Gregg and Wadsworth, 1995).

Analyses of the British 1 per cent Longitudinal Study (LS)[7] confirm that the difference between full-timers and part-timers is largely attributable to the sex differential in labour mobility (Tables 2.4 and 2.5). For example, entry to part-time jobs was almost four times higher than entry to full-time

[7] The British 1% Longitudinal Study is based on information for a 1% sample of the population taken from the 1971 Census, updated with information on the sample from the 1981, 1991, and future Censuses, and with other demographic information already held by OPCS such as birth and death registration, notification of cases of cancer, and internal and overseas migration as reflected in change of address in national health service records. The study aims to provide a dynamic population sample and a source for national statistics and research on fertility, mortality, migration, and labour mobility (OPCS, 1973; 1988). Geographical coverage of the study is now limited to England and Wales, excluding Scotland.

jobs over the 12-month period 1970–1, largely because female (re-)entrants outnumbered male (re-)entrants. Over the decade 1971–81 movement in and out of the workforce was twice as high among women as among men. Although women constitute less than half the workforce, they account for the majority of movements into and out of the workforce. Labour turnover is not influenced by the type of job held. Men in male-dominated, female-dominated, and integrated occupations[8] display the same unvarying exit rate from the workforce. Women in male-dominated, female-dominated, and integrated occupations all show the same unvarying exit rate from the workforce. Differences between full-time and part-time workers, both among new entrants to the workforce and among people leaving the work-force, are attributable almost entirely to the persistent sex differential in labour mobility, which is as strong among full-time workers as among part-time workers. Women working full-time are twice as likely to exit the workforce over a decade as men working full-time. The overwhelming importance of the sex differential in Table 2.4 persists after controls for age and type of occupation are added to the analyses.[9] Many women spend decades out of the labour force. The 1991 Census showed that among women aged 16–64 years, one-quarter had not had a job within the last ten years, and almost none of these women were unemployed and seeking work (Hakim, 1995*b*).

Denmark provides an even more stringent test case, with some of the highest rates of part-time work in Europe, among men as well as women, and full equalization of employment rights and benefits. Longitudinal analyses of the Danish Integrated Database for Labour Market Research show that by the 1980s sex differentials in job tenure and labour turnover

[8] The classification is described more fully in Hakim (1993*b*). Male-dominated occupations are those with <25% female workers; integrated occupations are those with 25% to 55% female workers; female occupations are those with >55% female workers.

[9] The 1% LS only provides data on labour-market status at each decennial census, with no information on the intervening decade. Labour mobility can only be measured in terms of workforce entries and exits in the LS, which inevitably underestimate the broader concept of total labour turnover. Age does affect turnover rates when analyses are extended to the very youngest and oldest age groups. Labour mobility is at its highest among young people, who may be combining education and work, and 'sampling' different types of work before they settle down to a longer-term choice of job (Baxter, 1975). Labour turnover rates of 60% per year have been recorded for young people under 18 years (Department of Employment, 1972: 351). Arguably, analyses of labour turnover and tenure rates should always exclude the especially volatile group of people aged under 20 years. From the age of 20 onwards, annual turnover rates of 30–5% per year are more common, declining to around 10% for people aged 50–9 years (Department of Employment, 1972: 351). Long job tenures are concentrated among older workers, logically. Unfortunately the phenomenon of early retirement and part-time retirement, which begins from age 50 onwards, makes it more difficult to identify a suitable upper cut-off point for analyses of labour mobility.

TABLE 2.4. *Workforce entries and exits 1971–1981: comparison of full-time and part-time jobs*

	Men	Women	All
	Entries to the workforce over the decade 1971–81 as % of people working in 1981		
People working full-time in 1981	26	55	34
People working part-time in 1981	17	48	45
All working in 1981	25	52	36
	Exits from the workforce over the decade 1971–81 as % of people working in 1971		
People working full-time in 1971	23	47	30
People working part-time in 1971	54	46	47
All working in 1971	24	47	33

Source: 1971 and 1981 Census data within the 1% LS, England and Wales. Data for people in work in 1971 or 1981 aged 16 and over, including entrants to labour force from education and exits from labour force to retirement.

had almost disappeared. However, labour mobility differentials between the full-time and part-time workforces remain marked (Table 2.6). Throughout the life-cycle, men and women enter and leave part-time jobs far more frequently than full-time jobs. Over a 12-month period 1988–9 turnover rates averaged 33 per cent for part-timers (50 per cent among male part-timers, most of whom are young, and 27 per cent among female part-timers) compared to 11 per cent for full-timers (13 per cent among women and 9 per cent among male full-timers). On average, one-quarter of all part-timers have been recruited within the last year, compared to 11 per cent of full-timers. A substantial proportion of the movers were moving in and out of the labour market, rather than just changing jobs or becoming unemployed (Table 2.6). Denmark seems to show that the work orientations and employment behaviour of full-timers and part-timers are significantly and consistently different, even when they are accorded equal status in employment law—no doubt because full-time workers are typically primary earners while part-time workers are almost invariably secondary earners.

I conclude that there is only weak evidence for the argument that high female turnover rates are a feature of the segregated occupations or part-time jobs they do rather than of the incumbents. On the contrary, it appears that women collectively have higher outflow rates and turnover rates than men, rather than female-dominated occupations and part-time jobs being organized by employers so as to produce higher turnover rates. Men in female-dominated occupations have the same turnover rates as

TABLE 2.5. *Flows into the workforce and occupational change over one year 1970–1971*

	Proportion (%) of each group who entered the 1971 workforce within the previous twelve months	Base 000s	Proportion (%) of those working in 1970 and 1971 who changed occupation within the year	Base 000s
All working in spring 1971	6	239	6	216
All men	3	152	6	141
working full-time in 1971	3	149	6	139
working part-time	7	3	9	2
All women	11	87	6	75
working full-time in 1971	8	59	6	52
working part-time	16	28	4	23
All working full-time	4	208	6	191
All working part-time	15	31	5	25
Male entries to				
male occupations	3	108	6	101
integrated occupations	3	25	7	23
female occupations	5	19	6	18
Female entries to				
male occupations	9	8	7	7
integrated occupations	9	14	6	11
female occupations	11	66	5	57

Note: Male occupations are those with <25% female workers; integrated occupations are those with 25–55% female workers; female occupations are those with >55% female workers. See Hakim (1993*b*) for details.

Source: 1971 Census data within the 1% LS, England and Wales.

TABLE 2.6. *Labour mobility in Denmark, 1988–1989*

| | Turnover from 1988 workforce | | | | Inflow to 1989 workforce | | | |
| | Total | | LF exits | | Total | | LF entries | |
	FT	PT	FT	PT	FT	PT	FT	PT
Men								
15–19	18	46	4	18	43	37	13	29
20–4	17	57	4	19	18	49	3	14
25–9	10	56	2	13	11	54	2	14
30–54	6	57	1	15	5	58	1	10
55–9	11	39	5	22	3	63	*	12
60+	19	35	13	24	3	54	1	14
Women								
15–19	24	39	8	19	52	37	20	32
20–4	20	54	4	19	22	47	5	22
25–9	14	43	2	13	15	40	3	11
30–54	9	18	2	3	10	13	1	4
55–9	20	18	9	10	11	8	1	2
60+	27	25	19	19	10	8	4	1
All men	9	50	3	17	9	45	2	21
All women	13	27	3	9	15	21	3	11
All persons	11	33	3	12	11	28	2	14

Notes: FT = employers and employees working over 30 hours a week
 PT = employees working less than 30 hours a week
 LF = labour force (workforce in employment plus unemployed)
 * = less than 0.5%

Source: Danish IDA database (Integrated Database for Labour Market Research) from Danmarks Statistik. Data on labour-market position in November 1988 and November 1989 for a 2.5% random sample from the database population, which covers the entire Danish adult population (9/365 of 5.1 million population).

men generally,[10] and women in male-dominated occupations have the same turnover rates as working women generally. At a further stage of development, as illustrated by Denmark, differences between full-timers and part-timers override sex differences. It would seem more appropriate in future to say that employers have adapted to the inevitability of labour mobility being substantially higher among women and part-timers than among men and full-timers, irrespective of the degree and pattern of occupational segregation, with part-time jobs simply displaying the trend most clearly. The combined effect of part-time work and discontinuous employment is to significantly depress women's earnings compared with men's earnings (Elias, 1988; Main, 1988*b*).

Across Europe and the USA, among men and women, part-time work is concentrated in the youngest and oldest age groups, during the labour-market entry and exit phases (Fig. 2.2). In some countries there are further sharp changes across the life-cycle for women (Fig. 2.2). This simple cross-sectional picture provides an initial explanation for the greater labour mobility of part-timers. Other chapters in this book employ event-history analysis to examine in more detail the destinations of women moving out of part-time jobs and how part-time jobs fit into the life-cycle.

Conclusions

Adopting Kohn's (1989) classification of cross-national research, the comparative analysis of part-time work treats nation as context in order to develop and test the generality of findings and interpretations about the position of part-time workers in the workforce, and the location of part-time work within individual work histories. Evidence for a number of industrialized countries, in this and the other chapters of this book, leads us to conclude that permanent part-time work is a qualitatively different type of labour-force involvement to the conventional full-time continuous employment which characterizes male work histories. Part-time work is not just a bit less of the same thing, and yet it is more than a wholly marginal and amateur contribution to the workforce. What makes it a distinctive choice is its subordination to other life interests, mainly but not necessarily non-market activities, so that it becomes a qualitatively different kind of instrumental work. For many (but not all) women and some men, part-time work is subordinate to the family-centred, non-market activities which are easily subsumed under the label of childcare responsibilities. Childcare as such is not the key factor among women collectively, as evidenced by

[10] The exception is that male exit rates from part-time jobs are the same as those for females, largely because men take part-time jobs in the years prior to their full withdrawal from the workforce and full-time retirement.

the fact that women start part-time work and carry on with it both before and long after any childcare responsibilities, plus the fact that those who choose part-time work have distinctively traditional views on women's role in the home and at work, as illustrated by the contrasts between France and the Netherlands in this volume. It would seem that women who explain their paid work with reference to 'childcare' responsibilities may be using this as an abbreviated label for their broad policy of giving first priority to their family-centred activities. The 'children' referred to are frequently old enough to be attending university or already working full-time themselves, or are represented by a retired husband. Childcare and other institutional factors are only important for particular groups of women, in particular female secondary earners, for whom employment is secondary to family priorities across the life-cycle.

The alternative work orientation is already acknowledged in economists' concept of the 'secondary earner', someone who relies on another person as the principal earner and contributes a partial or secondary income to the collective pot (Pott-Buter, 1993: 301–2; Hakim, 1996a: 65–74). Not surprisingly, most principal earners hold 'standard' jobs, whereas many secondary earners are in 'non-standard' jobs. As Pahl pointed out, the reason people in standard and non-standard jobs are content with that pattern of labour-market segmentation is that so many of them meet each other as partners in bed each night (Pahl, 1988: 603). It is worth noting in passing that debate on the minimum wage rarely takes account of the expanding numbers of secondary earners: it insists that all wages should be adequate to provide for a reasonable standard of living for an adult, or complete family, ignoring the fact that wage-earners differ qualitatively in work orientations, job priorities, and financial needs. Research on the largely illusory 'rise' of women's employment in recent decades has overlooked the fact that there has been little or no change in acceptance of the sexual division of labour and sex-role differentiation across Europe, among both women and men (Hakim, 1996a: 84–98). The vast majority of part-time workers are secondary earners; but not all secondary earners take part-time jobs, and not all wives become secondary earners. In the USA, for example, secondary earners typically have full-time jobs and pay for private childcare, and black women in the USA and Britain often remain primary earners throughout the life-cycle (Hochschild, 1990; Hakim, 1996a: 65–74).

Women working part-time are the most visible pioneers of the new instrumental work ethic. But the qualitatively different work orientations described are not necessarily limited to women or wives. Explanations of part-time work that focus exclusively on women (Duffy and Pupo, 1992; Pfau-Effinger, 1993) are not general enough, and may even be biased. Both men and women may have an overriding primary life interest other than their employment, and a family-centred orientation is only one of many

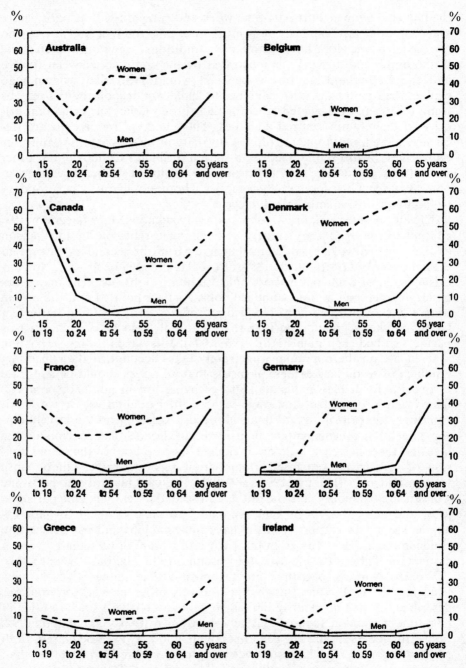

Fig. 2.2. The share of part-time jobs in total employment by age and sex in the EU, the USA, and other countries, 1985–1987

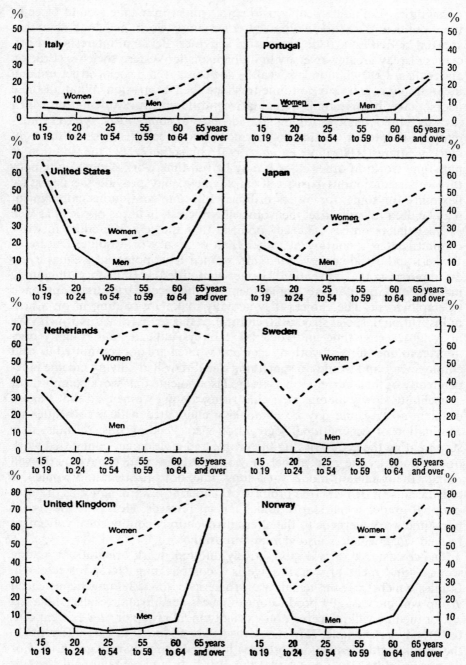

F<small>IG</small>. 2.2. *cont.*
Source: OECD, *Women and Structural Change,* 1994, pp. 85–6

possibilities. For some people paid employment may take second place to their political activities, voluntary community work, religious activities, sporting activities, artistic or creative activities. Personal interests and priorities display greater diversity in individualistic Western societies (Erikson and Vallas, 1990) than in less wealthy societies, even if social structural and institutional constraints continue to shape their expression. What all these people have in common is a qualitatively different work orientation which regards employment as taking second place to some other, typically non-market life interest, so that employment has to be fitted around the non-market interest (Hörning *et al.*, 1995). In some cases, the solution is part-time work; in other cases it may be full-time work done on a temporary or discontinuous basis; self-employment may provide the necessary flexibility for some; for others ordinary full-time continuous employment may be used to 'subsidize' their other life interest, in terms of social as well as financial resources. The key point is that the sex differential in work commitment is a contingent rather than necessary or absolute feature of Western industrial society. Men and women have potentially equal interest in pursuing the conventional career-committed work history, the purely instrumental approach to employment, or the secondary earner approach to employment. The choices they actually make are contingent on a host of institutional, social structural, cultural, and economic factors which vary in weight across time and societies. Surveys indicate that roughly one-quarter to one-third of working men and women are not committed to paid employment, and would do something else if they had a living income independently of their current job. Surveys also indicate that work commitment is declining slowly among men, and rising among women, so that the sex differential may one day be completely eliminated with a consequential elimination of occupational segregation also. Pending this, we must now stop treating the male working-life profile and male career-committed work orientations as the sole model of work attitudes and behaviour. It will remain the dominant model for a long time, both for men and women, if only because it delivers (the promise of) superior rewards in terms of occupational grade, social status, and financial rewards. However, the rise in part-time work alerts us to the alternative, entirely contingent involvement in paid work which is also gaining importance.

The coexistence of two qualitatively different work orientations among women (and men) of working age is a complicating factor for research. Studies which treat the female workforce as a single homogeneous social group will increasingly produce meaningless and invalid results: the average or median will refer to a non-existent modal group or non-existent central trend, for example. New measures will be required to help differentiate the groups and identify dichotomies in female employment patterns. For example Goldin (1989) notes that the distribution of years in paid work as

TABLE 2.7. *The decline in continuous employment and the marriage career*

| Year of labour-market entry | Proportion (%) of each cohort in each group 15 and 20 years after entering the workforce: | | | | | |
| | continuous employment | | marriage career | | discontinuous employment | |
	15	20	15	20	15	20
1941–5	20	13	44	36	36	51
1946–50	18	13	43	31	39	56
1951–5	15	10	38	23	47	67
1956–60	11	8	36	19	53	73
1961–5	13	—[a]	26	—[a]	61	—[a]
Total	15	11	37	27	48	62

Notes: [a] sample too young for results at 20-year stage in 1980 survey.
Continuous employment consists of continuous spells of paid work (full-time or part-time) without any breaks. The marriage career is defined as a single employment spell early in adult life that ended in a permanent exit from the workforce. Discontinuous employment consists of all other work histories combining spells of work and spells of non-work.

Source: Hakim (1996*a*: 132), Table 5.2 based on analysis of 1980 Women and Employment Survey, Great Britain, data for women aged 16–59 in 1980.

a percentage of a woman's married lifetime is U-shaped, with concentrations in the lowest and highest deciles. Another approach to revealing the heterogeneity of the adult female population is to differentiate those following the male profile of continuous full-time employment, those who work only until marriage or child-bearing and then devote themselves permanently to the marriage career, and those who engage in fragmented or discontinuous employment, usually associated with part-time work (Main, 1988*a*; 1988*b*; Hakim, 1996*a*; 1996*c*). The relative importance of these three employment profiles has changed dramatically in the post-war decades (Table 2.7). A sharp decline in the proportion of women in each cohort following the marriage career in Britain has not been translated into more women in continuous employment, which remains extremely rare, but into more women engaging in discontinuous employment, as well as part-time employment. Discontinuous employment, usually associated with part-time work, has become increasingly common, both among full-time housewives and among full-time career-oriented women. Part-time work plays a very different role in the lives of these two groups of women. This helps explain some contradictory research findings in the following chapters of this book. It also ensures that part-time work will remain a puzzle, and a challenge for social scientists.

REFERENCES

Alwin, D. F., Braun, M. and Scott, J. (1992), 'The Separation of Work and the Family: Attitudes towards Women's Labour-Force Participation in Germany, Great Britain and the United States', *European Sociological Review*, 8: 13–37.

Baxter, J. L. (1975), 'The Chronic Job Changer: A Study of Youth Unemployment', *Social and Economic Administration*, 9: 184–206.

Beatson, M. and Butcher, S. (1993), 'Union Density across the Employed Workforce', *Employment Gazette*, 101: 673–89.

Beechey, V. and Perkins, T. (1987), *A Matter of Hours: Women, Part-Time Work and the Labour Market* (Cambridge: Polity Press and Oxford: Basil Blackwell).

Blossfeld, H.-P. and Mayer, K. U. (1988), 'Labour Market Segmentation in the Federal Republic of Germany: An Empirical Study of Segmentation Theories from a Life-Course Perspective', *European Sociological Review*, 4: 123–40.

Bosch, G., Dawkins, P., and Michon, F. (eds.) (1994), *Times are Changing: Working Time in 14 Industrialised Countries* (Geneva: International Institute for Labour Studies).

Boyer, R. (ed.) (1989), *The Search for Labour Market Flexibility: The European Economies in Transition* (Oxford: Oxford University Press).

Braun, M., Scott, J., and Alwin, D. F. (1994), 'Economic Necessity or Self-Actualisation? Attitudes toward Women's Labour-Force Participation in East and West Germany', *European Sociological Review*, 10: 29–47.

Bruegel, I. and Hegewisch, A. (1994), 'Flexibilization and Part-Time Work in Europe', in P. Brown and R. Crompton (eds.), *Economic Restructuring and Social Exclusion* (London: UCL Press), pp. 35–57.

Burgess, S. and Rees, H. (1994), 'Lifetime Jobs and Transient Jobs: Job Tenure in Britain 1975–1991', Centre for Economic Performance Research Paper, London School of Economics.

—— —— (1996), 'Job Tenure in Britain 1975–1992', *Economic Journal*, 106: 334–44.

Castle, B. (1993), *Fighting All The Way* (London: Macmillan).

Centre for Economic Policy Research (1995), *Flexible Integration: Towards a More Effective and Democratic Europe* (London: CEPR).

Cockburn, C. (1996), *Strategies for Gender Democracy: Women and the European Social Dialogue*, *Social Europe*, Supplement 4/95 (Luxembourg: Office for the Official Publications of the European Communities).

Coleman, M. T. and Pencavel. J. (1993), 'Trends in Market Work Behaviour of Women since 1940', *Industrial and Labor Relations Review*, 46(4), 653–77.

Colling, T. and Dickens, L. (1989), *Equality Bargaining—Why Not?* (London: HMSO for the EOC).

Cordova, E. (1986), 'From Full-Time Wage Employment to Atypical Employment: A Major Shift in the Evolution of Labour Relations', *International Labour Review*, 125: 641–57.

Corti, L., Laurie, H., and Dex, S. (1995), *Highly Qualified Women*, Research Series No. 50 (London: Employment Department).

Curtice, J. (1993), 'Satisfying Work—If You Can Get It', in R. Jowell (ed.),

International Social Attitudes: The 10th BSA Report (Aldershot, Hants: Gower), pp. 103–21.

Dahrendorf, R., Kohler, E., and Piotet, F. (eds.) (1986), *New Forms of Work and Activity* (Dublin: European Foundation for the Improvement of Living and Working Conditions).

Dale, A. and Glover, J. (1990), *An Analysis of Women's Employment Patterns in the UK, France and the USA*, Research Paper No. 75 (London: Department of Employment).

Department of Employment (1972), 'Labour Turnover: Estimates based on Employment Surveys and New Earnings Surveys', *Employment Gazette*, 80: 347–51.

Dex, S. (1987), *Women's Occupational Mobility: A Lifetime Perspective* (London: Macmillan).

—— (1988), *Women's Attitudes Towards Work* (London: Macmillan).

—— and McCulloch, A. (1995), *Flexible Employment in Britain: A Statistical Analysis*, Research Discussion Series No. 15 (Manchester: EOC).

—— and Shaw, L. B. (1986), *British and American Women at Work: Do Equal Opportunities Policies Matter?* (London: Macmillan).

Dickens, L. and Colling, T. (1990), 'Why Equality won't Appear on the Bargaining Agenda', *Personnel Management* (Apr. 1990), 48–53.

Dickens, L., Townley, B., and Winchester, D. (1988), *Tackling Sex Discrimination through Collective Bargaining: The Impact of Section 6 of the Sex Discrimination Act 1986* (London: HMSO for the EOC).

Duffy, A. and Pupo, N. (1992), *Part-Time Paradox: Connecting Gender, Work and Family* (Toronto: McClelland & Stewart).

Elias, P. (1988), 'Family Formation, Occupational Mobility and Part-Time Work', in A. Hunt (ed.), *Women and Paid Work* (London: Macmillan), pp. 83–104.

—— and White, M. (1991), *Recruitment in Local Labour Markets: Employer and Employee Perspectives*, Research Paper No. 86 (London: Department of Employment).

Epstein, J. (1986), 'Issues in Jobsharing', in R. Dahrendorf, E. Köhler, and F. Piotet (eds.), *New Forms of Work and Activity* (Luxembourg: Office for the Official Publications of the European Communities), pp. 39–88.

Erikson, K. and Vallas, S. P. (eds.) (1990), *The Nature of Work: Sociological Perspectives* (New Haven, Conn. and London: Yale University Press).

European Commission (1984), *European Men and Women 1983* (Luxembourg: Office for the Official Publications of the European Communities).

—— (1989), *Employment in Europe 1989* (Luxembourg: Office for the Official Publications of the European Communities).

—— (1990), *Employment in Europe 1990* (Luxembourg: Office for the Official Publications of the European Communities).

—— (1993), *Employment in Europe 1993* (Luxembourg: Office for the Official Publications of the European Communities).

—— (1994), *Employment in Europe 1994* (Luxembourg: Office for the Official Publications of the European Communities).

—— (1995*a*), *Employment in Europe 1995* (Luxembourg: Office for the Official Publications of the European Communities).

European Commission (1995*b*), *Social Protection in Europe* (Luxembourg: Office for the Official Publications of the European Communities).

Fiorentine, R. (1987), 'Men, Women and the Premed Persistence Gap: A Normative Alternatives Approach', *American Journal of Sociology*, 92: 1118–39.

Gladstone, A. (ed.) (1992), *Labour Relations in a Changing Environment* (Berlin and New York: Walter de Gruyter).

Goldin, C. (1989), 'Life-Cycle Labour Force Participation of Married Women: Historical Evidence and Implications', *Journal of Labour Economics*, 7: 20–47.

—— (1990), *Understanding the Gender Gap* (New York and Oxford: Oxford University Press).

Goldthorpe, J. H. (1984), 'The End of Convergence: Corporatist and Dualist Tendencies in Modern Western Societies', in J. H. Goldthorpe (ed.), *Order and Conflict in Contemporary Capitalism: Studies in the Political Economy of Western European Nations* (Oxford: Clarendon Press), pp. 315–43; repr. in R. Roberts, R. Finnegan, and D. Gallie (eds.), *New Approaches to Economic Life* (Manchester University Press, 1985), pp. 124–53.

Gregg, P. and Wadsworth, J. (1995), 'A Short History of Labour Turnover, Job Tenure and Job Security, 1975–93', *Oxford Review of Economic Policy*, 11: 73–90.

Grint, K. (1988), 'Women and Equality: The Acquisition of Equal Pay in the Post Office 1870–1961', *Sociology*, 22: 87–108.

Hakim, C. (1987*a*), *Home-Based Work in Britain*, Research Paper No. 60 (London: Department of Employment).

—— (1987*b*), 'Trends in the Flexible Workforce', *Employment Gazette*, 95: 549–60.

—— (1989*a*), 'Employment Rights: A Comparison of Part-Time and Full-Time Employees', *Industrial Law Journal*, 18: 69–83.

—— (1989*b*), 'Workforce Restructuring, Social Insurance Coverage and the Black Economy', *Journal of Social Policy*, 18: 471–503.

—— (1990*a*), 'Workforce Restructuring in Europe in the 1990s', *International Journal of Comparative Labour Law and Industrial Relations*, 5: 167–203.

—— (1990*b*), 'Core and Periphery in Employers' Workforce Strategies: Evidence from the 1987 ELUS survey', *Work, Employment and Society*, 4: 157–88.

—— (1991), 'Grateful Slaves and Self-Made Women: Fact and Fantasy in Women's Work Orientations', *European Sociological Review*, 7: 101–21.

—— (1992), 'Explaining Trends in Occupational Segregation: The Measurement, Causes and Consequences of the Sexual Division of Labour', *European Sociological Review*, 8: 127–52.

—— (1993*a*), 'The Myth of Rising Female Employment', *Work, Employment and Society*, 7: 97–120.

—— (1993*b*), 'Segregated and Integrated Occupations: A New Approach to Analysing Social Change', *European Sociological Review*, 9: 289–314.

—— (1994), 'A Century of Change in Occupational Segregation 1891–1991', *Journal of Historical Sociology*, 7: 435–54.

—— (1995*a*), 'Five Feminist Myths about Women's Employment', *British Journal of Sociology*, 46: 429–55.

—— (1995*b*), '1991 Census SARs: Opportunities and Pitfalls in the Labour Market Data', *Work, Employment and Society*, 9: 569–82.

—— (1996a), *Key Issues in Women's Work: Female Heterogeneity and the Polarisation of Women's Employment* (London: Athlone Press).

—— (1996b) 'The Sexual Division of Labour and Women's Heterogeneity', *British Journal of Sociology*, 47: 178–88.

—— (1996c), 'Labour Mobility and Employment Stability: Rhetoric and Reality on the Sex Differential in Labour Market Behaviour', *European Sociological Review*, 12: 1–31.

—— (1996d), *Working Students: Students in Full-Time Education with Full-Time and Part-Time Jobs*, Working Paper No. 8 (London: London School of Economics Sociology Department).

—— (1996e), 'Theoretical and Measurement Issues in the Analysis of Occupational Segregation' in P. Beckmann (ed.), *Gender Specific Occupational Segregation (Beiträge zur Arbeitsmarkt- und Berufsforschung)* (Monographs on Employment Research) no. 188, 67–88 (Nurnberg: Institüt für Arbeitsmarkt- und Berufsforschung (IAB)).

—— (forthcoming), *Social Change and Innovation in the Labour Market* (London: Routledge).

Haller, M. and Hoellinger, F. (1994), 'Female Employment and the Change of Gender Roles: The Conflictual Relationship between Participation and Attitudes in International Comparison', *International Sociology*, 9: 87–112.

Hepple, B. A. (1990), *Working Time* (London: Institute of Public Policy Research).

—— and Hakim, C. (1996), 'Working Time in the United Kingdom', in R. Blanpain and J. Rojot (eds.), *Legal and Contractual Limitations to Working Time in the European Union Member States*, 2nd edn. (Leuven: Peeters).

Hinrichs, K. (1990), *Irregular Employment and the Loose Net of Social Security: Some Findings on the West German Development*, Working Paper No. 7/90, University of Bremen Centre for Social Policy Research.

Hochschild, A. (1990), *The Second Shift: Working Parents and the Revolution at Home* (London: Piatkus).

Hörning, K. H., Gerhard, A., and Michailow, M. (1995), *Time Pioneers: Flexible Working Time and New Lifestyles* (Cambridge: Polity Press).

Humphries, J. and Rubery, J. (1992), 'The Legacy for Women's Employment: Integration, Differentiation and Polarisation', in J. Michie (ed.), *The Economic Legacy of Thatcherism* (London: Academic Press), pp. 236–57.

Hunt, A. (1975), *Management Attitudes and Practices Towards Women at Work* (London: HMSO).

Hyman, R. (1991), 'European Unions: Towards 2000', *Work, Employment and Society*, 5: 621–39.

International Labour Office (1987), *La Flexibilité du Marché de l'Emploi: Un Enjeu Economique et Social* (Geneva: ILO).

—— (1989), *Conditions of Work Digest, vol. 8, no. 1. Part-Time Work* (Geneva: ILO).

Jacobs, S. C. (1995), 'Changing Patterns of Sex Segregated Occupations throughout the Life-Course', *European Sociological Review*, 11: 157–71.

Jenson, J., Hagen, E., and Reddy, C. (eds.) (1988), *Feminisation of the Labour Force: Paradoxes and Promises* (New York: Oxford University Press).

Jonung, C. and Persson, I. (1993), 'Women and Market Work: The Misleading

Tale of Participation Rates in International Comparisons', *Work, Employment and Society*, 7: 259–74.

Joshi, H. E., Layard, R., and Owen, S. J. (1985), 'Why are More Women Working in Britain?', *Journal of Labor Economics*, special issue on *Trends in Women's Work, Education and Family Building* ed. R. Layard and J. Mincer, S147-S176.

Kiernan, K. (1992), 'Men and Women at Work and at Home', in R. Jowell *et al.* (eds.), *British Social Attitudes—the 9th Report* (Aldershot, Hants: Gower), pp. 89–111.

Kohn, M. L. (1989), 'Cross-National Research as an Analytic Strategy', in M. L. Kohn (ed.), *Cross-National Research in Sociology* (Newbury Park, Calif. and London: Sage), pp. 77–102.

Kravaritou-Manitakis, Y. (1988), *New Forms of Work: Labour Law and Social Security Aspects in the European Community* (Luxembourg: Office for Official Publications of the European Communities for the European Foundation for the Improvement of Living and Working Conditions).

Lane, C. (1989), 'From Welfare Capitalism to Market Capitalism: A Comparative Review of Trends towards Employment Flexibility in the Labour Markets of Three Major European Societies', *Sociology*, 23: 583–610.

Lewenhak, S. (1977), *Women and Trade Unions* (London: Benn).

McRae, S. (1995), *Part-Time Work in the European Union: The Gender Dimension* (Dublin: European Foundation for the Improvement of Living and Working Conditions).

Main, B. (1988a), 'The Lifetime Attachment of Women to the Labour Market', in A. Hunt (ed.), *Women and Paid Work* (London: Macmillan), pp. 23–51.

—— (1988b), 'Women's Hourly Earnings: The Influence of Work Histories on Rates of Pay', in A. Hunt (ed.), *Women and Paid Work* (London: Macmillan), pp. 105–22.

Marsh, C. (1991), *Hours of Work of Women and Men in Britain* (London: HMSO).

Martin, J. and Roberts, C. (1984), *Women and Employment: A Lifetime Perspective* (London: HMSO for the Department of Employment).

Meulders, D., Plasman, R., and Vander Stricht, V. (1993), *The Position of Women on the Labour Market in the EC* (Aldershot: Dartmouth Publishing).

—— Plasman, O., and Plasman, R. (1994), *Atypical Employment in the EC* (Aldershot: Dartmouth Publishing).

Mincer, J. (1985), 'Intercountry Comparisons of Labor Force Trends and of Related Developments: An Overview', *Journal of Labor Economics*, 3: S1–S32.

MISEP (1995), 'Short-Time Work Schemes in France, Germany, Italy and Spain: From Cyclical to Structural Intervention', *Employment in Europe: Policies*, No. 52 (winter), 19–27.

Mückenberger, U. (1985), 'Die Krise des Normalarbeitsverhältnisses—Hat das Arbeitsrecht noch Zukunft?' ('The Crisis of the Standard Working Relationship'), *Zeitschrift für Sozialreform*, 31: 415–34 and 457–75.

—— (1989), 'Non-Standard Forms of Employment in the Federal Republic of Germany: The Role and Effectiveness of the State', in G. Rodgers and J. Rodgers (eds.), *Precarious Jobs in Labour Market Regulation* (Geneva: International Labour Office).

Müller-Jentsch, W. (1988), 'Industrial Relations Theory and Trade Union

Strategy', *International Journal of Comparative Labour Law and Industrial Relations*, 4: 177–90.

Nätti, J. (1995), 'Part-Time Work in the Nordic Countries: A Trap for Women?', *Labour*, 9: 343–57.

Nerb, G. (1986), 'Employment Problems: Views of Businessmen and the Workforce—Results of an Employee and Employer Survey on Labour Market Issues in the Member States', *European Economy*, 27: 5–110.

Neubourg, C. de (1985), 'Part-Time Work: An International Quantitative Comparison', *International Labour Review*, 124: 559–76.

OECD (1988), 'Women's Activity, Employment and Earnings: A Review of Recent Developments', *Employment Outlook* (Paris: OECD), pp. 129–71.

—— (1990), 'Involuntary Part-Time Work as a Component of Underemployment', in *Employment Outlook* (Paris: OECD), pp. 179–93.

—— (1991), 'Absence from Work Reported in Labour Force Surveys', *Employment Outlook* (Paris: OECD), pp. 177–98.

—— (1994), 'Part-Time Employment', in *Women and Structural Change: New Perspectives* (Paris: OECD), pp. 73–100.

—— (1995), 'Recent Labour Market Developments' and 'Supplementary Measures of Labour Market Slack: An Analysis of Discouraged and Involuntary Part-Time Workers', in *Employment Outlook* (Paris: OECD), pp. 3–42 and 43–97.

OPCS (1973), *Cohort Studies—New Developments*, Studies on Medical and Population Subjects No. 25 (London: HMSO).

—— (1988), *Census 1971–1981: The Longitudinal Study—England and Wales*, CEN81LS (London: HMSO).

—— (1992), *Labour Force Survey 1990 and 1991* (London: HMSO for the Office of Population Censuses and Surveys).

—— (1993), *General Household Survey 1991* (London: HMSO for the Office of Population Censuses and Surveys).

Pahl, R. E. (ed.) (1988), *On Work: Historical, Comparative and Theoretical Approaches* (Oxford: Basil Blackwell).

Pfau-Effinger, B. (1993), 'Modernisation, Culture and Part-Time Employment: The Example of Finland and West Germany', *Work, Employment and Society*, 7 (3), 383–410.

Plantenga, J. (1995), 'Part-Time Work and Equal Opportunities: The Case of the Netherlands', in J. Humphries and J. Rubery (eds.), *The Economics of Equal Opportunities* (Manchester: Equal Opportunities Commission) pp. 277–90.

Pollert, A. (1983), *Girls, Wives, Factory Lives* (London: Macmillan).

Pott-Buter, H. A. (1993), *Facts and Fairy Tales about Female Labor, Family and Fertility* (Amsterdam: Amsterdam University Press).

Rodgers, G. and Rodgers, J. (eds.) (1989), *Precarious Jobs in Labour Market Regulation* (Geneva: International Labour Office).

Rojot, J. and Blanpain, R. (eds.) (1997), *Legal and Contractual Limitations on Working Time*, 2nd edn. (Leuven: Peeters).

Rose, S. (1992), *Limited Livelihoods: Gender and Class in Nineteenth-Century England* (London: Routledge).

Rosenfeld, R. A. and Birkelund, G. E. (1995), 'Women's Part-Time Work: A Cross-National Comparison', *European Sociological Review*, 11: 111–34.

Rubery, J. and Fagan, C. (1993), *Occupational Segregation of Women and Men in the European Community*, *Social Europe*, Supplement 3/93 (Luxembourg: Office for Official Publications of the European Communities).

—— —— (1995), 'Comparative Industrial Relations Research: Towards Reversing the Gender Bias', *British Journal of Industrial Relations*, 33: 209–36.

—— Horrell, S., and Burchell, B. (1994), 'Part-Time Work and Gender Inequality in the Labour Market', in A. M. Scott (ed.), *Gender Segregation and Social Change* (Oxford: Oxford University Press).

Schoer, K. (1987), 'Part-Time Employment: Britain and West Germany', *Cambridge Journal of Economics*, 11: 83–94.

Scott, J. (1990), 'Women and the Family', in R. Jowell *et al.* (eds.), *British Social Attitudes: The 7th Report* (Aldershot, Hants: Gower), pp. 51–76.

—— Braun, M., and Alwin, D. (1993), 'The Family Way', in R. Jowell *et al.* (eds.), *International Social Attitudes: The 10th BSA Report* (Aldershot, Hants: Gower), pp. 23–47.

Thomson, K. (1995), 'Working Mothers: Choice or Circumstance?', in R. Jowell *et al.* (eds.), *British Social Attitudes: the 12th Report* (Aldershot, Hants: Dartmouth), pp. 61–91.

Tilly, C. (1991), 'Reasons for the Continuing Growth of Part-Time Employment', *Monthly Labor Review*, 114(3), 10–18.

Vogler, C. (1994), 'Segregation, Sexism and Labour Supply', in A. M. Scott (ed.), *Gender Segregation and Social Change* (Oxford: Oxford University Press), pp. 39–79.

Walby, S. (1986), *Patriarchy at Work* (Cambridge: Polity Press).

Warr, P. (1982), 'A National Study of Non-Financial Employment Commitment', *Journal of Occupational Psychology*, 55: 297–312.

Watson, G. and Fothergill, B. (1993), 'Part-Time Employment and Attitudes to Part-Time Work', *Employment Gazette*, 101: 213–20.

Wedderburn, A. (ed.) (1995), *Part-Time Work*, No. 8 of BEST: Bulletin of European Studies on Time (Dublin: European Foundation).

Witherspoon, S. (1988), 'Interim Report: A Woman's Work', in R. Jowell *et al.* (eds.), *British Social Attitudes: The 5th Report* (Aldershot, Hants: Gower), pp. 175–200.

Zighera, J. (1996), 'How to Measure and Compare Female Activity in the European Union', in P. Beckmann (ed.), *Gender Specific Occupational Segregation (Beiträge zur Arbeitsmarkt- und Berufsforschung)* no. 188, 189–105 (Nurnberg: Institut für Arbeitsmarkt- und Berufsforschung (IAB)).

Part-Time Work in Central and Eastern European Countries

SONJA DROBNIČ

Introduction

In most Western European countries, the number of people engaged in some type of non-standard employment has increased considerably in both absolute and relative terms in recent years. Also, part-time employment, defined as any employment arrangement involving normal weekly working hours below the 'standard' duration of working time, grew remarkably, especially compared to full-time jobs (Büchtemann and Quack, 1990; Hakim, 1993; Kiernan, 1991; Meulders and Plasmann, 1992). These developments prompted intensive theoretical and policy debates, and revealed disparate views on the advantages and disadvantages of part-time work.

On the one hand, part-time employment is often condemned as a precarious form of employment carrying heavy penalties—low pay, little job security, inadequate legal protection, lack of social benefits, and poor career prospects. Higher status part-time work opportunities are unusual although feasible (Sidaway and Wareing, 1992). Employers have often regarded part-time workers as a marginal labour force, used to meet temporary overload and minimize costs by avoiding overtime salaries for full-time workers. Since most part-time workers are women, this type of employment is seen as a source of unequal treatment of female workers and their marginalization in the labour market.

On the other hand, it is also defended as a flexible, effective, and relatively well-protected way of reconciling the needs and preferences of workers with the requirements of enterprises on the demand side of the labour market. It is particularly beneficial to individuals with family responsibilities, workers approaching retirement, and other special groups. Part-time employment can also increase the continuity of labour-force attachment of women, and strengthen their position in the labour market, as has been argued in the case of Sweden (Sundström, 1991).

Regardless of whether part-time work is seen as a resource and an

opportunity, or as a path to marginalization in the labour market and in society, the arguments have so far referred exclusively to the situation in developed market economies. Little is known about part-time work and labour markets in general in Central and East European countries. This is true not only for the employment arrangements in the past; relatively little attention has also been paid to the reallocation of labour and changing employment patterns in the 1990s. Yet the fundamental restructuring of economic, political, and social systems in these countries is manifested perhaps most strikingly in the sphere of employment.

Employment Characteristics of Planned Economies

Employment in former socialist countries was defined as a state-guaranteed social right. Full employment was one of the essential concepts and objectives of state socialism, and an important factor of legitimation (Ferge, 1992). Official unemployment was non-existent or negligible, and as a rule the demand for labour exceeded the labour supply. The only exception in Central and Eastern Europe was former Yugoslavia, where the constitutional right to work was in practice not realized. In Yugoslavia, early attempts to introduce elements of a market system into a planned economy resulted in persistent and increasing unemployment from the 1950s onwards. By the end of the 1980s, the country had an average unemployment rate of over 15 per cent and there were enormous regional disparities (Drobnič and Rus, 1995).

Full employment, which prevailed until the end of the 1980s, did not imply full and efficient allocation and use of human resources. Firms used manpower inefficiently, and maintained too many and often overqualified workers. The demand for labour was basically independent of conditions in product markets. It was supported by government subsidies, investments in labour-intensive sectors, and overall low real wages due to centrally imposed wage regulations. In addition to the cheap price of labour, 'soft budget constraints' at the enterprise level, and ideological justifications, overmanning had additional practical functions, particularly in those economies that relied solely on central planning within the framework of a 'shortage economy'. Firms in such environments frequently experienced breakdowns and supply bottlenecks that disrupted production; this made it difficult to meet plan requirements. During the supply bottlenecks, many workers were idle. After the production process was resumed, the 'rush work' at the end of monthly, quarterly, or yearly planning periods required intensive, often uninterrupted production (Laki, 1980). Firms needed an extensive labour force for these peak periods. In a sense, this process parallels labour hoarding in Western economies, but it reached much larger

proportions and was systemically stipulated.[1] Thus, under the conditions of central planning, the demand for labour was enormous, and a chronic shortage of workers was a permanent concern.[2]

There were also a number of factors that promoted high rates of labour-force participation on the supply side. Due to low wages and the official doctrine emphasizing the role of work and gender equality, there was strong financial and ideological pressure on women to enter paid employment. In addition, and perhaps more importantly, non-participation in formal paid employment could lead to social and economic deprivation and marginalization, as many social rights, services, and benefits[3] were provided to the population through enterprises. Business firms also performed the role of social policy agencies.

Taking these structural characteristics of both the supply and demand side of the labour market into account, it comes as no surprise that labour-force participation in most Central and East European countries was significantly higher than that in Western Europe, despite the fact that the retirement age was on average much lower. The difference in participation rates mainly reflected very high female labour-force participation.

Labour-Market Rigidities

In spite of official denial of the very existence of the labour market, both legally and theoretically in the past, labour markets also existed in planned economies in rudimentary form (Vodopivec, 1991; Lehmann and Schaffer, 1991); however, they were characterized by various constraints and rigidities. Rigidity in this context means that firms and individuals had narrow options in allocation decisions; alternatives were very limited or non-existent. Rigidities could be found in all spheres related to labour—in terms of ownership relations, sectoral characteristics, types and size of firms, and inflexible work arrangements (Drobnič, 1992). Such rigidities are

[1] Reliable estimates of overmanning or hidden unemployment are difficult to come by; they differ widely according to the concepts used and the methods of estimation. When we compared estimates for different countries, it appeared that in planned economies between 10 and 25% of all working time was effectively hoarded labour (Mencinger, 1989; Miron, 1992; Nešporová, 1995; Rutkowski, cited in Socha and Sztanderska, 1991).

[2] Just one illustration: in Poland there were 86 registered vacancies for every job seeker in 1988; even in December 1989, after the programme for system transformation was announced, there were still 25 registered vacancies per job seeker (Socha and Sztanderska, 1991).

[3] Non-wage benefits were a major component of employment remuneration under central planning. These included goods and services such as childcare facilities, housing, holiday facilities, and other benefits.

often seen as distortions which hinder the desired transformation towards a market economy. Since I argue that current changes aimed at abolishing rigidities will potentially have a strong impact on part-time employment in these countries in the future, let us briefly examine some of the characteristics of the labour markets and employment arrangements of the past.

Rigidities concerning the predominance of the social or state sector over the private sector can be traced back to the nationalization of the means of production. The private sector was kept insignificant by legal limitations (especially on the size of private firms), discriminatory taxation, and limited access to and unfavourable terms for credit (Vodopivec, 1991). Private agriculture was an exception in Poland and former Yugoslavia, but even there, the limitations in terms of size of the private farms were very restrictive.

According to ILO data for the 1980s, only 0.1 per cent of the economically active population in Czechoslovakia were employers or self-employed. The percentages for other countries were slightly higher: Bulgaria 0.3, Hungary 3.6, Poland 14.2, and Yugoslavia 17.2. Disproportionately high figures for Poland and Yugoslavia reflect to a large extent the existence of private property and employment in the agricultural sector.

Within the social or state sector, employment was concentrated in agriculture and particularly in industry. The service sector was underdeveloped, both in terms of its share of national income, and in terms of service employment. Bićanić and Škreb (1991) computed the average proportion of the labour force in agriculture, industry, and services for Bulgaria, Czechoslovakia, GDR, Hungary, Poland, Romania, and Yugoslavia. Services here consisted of everything not included in agriculture, forestry, industry, and construction. On average, 22 per cent of the labour force in these countries were employed in agriculture, 43 per cent in industry, and 35 per cent in services (with Romania as an extreme case with only 26 per cent of the labour force in the service sector) in 1985. These figures were well below those for developed market economies, where the majority of workers were employed in services.

Work arrangements in Central and East European countries can tentatively be described as standard employment arrangements, with life-long, secure, permanent, full-time jobs.[4] Even in former Yugoslavia, with its high unemployment rates, unemployment had specific characteristics reflecting the state regulation and legal structure of the socialist system. When a person obtained a job, it was generally a permanent full-time job. It was only in exceptional cases that workers could be reassigned to other jobs and

[4] Caution is needed, however, when such terminology is used for countries in which institutional regulations and policies as well as economic and social frameworks profoundly differed from those in Western labour markets.

organizations or even be sacked. Strict regulation of hiring and lay-off practices resulted in high job stability and job security, but also shaped the structure of unemployment decisively. Most of the unemployed in Yugoslavia were new entrants into the labour market who had not yet succeeded in securing their first regular employment position, or those whose time-limited contracts had expired, as was the case with workers who were hired on a temporary basis to replace women (seldom men) on parental leave.

Working hours were also rigid in former socialist economies. As observed by Vodopivec (1991), rigidity in work arrangements appeared to be used to fight the illegal and semi-legal activities in the second economy. And finally, employment was almost exclusively full-time. Part-time work was of marginal importance and reserved for special groups of workers.

Part-Time Work

It is symptomatic that no comprehensive data on part-time workers in the past is available for Central and East European countries. Only recently have standard labour-market concepts and definitions—including part-time work—found their way into employment statistics. This resulted from the establishment of Employment Offices and the adoption of the Labour Force Survey methodology. However, even today the concept of part-time work is ambiguous and data are not necessarily internationally comparable.

This lack of hard statistical data does not mean that no part-time work existed in former socialist countries. However, under conditions of labour shortages, part-time employment had different functions than in developed market economies, and it was restricted to special categories of workers. Although there were differences among countries in Central and Eastern Europe with respect to legal rules and regulations, some common principles and characteristics can be identified. Part-time work was basically used as a means of increasing labour input, or to keep people in the labour force who would otherwise have probably been excluded from it. Thus, it was common among people who held a second job. This was not only the case with widespread moonlighting, but also common in the formal economy. In Czechoslovakia, for example, registered second jobs contributed 4.2 per cent of employment in 1989 (Nešporová, 1995).

Another large category of part-timers were pensioners. Iovcheva (1992) reports that recruiting pensioners was a widespread practice in Bulgaria due to labour shortages. Some countries adopted special measures to induce more pensioners to continue working or to return to work (in particular on a part-time basis) and supported pensioners' employment with

generous remuneration policies. In addition to pay proportional to the hours worked, pensioners could receive their full pension if their part-time salary did not exceed a certain level (see the sections on Poland and USSR in the ILO 1989). However, if this level was exceeded, their pensions were reduced. In Poland, this reduction did not apply if a pensioner was employed in an occupation that had a labour shortage (ILO, 1989).[5]

Central and East European countries have set up comprehensive and relatively generous systems of family benefits, including—in particular— lengthy periods of paid maternity and childcare leave. Eligibility criteria and duration varied across countries. Mothers frequently stayed at home to look after their children in the first years of life, but typically re-entered the labour market when the subsidies expired. The common family pattern was based on two full-time earners, except for periods of paid leave. The right to re-employment was guaranteed by law. In addition to pregnancy and maternity leave (typically lasting around 6 months), childcare leave could sometimes be extended until the child was 2 or 3 years old (as noted in an overview for Hungary, Czechoslovakia, and Bulgaria in Göting, 1993).

Part-time work was sometimes considered appropriate for women with young children; this option would help women bringing up children to combine their employment, social life, and family responsibilities. It must be noted, however, that normative rights and practice often diverged. In Slovenia, for example, working mothers (also fathers, adoptive parents, or others caring for a young child) had the option of taking one year's paid parental leave and then returning to their full-time job; or they could return to work earlier on a part-time basis, and in this way extend the duration of partial parental leave beyond the one-year period. As a rule, workers on parental leave chose the option of returning to their full-time job, which was seen as more desirable from the standpoint of the individual parent as well as the enterprise.

Another group of part-timers were disabled people who were legally entitled to shorter working hours due to their medical condition. Job invalids, in particular, who did not fulfill criteria for early retirement, were often reassigned to physically less demanding and/or part-time jobs. Thus, part-time work in the former socialist economies of Central and Eastern Europe was primarily associated with second jobs, the disabled, and pensioners. Part-time employment was not a typically female phenomenon.[6]

[5] Again, the situation was different in former Yugoslavia, where legal obstacles were imposed and occasional political campaigns against employment of workers above the statutory pensionable age were launched to give young unemployed generations a better chance of entering the secure segments of regular employment.

[6] Older studies on the desirability of part-time work reveal that part-time employment would have been an attractive option for certain segments of the working

Changes in Employment Regulations

Labour-market adjustments following the economic restructuring of transition economies have resulted in a massive displacement of workers. Thus, the permanent excess demand for labour has been replaced by rising unemployment over a very short period. This has been happening at a time when East European countries have been experiencing serious problems in the economic, social, and political spheres, such as a loss of markets, falling output, inflation, political instability, and the lack of legal regulations and institutional routines. Newly established employment offices and services are underdeveloped; comprehensive social policy programmes and even basic safety-nets are lacking.

The severity of the unemployment problem has focused the attention of labour-market researchers and policy-makers on unemployment issues. Other new features of employment, following a specific CEE labour market restructuring and deregulation, have remained largely unnoticed or neglected. Therefore, it is a demanding task to make international comparisons in the employment sphere, even if data on part-time employment are currently available in some countries.

New legal regulations concerning employment relations have been introduced in all CEE countries. The new rules have simplified hiring and firing procedures, made the reassignment of workers within firms more flexible, and introduced opportunities for workers to be assigned to other firms. The most radical break with past practice is embodied in redundancy legislation and regulations concerning mass layoffs. Social policy measures and labour-market intervention have taken several directions, for example, establishing employment offices and unemployment insurance schemes, organizing public employment programmes, subsidizing new jobs in the social and particularly private sector, assisting unemployed people to become entrepreneurs, using early retirement on a massive scale, and making work arrangements more flexible. Legal options for fixed-term employment and part-time work have been opened up.

population if opportunities for part-time work had existed. In a survey conducted among women by the Hungarian Central Statistical Office in 1986, a large majority of women (78%) would have preferred working shorter hours, although 80% of all respondents would not have wished to give up their employment, even if they could have afforded it (Frey and Gere, 1994). A sociological study on attitudes towards work in Slovenia in 1984 revealed that about 20% of the employed population would have preferred shorter working hours than their current working time, even with a proportional reduction in their earnings (Rus, 1984).

Part-Time Work in the Transition Period

What consequences have the recent changes in institutional framework and new employment practices had for part-time work? Data on part-time employment in Poland, Hungary, and Slovenia illustrate current developments.[7]

Poland

According to the 1992, 1993, and 1994 Labour Force Surveys, about 11 per cent of people in employment in Poland held part-time jobs (Table 3.1). The differences between men and women were small. Women were somewhat more likely to have a part-time job: 13 per cent compared to 9 per cent of men. However, there is little evidence that part-time work is related to the family cycle and child-rearing in the same sense as in West European countries. Women of child-bearing and child-rearing age are less likely than very young women or women over retirement age (over age 55) to work part-time.

Part-time jobs are held by women in much the same pattern as among men. They are concentrated among the very young or the old. Part-time workers have relatively low levels of education, and they are disproportionately concentrated in rural areas, particularly in agriculture. Every second part-time job is in agriculture, indicating that many part-time jobs are connected with family farms. Among part-time jobs held by women in the private sector, over 40 per cent are unpaid family workers. This is in sharp contrast to the Western European situation, where part-time jobs are concentrated in services.[8]

Hungary

In Hungary, the proportion of part-timers is very low. In the one-year period between 1992 (when the Labour Force Survey was introduced as a

[7] These countries provide information on part-time employment based on Labour Force Surveys. Data for Poland used in this chapter were kindly provided by Janusz Witkowski, Central Statistical Office, Warsaw, and data for Hungary by Mária Frey, Ministry of Labour, Budapest. Unpublished Slovenian data were made available by Sonja Pirher and Alenka Gorše, Employment Office of Slovenia, Ljubljana.

[8] The Employment Act regulation (introduced in Poland in 1991), limiting the status 'unemployed' to persons ready to take on a full-time job, showed how marginal and insignificant the notion of part-time job had remained. Persons prepared to work only part-time were not considered part of the 'normal' labour force: they could not register as unemployed and had no rights to unemployment benefits and services. According to the Labour Force Survey, about 14% of the unemployed in 1992 were seeking a part-time job, and gave this as a reason for not being registered in labour offices (Witkowski, 1995).

TABLE 3.1. *Part-time employment in Poland*

	1992	1993	1994
Proportion part-time of total	11	11	11
Men	10	9	9
Age:			
15–17	88	83	67
18–19	40	37	29
20–4	7	7	11
25–9	6	4	4
30–4	4	4	4
35–44	5	4	5
45–54	6	6	7
55–9	14	13	14
60–4	32	32	30
65 and over	44	54	49
Educational level:			
University degree	8	8	7
Some college	9	6	7
Secondary vocational	6	5	6
Secondary general	14	11	11
Basic vocational	6	6	7
Primary school or less	19	18	17
Women	13	14	13
Age:			
15–17	94	84	82
18–19	53	52	32
20–4	12	12	13
25–9	8	11	9
30–4	8	9	10
35–44	6	7	8
45–54	9	10	10
55–9	26	27	27
60–4	39	40	41
65 and over	51	55	56
Educational level:			
University degree	10	11	10
Some college	6	8	7
Secondary vocational	8	8	9
Secondary general	9	10	8
Basic vocational	10	11	12
Primary school or less	24	24	24

Sources: Labour Force Survey; Central Statistical Office, Warsaw.

regular instrument for collecting data on labour and employment issues) and 1993, the number of part-time employees fell from 68.6 thousand to 49.7 thousand. In 1993, 0.6 per cent of male and 1.8 per cent of female employees worked part-time (Table 3.2). Almost 56 per cent of part-timers were 55 or older. Women represented about two-thirds of part-timers; however, every second woman in part-time employment was already retired and drawing a pension (Frey and Gere, 1994).

In a recent survey on the desirability of part-time work in Hungary that was conducted by the Central Statistical Office in June 1993, about 20 per cent of women working full-time and 8 per cent of men expressed an interest in working part-time with a pro rata reduction in earnings. Of those who rejected this option, another 8 per cent of men and 13 per cent of women stated that they would accept a part-time job on condition that they received at least partial compensation for the wage loss (Frey and Gere, 1994). For women, household responsibilities and more time for children were the major incentives for choosing part-time employment, whereas men more often referred to better opportunities for participation in the second economy. The study also revealed that a large majority of the unemployed would be prepared to accept part-time employment if full-

TABLE 3.2. *Part-time employment in Hungary*

	1st quarter 1992	1st quarter 1993
Proportion part-time of all employed	1.6	1.3
Men	1.1	0.6
Age:		
15–19	1.5	0.4
20–4	0.7	0.2
25–9	0.2	0.2
30–9	0.2	0.1
40–54	0.3	0.3
55–9	1.6	1.2
60–74	17.4	12.3
Women	2.1	1.8
Age:		
15–19	1.9	2.5
20–4	1.3	0.7
25–9	1.1	1.2
30–9	1.2	1.2
40–54	0.9	0.7
55–9	11.7	9.3
60–74	23.5	22.6

Sources: Labour Force Survey, *Annual Report 1992, Annual Report 1993*; Central Statistical Office, Hungary.

time jobs were not available. However, the number of preferred working hours in such a hypothetical part-time job is high—the majority of men would like to have a 7-hour and the majority of women a 6-hour working day. And less than 5 per cent of the unemployed were explicitly looking for part-time employment (Frey and Gere, 1994).

Slovenia

Labour Force Surveys in Slovenia revealed that less than 2 per cent of the employed worked part-time in the early 1990s (Table 3.3). There were no significant differences between men and women, and no important differences among various employment sectors.[9] On average, part-timers worked

TABLE 3.3. *Part-time employment in Slovenia*

| | Proportion of part-time employment | | | |
	1991	1992	1993	1994
Total	2.5	1.6	1.8	1.6
Men	(2.1)	(1.4)	(1.5)	(1.4)
Agriculture	(2.1)	(0.9)	—[a]	—[a]
Industry	(2.5)	(1.3)	(1.7)	(1.6)
Services	(1.7)	(1.6)	(1.5)	(1.1)
Women	3.1	(1.9)	(2.1)	(1.9)
Agriculture	(3.4)	(1.9)	—[a]	—[a]
Industry	(2.4)	(1.3)	(1.7)	(1.7)
Services	(3.6)	(2.3)	(2.6)	(2.1)
Married women	(3.5)	(1.9)	(2.0)	(1.9)
Agriculture	(2.2)	(2.4)	—[a]	—[a]
Industry	(2.8)	(1.3)	(1.8)	(2.0)
Services	(4.1)	(2.4)	(2.4)	(1.9)

Notes: () results are unreliable due to small numbers.
[a] not zero but extremely inaccurate estimation.

Sources: 1991: M. Ignjatovič, I. Svetlik, and V. Vehovar, *Employment Barometer: Slovenia in Europe* (Ljubljana: Center for Welfare Studies), July 1992.
1992: M. Ignjatovič, I. Svetlik, and V. Vehovar, *Employment Barometer: Slovenia 92—Europe 90* (Ljubljana: Center for Welfare Studies), Jan. 1993.
1993: Results of Surveys, No. 607, Labor Force Survey Results, Statistical Office of the Republic of Slovenia and the National Employment Office, Ljubljana, 1994.
1994: Data obtained directly from the National Employment Office, Ljubljana.

[9] It should be noted, however, that unpaid family workers were not included in the statistics. This might at least partly contribute to the relatively large discrepancies between Poland on the one hand, and Slovenia and Hungary on the other.

about 25 hours per week, whereas 19 hours was the average for the EU countries[10] (Results of Surveys, 1994).

Almost half of all part-timers worked less than full-time due to health problems and various disabilities, as was already the case before the transition period (Table 3.4). More women than men referred to the family as the reason for working part-time, but even among women, numbers working part-time were very low. What seems to be growing is involuntary part-time employment, particularly among women. One out of five women worked part-time because she could not find a full-time job. Among the unemployed, less than 4 per cent were explicitly looking for part-time employment; however, a large majority of the unemployed were also prepared to accept a part-time job if there were one available.

TABLE 3.4. *Reasons for working part-time in Slovenia, 1993*

Reasons	All	Men	Women
Health problems, disability	46	45	47
Could not find a full-time job	15	9	19
Family reasons	5	1	7
Retired	5	8	2
Do not want full-time employment	4	4	4
In school or training	4	3	4
Other reasons	9	13	5
No answer	15	18	11

Note: Total may not add up to 100 due to rounding.

Source: D. Verša, 'Zaposlitve s krajšim delovnim časom' ('Part-time Employment'), in S. Pirher and I. Svetlik (eds.) (1994), *Zaposlovanje: Približevanje Evropi* (Ljubljana: Fakulteta za družbene vede), Table 2, p. 144.

To explore the demand for part-time work, we carried out a descriptive analysis of survey data on preferred work hours based on the 1994 Quality of Life Survey in Slovenia. Our objective was to examine to what extent the non-availability of part-time jobs determines the absence of part-time employment. Further, gender differences and the effects of children on the desired working time were assessed. Respondents were first asked about their actual weekly hours of work.[11] Next, they were asked whether (1) they were satisfied with their current length of working time, or whether they would prefer (2) longer, or (3) shorter working hours. These prefer-

[10] More precisely, 12% of part-timers work less than 20 hours per week; 58% of part-timers work 20–9 hours; the remaining 30% work 30 or more hours per week (Svetlik, 1994).

[11] As a rule, regular full-time work in Slovenia cannot be longer than 42 hours or shorter than 36 hours per week, including compulsory daily breaks. However, the 'actual' working hours quoted in the QLF survey also included 'usual' overtime.

ences were made under the condition that earnings varied with the length of working time.

Results are presented in Table 3.5. A small proportion of the employed worked less than 36 hours a week (the average for women was 24 hours, and for men 23 hours), but the numbers were too small for statistical analysis. Therefore, only respondents who worked 36 hours per week or more were included in the analysis. Of these, about three-quarters were satisfied with their current working time, about 2 per cent wanted longer working hours, and less than a quarter would have preferred a shorter working week. The differences between men and women were very small; women tended to be somewhat more satisfied and a slightly higher proportion of men wanted to work shorter hours. At first sight, we might conclude that there is a considerable demand for part-time employment which cannot be realized, presumably because of the lack of part-time jobs. However, a more detailed examination of the data shows that this is not the case. Most of the men and women who wished to work shorter hours were working longer than standard full-time hours. Average working hours for these men were 47 hours, and for women 44 hours. Once we consider only workers who wished to work less than 36 hours a week, only 6 per cent of men and 8.8 per cent of full-time women preferred part-time employment. Thus, the demand for part-time employment exists, but it is not particularly high.

Let us now look at the effects of children on preferences for working fewer hours. In Table 3.5 four groups have been distinguished: men and women who either have no children or no child younger than 15; those with one child under the age of 15; those with two children where at least one is younger than 15; and finally those who have three or more children where at least one child is under 15. There are slight indications that children can play a role in women's working time preferences. Only 18 per cent of women with no children or already grown-up children, but almost 30 per cent of those with one young child, preferred working fewer hours. When two or more children were present, this percentage fell again, presumably due to increased financial pressure in larger families. The proportion of men desiring shorter working hours was similar to that of women and there was little variation with respect to children. The only exception was a somewhat puzzling high proportion of fathers with several children who stated that they too would prefer a shorter working week. Due to small numbers in the subgroups, no definite conclusions can be drawn, but the data strongly suggest the absence of a typical male breadwinner model with the man specializing in market work and the woman specializing in home production. When there was increased financial need, as was probably the case in families with numerous young children, both men and women showed equal preferences for longer working

TABLE 3.5. *Preferences for shorter working hours in Slovenia, 1994*

	Men	Women	No children or all older than 15		1 child, under 15		2 children at least 1 under 15		3 or more at least 1 under 15	
			M	W	M	W	M	W	M	W
Satisfied with current hours	73	76	76	79	73	71	73	76	63	68
Prefer longer working hours	2	1	2	3	3	0	2	0	5	5
Prefer shorter working hours	25	23	23	18	24	30	25	24	32	26
N	431	362	212	145	74	78	107	120	38	19

Note: Total may not add up to 100 due to rounding.

Source: The Quality of Life in Slovenia Study, 1994 (author's calculations). Respondents are employed persons (excluding self-employed and farmers), working 36 hours or more at the time of interview.

hours and in this way expressed equity in assuming the provider role in the family.[12]

Conclusions

Part-time work in the former socialist economies of Central and Eastern Europe was not a typical female phenomenon. This type of work was primarily done by persons who held a second job, had health problems or various disabilities, and pensioners who remained in the labour market after retirement. In the transition period, part-time remained a peripheral type of employment, concentrated particularly among the people of statutory retirement age or workers with disabilities. Although the LFS shows low levels of part-time employment in the early 1990s, its importance seems to be growing. It receives increasing attention from political and professional groups who—with different objectives—perceive it as an attractive new development in the labour market. One such viewpoint originates from attempts to redefine the role of women in society. Some political parties in the region, particularly those associated with the Catholic church, but also nationalistic forces alarmed by low fertility rates, promote the idea of motherhood as women's prime job. These groups believe that women's participation in the labour market should be subordinated to their family responsibilities; part-time employment is sometimes perceived as a suitable mechanism for reconciling domestic responsibilities and the financial needs of the family.

Second, and perhaps more important, support for part-time work comes from experts who have been dealing with labour-market problems in the transition period. A swift change in the labour-market situation in the former socialist countries which led to the emergence of unemployment provoked the adoption of measures aimed at levelling off the demand and supply of labour. Besides attempts to increase the demand for labour, the flexibilization of labour markets and the reduction of labour supply are explicit or implicit objectives of labour-market policies. Several measures to reduce labour supply, such as early retirement, part-time work, job-sharing, and delayed entry into the labour market are being embraced enthusiastically, apparently based on the fallacious assumption that there

[12] This may be specific to Slovenia due to a relatively small wage gender gap. According to a World Bank report, relative wages for women in Central and Eastern Europe were comparable to those in Western Europe, but relative wages for Yugoslav women at the end of the 1980s were higher than in all other European countries included in the study. The female–male ratio in Slovenia was 0.88 in 1987 and rose to 0.90 in 1991 (Vodopivec, 1995).

is a fixed amount of work to be divided up among the labour force.[13] Although such policies are in most cases not specifically aimed at women, reducing female labour supply is seen as a 'not undesirable' outcome of interventions in the labour market.

Other flexible forms of work have also been adopted, and a tendency towards various kinds of precarious, less-protected, or even non-protected forms of employment can clearly be detected in Central and East European countries. Particularly widespread are time-limited contracts; even illicit employment without work contracts is becoming notorious in the newly emerging private sector. In a period of high unemployment, growing poverty, and against the backdrop of a chaotic institutional framework with rapidly changing employment legislation, employment contracts are becoming lax and previously overprotected workers are being exposed to market competition without sufficient legal protection. There are slight indications that part-time work may become part of this emerging non-standard secondary labour market.

Despite these developments, it should be kept in mind that the characteristics of part-time jobs are not necessarily negative and part-time work may be a welcome solution for some segments of the population at certain stages of the life-cycle—not only with respect to the family cycle, but also as a means to combine education and employment at the time of entry into the labour market, or, in the case of partial retirement, at the time of exit from the labour market.

There is a high probability that part-time employment will gain in importance with the abolition of the labour-market rigidities that characterized the former planned economies. Current ownership reforms will result in a large private sector, which may increase the need for a more flexible part-time labour force. Restructuring the industrial sector will bring an expansion of the service sector, for which there is a high demand. In countries with a high proportion of part-time workers, services have traditionally offered opportunities for part-time work. Work arrangements are becoming more flexible, and attempts have been made to introduce work schedules similar to those in Western Europe.[14] A nine-to-five work scheme will make the combination of paid work and family much more strenuous than in the past, and this might make part-time work—following the example in Western Europe—more attractive to women. The crisis of the

[13] On the basis of survey results in Hungary, Frey and Gere (1994) calculated how many new jobs would be created if full-timers who expressed interest in part-time employment did in fact switch to part-time jobs. Redistribution of work among the population and the reduction of unemployment are clearly the major objectives of such undertakings.

[14] In the past, the usual working day started very early in the morning for most people. As a consequence, most workers finished their job at 2 or 3 pm, giving them more time for their families and other activities.

welfare state and the deterioration or collapse of firm- and family-related social services will also contribute to the need for more part-time job opportunities.

At present, it seems that part-time work will expand in Central and Eastern Europe, although certainly not to the extent observed in North-Western European countries. However, the future directions of part-time work developments remain open. It is conceivable that the extent and the level of regulation of part-time work will vary across Central and East European countries. Market-oriented economies in Western Europe exhibit very different levels of part-time work and important variations in terms of legal protection. In Central and Eastern Europe, it remains to be seen—for each country separately—whether part-time work will turn into a marginal employment form or become a legally protected but flexible work arrangement that reconciles needs and preferences on both sides of the labour market.

REFERENCES

Bićanić, I. and Škreb, M. (1991), 'The Service Sector in East European Economies: What Role Can it Play in Future Development?', *Communist Economies and Economic Transformation*, 3 (2), 221–33.

Büchtemann, C. F. and Quack, S. (1990), 'How Precarious is "Non-Standard" Employment? Evidence for West Germany', *Cambridge Journal of Economics*, 14: 315–29.

Drobnič, S. (1992), 'Rigidities in the Labor Markets of Transition Economies and New Organizational Forms', Discussion Paper No. 7/1992, The Leuven Institute for Central and East European Studies, Leuven.

—— and Rus, V. (1995), 'Unemployment in Transition Economies: The Case of Slovenia', in M. Jackson, J. Koltay, and W. Biesbrouck (eds.), *Unemployment and Evolving Labor Markets in Central and Eastern Europe* LICOS Studies on the Transitions in Central and Eastern Europe, vol. 4 (Aldershot: Avebury), pp. 93–122.

Ferge, Z. (1992), 'Unemployment in Hungary: The Need for a New Ideology', in B. Deacon (ed.), *Social Policy, Social Justice and Citizenship in Eastern Europe* (Aldershot: Avebury).

Frey, M. and Gere, I. (1994), 'Part-Time Employment: The Unutilized Possibility', Summary Research Report on Individual Needs for Part-time Work and its Employers Receptiveness, Research Institute of Labour, Budapest (mimeo).

Göting, U. (1993), 'Welfare State Development in Post-Communist Bulgaria, Czechoslovakia, and Hungary: A Review of Problems and Responses (1989–1992)', Working Paper No. 6/93, Center for Social Policy, Bremen,

Hakim, C. (1993), 'The Myth of Rising Female Employment', *Work, Employment & Society*, 7 (1), 97–120.

ILO (1989), *Conditions of Work Digest*, 8, 1/1989 (Geneva: ILO).

Iovcheva, S. (1992), 'Labour Market Developments in Bulgaria during the Stabilization', paper prepared for the conference on 'Analytical Challenges in Restructuring Post-Communist Economies', Leuven, June.

Kiernan, K. E. (1991), 'The Respective Roles of Men and Women in Tomorrow's Europe', Paper prepared for the international conference on 'Human Resources in Europe at the Dawn of the 21st Century', Luxembourg, 27–9 Nov.

Laki, M. (1980), 'End-Year Rush-Work in Hungarian Industry and Foreign Trade', *Acta Oeconomica*, 25 (1–2), 37–65.

Lehmann, H. and Schaffer, M. (1991), 'Productivity, Employment and Labour Demand in Polish Industry in the 1980s: Some Preliminary Results from Enterprise-Level Data', London School of Economics, London (mimeo).

Mencinger, J. (1989), 'Economic Reform and Unemployment', *Privredna kretanja Jugoslavije*, 19 (March).

Meulders, D. and Plasmann, R. (1992), 'Part-Time Work in the EEC Countries—Evolution during the Eighties', in U. Ebbing (ed.), *Aspects of Part-time Working in Different Countries*, working paper 1992–7 (Gelsenkirchen: SAMF).

Miron, M. (1992), 'Romania: The Menace of Unemployment', paper prepared for the conference on Analytical Challenges in Restructuring Post-Communist Economies, Leuven, June.

Nešporová, A. (1995), 'Recent Labour Market Developments in Former Czechoslovakia', in M. Jackson, J. Koltay, and W. Biesbronck (eds.), *Unemployment and Evolving Labor Markets in Central and Eastern Europe*, LICOS Studies on the Transitions in Central and Eastern Europe, vol. 4 (Aldershot: Avebury), pp. 71–92.

Results of Surveys, No. 607 (1994), Statistical Office of the Republic of Slovenia and the National Employment Office, Ljubljana.

Rus, V. (1984), 'Kvaliteta življenja v Sloveniji' ('Quality of Life in Slovenia'), Research Report, Institute for Sociology, Ljubljana.

Sidaway, J. and Wareing, A. (1992), 'Part-Timers with Potential', *Employment Gazette*, 100 (Jan.).

Socha, M. W. and Sztanderska, U. (1991), 'Labor Market in the Transition to the Market Economy in Poland', PPRG Discussion Papers, no. 2, Polish Policy Research Group, Warsaw University.

Sundström, M. (1991), 'Part-Time Work in Sweden: Trends and Equality Effects', *Journal of Economic Issues*, 25 (Mar.).

Svetlik, I. (1994), 'Fleksibilne oblike dela in zaposlitve v Sloveniji' ('Flexible Forms of Work and Employment in Slovenia'), in S. Pirher and I. Svetlik (eds.), *Zaposlovanje: Približevanje Evropi* (Ljubljana: Fakulteta za družbene vede), pp. 123–38.

Verša, D. (1994), 'Zaposlitve s krajšim delovnim časom' ('Part-Time Employment'), in S. Pirher and I. Svetlik (eds.), *Zaposlovanje: Približevanje Evropi* (Ljubljana: Fakulteta za družbene vede), pp. 139–48.

Vodopivec, M. (1991) 'The Labor Market and the Transition of Socialist Economies', *Comparative Economic Studies*, 33 (summer).

——(1995), 'The Slovenian Labor Market in Transition: Evidence from Microdata', paper prepared for the OECD conference on active labor market

policies and income support in Central and Eastern European countries, Vienna, 30 Nov.–2 Dec.

Witkowski, J. (1995), 'Unemployment in Poland in the Period of Transition', in M. Jackson, J. Koltay, and W. Biesbrouck (eds.), *Unemployment and Evolving Labor Markets in Central and Eastern Europe*, LICOS Studies on the Transitions in Central and Eastern Europe, vol. 4 (Aldershot: Avebury), pp. 123–82.

4

Full-Time and Part-Time Employment of Women in Greece: Trends and Relationships with Life-Cycle Events

HARIS SYMEONIDOU

Introduction

In Greece after the Second World War there was no notable development of the welfare state similar to that observed in almost all Western societies. It was only as recently as 1974 that Greece became actively interested in developing collective consumption. However, the welfare state developed mostly at a statutory level, while state expenditure on social welfare remained very low. Expansion of the social budget was impeded by economic recession. Taking into account the very low level of state support for the family and, by extension, for working women with children, and given that Greek women continue to bear most responsibility for the care of family members, the very low rate of participation of women in the labour force (35 per cent in 1993) is not surprising. The prevailing differentiation between the roles of men and women; between working and raising a family; and between the private and the public domains overlooks the fact that women make an economic contribution to their household. The well-established sexual division of labour also produces peculiar and generally unfavourable attitudes toward the hiring of women, their pay scales, and their professional development.

This chapter reviews long-term trends in female full- and part-time employment in Greece; the factors associated with the low participation of Greek women in the labour market; and the connections between employment and life-cycle events. It also discusses relevant employment law and draws conclusions about the future of part-time work in Greece.

Post-War Trends in Women's Economic Activity Rates

Analysis of the history of women's economic activity in Greece is frustrated by the changing definitions which the National Statistical Service of

Greece (NSSG) has applied to population censuses and labour-force statistics. We shall nevertheless present a fairly complete picture of the evolution of women's economic activity through two statistical series: both (*a*) raw and (*b*) adjusted population census data for 1951–81; and annual labour-force statistics from NSSG[1] for 1982–93 (sometimes also for 1981). Our data indicate that female economic activity rates throughout the period 1951–93 are relatively stable within the 30–5 per cent range, with only minor fluctuations. In contrast, male activity rates show a sharp fall in the 1961–71 period and a slight gradual decline after that (Table 4.1).

Comparative data for all European Union (EU) countries for the period 1983–92 show that the economic activity of women in Greece and, with

TABLE 4.1. *Economic activity rates by sex, 1951–1993*

	Total		Men		Women	
1951	46	(53)	78	(77)	17	(31)
1961	53	(54)	74	(77)	34	
1971	45	(50)	66	(70)	24	(31)
1981	43	(49)	65	(71)	23	(30)
1982	49		71		30	
1983	51		71		33	
1984	51		70		33	
1985	51		69		34	
1986	50		68		34	
1987	50		67		34	
1988	50		67		35	
1989	50		66		35	
1990	49		65		35	
1991	47		64		33	
1992	48		64		34	
1993	49		64		35	

Notes: Census data for 1951–81 refer to the population aged 15 years and over; Labour Force Survey (LFS) data for 1981–93 refer to the population aged 14 and over.

Figures in parentheses for 1951, 1961, and 1971 incorporate adjustments for the underestimation of unpaid family workers during the 1951 and 1971 Censuses and to exclude men in the Armed Forces in 1961 (see Frangos, 1980).

Figures in parentheses for 1981 present results from the national Labour Force Survey initiated in 1981 which differ slightly from 1981 Census results.

Figures for 1983–93 are taken from the national Labour Force Survey. The 1981 and 1982 LFS used a different questionnaire from the LFS in 1983 and following years, so there are small discontinuities in LFS data between 1982 and 1983.

Sources: NSSG Population Census of Greece, 1951–81; Eurostat (1993*a*) presenting LFS data for Greece 1983–91; NSSG Greek Labour Force Survey 1992 and 1993; Frangos, 1980.

[1] My analysis relies on adjusted data for 1951, 1961, and 1971, although Table 4.1 presents both raw and adjusted data for these years.

the singular exception of Portugal, all southern Europe, is well below levels in northern EU countries (Eurostat, 1993*a*; 1993*b*; 1994*a*). In 1994 Greece, together with Italy and Spain, held the lowest position (see Tables 1.1 and 5.1). The notable stability of female labour-force participation in Greece—up to the present—characterized most European countries from the mid-nineteenth century up to the 1970s or somewhat later, after which period women's work rates started rising.[2] In most European countries, the sharpest rise occurred during the 1980s, as noted by Hakim (1993) and throughout the chapters of this book. However, Italy and Greece both had almost no change in female employment rates in the 1980s (Tables 4.1, 4.5, and 5.1). This leads us to ask what are the causes of the different pattern of female economic activity in Greece as compared with countries displaying a more dynamic pattern, such as Britain or Denmark.

Low female work rates in Greece compared with other industrial countries (OECD, 1983) are usually explained by demographic factors and various socio-economic factors. To begin with, after the Second World War Greece did not experience a so-called baby boom, as happened in other European countries. Fertility declined sharply in Greece after 1980, again unlike the rest of Europe, where the decline started around 1965. The results were population ageing[3] and its negative effects on labour-force size and structure. No economic boom occurred after the Second World War, and the lack of work produced significant emigration flows during the 1960s and early 1970s, to the countries of Western Europe—mostly the former Federal Republic of Germany. It is notable that in the decade 1961–71 the Greek labour force declined by 9 per cent. The lower overall demand for labour had a direct effect on female employment. Moreover, the internal migration flow to urban centres in the period 1961–81 must have played an important role in the decline (1961–71) and subsequent slow increase (1971–81) in the labour force (by 9 per cent between 1971 and 1981 and by 12 per cent between 1981 and 1991). The percentage of urban population in Greece rose from 43 per cent in 1961, to 58 per cent in 1981, and to 65 per cent in 1991. The structure of the labour force changed significantly (Table 4.2). The percentage of women employed in the primary sector declined by more than 50 per cent between 1961 and 1991, and the decline was even sharper for men. Employment in the service sector increased correspondingly, particularly for women, while in the secondary sector there was a slight rise for men and an even slighter rise for women.

[2] In northern European countries, women's economic activity started rising somewhat later, towards the end of the 1960s and in the early 1970s (Hakim, 1993; Blossfeld, 1994).

[3] The percentage of persons aged 65 and over in the overall population rose from 7% in 1951, to 11% in 1971, and 14% in 1991. The rate of ageing in the Greek population is one of the fastest in the EU (Emke-Poulopoulou, 1994).

The rise in secondary sector employment might be attributed to increased building construction, a predominantly male occupation that does not favour women. Moreover, female participation in manufacturing did not rise any faster.

TABLE 4.2. *Employment by sex and industrial sector, 1961–1991*

	1961		1971		1981		1991	
	M	F	M	F	M	F	M	F
Agriculture	48	56	36	53	26	42	20	27
Industry	22	13	29	16	34	18	30	17
Services	30	31	25	31	40	40	50	56
Total	100	100	100	100	100	100	100	100

Sources: NSSG Population Censuses 1961, 1971, and 1981; NSSG Labour Force Survey 1991.

These changes in overall employment had a sharp impact on particular occupations. We note a significant decline in the number of 'unpaid family workers', who are mostly women working mainly in agriculture, who are included among the economically active in labour statistics. The percentage of women working as unpaid family workers declined sharply from 57 per cent in 1961 to 36 per cent in 1981 and to 25 per cent in 1991[4] (Table 4.3). The declining number of female family workers was not counterbalanced by an increase in women's wage work (Petrinioti, 1989). The difficulty of finding paid employment in urban centres, in combination with unfavourable living conditions and greater difficulty in achieving compatibility between family and working life (due to long distances between home and work and childcare difficulties) were significant factors that kept female employment at low levels.

Additionally, for reasons discussed below, lower fertility rates did not have a positive effect on female employment in Greece, as was the case in Belgium, France, Denmark, Sweden, Germany, and Britain (Pott-Buter, 1993: 179–87, 311). Inflexible labour-market conditions in Greece do not permit women to interrupt their employment for any serious length of time after childbirth, and subsequently return to the workforce. What usually happens is that they are compelled either to keep on working or to withdraw permanently from the workforce upon their marriage or, more commonly, at the birth of their first child. Those who have never worked before have difficulty in finding a first job (Symeonidou, 1989). The combined

[4] Despite a considerable reduction in the percentage of women working as unpaid family workers, the figure remains much higher in Greece than in other EU states, where figures average only 5%.

TABLE 4.3. *Persons in employment by sex and employment status, 1961–1991*

	1961		1971		1981		1991	
	M	F	M	F	M	F	M	F
Employers and self-employed	46	13	48	18	46	20	43	20
Employees	37	26	44	37	50	44	52	55
Family workers	15	57	7	44	4	36	5	25
Not specified	2	4	1	1	*	*	*	*
Total	100	100	100	100	100	100	100	100

Sources: NSSG Population Censuses 1961, 1971, and 1981; NSSG Labour Force Survey 1991.

TABLE 4.4. *Economic activity rates by education, 1991*

	Men	Women	Total	Total base 000s=100%
University education	80	75	78	626
Post-compulsory school education and vocational education	72	48	58	2,075
Up to minimum compulsory schooling	59	29	42	5,025
Education not stated, no schooling	31	11	15	390
All persons	64	33	47	8,296
Economically active population	2,530	1,410	3,940	

Source: NSSG Labour Force Survey 1991.

effect of all these factors is that the female labour force continues to shrink when it should be growing.

Women's labour-force participation also varies strongly with level of education. Only 26 per cent of women who have the minimum compulsory education are economically active, compared to 45 per cent of women with post-compulsory education and 76 per cent of women with professional or university education. In contrast, men show little variation in work rates between educational levels (Table 4.4). The low level of education among women is yet another significant factor in their reduced economic activity rates.

One study found the significant determinants of the supply of female labour to be salary levels, women's educational level, their age, and their fertility (Petrinioti-Consta, 1981). A more recent study indicates that the principal, statistically significant, factors affecting female employment are: the opportunity cost for women (the income they lose when they do not

work but instead are fully occupied in child-rearing); their educational level; and also any help they might have with childcare. Family income and the number of owned rooms per household are negatively correlated with female employment. In addition, there is a significant positive correlation with employment before marriage, if any, in a country where this is still not universal. Finally, a husband's opposition to his wife's employment has a strongly statistically significant negative correlation with employment. In this respect, Greek women are not entirely different from women in Western Europe (Hakim, 1991: 110–11), although the impact of husbands' attitudes seems to be stronger in Greece (Magdalinos and Symeonidou, 1989; Symeonidou and Magdalinos, 1993).

Despite the relatively rapid rate of economic growth in the initial period after the Second World War, the welfare state only developed to a very limited extent in Greece—unlike France, Britain, and Germany, for example—and did not help working women to reconcile family life with employment. Quite the contrary, Greek women have always had and still have to care for all family members, since public services for childcare and care of the aged have always been and still are practically non-existent.[5] In the absence of welfare services, Greek families have a major role in supporting and financing non-active cohabiting members—not only young people in full-time education but also young adults who are waiting for (or postponing) their active participation in the workforce, and older people who have retired from work (Tsoukalas, 1987: 230). Because of family support, employment rates for young women and men (aged 14–24) are, together with Spain, the lowest in the EU (Table 4.5; see also Eurostat, 1993*a*). In the period 1983–91, work rates for young people declined slightly, probably due to increased enrolment in education.

In contrast, the 25–49 age group shows an increase in employment, the only one observed in this period. Employment rates among prime-age women are the lowest in the EU, while for men they are at levels similar to other EU countries. The 50–64 age group shows a decrease, with work rates similar to those of Italian women but lower than in France, Germany, and Britain (see Table 5.1). For women aged 65 and over economic activity rates are low, as expected, yet higher than in more industrialized EU countries, due mainly to the extended employment of men and women in agriculture and in family enterprises—as is also the case in Italy.

A distinctive feature of employment in Greece is the extremely low percentage of people working as salaried employees (Table 4.3). Despite a significant rise in the percentage of salaried women workers (from 26 per cent in 1961 to 44 per cent in 1981 and 55 per cent in 1991), Greek figures

[5] According to data from Eurostat (1994*b*), Greece has the lowest expenditure on social welfare in the EU: 1,127 ECU per resident compared to the EU average of 4,348 ECU in 1992.

TABLE 4.5. *Economic activity rates by sex and age, 1983–1991*

	14–24 years		25–49 years		50–64 years		65+ years		All ages	
	M	F	M	F	M	F	M	F	M	F
1983	46	33	96	45	78	30	20	8	71	33
1985	44	31	96	49	76	32	15	5	69	34
1987	40	30	96	51	72	31	14	5	67	34
1989	41	32	93	49	69	29	12	4	63	31
1991	39	31	95	54	68	29	11	5	64	35

Source: Eurostat, Greek Labour Force Survey data for 1983, 1985, 1987, 1989, and 1991.

remain the lowest in the EU, far below the EU average of 85 per cent of working women in salaried jobs in 1991 (Eurostat, 1993*a*). Much the same picture, and changes, are found for men. The inability of the manufacturing sector to create enough jobs to absorb the labour surplus of the agricultural sector, together with the existence of other significant sources of income such as earnings transfers from migrants abroad and from sailors in the merchant marine; real estate transfers serving as dowry; and income from tourism, all help to explain the resistance of the Greek population to salaried work. Given their traditional capability of working productively within the household, women are subject to even less pressure to engage in salaried employment. Conversely, the proportion of the workforce who are self-employed or employers has always been very high and is currently the highest in the EU: 20 per cent for women and 43 per cent for men in 1991 compared to the EU averages of 10 per cent for women and 19 per cent for men (Eurostat, 1993*a*).

In sum, the Greek workforce is shaped by the Greek economy which, along with the predominantly capitalist production structure, is also characterized, to a great extent, by family-based enterprise: family farms, family-run craft shops, and self-employed professionals. Women's position in the labour market is largely explained by their significant role in various types of family business. At the same time, self-employment favours multiple employment both in the official economy and in the underground economy. The large size of the underground economy is yet another particularity of the Greek labour market. According to recent studies, the income from the underground economy amounts to 28–35 per cent of the Greek GNP (Dermenakis, 1987; Pavlopoulos, 1987).

One significant reason for the low work rates reported by Greek women is that official statistics do not reflect the whole reality, because of the existence of massive undeclared employment in many sectors dominated by female employment, such as textiles, clothing, tourism, and retailing

(Cavouriaris, Karamessini, and Symeonidou, 1994). Unfortunately no official data exist and few studies have endeavoured to measure the extent of the underground economy.[6] In the case of sub-contract production (*facon*), it is well known that such work is done exclusively by women trying to meet pressing household needs. The work is very poorly paid, generally without any formal agreement and without social security contributions or coverage. In recent years, new types of homework have developed, such as telephone interviewing, clerical work such as accounting and typing, child-care services, and pressing clothes.

Trends in Women's Part-Time Employment

Part-timers are people working fewer hours than those stipulated in collective agreements applicable to the type of work the person is performing (Eurostat, 1985). However, in the Greek LFS the distinction between full-time and part-time work is generally made on the basis of a spontaneous answer given by the interviewee. Given that some interviewees will not be familiar with the concept of part-time work, LFS data may understate the level of part-time employment. The available data[7] show that throughout the decade 1983–92 part-time employment remained at an unvarying low level in Greece among both men and women, at 3 and 8 per cent respectively (Table 4.6). Part-time work remains lower in Greece than in any other EU country, lower even than in other southern European countries: Italy, Spain, and Portugal (see Table 1.1). Moreover, the percentage of part-time jobs was declining over the period 1983–91, with an increase only in 1991–2. In contrast, part-time employment has generally been higher and increasing over this period in most northern EU countries, as noted in Chapters 6–9 on France, Germany, the Netherlands, and Britain.

Part-time work is most common within the declining category of unpaid family workers who are typically employed in agriculture in Greece—70 per

[6] One survey of a sample of 115 industrial establishments operating in northern Greece found that the highest percentages of employment without contract occur in establishments with 11–80 workers and those with over 80 workers. Workers 'without contracts' are usually unskilled, their pay is minimal, and they are not protected by any labour union. These 'marginal' workers are usually women, and they appear to be constantly switching between part-time work and full-time unemployment. They are hired and fired according to production needs without contract or social insurance. The study also found that 62% of all sub-contract work is concentrated in four branches of industry (textiles; footwear and clothing; printing and publishing; and the fur and leather industry), which together account for 35% of overall employment. In one area of urban Thessaloniki, one or more persons were employed in sub-contracting (*facon*) in about 10% of all households (Vaiou *et al.*, 1991).

[7] Reliable data on part-time employment are available for the 1983–92 period.

TABLE 4.6. *Proportion (%) of employees working part-time, 1983–1992*

	Males	Females	Married Women
1983	3.3	8.5	10.9
1984	2.7	7.6	9.6
1985	2.6	8.3	10.2
1986	2.6	7.8	9.8
1987	2.1	8.0	9.9
1988	2.3	7.4	8.3
1989	2.1	6.8	7.3
1990	1.9	5.7	6.0
1991	1.7	4.8	4.6
1992	2.8	8.4	8.4

Source: Eurostat, Greek Labour Force Survey data for 1983–92.

cent of women working in agriculture in 1991 were unpaid family workers. Agricultural work is seasonal and hence is not truly part-time. Secondly, the fact that part-time employment was only very recently officially recognized in Greece (through Law 1829/1990) may offer another explanation for its low incidence. However, the main explanation for the extremely low level of part-time employment in Greece must be sought among the factors used above to explain the low overall economic activity of women.

To a large extent national statistics of part-time work must be fictitious in that part-time work is most common in the underground economy, where employment is concealed. The second job is widespread in Greece and allows many households to meet basic needs that are not covered by earnings from the main job. As a rule, the second job is both part-time and undeclared. Employees in this sector accept the situation because they enjoy social insurance coverage from their main activity. Women who are indirectly insured by their fathers or husbands readily accept employment in undeclared jobs, often part-time (Cavouriaris, Karamessini, and Symeonidou, 1994).

In one respect, part-time work in Greece conforms to the Western European pattern: most part-time workers in Greece are women, 63 per cent in 1991 (Eurostat, 1993*a*). Part-time employment is low across all sectors of economic activity and professional status (Eurostat, 1994*b*), with a consistently higher incidence among women than among men. The highest incidence of part-time working are found among family workers (8 per cent for men and 11 per cent for women) and the self-employed (2 per cent for men and 9 per cent for women) on the one hand and in the agricultural sector on the other (4 per cent for men and 11 per cent for women). The largest concentrations of part-time workers are in agricultural work and, for men, production jobs followed by service workers (Table 4.7).

In contrast with part-time employment, Greece has one of the highest levels of temporary employment within the EU, because of the substantial volume of seasonal employment in agriculture, tourism, and construction. Temporary work accounted for 15 per cent of all male and female employee jobs in 1991. As in Italy, there is a substantial overlap between part-time and temporary work: 56 per cent of female employees working part-time have temporary jobs compared to 10 per cent of full-time workers (Cavouriaris, Karamessini, and Symeonidou, 1994).[8] In contrast, the great majority of part-time jobs in Britain are permanent jobs, as noted in Chapters 2 and 9.

TABLE 4.7. *Occupations of the part-time workforce, 1991*

	Male	Female	All
Professional and technical workers	13	15	14
Administrative and managerial workers	*	*	*
Clerical and related workers	4	10	8
Sales workers	8	12	11
Service workers	6	16	12
Agricultural workers	33	39	37
Production workers	36	8	18
Total	100	100	100
Base 000s=100%	52	88	140

Source: NSSG Labour Force Survey, 1991.

One report indicates that part-time work is used very little in manufacturing industry but appears primarily in commerce and involves largely unskilled personnel (Kouzis, 1994). Partly due to the small number of part-time jobs and partly due to the large number of self-employed workers, the Greek workforce has the longest working week in the EU, with the highest average working hours per week, even though that figure declined between 1983 and 1991.[9] Double jobbing contributes to these long hours, as does the importance of the underground economy.

[8] Survey data for a sample of 44 enterprises operating in the Athens region, each employing over 120 workers, showed that part-time employment was used in 24% of the firms, but that irregular part-time employment involved more staff than permanent employment in a ratio of 3 to 2. These data show a rising trend of part-time employment, beyond the 5% recorded in 1991.

[9] In 1983 it was 43.3 hours per week. It fell to 40.9 hours in 1991, with the 1991 EU average at 34.1 hours.

TABLE 4.8. *Women's economic activity rates by marital status, 1951–1992*

	Single	Married	Widowed or divorced	All women
1951	28	10	16	17
1971	40	24	16	26
1981	42	22	15	25
1983	42	35	15	33
1985	39	37	15	34
1987	38	37	15	34
1989	40	39	15	35
1991	39	35	15	33
1992	40	37	16	34

Source: NSSG Population Censuses 1951, 1971, 1981; NSSG Labour Force Surveys 1983–92.

Life-Cycle Events and Female Employment

Life-cycle events are considered to be particularly significant in the study of women's paid work and the evolution of family life. A central concept in this area is the 'career line', defined as a person's life history through various roles such as marriage, parenthood, and work (Rexroat, 1985). By examining the economic activity of women in relation to their marital status over 1951–92 (Table 4.8), we observe that the highest activity rates occur among single women, as could well be expected, while activity falls among married women and falls still further among widowed and divorced women. Marriage and children interrupt women's labour-force participation, either temporarily or permanently, and may lead women into atypical forms of employment. From 1951 to 1981 there was a significant increase in the economic activity rates of single women, while for married women an increase is seen only between 1951 and 1971. Among widowed and divorced women economic activity rates remain almost constant from 1951 to 1992. Stability also characterizes single and married women's work rates in the 1983–92 period. The abrupt increase in the activity rate for married women over 1981–3 is probably due to differing definitions of economic activity in the 1981 Population Census as compared with the annual Labour Force Survey, as well as to other differences in data collection procedures. In other words, unlike in most other European Union countries where economic activity rates have been rising steadily in recent years, Greece shows relatively stable rates in all groups throughout the 1980s and 1990s, along with Italy. Similarly, part-time work rates have remained relatively stable among both married and other women, with little difference between them (Table 4.6).

TABLE 4.9. *Women's work history in Greece by area of residence*

	Athens area		Other urban areas		Rural areas		All of Greece	
	%	N	%	N	%	N	%	N
Always worked, before and after marriage	17	327	13	278	19	342	16	1041
Never worked, before or after marriage	21	389	26	572	22	497	23	1463
Quit work before marriage, no resumption	8	147	7	156	5	106	6	409
Quit work before marriage resumed at least once	3	56	3	61	3	61	3	178
Quit work at marriage no resumption	16	293	14	315	12	279	14	887
Quit work at marriage resumed at least once	7	127	8	166	13	299	9	594
Quit work at first birth, no resumption	9	175	6	127	2	46	6	349
Quit work at first birth resumed at least once	5	95	3	75	4	95	4	266
Quit work at some later stage	8	143	9	202	10	222	9	569
First started to work after marriage	7	129	11	230	11	238	9	598
Totals	100	1881	100	2182	100	2275	100	6354

Source: 1983–5 Greek fertility survey results reported in Symeonidou (1989) and Symeonidou (1994).

When we examine the work history of women in more detail, in relation to marriage and to the birth of their first child (Tables 4.9 to 4.11) some interesting findings emerge. The data come from a Greek fertility survey, the 'Socio-Economic Factors Affecting Fertility in Greece Study' conducted in 1983–5 by the National Centre of Social Research under the author's direction (Symeonidou, 1989; Magdalinos and Symeonidou, 1989; Symeonidou *et al.*, 1992; Symeonidou and Magdalinos, 1993; Symeonidou *et al.*, 1996). The survey was based on a stratified sample of 6,530 married women aged 15–44 and living with their husband, whose first marriage was intact. The survey was restricted to married women because 98 per cent of births take place within marriage in Greece. Personal interviews were used to collect a wide range of socio-demographic and attitudinal information, including detailed employment histories. The main findings of this study (Table 4.9) are as follows:

- 23 per cent of women aged 15–44 years have never done any paid work;
- 26 per cent of women quit work before or soon after marriage and never resumed;
- 16 per cent of women aged 15–44 have always worked, before and after marriage;
- 14 per cent of the women in the sample quit work at marriage; and
- 6 per cent quit work at their first birth—and never resumed;
- 9 per cent of the women in the sample quit work at marriage; and
- 4 per cent quit work at the first birth—and resumed at least once;
- 55 per cent of women aged 15–44 who have ever worked, either worked without interruption or they stopped work and never resumed;
- women who interrupted work and later resumed it, one or more times, make up 21 per cent of the total number of women aged 15–44 who have done paid work;
- area of residence has an effect on employment interruptions: rural areas have a higher percentage resuming work after an interruption: 26 per cent versus 19 per cent in urban areas.

It is clear that the relationship between employment and life-cycle events in Greece is quite different from EU countries such as France, where it has become more common for women to return to the workforce after an interruption due to child-rearing (for example see Bouillaguet-Bernard, Gauvin, and Prokovas, 1985). One possible explanation for the difference lies in the extreme inflexibility of the Greek labour market. In Greece the cost of leaving work and of returning to the workforce is very high, and that is one of the principal factors affecting the decisions of women concerning both their work and the number of children they plan and eventually bear. There is little variety in the types of work available and no substantial maternity leaves or facilitating provisions for part-time employment. It is

notable that the number of women who return to the labour force after marriage and child-bearing is somewhat higher in rural areas. This is explained by greater flexibility in the rural labour market and greater compatibility between motherhood and women's work in agriculture, especially on family farms.

Besides, finding employment becomes increasingly difficult with age, while at the same time the social insurance and welfare systems are extremely complex and often it is very difficult for a woman to transfer her insurance rights and benefits from one job to another. These difficulties are reflected in the tendency among Greek women either to keep on working through marriage, childbirth, and child-rearing (16 per cent) or never to return to the labour force once they leave work (26 per cent).

Among Greek women, age at marriage and at the first birth is also a significant factor in employment before and after marriage and in the work history in general. The fertility study showed that women who are older when they marry and have a first child are much more likely to maintain employment during marriage, while women who marry and bear children at a younger age are more likely to have never worked. There do not seem to be any distinct trends in the category of women who give up work at marriage or childbirth and later resume (Tables 4.10 and 4.11).

An examination of the relationship between women's employment and the number and ages of any children (Tables 4.12 to 4.14) shows only a very weak association, in contrast with most other EU countries. Between 1987 and 1991 there was a slight increase in employment among younger women (aged 20–39 years) with children (Table 4.12), in line with trends in other EU countries (Commission of European Communities, 1993). Women's employment rates are depressed only by the third child and in the younger age group (Table 4.12). One effect of the number of children rising to three or more is a small increase in part-time employment (Table 4.13). The age of the youngest child is positively associated with part-time employment, when the child is under two years old (Table 4.14).

Legislation Concerning the Working Mother

The low employment rates of women in Greece and the limited impact of children on work patterns are closely linked to existing legislation, among other factors. Greece has never had an explicit family policy. Nevertheless, legislation on employment, fiscal policy, social insurance, and other areas of social welfare all contain a number of regulations which take into consideration roles, responsibilities, and dependencies within marriage and the duties of parents towards their children. Among the existing regulations for the protection of working women the following can be noted.

TABLE 4.10. *Women's work history in Greece by age at marriage*

	Under 20 years		20–4 years		over 25 years	
	%	N	%	N	%	N
Always worked, before and after marriage	9	188	16	475	29	378
Never worked, before or after marriage	31	676	20	595	15	192
Quit work before marriage, no resumption	5	116	7	193	8	100
Quit work before marriage resumed at least once	2	51	4	103	2	24
Quit work at marriage no resumption	13	281	14	416	15	190
Quit work at marriage resumed at least once	10	208	10	288	8	98
Quit work at first birth, no resumption	4	84	6	187	6	78
Quit work at first birth resumed at least once	4	79	5	150	3	37
Quit work at some later stage	6	138	10	290	11	141
First started to work after marriage	15	328	8	222	4	48
Totals	100	2149	100	2919	100	1286

Source: 1983–5 Greek fertility survey results reported in Symeonidou (1989) and Symeonidou (1994).

TABLE 4.11. *Women's work history in Greece by mother's age at birth of first child*

	Under 20 years		20–4 years		over 25 years	
	%	N	%	N	%	N
Always worked, before and after marriage	8	100	13	38	26	451
Never worked, before or after marriage	33	435	23	656	16	277
Quit work before marriage, no resumption	6	80	6	175	7	120
Quit work before marriage resumed at least once	2	28	3	100	2	42
Quit work at marriage no resumption	13	176	14	414	13	233
Quit work at marriage resumed at least once	10	137	10	295	9	148
Quit work at first birth, no resumption	3	36	6	181	8	133
Quit work at first birth resumed at least once	3	40	5	153	4	75
Quit work at some later stage	6	74	9	270	11	185
First started to work after marriage	17	224	9	271	5	82
Totals	100	1330	100	2896	100	1746

Source: 1983–5 Greek fertility survey results reported in Symeonidou (1989) and Symeonidou (1994).

TABLE 4.12. *Female economic activity rates by woman's age and number of children, 1987 and 1991*

Number of children under 14 years	1987		1991	
	20–39 years	40–59 years	20–39 years	40–59 years
0	59	39	61	36
1	49	44	51	45
2	44	46	47	47
3 or more	39	45	37	42
All women in age group	48	40	51	38

Source: NSSG Labour Force Survey 1987 and 1991.

TABLE 4.13. *The choice between full- and part-time work among female employees aged 20–59 years by number of children, 1987 and 1991*

Number of children under 14 years	Full-time work		Part-time work	
	1987	1991	1987	1991
0	92	94	8	6
1	89	94	11	6
2	86	94	14	6
3 or more	86	90	14	10
Total	90	94	10	6

Source: NSSG Labour Force Survey 1987 and 1991.

TABLE 4.14. *The choice between full- and part-time work among female employees aged 20–59 years by age of youngest child, 1987 and 1991*

Number of children under 14 years	Full-time work		Part-time work	
	1987	1991	1987	1991
under 2 years	76	91	24	9
3–6 years	89	96	11	4
7–13 years	91	94	9	6
Total	87	94	13	6

Source: NSSG Labour Force Survey 1987 and 1991.

Employers are required to assign pregnant women to less fatiguing work than originally agreed (Civil Code article 662) and they are forbidden to terminate the work relationship with a female employee during the course of pregnancy and for one year after childbirth (Law 1483/1984 article 15). However, these regulations are often circumvented by employers. All female employees are entitled to maternity leave and all employees to unpaid parental leave. Working women are assured maternity leave for up to 16 weeks, 8 before and 8 after childbirth. For 'working parents with family commitments' Law 1483/1984 introduced 6 days of paid leave per year to be used in the case of illness of a dependent child plus 4 days to be used for visiting the child's school. The same law introduced parental leave in the private sector, amounting to 3 months for each parent until the child reaches 2.5 years of age, a provision that was later extended to cover the public sector as well (Presidential Decree 193/1988). With the National Collective Agreement of 1993, the length of maternity leave rose to 3.5 months and, for parental leave, the age limit of the child was increased to 3 years.

Nevertheless these laws had only a limited impact. First, they only apply to firms employing over 50 people and such firms are rare in Greece, given the structure of the Greek economy. Eligibility is further limited to people who have been employed in the firm for at least one year, and their spouse must also be working. Finally, employees are not paid any wages while on parental leave but they are still required to pay their own social insurance contributions plus their employer's contributions. Because of these constraints, few working parents ever use the parental leave facility, as shown by a 1988 survey carried out by the General Secretariat of Equality.

A more recent law (2085/1992) provided that women working in the public sector are entitled to unpaid leave up to a total of 2 years if they have a child under age 6, plus one more year for each additional child. However, it is not expected that this maternal leave option will be used much, since it is also unpaid and does not count towards promotion.

In the area of childcare, public childcare facilities are very limited in number and of very poor quality. However, there is a new law (2082/1992) that provides for 'creative occupation centres for babies and infants', daycare for infants provided by the mothers, and social help at home. If that law is put into practice, then the reconciliation between family life and employment is expected to make substantial progress. The General National Collective Agreement of 1993 provides for the formation of a joint permanent commission composed of the representatives of employers and labour unions, who are supposed to monitor the application of the legislation concerning equal treatment of men and women with parental obligations. These and other measures concerning the working mother in Greece are discussed more fully elsewhere (Symeonidou, 1989; 1990; 1992*a*; 1992*b*; 1993; 1996).

Evaluation of Women's Part-Time Employment

The increase in unemployment in Greece (from 281,000 in 1990 to 376,000 in 1992), particularly long-term unemployment, has been accompanied by extensive disorganization of the labour market, including higher employment in the underground economy and extensive use of atypical employment: six out of every ten salaried employees are either unemployed or underemployed, or employed in the underground labour market (Rombolis, 1994).

The EU White Book recommends two forms of employment that help redistribute work and income between the employed and the unemployed: part-time employment and employment with a flexible time schedule. The White Book also proposes a readjustment of the legal and fiscal framework to facilitate the flexibility of work. At the same time it indicates that 'not all countries are in a position to do that, probably because per capita income levels are lower', a remark which applies to Greece, among others. Besides, even when certain forms of work are regulated by extensive legislation, that legislation is often not upheld. The phenomenon of working women who do not enjoy social insurance, and in fact are nowhere registered as working, is well known. As far as labour relations are concerned, Law 1892/90 provides the operational framework for flexible forms of employment, such as part-time employment, and also assures the work-related and social rights of persons working part-time. However, the possibility that the law may be circumvented or ignored remains high.

According to a study of 'Special and Flexible Forms of Employment' (Kouzis, 1994), the institution of full and permanent employment is under serious attack, although it remains dominant in the employment policy of private enterprise, in contrast to labour union policy.[10] Employers and trade unions agree that part-time employment helps enterprises to cover market needs (37 and 32 per cent respectively) and decreases business costs (24 and 33 per cent respectively), but that it also causes low productivity due to lack of specialization among part-time workers (63 and 58 per cent respectively) and to their insufficient adaptation to the work environment. This survey suggests that part-time employment is regarded with major misgivings by a significant proportion of employers. The report concluded that part-time employment does not improve the competitiveness of 'large' manufacturing firms in the Attiki region. It is questionable whether smaller manufacturing firms have their own reasons for favouring part-time employment.[11]

[10] Two-thirds of all employers in the sample believe that full-time regular employment is not a suitable choice for their business in the long term in an increasingly competitive environment.

[11] It is worth noting that 97% of all private firms employ less than 15 persons, and obviously have greater problems with employment flexibility.

Women's organizations often express their negative opinion on part-time employment, using arguments that are justified in view of employers' attitudes expressed in the above study. These organizations have no doubt that women's position in employment will become even more vulnerable if part-time work is institutionalized, widening gender inequalities rather than reducing them. However, the relative inflexibility of full-time employment patterns at present often compels women to stop work permanently and/or to find work in the underground economy, because of their family responsibilities. If part-time employment became more prevalent, it might lead to a significant rise in female work rates, as it facilitates the reconciliation of family and working life among women.[12]

The current situation of extensive atypical employment is clearly less favourable for women since it does not provide any social insurance coverage. On the subject of insurance, there is a law that stipulates coverage for unpaid family workers (Law 1759/88). There is no reliable information on whether the law is actually observed. Similarly Law 1654/86 provides that all employees working at home should be insured as dependent workers by their employers, but this too is rarely implemented. Full application of this law would entail a 30–40 per cent increase in labour costs, so it has been implemented to a very limited extent, if at all, to date.

Summary and Conclusions

Women's employment rates in Greece have remained stable throughout the 1951–92 period, and are among the lowest in the EU. Part-time employment is the lowest in the EU. Falling fertility, the increase of mean life expectancy at birth, along with migration of younger age groups, have all contributed to an ageing of the workforce, while urbanization has altered the industrial structure, lowering the number of workers in the primary sector, particularly women employed as unpaid family workers, while the tertiary sector has grown. Throughout this period, the secondary sector was unable to provide enough jobs to absorb the surplus labour force from the primary sector. However, lower fertility rates did not increase employment rates, due to the absence of state assistance in reconciling family and

[12] Female unemployment in Greece is among the highest in the EU. It is notable that, although overall unemployment did not show any significant increase between 1983 and 1991, long-term unemployment, lasting over one year, rose considerably. In 1991 female unemployment in Greece was 13%, compared with an EU average of 11%. However, male unemployment was among the lowest in the EU at 5%, compared to the EU average of 7%. Long-term unemployment as a percentage of all unemployment rose in the period 1983–92 from 42% to 54% among women and from 22% to 37% among men (Eurostat, 1993*a*; 1994*a*).

working life, and to the inflexibility of the Greek labour market. Extended full-time education and earlier retirement, in combination with continued economic sharing within the family, also contribute to women's low labour-force participation.

Other studies indicate that the factors affecting female employment include the opportunity cost of not working for women; their level of education; the presence of home help for childcare, if any; the overall family income; the number of owned rooms per household; the woman's employment prior to marriage; and the attitude of a woman's husband on the matter. Finally, full- and part-time employment rates, as these appear in official statistics, do not reflect the complete picture, due to the existence of an extensive underground economy and the prevalence of atypical employment, particularly among women, as exemplified by piecework (*facon*) done at home, which is almost always poorly compensated, without contract and social insurance.

EU White Book recommendations to extend flexible forms of employment, in order to reduce unemployment, would further compress the already low social cost of work in Greece, but also, as employers already argue, would have negative effects on productivity. For that reason, there is no consensus concerning flexible forms of employment, particularly part-time employment.

Marriage and the birth of children do not affect women's choice between full-time and part-time employment to any significant extent: Greek women either work without interruption or, if they leave the labour force after marriage or the birth of a child, they have difficulty reintegrating into the labour force. Only in certain special cases (women with three children or more, women with a child under two years old) is there any impact of family responsibilities on the choice of part-time work, but the association is very weak. Although legislation concerning working mothers provides for parental leave for working couples, in practice such leave is circumvented due to its inherent limitations, especially where parental leave is concerned. At the same time, childcare facilities are inadequate both in quantity and quality.

In sum, women's employment in Greece is still dominated by the marriage career described by Hakim in Chapter 2. Half of all women aged 15–44 have either never had a job or else stopped work around the time of marriage. Some 40 per cent have worked at some point after marriage, but often on a family farm or in a family business rather than as a salaried employee, and sometimes doing industrial homework in the underground economy. These types of work provide an alternative source of the flexible and convenient working hours offered by part-time jobs in the more industrialized economies of northern Europe. This suggests that there is a hidden demand for part-time jobs among Greek women, but

the structure of the labour market and the economy do not, as yet, provide such jobs.

REFERENCES

Blossfeld, H.-P. (1994), 'Family Cycle and Growth in Women's Part-Time Employment in Western European Countries', European Commission, DGV (mimeo; Brussels).

Bouillaguet-Bernard, P., Gauvin, A., and Prokovas, N. (1985), *Changes in Activity and Employment of Women in the European Economic Community* (Paris: Centre National de la Recherche Scientifique).

Cavouriaris, M., Karamessini, M., and Symeonidou, H. (1994) 'Changing Patterns of Work and Working-Time for Men and Women: Towards the Integration or the Segmentation of the Labour Market', *Network for Women's Employment* (mimeo; Brussels: Commission of the European Communities).

Commission of the European Communities DGV-BU (1993), *Mothers, Fathers and Employment* (Brussels: CEC, DGV/1731/90-FR).

Dermenakis, P. (1987), 'The Underground Economy in Greece', *Economic Bulletin of the Commercial Bank of Greece*, 134: 16–33.

Emke-Poulopoulou, H. (1994), *The Demographic Situation of Greece* (Athens: Ellin).

Eurostat (1985), *Labour Force Survey Methods and Definitions* (Luxembourg: Office of Official Publications of the European Community).

—— (1993a), *Labour Force Survey 1983–1991* (Luxembourg: Office of Official Publications of the European Community).

—— (1993b), *Labour Force Survey 1991* (Luxembourg: Office of Official Publications of the European Community).

—— (1994a), *Labour Force Survey 1992* (Luxembourg: Office of Official Publications of the European Community).

—— (1994b), *Rapid Reports,* 'Population and Social Conditions', 4 (Luxembourg: Office of Official Publications of the European Community).

—— (1983, 1985, 1987), *Labour Force Surveys* (Luxembourg: Office of Official Publications of the European Community).

Frangos, D. (1980), *The Economically Active Population of Greece* (Athens: The National Centre of Social Research).

Hakim, C. (1991), 'Grateful Slaves and Self-Made Women: Fact and Fantasy in Women's Work Orientations', *European Sociological Review*, 7: 101–21.

—— (1993), 'The Myth of Rising Female Employment', *Work, Employment and Society*, 7: 97–120.

Kouzis, G. (1994), 'Special or Flexible Forms of Employment', *Information Bulletin of the GESEE/INE Labour Institute*, 40–1: 32–7.

Magdalinos, M. and Symeonidou, H. (1989), 'Modelling the Fertility-Employment Relationship: Simultaneity and Misspecification Testing', *European Journal of Population*, 5: 119–43.

NSSG, *Census Results*, 1951, 1961, 1971, 1981.

—— *Labour Force Survey*, 1987, 1991.

NSSG, *Labour Force Survey*, 1992, 1993.

OECD (1983), *Labour Statistics 1970–1981* (Paris: OECD).

Pavlopoulos, P. (1987), *Underground Economy in Greece: An Initial Quantitative Position* (Athens: IOVE).

Petrinioti, X. (1989), 'Participation of Women in the Labour Force and the Case of Greece', *The Greek Review of Social Research*, 74: 105–40.

Petrinioti-Consta, X. (1981), 'Determining Factors of Female Participation in the Workforce in Greece: Econometric Investigation' (Ph.D. thesis, Athens).

Pott-Buter, H. A. (1993), *Facts and Fairy Tales about Female Labor, Family and Fertility* (Amsterdam: Amsterdam University Press).

Rexroat, C. (1985), 'Women's Work Expectations and Labour-Market Experience in Early and Middle Family Life-Cycle Stages', *Journal of Marriage and the Family*, 47: 131–42.

Rombolis, S. (1994), 'The Developmental Strategy of the White Book and the Prospects of the Greek Economy' *INE (GESEE Labour Institute) Information Bulletin*, 38–9: 3–8.

Symeonidou, H. (1989), 'Fertility and Employment of Women in the Greater Athens area' (Ph.D. thesis, London).

—— (1990), 'Family Policy in Greece', in W. Dumon (ed.), *Family Policy in EEC-Countries* (Leuven: Katholieke Universiteit Leuven), pp. 125–71.

—— (1992*a*), 'Family Policy in Greece: Evolution and Trends 1990–1991', *European Observatory on National Family Policies* (mimeo; Brussels: Commission of the European Communities, Brussels).

—— (1992*b*), 'Family Policy in Greece: Evolution and Trends 1991–1992', *European Observatory on National Family Policies* (mimeo; Brussels: Commission of the European Communities).

—— (1993), 'Family Policy in Greece 1992–1993', *Summary Report, European Observatory on National Family Policies* (mimeo; Brussels: Commission of the European Communities).

—— (1994), 'The Incompatibility between Women's Family and Working Life', *Dini*, 7: 113–31.

—— (1996), 'La question sociale de la reproduction biologique de la société', in J. Commaille and F. de Singly (eds.), *Les Cahiers du Ceripof* (Paris: FNSP. CNRS), 201–18.

—— and Magdalinos, M. (1993), 'Fecondité et travail féminin en Grèce: un modèle micro-économique' ('Fertility and Female Employment in Greece: A Micro-Economic Model'), *Cahiers Québéquois de Démographie*, 22: 285–312.

—— et al. (1992), *Socio-Economic Factors Affecting Fertility in Greece*, i. *Analysis for the Greater Athens Area* (Athens: The National Centre for Social Research).

—— et al. (1997), *Socio-Economic Factors Affecting Fertility in Greece, xiii. Analysis for the Rest of Greece* (Athens: National Centre for Social Research).

Tsoukalas, K. (1987), *State, Society, Work in Post-War Greece* (Athens: Themelio).

Vaiou, N., Lambrinidis, O., Hadzimichalis, L., and Chronaki, Z. (1991), 'Diffused Deindustrialisation in Thessaloniki', *Synchrona Themata*, 45: 70–9.

5

Part-Time Work in Italy

TINDARA ADDABBO

Introduction

Italy is distinctive, among the four largest European Union countries, in having a very low level of part-time work. Greece is the only EU country with a lower share of part-time jobs. This chapter explores the characteristics of the part-time workforce in Italy and how it compares with the much larger part-time workforces of France, Germany, and the United Kingdom. Any explanation for this low level of part-time working has to be informed by the generally lower level of women's employment in Italy as compared with the three other large EU members. Whether low female work rates are seen as cause or consequence of low levels of part-time working, it is clear that the two are inextricably linked. This chapter therefore explores women's employment patterns before addressing part-time work.

Female employment in Italy has been increasing since 1972 and the main component of the increase has been, as in other industrialized countries, married women's labour supply. In the next section we present data on female labour supply in Italy with particular reference to the labour-force participation of married women. We describe the constraints on women's labour supply, and summarize the findings from the estimation of econometric models using cross-sectional data with regard to factors affecting the expansion of part-time work. The expansion of part-time work in Italy in the 1980s is examined, in particular the limited impact of the 1984 law which aimed to facilitate this option. Employers' demand for part-time work is found to be limited, with other mechanisms used to achieve flexibility.

Female Labour-Market Participation in Recent Decades

From 1972 onwards, women's participation in the labour market has been increasing, reversing the steady decline that prevailed until the late 1960s,

but it still is lower than in other industrialized countries. According to the 1991 Labour Force Survey (LFS), 36 per cent of women aged 14 and over in Italy were economically active compared to 46 per cent in France, 44 per cent in Germany, and 52 per cent in the UK. Among women aged 25 to 49 years, just over half of Italian women were in the labour force, compared to two-thirds in Germany and three-quarters in France and the UK (Table 5.1). Amongst the possible factors interrelated with this lower level of participation we can list, following Stirati (1990) and Bettio and Villa (1993):

• the slower growth of employment from 1960 to 1990;
• the limited growth of service sector employment and its less pronounced feminization.

The 1991 LFS shows women's share of service sector employment to be 69 per cent in Italy compared to 82 per cent in the UK, 71 per cent in Germany, and 78 per cent in France; the main difference between Italy and the UK is the lower level of female employment in the Banking, Finance, and Insurance industry: only 5 per cent of women employees in Italy against 12 per cent in the UK. Other factors of importance are:

• the smaller number of part-time jobs; and
• more restricted availability of childcare services and the incompatibility of working time with the opening times of schools, shops, and offices.

Italy has seen a significant increase in the economic activity rates of women aged 25 to 49 in recent years, rising from 49 to 57 per cent between 1985 and 1991 (Table 5.1) and the increase was greatest among married women (Tables 5.2 and 5.3). The difference between economic activity rates and employment rates shown in Tables 5.2 and 5.3 is due to high unemployment rates, especially among younger people. However, as Bettio (1988b) stresses, the increase in married women's work rates is not a very recent phenomenon in Italy, as married women's labour supply was stable or rising slowly before the Second World War. This long-term increase in married women's work rates is connected with changes in the economy of the family. As Bettio argues:

the long term opposing trends for the married and the non-married components do not require different explanations: instead they can be seen as two sides of the same coin. Both are traceable to a fundamental development affecting the economy of the family, namely the decreasing value of offspring as contributors of income and services to the original nucleus. The spread of public welfare provision such as education, health care and security schemes for the elderly form a significant part of this development. The related modifications in the economy of the family changed both the constraints on and the convenience of paid work for married women through their influence on fertility, while at the same time entailing a reduction in the activity of single women (Bettio, 1988b: 196).

TABLE 5.1. *Economic activity rates as a percentage of each age group, Italy, France, Germany, and the UK*

	1985			1991		
	M	F	T	M	F	T
Italy						
14–24	48	38	43	47	38	42
25–49	96	49	72	95	57	76
50–64	67	21	43	65	23	43
65+	8	2	5	8	2	5
Total	67	32	49	66	36	50
France						
14–24	50	44	47	39	35	37
25–49	97	71	84	96	75	86
50–64	61	37	49	55	38	47
65+	4	2	3	3	1	2
Total	68	46	56	64	46	50
Germany						
14–24	56	52	54	56	52	54
25–49	95	61	78	94	68	81
50–64	72	32	51	72	39	56
65+	5	2	3	5	2	3
Total	70	41	54	70	44	57
UK						
14–24	69	59	64	69	61	65
25–49	96	68	82	96	74	85
50–64	77	45	60	75	49	62
65+	9	3	5	9	3	5
Total	73	48	60	73	52	62

Source: EU Labour Force Survey, 1985 and 1991, Eurostat.

Tables 5.2 and 5.3 present cross-sectional data from two LFS surveys over just six years, and cannot give us a precise picture of the evolution of female labour supply over the life-cycle since they combine cohort and ageing effects. By identifying the same 5-year age cohorts in consecutive surveys Oneto (1991) constructed synthetic cohort data and work profiles, demonstrating that younger cohorts of Italian women have markedly higher attachment to the labour market than was found in the recent past. In particular, among women born from 1955 to 1959, economic activity rates do not decline sharply during the child-bearing and child-rearing years as they did among older cohorts of women.

Higher attachment to labour market activity and higher activity rates also characterize more educated women according to the results of an ISTAT survey on the family (Fadiga Zanatta, 1988) and the LFS (Oneto,

TABLE 5.2. *Economic activity rates as a percentage of each group by gender, marital status, and age, Italy*

	1985			1991		
	M	F	T	M	F	T
Single						
14–24	46	38	42	45	37	42
25–49	87	74	82	87	79	84
50–64	61	34	46	60	34	47
65+	11	3	5	12	2	5
Total	57	42	50	59	44	52
Married						
14–24	90	40	50	86	47	56
25–49	99	44	70	98	52	73
50–64	69	20	45	66	22	44
65+	9	3	7	8	4	6
Total	74	33	53	71	36	54
Widowed or divorced						
14–24	70	64	66	61	47	54
25–49	95	72	80	94	77	82
50–64	54	21	27	51	24	29
65+	4	1	2	4	1	2
Total	35	14	19	34	16	19

Source: Italian Labour Force Survey, 1985 and 1991.

1991). More educated women seem to be less affected by the presence of children in their labour supply decisions (Fadiga Zanatta, 1988). This may be due to the fact that more educated women have better access to jobs in the service sector, mainly as teachers, where working hours are 36 hours a week or less, offering greater compatibility with childcare and domestic activities.

Mothers' labour supply is determined in part by the number of children in the family. The 1985 ISTAT survey on family behaviour showed that married women's participation rates tend to fall with each additional child: the wife is working in 40 per cent of Italian families with only one child, and this proportion falls to 20 per cent for families with five children or more. However, the reduction is not as marked as in other industrialized countries where, as noted by Delacourt and Zighera (1988), mothers' work-force participation seems to vary more with the number of children than with their age. Female employment rates are markedly lower in the Centre-South of the country than in the North. This is due to generally lower labour demand and to the more restricted availability of childcare services. The percentage of children under 3 years attending kindergarten is only 1.4

TABLE 5.3. *Employment rates as a percentage of each group by gender, marital status, and age*

	1985			1991		
	M	F	T	M	F	T
Single						
14–24	34	22	28	34	25	30
25–49	78	62	72	77	64	72
50–64	59	33	45	58	33	46
65+	11	3	5	12	2	5
Total	47	29	38	49	33	41
Married						
14–24	84	30	41	77	33	43
25–49	97	41	67	96	46	69
50–64	68	20	45	65	21	44
65+	9	3	6	8	4	6
Total	73	30	51	70	32	51
Widowed or divorced						
14–24	64	40	48	50	—	41
25–49	92	66	75	91	70	76
50–64	53	20	26	50	23	28
65+	4	1	2	4	1	2
Total	34	14	18	33	15	18

Source: Italian Labour Force Survey.

per cent in the South of Italy compared with 8.3 per cent in the North and 6.3 per cent in the Centre, as noted in a 1988 European Parliament report quoted by Stirati (1990). Differences between the three regions in employment rates are highest for married women with children of pre-school age (Addabbo, 1995).

Notwithstanding a slow decline, occupational segregation by gender is widespread and persistent in Italy as shown by Bettio (1988*a*, 1988*b*, and 1991) in her analyses of sex-typing and its effect on female labour supply over the century. On the other hand, pay differentials have been significantly reduced. By 1985 women workers in manufacturing industry earned 83 per cent of men's wage, against about 50 per cent in 1938 (Eurostat data quoted in Bettio, 1991). A recent analysis by Addis and Waldmann (1995) based on Bank of Italy data for 1989, shows that even after controlling for seniority, education, and hours worked, there is a 13 per cent pay gap between men and women and Addis (1994) finds that gender differentials in earnings are higher for more educated women. Equal opportunity legislation was approved in 1977 (Livraghi, 1989), but a law introducing affirmative action for women was only approved in 1991. Law 125/91

subsidizes affirmative action in training and retraining and funds projects of work reorganization and restructuring of working time and employment conditions (Treu, 1991; Ponzellini, 1994). Projects funded to date have consisted mainly of additional training for women.

Findings from Econometric Models Using Microdata

Findings from econometric models of female labour supply based on microdata help explain the expansion of part-time work in Italy. These research results come from analyses of interview survey microdata for three industrialized towns in the North of the country collected in the early 1980s (Milan, Turin, and La Spezia); from a survey of women's employment conducted in Trento in 1992 (Borzaga, 1994); from Del Boca's (1993) analysis of 1987 Bank of Italy data; and from Addabbo's (1995) analysis of Bank of Italy data for 1989–93.

The effect of education on married women's labour supply is positive and significant (Del Boca, 1993; Addabbo, 1995), but its effect changes with the type of the labour-market structure (IRER, 1983). All the surveys find that the number of children in the family is an important factor reducing married women's labour supply (IRER, 1980; 1983; Ventrella *et al.*, 1981; Del Boca, 1980; 1982; 1993; Addabbo, 1995). They also find that the negative effect of the presence of children on their mothers' labour supply is lower for younger cohorts (Del Boca, 1980 and 1982 based on microdata for Turin; Colombino and De Stavola, 1985, based on time-series data).

One important finding is that women's employment appears to be in disequilibrium. For example the Trento survey (Borzaga, 1994) showed that 30 per cent of working women would prefer different working hours: 20 per cent would like to work for fewer hours and 10 per cent would prefer to work longer hours. Amongst those who wished to work shorter hours (reduced from 31–40 hours a week to less than 20 hours a week) the majority were aged 25 to 39 years, married, and with a child. What might be termed 'overemployment' seems to be a feature of a large proportion of women who work during the reproductive stage of the life-cycle. On the other hand the 'underemployed', who worked less than 20 hours a week and wished to work 31–40 hours, are mainly younger (aged 14 to 29), unmarried and without any children. A survey carried out in Turin showed that 12 per cent of working women were 'overemployed' and would have preferred to work one-third fewer hours (Colombino, 1982). Difficulties in accommodating family needs to working time were reported by one-fifth of the Trento sample (Borzaga, 1994). There is clear evidence that relatively inflexible full-time working hours in Italy present a major barrier to women's labour-force participation.

The Expansion of Part-Time Work

The issue of the significance of part-time work across the life-cycle would require several waves of panel data or, at the very least, retrospective survey data that are simply not available in Italy or have only very recently become available—such as the panel within the Bank of Italy's new Survey of Household Income and Wealth. Dynamic models of part-time work (such as that of Blank, 1994) are thus ruled out. Instead, we exploit existing data-sets to shed some light on the expansion of part-time work; on the phases of the life-cycle where part-time employment is most common; and on the factors limiting its development in Italy.

In common with trade unions in other European countries, Italian trade unions have been opposed to part-time work for many years, as noted by Gasparini (1988) and Bracalente and Marbach (1989). Only in the early 1980s did the system of industrial relations start to take a serious interest in employment flexibility (see Garonna, 1988), including part-time work. However, employers express greater interest in other mechanisms for achieving flexibility.

Legal recognition and regulation of part-time work only commenced in 1984. Law No. 863 of December 1984 defines part-time work as a job done for a shorter number of hours than the usual hours stipulated in the relevant collective agreement, or for previously established periods of time within the week, month or year. The remaining characteristics of part-time work, not defined by Law 863, are governed by the general provisions of labour law and by collective agreements. Collective agreements now often include reference to part-time work. A part-time contract must be confirmed in writing and must indicate the duties and hours to be worked per day, month, or year. Wages, social security, and other working conditions are generally fixed pro rata to the equivalent full-time job in order to adapt contributions and benefits to the reduction in the working hours. Ichino (1985), Bracalente and Marbach (1989), and Mele (1990) provide critical assessments of Law 863, noting that the law did not fix any precise upper limit of hours in its definition of part-time work and did not provide any incentive for firms to employ part-time workers. Incentives for employers to use part-time workers (such as a reduction in social security contributions) were only introduced in 1994 (in D.L. 185/94) in the context of a series of laws aimed at introducing more flexibility into the Italian labour market (Ministero del Lavoro, 1994). In 1988 a law (No. 554) was passed authorizing the recruitment of part-time workers in the public-sector services and agencies. The aim was to increase the number of part-timers in the public sector to up to 20 per cent of the workforce. Law 223/1991 introduced phased retirement with a transition from full-time to part-time work

before full retirement, with pension still based on full-time pay. However, part-time employment in the public sector remains low at present.

Before the introduction of the law in 1984, part-time work was limited to isolated cases governed by collective bargaining (Frey, 1989). Before the law on part-time work was introduced, a survey of 18,152 people by the Soroptimist International (1981) showed that 71 per cent of those interviewed were in favour of the introduction of part-time jobs, with higher percentages among married women living in the North of the country, and amongst full-time housewives. The most common reasons for being in favour of part-time jobs were connected with family life, especially among women living in the South of Italy where childcare services are rare.

The impact of Law 863/84 on part-time work in Italy can be assessed with national Labour Force Survey data from ISTAT, with a consistent time-series available for 1985 onwards, or with Ministry of Labour statistics on the application of Law 863. Relevant data can also be found in some local surveys of women's employment, such as those described earlier, and surveys which focused explicitly on part-time work (Bracalente and Marbach, 1989). These various sources provide quite different pictures of recent trends. In particular, the two national data-sets employ completely discrepant definitions of part-time work: the Ministry of Labour statistics are based on the definition of part-time jobs given in Law 863, and exclude workers in agriculture and all temporary jobs, while LFS data include temporary part-time jobs and part-time work in agriculture. Agriculture provides more seasonal work than other industries. The Ministry of Labour statistics only measure the flow into part-time jobs (with no information on how long they last) while the LFS data describe the total stock of part-time workers.

Ministry of Labour statistics based on Law 863 (Tables 5.4 and 5.5) indicate a substantial increase in entries to part-time employee jobs, with the annual inflow rising from 100,000 to 247,000 a year within the first decade. The increase in numbers switching from full-time to part-time work was even larger, from 25,000 to 85,000 a year within the first decade. In both cases, the majority of part-time workers were women (Table 5.4).

These statistics imply a total increase of 891,000 non-agricultural part-time employee jobs between 1985 and 1991, in effect, that part-time jobs almost doubled over the six-year period. However, the Italian LFS shows a total part-time employee workforce of 791,000 in 1991, an increase of only 136,000 on the total in 1985 (Table 5.7) or a growth rate of 21 per cent over six years, which is not consistent with that shown in Table 5.4. These contradictory results indicate that, in practice, the great majority of the new part-time jobs were of short duration. The 1993 LFS shows a further increase in part-time work, of 19 per cent compared to 1992, concentrated in small to medium sized firms with less than 49 employees (where

Table 5.4 *The growth of part-time employment, as defined in Law 863/1984, Italy,*
1985–1993

	People entering part-time employee jobs			Employees switching from full-time to part-time work		
	Men %	Women %	Total N	Men %	Women %	Total N
1985	23	77	111 198	17	83	24 805
1986	29	71	108 687	17	83	27 690
1987	25	75	142 692	19	81	34 914
1988	26	74	161 307	19	81	37 117
1989	25	75	182 234	16	84	45 609
1990	25	75	184 786	17	83	38 664
1991	29	71	211 670	19	81	56 627
1992	25	75	234 840	19	81	63 563
1993	26	74	246 910	23	77	84 286

Source: Author's analysis of Italian Ministry of Labour (1994) data.

part-time work increased by 23 per cent) and in the service sector (an increase of 19 per cent). This recent increase in part-time employment is attributable more to economic recession than to changes in the legislative framework, as shown by the significant increase in the number of men switching from full-time to part-time jobs (Table 5.4), presumably due to short-time working.

Ministry of Labour statistics show the growth in part-time jobs to be concentrated in the Centre-North of Italy: in 1993 only 14 per cent of people who entered a part-time contract (according to Law 863) lived in the South of the country whereas 67 per cent lived in the North (Table 5.5). LFS data give a different picture, since the presence of seasonal work in agriculture (excluded from Ministry of Labour statistics) increases the proportion of part-timers in the South of the country. The 1986 LFS shows that only 42 per cent of part-timers have a permanent job, and this percentage falls to 23 per cent for part-timers employed in agriculture, where seasonal work is common. Clearly, most part-time jobs are also temporary jobs. This helps explain why the apparently dramatic impact of Law 863/84 in creating new part-time jobs has had a negligibly small effect on the net increase in part-time jobs as shown in the LFS (Tables 5.6 to 5.9), particularly when compared with the faster pace of change in the other three large EU economies. Over the six years 1985–91, the total part-time workforce grew by only 10 per cent in Italy compared to 15 per cent growth in France, 36 per cent in Germany, and 13 per cent in the UK (Table 5.6); the number of part-time employees grew by 21 per cent in Italy compared

TABLE 5.5. *The impact of Law 863/1984 on part-time employment in Italy, 1987–1993*

	North %	Centre %	South %	Total N
People entering part-time employee jobs, as defined by Law 863, by region				
1987	72	20	8	142 692
1988	71	20	9	161 307
1989	69	21	10	182 234
1990	52	37	11	184 786
1991	67	21	12	211 670
1992	67	20	13	234 840
1993	67	19	14	246 910
Employees who changed from full-time to part-time work, as defined by Law 863, by region				
1987	72	22	6	34 914
1988	72	21	7	37 117
1989	71	21	8	45 609
1990	64	28	8	38 664
1991	72	21	7	56 627
1992	70	21	9	63 563
1993	71	21	8	84 286

Source: Author's analysis of Italian Ministry of Labour (1994) data.

to 24 per cent growth in France, 41 per cent in Germany, and 13 per cent in the UK (Table 5.7).

Part-time work thus remains at a very low level in the Italian workforce, even in the 1990s, especially when compared with other European countries: 6 per cent of total employment in 1991, against 22 per cent in the UK, 12 per cent in France, and 16 per cent in Germany (Table 5.6). The difference is even more marked in relation to women's employment: 10 per cent of women in employment in 1991 (and 12 per cent of married women) compared to 24 per cent in France, 34 per cent in Germany, and 44 per cent in the UK (and 50 per cent of married women in the UK). Figures for the employee workforce are very similar (Table 5.7). Women do not dominate part-time work as much as they do elsewhere: of the 1,192 thousand people working part-time in 1991, only 780,000 (65 per cent) were women against 86 per cent of part-timers in the UK and 90 per cent in Germany (Table 5.6). Similarly, married women constitute a minority of part-timers rather than the clear majority as in France, Germany, and the UK, with little change over the period 1985–91 (Table 5.8).

TABLE 5.6. *The part-time workforce in Italy, France, Germany, and the UK*

	1985				1991				1985–1991 change
	M	F	MW	T	M	F	MW	T	
Number of part-time workers (000s)									
Italy	416	669	494	1086	412	780	557	1192	+ 106 +10%
France	395	1928	1469	2323	427	2238	1625	2666	+ 343 +15%
Germany	318	3019	2525	3337	474	4066	3388	4540	+1203 +36%
UK	611	4474	3747	5085	799	4933	4042	5733	+ 648 +13%
Part-time workers as % of all in employment in each group									
Italy	3	10	11	5	3	10	12	6	
France	3	22	26	11	3	24	27	12	
Germany	2	30	43	13	3	34	49	16	
UK	4	45	54	21	5	44	50	22	

Note: M = men, F = women, MW = married women, T = total.

Source: EU Labour Force Survey, 1985 and 1991, Eurostat.

TABLE 5.7. *The employee part-time workforce in Italy, France, Germany, and the UK*

	1985				1991				1985–1991 change
	M	F	MW	T	M	F	MW	T	
Number of part-time employees (000s)									
Italy	235	421	293	655	239	552	383	791	+ 136 +21%
France	280	1579	1165	1859	335	1968	1395	2302	+ 443 +24%
Germany	192	2632	2206	2824	338	3651	3041	3989	+1165 +41%
UK	479	4133	3450	4611	638	4569	3734	5207	+ 596 +13%
Part-time employees as % of all employees in each group									
Italy	2	9	10	5	3	10	11	5	
France	3	21	25	11	3	24	28	12	
Germany	1	29	45	12	2	34	50	15	
UK	4	45	55	22	5	44	50	23	

Note: M = men, F = women, MW = married women, T = total.

Source: EU Labour Force Survey, 1985 and 1991.

TABLE 5.8. *Distribution of the part-time workforce, Italy, France, Germany, and the UK*

	1985				1991			
	M	F	MW	T	M	F	MW	T
Italy								
14–24	7	10	2	17	8	10	2	18
25–49	14	37	32	51	14	41	34	55
50–64	12	13	10	25	8	12	9	20
65+	5	2	1	7	5	2	1	7
Total	38	62	45	100	35	65	46	100
France								
14–24	5	11	3	16	4	11	2	15
25–49	6	53	45	59	7	56	46	63
50–64	4	18	15	22	4	16	13	20
65+	2	1	*	3	1	1	*	2
Total	17	83	63	100	16	84	61	100
Germany								
14–24	1	4	2	5	2	3	1	5
25–49	4	64	56	68	5	61	54	66
50–64	2	21	17	23	2	23	19	25
65+	2	2	1	4	2	2	1	4
Total	9	91	76	100	11	89	75	100
UK								
14–24	5	9	3	14	5	10	2	15
25–49	2	55	52	57	2	55	50	57
50–64	2	22	18	24	3	20	17	23
65+	3	2	1	5	3	2	1	5
Total	12	88	74	100	13	87	70	100

Note: M = men, F = women, MW = married women, T = total.
 * = less than 0.5%

Source: EU Labour Force Survey, 1985 and 1991.

Most part-time workers are aged 25 to 49 years (Table 5.8). In Italy, the concentration of part-timers in this prime-age group is increasing, as it is in France, whereas it is stable or declining in Germany and the UK. None the less, in all four countries part-time jobs are frequently taken up by young people in the labour-market entry phase and by older workers in the pre-retirement phase of the life-cycle: almost one-half of all part-timers are accounted for by these other groups in Italy and the UK.

In 1991, 9 per cent of the female workforce was in agriculture in Italy compared to 5 per cent in France, 4 per cent in Germany, and only 1 per cent in the UK. A correspondingly lower proportion worked in the service sector: 69 per cent in Italy compared to 71 per cent in Germany, 78 per cent in France, and 82 per cent in the UK. Italy is also distinctive in that

only 10 per cent of women working in the service sector are in part-time jobs, compared to 26 per cent in France, 37 per cent in Germany, and 47 per cent in the UK (Table 5.9). Part-time jobs for women are more common in the small agricultural sector than in the service sector in Italy. However, agriculture as a whole does not offer a higher level of part-time working than is found in the other three countries (15 per cent compared to 14 and 21 per cent), whereas the service sector offers a far lower level of part-time jobs in Italy (5 per cent) compared to France (16 per cent), Germany (21 per cent), and the UK (29 per cent), as shown in Table 5.9. Differences in industrial structure are clearly far less important than cross-national differences in the creation of part-time jobs, particularly in the service sector.

Working hours are relatively long in Italy and many women work over 31 hours a week, especially in the service sector. A 1984 survey of 3,000 Italian families (Bracalente and Marbach, 1989) found that horizontal part-time work (where the employee works shorter hours each day of the working week) is more common than vertical part-time jobs (where full-time hours are worked on only 3 or 4 days a week). Horizontal part-time jobs are most popular among women.

The LFS shows a higher level of involuntary part-time work in Italy than in the UK or in Germany (Meulders *et al.*, 1994). In 1990, for example, 45 per cent of men and 33 per cent of women working part-time reported that they did so because they could not find full-time employment. Part of the explanation is that short-time working (hence part-time jobs) has been introduced as an alternative to firing workers in manufacturing industry (Stirati, 1990). On the other hand, there is evidence of 'overemployment', as noted earlier, with 20 per cent of female full-time workers preferring jobs with shorter hours. Further, the 1993 LFS shows that among the unemployed, the highest level of interest in part-time work is expressed by prime-age married women. Both Bracalente and Marbach (1989) and Borzaga (1994) found that a significant proportion of non-working women would be interested in part-time jobs if they were available. Borzaga suggests that some two-thirds of non-working women who wish to have a paid job would prefer half-time work with less than 20 hours a week. However, the LFS indicates a total of some 200,000 non-working people nationally who would like a part-time job, a relatively low level of interest given a total workforce of 20 million and a population of working age of 40 million in Italy (see Table 1.1).

Research in Italy, as elsewhere, confirms the importance of 'family reasons' for women working part-time (Bracalente and Marbach, 1989; Borzaga, 1994, especially Tables 13–16 in Appendix B). However, Bettio and Villa's (1993) analysis of national 1986 LFS data demonstrates that in Italy women's part-time employment is only very weakly affected by the

TABLE 5.9. *Part-time workers' share of employment in Italy, France, Germany, and the UK by economic sector*

	Agriculture				Industry				Services			
	M	F	MW	T	M	F	MW	T	M	F	MW	T
Part-time workers as % of all in employment in each group												
Italy	11	24	24	15	2	8	10	3	3	10	10	5
France	7	28	29	14	1	12	16	4	5	26	30	16
Germany	9	36	38	21	1	26	38	7	4	37	54	21
UK	7	48	52	16	2	26	33	8	8	47	53	29
Part-time employees as % of all employees in each group												
Italy	13	29	31	19	2	7	9	3	2	10	10	5
France	6	30	35	13	1	11	14	4	5	26	31	16
Germany	4	32	43	14	1	25	37	7	4	38	56	22
UK	7	58	64	20	2	25	31	8	8	48	53	30

Note: M = men, F = women, MW = married women, T = total.

Source: EU Labour Force Survey 1991, Eurostat.

number and age of children whereas in countries with high levels of part-time employment, such as the UK or Germany, the two are strongly associated. An econometric model of part-time employment (Del Boca, 1984) showed that women working part-time in Italy are different from those in other industrialized countries: they are more educated and are not confined to secondary jobs. However, this analysis defined all women working less than 35 hours a week as part-timers, including teachers who are normally classified as full-timers (Frey, 1981; Bracalente and Marbach, 1989). When teachers are excluded, part-time jobs in Italy have similar characteristics to those in other European countries: they consist of less qualified posts with little scope for long-term careers.

The Demand for Part-Time Workers

Even before the introduction of the 1984 law regulating part-time work, few firms appeared to be interested in it. A survey of medium-to-large firms described by Marchese and Ortona (1984) found only 20 per cent of the firms interviewed to be interested in part-time work. However, employers preferred temporary work as the mechanism for achieving flexibility in labour usage. In practice, hardly any employers make any use of part-time work as a means of achieving employment flexibility. The 1992 Censis (1992: 190) shows only 3 per cent of interviewed employers using vertical part-time work and 1 per cent using horizontal part-time work to achieve greater flexibility. They generally prefer to use overtime work or subsidized training contracts instead, as noted by Casavola (1993), Demekas (1995), and Treu *et al.* (1993). As noted earlier, the law on part-time work did not include any employer incentives, which were only introduced in D.L.185/1994, in the form of reductions in social security contributions.

Hours of work for part-timers must be fixed in advance and part-time workers cannot work overtime in Italy (Delsen, 1991). Thus employers find it more costly to hire two part-timers instead of one full-timer (Confindustria, 1993). Employers' reluctance to introduce or extend part-time work is also linked to their strong preference for full-time workers, given the organizational problems involved in part-time work (Delsen, 1993). A 1986 survey of 300 firms' use of part-time workers (Bracalente and Marbach, 1989) found that 40 per cent of firms did not employ part-timers and did not wish to do so. The other firms not employing part-timers would do so only under special conditions, typically by converting full-time jobs to part-time work. In general, part-time work was least common in medium-to-large firms and more common in firms with less than 50 employees.

Conclusions

In sum, the key reasons for the low level of part-time work in Italy compared to France, Germany, and the UK are:

- the very recent introduction of a law legitimating and regulating part-time work and subsequent introduction of incentives for firms to use part-time workers;
- the relatively low interest in part-time work among employers who prefer temporary contracts and other means of achieving employment flexibility;
- the opposition of trade unions;
- the smaller size of the service sector.

In effect, organizational and institutional barriers seem to be more important than any lack of interest in part-time jobs among working women, the unemployed, and the inactive population. Married women tend to favour part-time work for family reasons. Demand side constraints seem to be the overriding determinants of the level of part-time work. The picture of part-time work in Italy is clouded by the creation of involuntary part-time jobs in the form of short-time working due to the economic recession. This suggests that disequilibrium analyses of survey microdata would be most useful for illuminating the relationship between labour supply and the availability of part-time jobs. Longitudinal data has only very recently been made available, but could more fruitfully be explored in a non-recessionary context.

REFERENCES

Addabbo, T. (1995), 'The Employment Probability of Married Women: The Case of Italy', paper submitted to the X Convegno Nazionale di Economia del Lavoro, AIEL, Bologna, Oct.

Addis, E. (1994), 'I differenziali salariali e retributivi per sesso in Italia: una ipotesi interpretativa' ('Gender Wage and Redistribution Differentials'), *Economia, Società e Istituzioni*, 1: 33–69.

—— and Waldmann, R. (1995), 'Struttura salariale e differenziali per sesso in Italia' ('Wage Structures and Differentials by Sex in Italy'), paper submitted to the X Convegno Nazionale di Economia del Lavoro, AIEL, Bologna, Oct.

Bettio, F. (1988a), 'Sex-Typing of Occupations, the Cycle and Restructuring in Italy', in J. Rubery (ed.), *Women and Recession* (London: Routledge & Kegan Paul).

—— (1988b), 'Women, the State and the Family in Italy: Problems of Female Participation in Historical Perspective', in J. Rubery (ed.), *Women and Recession* (London: Routledge & Kegan Paul).

Bettio, F. and Addis, E. (1991), 'Segregazione e discriminazione sul mercato del lavoro: letteratura straniera e italiana a confronto. Parte II: la letteratura italiana' ('Segregation and Discrimination in the Labour Market'), *Economia e Lavoro*, 1: 49–66.

—— and Villa, P. (1993), 'Strutture familiari e mercati del lavoro nei paesi sviluppati: l'emergere di un percorso mediterraneo per l'integrazione delle donne nel mercato del lavoro' ('Family Structures and Labour Markets in Developed Countries'), *Economia e Lavoro*, 2: 3–30.

Blank, R. M. (1994), *The Dynamics of Part-Time Work*, NBER, Working Paper No. 4911 (Cambridge, Mass.: NBER).

Borzaga, C. (ed.) (1994), *Il Mercato del Lavoro Femminile: Aspettative, Preferenze e Vincoli—Una Ricerca con Microdati nel Comune di Trento* ('The Female Labour Market: Expectations, Preferences and Constraints'), (Milano: Angeli).

Bracalente, B. and Marbach, G. (1989), *Il Part-Time nel Mercato Italiano del Lavoro* ('Part-Time Work in the Italian Labour Market), (Milano: Angeli).

Casavola, P. (1993), 'La regolamentazione del mercato del lavoro' in S. Rossi (ed.), *Competere in Europa* (Bologna: Il Mulino).

Censis (1992), *Rapporto Sulla Situazione Sociale del Paese 1992* ('Report on the Social Situation in the Country') (Milano: Angeli).

Colombino, U. (1982), 'L'offerta di lavoro: prezzi e (dis)-equilibri' ('Labur Supply: Prices and (Dis)equilibrium'), in G. Martinotti (ed.), *La Città Difficile: Equilibri e Diseguaglianze nel Mercato Urbano* (Milano: Angeli).

—— and De Stavola, B. (1985), 'A Model of Female Labor Supply in Italy using Cohort Data', *Journal of Labor Economics*, 3 (1): S275–S292.

Confindustria (1993), *Previsioni dell'Economia Italiana* ('Forecast for the Italian Economy'), 2 (Roma: Confindustria).

Delacourt, M.-L. and Zighera, J. A. (1988), *Women's Work and Family Composition: A Comparison of the Countries of the European Economic Community,* Final Report to the Directorate General of Employment, Social Affairs and Education, V/1795/88-EN.

Del Boca, D. (1980), 'Comportamenti motivazioni e aspettative delle donne nel mercato del lavoro' ('Behaviour, Motivations and Expectations of Women in the Labour Market'), *Economia Istruzione e Formazione Professionale*, 11: 127–32.

—— (1982), 'Strategie familiari ed interessi individuali' ('Family Strategies and Individual Interests'), in G. Martinotti (ed.), *La Città Difficile: Equilibri e Diseguaglianze nel Mercato Urbano* (Milano: Angeli).

—— (1984), 'Differenziali salariali e alternative di orario' ('Wage Differentials and Time Alternatives'), *Economia e Lavoro*, 4: 3–16.

—— (1993), *Offerta di Lavoro e Politiche Pubbliche* ('Labour Supply and Public Policies'), (Roma: NIS).

Delsen, L. (1991), 'Atypical Employment Relations and Government Policy in Europe', *Labour*, 5 (3), 123–49.

—— (1993), 'Part-Time Employment and the Utilisation of Labour Resources', *Labour*, 7 (3), 73–91.

Demekas, D. G. (1995), 'Labour Market Institutions and Flexibility in Italy', *Labour*, 9 (1), 3–43.

Fadiga Zanatta, A. L. (1988), 'Donne e lavoro' ('Women and Work'), in *Immagini Della Società Italiana*, ISTAT (Rome: ISTAT).

Frey, L. (1981), 'Prospettive di gestione del tempo femminile' ('Female Perspectives in Time Planning'), in *Il Part-Time: Storia, Realtà, Prospettive*, Atti dei Lavori del Seminario di Studi, Soroptimist International, Sirmione-Brescia, 4–5 April.

—— (1989), 'Le politiche del lavoro e dell'occupazione' ('Labour and Employment Policies'), in R. Brunetta and L. Tronti (eds.) *Rapporto '89—Lavoro e Politiche della Occupazione in Italia* (Rome: Ministero del lavoro e della Previdenza Sociale, Istituto Poligrafico e Zecca dello Stato).

Garonna, P. (1988), 'Le politiche sul tempo di lavoro e il sistema di relazioni industriali in Italia' ('Policies Concerning Work Time and Industrial Relations in Italy'), in V. Valli (ed.), *Tempo di Lavoro e Occupazione: Il Caso Italiano* (Rome: NIS).

Gasparini, G. (1988), 'Il dibattito sul tempo di lavoro in sociologia' ('The Sociological Debate about Labour Time'), in V. Valli (ed.), *Tempo di Lavoro e Occupazione: Il Caso Italiano* (Rome: NIS).

Ichino, P. (1985), 'Verso una nuova concezione e struttura della disciplina del tempo di lavoro: spunti critici sull'articolo 5 della legge 19 Dicembre 1984 N.863' ('Towards a New Conception and Structure of Labour Time Regulation'), *Rivista Italiana di Diritto del Lavoro*, 2: 241–68.

IRER (1980), *Lavoro Femminile e Condizione Familiare* ('Female Labour and Family Conditions') (Milano: Angeli).

—— (1983), *L'Offerta di Lavoro delle Donne Sposate* ('The Supply of Labour by Married Women') (Milano: Documenti IRER).

Livraghi, R. (1989), 'Problematica del lavoro femminile e le azioni positive in Italia' ('Problems of Female Labour and Affirmative Action in Italy'), in R. Brunetta and L. Tronti (eds.), *Rapporto '89—Lavoro e Politiche della Occupazione in Italia* (Rome: Ministero del Lavoro e della Previdenza Sociale, Istituto Poligrafico and Zecca dello Stato).

Marchese, C. and Ortona, G. (1984), 'La domanda di lavoro a tempo ridotto: alcuni risultati da una indagine preliminare sulle imprese e indicazioni per una ricerca più ampia' ('The Demand for Part-Time Labour'), *Micros*, 2–3: 21–34.

Mele, L. (1990), *Il Part-Time* ('Part-Time Labour') (Milano: Giuffrè).

Meulders, D., Plasman, O., and Plasman, R. (1994), *Atypical Employment in the EC* (Aldershot: Dartmouth).

Ministero del Lavoro e della Previdenza Sociale (1994), *Report '93-94: Labour and Employment Policies in Italy* (Rome: Istituto Poligrafico and Zecca dello Stato).

Oneto, G. (1991), 'Recenti tendenze dell'offerta di lavoro in Italia: un'analisi della partecipazione al mercato del lavoro' ('Recent Trends in Labour Supply in Italy'), *Economia e Lavoro*, 1: 81–102.

Ponzellini, A. M. (1994), 'Uguali e diverse: tre anni di "azioni positive" ' ('Equal and Different'), *Politica ed Economia*, 2: 87–90.

Soroptimist International (1981), *Il Part-Time: Storia, Realtà, Prospettive* ('Part-Time Labour: History, Reality, Perspectives'), Atti dei Lavori del Seminario di Studi, Sirmione-Brescia, 4–5 April.

Stirati, A. (1990), 'Comportamenti lavorativi e posizione delle donne nel mercato

del lavoro in una prospettiva comparata' ('Women's Behaviour and Position in the Labour Market in a Comparative Perspective'), in A. M. Nassisi (ed.), *Il Lavoro Femminile in Italia tra Produzione e Riproduzione* (Rome: Fondazione Istituto Gramsci).

Treu, T. (1991), 'La nuova legge italiana sulle pari opportunità delle donne nel lavoro' ('The New Italian Law on Equal Opportunities for Women in the Labour Market'), *Quaderni Europei*, 3.

—— Geroldi, G., and Maiello, M. (1993), 'Italy: labour relations' in J. Hartog and J. Theeuwes (eds.), *Labour Market Contracts and Institutions* (Amsterdam: Elsevier Publishers).

Ventrella, A. M., Buratto, F. O., De Santis, G., and Vacirca, F. (1981), *Le Donne e il Mercato del Lavoro: Contributo per un Osservatorio Locale sull'Offerta Femminile* ('Women and the Labour Market'), Documenti ISVET (Milano: Angeli).

The Family Cycle and the Growth of Part-Time Female Employment in France: Boon or Doom?

LAURENCE COUTROT, IRÈNE FOURNIER, ANNICK KIEFFER, AND EVA LELIÈVRE

Since the early 1980s, a number of public policies have been implemented in France to develop part-time work. Although political debate did not focus explicitly on part-time work, it treated work-sharing as a way of fighting unemployment and attempted to improve the status of homekeepers, as illustrated by the current debate on a maternal salary. Surprisingly, this debate did not refer to gender, even though women form the majority of part-time workers, as well as of adults who are outside the labour force.

In this chapter, we analyse the role played by part-time employment both from the labour supply and labour demand viewpoints. The rise in part-time work reflects women's attachment to paid work. A major change can be observed in women's employment patterns: they tend to quit the labour force less frequently and they switch more often from full-time to part-time work, or vice versa. Part-time work becomes a way for women to remain in the labour force at various stages of their family cycle, including when they are in charge of young children. On the other hand, employers offer so-called 'atypical' jobs which are specifically targeted at the female population. Part-time work is a key element in the employment flexibility policy. However, it locks women into disadvantaged economic positions, in terms of income and prospects for future upward occupational mobility, thus maintaining a certain type of division of labour between men and women.

In order to explain the sharp rise of part-time work in the last twenty years, we will first summarize the key features of female employment in the post-war period and the legal background. We then analyse the main characteristics of part-time jobs and of the people who hold them. Our

The authors thank Gwenneth Terrenoire (CESE, CNRS, Paris) for translating this paper from French into English.

objective is to test whether part-time employment is mainly a response to the needs of the market or a way for women to make working compatible with the demands of their family life. We also consider how the growth of part-time employment can be related to other social trends in education, marriage, and fertility. A secondary analysis of three waves of the French Labour Force Survey (LFS) provides a solid basis for understanding women's movement into and out of part-time work over the life-course. The evidence shows that the age of the last child has a marked influence on female employment patterns, though the effect differs between social groups. Social origin and partner's occupation also shape women's attitudes towards employment.

The Historical Record: From Family Worker to Part-Time Female Employee

The rise in female labour participation is often claimed to be one of the most important changes experienced by industrial societies since the Second World War. However, Léry and Deville (1978) note that the proportion of women in the labour force appears not to have changed in France since the beginning of the century. From the 1930s up to 1968, women's labour-force participation rates as a proportion of the working age population are broadly stable, at around 40 per cent (Table 6.1). Admittedly, this result is affected by the varying upper and lower limits used to define the working age population, in particular by the lack of any upper age limit. In fact, this apparent overall stability hides a continuous rise in the labour-force participation of adult women aged 25–55 since the

TABLE 6.1. *Female labour-force participation, 1911–1990*

	Size of labour force		Activity rate as % of all females of working age	Activity rate for women aged		
	Women 000s	Men 000s		25–39	40–54	15–64
1911	7 217	12 879	46	47	48	55
1921	7 231	12 776	43	43	45	52
1931	6 986	13 411	41	42	41	48
1936	6 542	12 650	38	42	40	47
1955	6 875	12 856	39	40	46	49
1962	6 740	13 162	40	42	44	47
1974	8 225	14 010	48	58	50	48
1990	10,455	13 935	59	74	66	56

Source: Marchand and Thélot, *Deux Siècles de Travail en France* (Paris: INSEE 1991).

mid-1950s. Among younger females, labour-force participation rates have decreased, since they tend to leave school at a later age; at the other end, older women tend to leave the labour market at an earlier age than previously due to a fall in the official retirement age.

Before the First World War, a large share of manufacturing jobs were held by women: 38 per cent in 1911 as against 25 per cent in 1991 (Marchand and Thélot, 1991), but female participation in manufacturing then declined as their participation in the service sector increased. This trend is related to women's increasing educational attainment, and to a large degree of gender segregation in fields of study: most girls attend non-technical, general courses or are geared towards a narrow range of careers such as health-related professions, social, and secretarial work, whereas boys can be found in vocational courses, technical and industrial courses, business, accountancy, and finance. The strong economic growth of the 1950s was made possible by filling unskilled or semi-skilled manufacturing and construction jobs with foreign workers. Unskilled jobs in the textile, electronics, and service industries and middle-range jobs in services requiring a good basic education were held by female workers.

The increase in women's labour-force participation cannot be dissociated from the constant increase in their educational level. In the 1960s, we saw a major rise in educational attainment for both boys and girls, but more young women than young men pass the Baccalauréat, the final secondary school exam taken at age 18. Starting with the 1946–50 cohort, French women became more likely to go to college and get a higher education degree than their male counterparts: more than 30 per cent of women born between 1956 and 1960 hold a qualification equal or superior to the Baccalauréat as against 24 per cent among men of the same cohort (Table 6.2). Female educational attainment is as much a factor in their labour-force participation as their family status or the number of children they bear: within the same cohort, 86 per cent of mothers of two with a higher education degree are in the labour force compared to 57 per cent of mothers of two without higher education.

The fall in female employment between the two World Wars occurred simultaneously with the decline of farming and the vanishing of peasantry. This phenomenon happened throughout the first half of the twentieth century and later in France than in any other industrialized country, for example much later than in Great Britain or Germany. The steady decline in the numbers of self-employed (with independent worker status) is related to this trend. Self-employed farmers and small proprietors in manufacturing industry and commerce still represented about 45 per cent of the female and 38 per cent of the male workforce in 1911. By 1931 these figures were down to 42 per cent and 33 per cent respectively; they fell again to 29 and 24 per cent in 1962; finally dropping to 12 and 15 per cent in 1982.

TABLE 6.2. *Educational attainment of men and women by age cohort*

	1913–20	1921–5	1926–30	1931–5	1936–40	1941–5	1946–50	1951–5	1956–60
Men									
University level	5	6	5	6	10	13	14	13	13
Bacc. (A-level)	6	9	8	8	10	12	10	11	10
BEPC	8	6	12	20	25	29	31	34	35
CAP, vocational level	7	5	4	4	5	6	8	7	11
CEP	40	45	39	30	27	22	22	18	10
No qualifications	35	29	32	33	24	18	16	17	20
Total	100	100	100	100	100	100	100	100	100
Women									
University level	2	3	3	4	6	12	14	16	16
Bacc. (A-level)	5	5	6	7	9	11	12	12	14
BEPC	6	7	10	14	18	23	23	23	26
CAP, vocational level	7	7	7	6	7	8	8	11	13
CEP	39	45	42	37	33	30	26	22	11
No qualifications	41	33	32	32	27	16	17	16	20
Total	100	100	100	100	100	100	100	100	100

Source: Gollac *et al.* 'FQP Survey', *Les Collections de l'INSEE*, D129 (Paris: INSEE, 1988).

Statisticians define the status of the non-salaried worker as 'someone who is mainly helping the family head on the farm or in his craft or commercial activities' (Salais, 1973); such workers are labelled 'family workers' in the LFS. It is a convenient category for classifying women and young men who both live and work in these households. For example, in 1962 three farmers' wives out of four and more than half of all female shopkeepers or small business owners were counted as 'family workers' (INSEE, 1975). There is some degree of overlap between domestic activities and business: cooking and cleaning chores concern both home and work, though they are not counted as 'employment' time.

For a long time women's employment depended on their family status. Until the end of the 1960s, the link between marital status, child-bearing, and the occupation of female salaried workers remained close. Later on, women experienced a drastic change in their relationship to both employment and the family; younger women were the pioneers of this new social arrangement, which came about gradually. The last two censuses show a rapid increase in labour-force participation by women aged 25–54 from 64 per cent in 1982 to 74 per cent in 1990. In 1990 participation rates for those aged 45 are nearly as high as for those aged 30. In this age group the rates for single women are comparable to men's (over 90 per cent), among childless women living with a partner labour-force participation exceeds 80 per cent, while over half of all mothers aged 35–44 with three children are in the labour force. Fewer and fewer women leave the labour market after their children are born. As a result, women's careers are much more stable than they used to be. The growth rate for female labour-force participation reaches a peak for mothers of two children. A drop can only be observed among mothers of three children or more, and these represent a decreasing proportion of all mothers. Currently, two-children families are the most common. Moreover it can be proved that women with three children were already less strongly attached to employment before their children were born.

Using a different source, INSEE's 'Career Survey' supplement to the 1989 LFS, Félicité Hay des Nétumières (1994) stresses that getting married has little impact on female labour-force participation: 77 per cent of the respondents declared that marriage did not change their employment status, with a clear contrast between age groups: 70 per cent of women aged 50 and over compared with 84 per cent of women under 30. The majority of mothers (60 per cent) did not stop working after the birth of their children, but half of the mothers of three children or more were forced or decided to quit the labour market or to work part-time, usually as soon as their first child was born. 'If the birth of the third child does not actually make women decide to stop working', observes Hay des Nétumières, 'it does mark a threshold beyond which the length of time out of work becomes much longer.'

A Family Policy Aimed at Encouraging Women's Employment

Since the Second World War, French public policy has aimed at stimulating fertility without dragging women away from the labour force. Decision-makers interpreted the steady decline in birth rates as a sign of women's attachment to paid work and their distaste for having many children. Consequently, they redefined the conditions for obtaining family benefits and reduced the additional taxes for firms employing part-time workers in order to encourage them to develop this type of employment. This produced a slight increase in part-time employment rates among mothers whose youngest child is aged 3–5.

France has one of the most sophisticated childcare schemes in Europe. For infants, daycare centres and home-based child-minders (*nourrices agrées*, government-licensed workers who take care of other working mothers' children in their own home) enable mothers to work full-time whereas mothers of older children may have trouble finding someone to pick their children up and take care of them after school and on Wednesdays, when there is no school in France. Local factors are important here, as some town councils are more efficient than others in this area. The very high schooling rate among young children (35 per cent for 2-year olds in 1992, and up to 98 per cent for 3-year olds) is another indicator of the importance of a school system which takes care of children at earlier and earlier ages. These community facilities have contributed in two ways to female labour-force involvement: first, the birth of a child is not an insurmountable obstacle to employment; secondly, female employment contributes significantly to the expansion of jobs for women in childcare and healthcare. 'The increase of working mothers stimulates a demand for specialized facilities (daycare centres, school cafeteria . . .), which in turn require the hiring of part-timers' (Tomasini, 1994). More than 60 per cent of the 120,000 daycare jobs created between 1982 and 1992 were part-time.

Moreover, other policies were implemented to encourage child-bearing. 'Family benefits (child allowances, single wage benefits, rises in other existing benefits, and tax exemptions) are all important: if a child is born and the mother decides to quit her job at the same time, family allowances will cover about a third of the woman's previous wages' (Charraud, 1978). Nevertheless, quitting the labour market involves a significant drop in the household's standard of living; this helps to explain why so many French women decide to keep on working.

The Sharp Rise in Female Part-Time Employment in the Last 20 Years

In France, the 'economic emergence of women' appeared first with full-time work. This is worth stressing, since the French pattern of development is very different from other European countries. It was not until the surge of unemployment and the manufacturing crisis of the mid-1970s that part-time work began to increase significantly.

In 1971, for the first time, the LFS included a question on the type of employment: 'Is your job full-time or part-time?', and identified almost one million women working part-time, 962,404 or 13 per cent of all working women. The part-time work rate was 27 per cent among women in farming, 31 per cent among female craftworkers, 63 per cent among cleaners, and 10 per cent among shop assistants. Prior to 1971, government statistics recorded the number of hours worked in order to measure overtime. The actual number of hours worked per week (40 hours has been the official duration since 1936, but most workers would state 45 hours, especially in manufacturing), the usual number of hours worked, and the average work schedule of the plant were all recorded under three different headings. The sharp decrease in worktime after 1968 (from an average of 41 hours a week for women in 1968 to 38 in 1975) and the subsequent change in government regulations account for the introduction of the new question in the 1971 LFS. In 1972, 15 per cent of all working women (and 28 per cent in agriculture) declared they had worked fewer than 30 hours during the preceding week; 48 per cent worked between 30 and 44 hours; 30 per cent (and 39 per cent of women in farming) worked even longer hours. Five years later in 1977, 15 per cent worked fewer than 30 hours and 20 per cent worked 40 hours and more. In 1981 these proportions were 16 and 18 per cent respectively. Subsequently, anyone classifying herself as a part-time worker in the LFS was treated as such, including people working more than 30 hours per week. In 1986, 19 per cent of working women worked fewer than 30 hours a week and another 4 per cent claimed to be part-timers while working more than 30 hours.

Today, according to the March 1993 Employment survey, the 22.2 million workforce comprises 12.6 million men and 9.6 million women. Part-time jobs are held mainly by women: 26 per cent compared to 4 per cent of men. Between 1971 and 1993, part-time work doubled from 13 to 26 per cent of all working women, growing faster than full-time jobs. During the last twenty years, part-time work has accounted almost entirely for the increase in female labour-force participation, while female full-time work has remained stable, with the largest increase occurring during the last ten years (Table 6.3). Along with other forms of so-called 'atypical' employment, it is another symptom of discrimination against women in the labour

TABLE 6.3. *Trends in part-time work since 1971*

	Full-time work		Part-time work		Unemployment	
	000s	index	000s	index	000s	index
1971	6521.0	100	962.0	100	360	100
1977	6793.3	104	1483.7	154	672	187
1981	7073.2	109	1516.0	158	1008	280
1987	7035.5	108	2091.0	217	1398	388
1993	7072.5	109	2538.5	264	1527	424

Source: Calculated by the authors from Bordes and Guillemot (1994: 62–3).

market, restricting them to poorly paid, low-skilled jobs in a restricted number of occupations. Between 1985 and 1992, out of the 694,000 new job openings for women, 414,000, or 30 per cent, were part-time. 'In the last ten years, nearly all the new jobs created (net job creation) for manual workers and employees in commerce and the personal service sector were part-time' (Goux and Maurin, 1993). During this period, female jobs expanded fastest, while male jobs increased by a mere 118,000.

For all women, young or old, skilled or unskilled, married or single, with or without children, part-time work is the fastest growing form of employment. It is found in all the female Socio-Economic Groups (the French PCS), including occupations with the slowest growth rates, such as health-care professionals (+62 per cent) and female employees in the public sector (+54 per cent). Not only has part-time work become more common in the fastest growing occupations but its share of jobs even in occupations with moderate growth or in decline is steadily increasing.

Women, especially younger and less skilled women, are hit harder by unemployment than their male counterparts; nevertheless they remain strongly attached to the labour force. For women aged 24–49, the unemployment rate was 12.3 per cent in the mid-1990s as opposed to 8.4 per cent for men of the same age. Out of the 80 per cent of unemployed women looking for a full-time job, more than half (54 per cent) declared that they would accept a part-time job for lack of anything better. In France, part-time work can be a makeshift solution that women accept temporarily and intend to modify as soon as possible. Most French women regard a full-time job as the norm, leading to the widespread view that part-time work is typically involuntary in France, even among women, in contrast with the situation in Britain, Denmark, and the Netherlands, where part-time jobs are popular among women. In reality, involuntary part-time work, usually termed under-employment in France, accounts for a minority of part-timers; but it has been growing steadily in recent years—from 29 per cent

TABLE 6.4. *Trends in part-time work by socio-economic group*

	1. Farmers		2. Proprietors, artisans		3. Professionals, administrators, and managers (higher grade)		4. Lower grade professionals, technicians, and supervisors		5. Routine non-manual employees		6. Manual workers	
	000s	%	000s	%	000s	%	000s	%	000s	%	000s	%
Men												
1982	60	6	37	3	39	3	43	2	51	3	96	2
1983	57	6	35	3	43	3	56	2	45	3	95	2
1984	57	6	33	3	47	3	57	2	53	4	102	2
1985	60	6	38	3	49	3	65	3	73	5	125	2
1986	44	5	41	4	48	3	70	3	86	6	150	3
1987	58	7	39	3	47	3	68	3	85	5	160	3
1988	49	6	35	3	52	3	69	3	82	5	148	3
1989	46	6	34	3	52	3	70	3	92	6	162	3
1990	46	6	34	3	62	4	67	3	75	5	145	3
1991	48	7	29	3	58	3	67	3	78	6	150	3
1992	48	7	29	3	63	3	74	3	83	6	158	3
1993	44	8	28	3	66	4	92	4	104	7	175	4
Women												
1982	196	33	115	18	82	18	188	11	870	19	223	14
1983	213	35	128	19	83	17	219	13	910	20	226	15
1984	215	34	142	21	82	16	253	14	963	21	209	14
1985	186	31	127	20	95	19	272	15	1018	22	244	15
1986	187	35	132	20	112	19	284	15	1148	23	255	17
1987	164	32	130	21	106	18	305	16	1134	23	256	16
1988	159	32	119	19	122	19	323	17	1211	24	252	17
1989	148	31	108	18	119	18	311	16	1253	24	266	18
1990	129	30	112	18	132	18	306	17	1250	28	291	23
1991	121	29	103	17	139	18	320	17	1269	28	286	23
1992	126	32	111	19	142	17	342	17	1341	30	282	23
1993	101	29	102	19	155	18	381	18	1502	32	298	26

of all part-timers (28 per cent of female part-timers) in 1991 to 37 per cent of part-timers (35 per cent of female part-timers) in 1994. Involuntary part-time work is clearly a much more important problem in France, even if it still applies to a minority of the part-time workforce, both male and female.

Sociologists make a distinction between two kinds of part-time employment (Maruani and Reynaud, 1993). The 'reduced hours schedule' introduced by a 1982 regulation allowing people to work shorter hours, at their request, with a moderate cut in wages, has been most popular among female employees working in the civil service or in large corporations. Working 80 per cent of the full work-load is often a way for working mothers to stay at home on Wednesdays when children do not attend school. The second type is 'part-time jobs' as defined by the employer, which are most common in sales and service occupations. It is mainly young people, of either sex, who have been hired as part-timers in recent years. The spread of part-time employment since the 1980s has been largely an effort to make manpower flexible to thwart persistent unemployment among young people. The 'transition period', with a fixed-term or part-time contract, is used as a period of socialization into paid work, and as a probationary period, enabling employers to make an informed selection of permanent employees.

Legal Issues in Part-Time Employment

French legislation defines a job as 'part-time' when it involves work hours one-fifth shorter than the legal norm (which was set at 39 in 1982). Thus, any job requiring less than 32 hours per week is considered part-time. The legislative framework reflects the absence of consensus on part-time employment. The regulation of part-time work reflects two major concerns:

- the protection of employees' right to switch from full-time to part-time work and vice versa;
- the definition of specific working conditions for part-time workers with respect to public and bank holidays, wages and gratuities, promotion, training, and dismissal benefits.

The French government designed a policy aimed at developing part-time work as a form of new job creation. However, employers, managers, and supervisors are often hostile to part-time work, complaining that it disorganizes production. For instance, the public sector suffers from the 'Wednesday syndrome': part-time female workers concentrate their day off on this day when schools are closed. This has caused problems in parts of the public sector employing large numbers of women.

The legal framework was laid down in the 1980s and consists of the following elements: the law of 28 January 1981, stressing the need to develop part-time work; the government decree of 26 March 1982, stressing the importance of protecting part-timers' rights and protecting them against eventual marginalization within their firm; and the decree of 31 March 1982, providing a framework for part-time employment in the public sector. A further series of legal dispositions were made later, in 1986 (11 August 1986) and 1987 (19 June 1987). The law of 3 January 1991 also deals with part-time work issues; it stresses that part-time work should be developed on a voluntary basis: in principle, full-time employees refusing to work part-time cannot be dismissed. During these years the government attempted to make jobs more flexible and adjustable to individual needs: workers can work from 50 to 90 per cent of a full-time job and strong financial incentives were provided to encourage part-time work as a way of concealing unemployment. As a result, part-time employment expanded in the public sector, from 9 per cent in 1982 to 12 per cent of the workforce by 1989.

However, little attention has been paid to part-time workers in collective bargaining within the manufacturing industry: out of some 108 sector agreements, only 10 per cent deal specifically with part-time issues. Collective bargaining was scarcely more effective at the company level than at the sector level, reflecting the ambivalent attitude of most employers towards part-time work: it may be a convenient way of cutting labour costs without dismissing employees, but it may also disorganize production.

Characteristics of Part-Time Occupations

An important distinction can be drawn between imposed and voluntary part-time employment. The political discourse emphasizes that part-time is a convenient arrangement for women, enabling them to make work compatible with domestic chores and to secure their financial independence. However, part-time is also a way for employers to meet organizational needs; in a large part of the private sector, mainly in unskilled, low-paid occupations, such as marketing and saleswork and in the service sector (shop assistants, cashiers, nurses, daycare workers, waitresses, maids, and housekeepers), part-time work allows employers to secure a flexible labour force (Maruani, 1994). It can be more profitable for employers to hire two part-time employees rather than a single full-time one. For instance, a high level of attention is required of cashiers who are frequently hired on a part-time basis. Shop assistants are expected to be on the job six or seven days a week, even if for a limited number of hours. Health-related occupations, such as nurses in hospitals, require night staff. Part-time employees are

more often required to work at weekends than full-timers and their wages are often lower. For instance, shop assistants can get extra pay in the form of a percentage of sales. Part-time workers are either excluded from this arrangement or get a lump-sum payment. Employers admit that their part-time staff work harder, are more reliable, and more flexible, as most of them are willing to work longer hours.

Most female part-time workers are employees, 32 per cent of the occupied female labour force. Large concentrations of part-time jobs are found in agriculture (30 per cent of all women employed in 1993) and services (29 per cent) and relatively few are in manufacturing industry (11 per cent). As Table 6.5 shows, female part-time workers are concentrated in the least qualified jobs in the tertiary sector; there are far fewer of them in manual production work and among the intermediate and higher professions. Part-time work attracts those with the poorest educational attainment: 44 per cent of all women employed part-time in 1992 had no qualifications at all, as opposed to 31 per cent of all women in employment.

TABLE 6.5. *Occupations with the highest part-time work rates, 1992*

Occupations	000s	% female	% part-time
Residential care	198	99	73
Cleaning personnel	343	75	53
Daycare assistants	342	100	47
Cashiers	137	94	47
Socio-cultural counsellors	137	63	46
Domestic helpers	149	97	44
Artistic entertainers	101	37	39
Salaried health-related occupations	84	66	36
Hostess	50	89	34
Gas station employee	83	67	34
Government clerks	152	79	33
Service personnel, ambulance drivers	655	83	32
Librarians, information scientists	42	81	30
Sales persons	383	86	29
Waiters, chambermaids	283	27	27
Social workers	37	95	26
Concierge	78	69	25
Sports coach, continuing education teacher	118	35	24
Hairdressers	98	89	23
Government non-manual workers	576	78	20
Nurses, midwives	216	90	20
Private sector administrative personnel	334	74	19
Telephone switchboard operators	32	91	19
Secretaries	717	98	19

Part-Time Work Across the Family Life-Cycle

It is argued that part-time employment is an arrangement favourable to working mothers with young children. In France, the average number of children per working mother differs little between full-time and part-time women. It is only among mothers of three or more children, a very small group these days, that the incidence of part-time work increases, as it does among mothers whose last child is aged 3–5. Because the childcare system in France is one of the most highly developed in Europe, mothers can choose to continue working full-time if they want to. In France, part-time jobs serve other purposes.

The recent strong increase in part-time work among young people in the 15–24 age group indicates that part-time work is used increasingly to mask under-employment in France. Some low-skilled occupations, held mainly by young people aged 15–24, are created specifically as permanent part-time jobs, labelled CDI. The large number of jobs involving fewer than 15 hours per week (25 per cent of this category in 1992) among 'housekeeping and restaurant services workers' and 'personal care and related workers' illustrates the new types of involuntary part-time job in France.

In sum, part-time work has only expanded beyond a very low level in France in response to economic recession, especially in the last decade. Part-time employment contributes to 'work-sharing' between men and women, but it forces women into disadvantaged jobs. Access to paid work is relatively recent for women, and for a long time a woman's salary was considered as a supplement to her partner's. This may explain women's willingness to choose these new jobs. What is uncertain is whether they will eventually wish (and be able) to return to full-time work or whether the choice of part-time work will become permanent, willingly or otherwise. Most commentators see part-time work as a reflection of women's attachment to the labour force. However, the substantial and rising level of involuntary part-time work, reaching 38 per cent of all part-timers by 1995, is a worrying development. In France the rise in part-time work is part of the broader trend towards the casualization of employment, with more precarious jobs created since the early 1980s under the label of increasing flexibility. As such, its main feature may be under-employment rather than a new adaptation to the family life-cycle.

Employment Profiles in Female Careers 1990–1992

The INSEE Labour Force Surveys document the growth in female part-time work over the last 20 years. They also show that approximately one out of two women has experienced part-time work at some point in her career, although only one in four working women currently has a part-time

job. The 1989 Career Survey showed that almost all women holding a job (90 per cent) started work in a full-time post. Richer data is supplied by longitudinal studies.

Bouffartigue *et al.* (1992) and de Coninck and Godard (1992) conducted a longitudinal study of the female population working part-time based on the 1986–7 survey of two generations of women in the Côte-d'Azur region entering the labour force. The sharp increase in part-time work from the early 1980s onwards, particularly among younger women, is reflected in their results. In some countries, such as Britain, the switch to part-time work is a consequence of childbirth and associated family constraints, leading women to choose to reduce their work time. This study found that in France, however, the switch to part-time work occurred at the same time as a change of employment and not during a given job, which suggests that labour-market strategies precede family events.

Box 1. *Construction of the panel data for 1990–1992*

Households in three stratified samples of geographical areas (the 'thirds') were interviewed during the month of March for three successive years 1990, 1991, and 1992. From this panel of households we extracted a panel of individuals, using the following procedures.

1. All women aged 16–59 interviewed for the second time in the 1991 Labour Force Survey were selected—that is, 17,419 women.
2. Then in the 1992 Survey, all women belonging to households interviewed a third time were included—that is, 23,978 observations.
3. The two files were matched by a series of identifiers, in order to identify the same women and not different women within the same dwellings; the identifiers were:
 • identification number of the household
 • year and month of birth
 • no move between 1991 and 1992

This provided us with a panel sample of 11,562 women observed in two successive years.

4. Using the 1991 LFS we retrieved retrospective information for 1990 for this panel of women. We thus obtained a single file containing identical information for the same individuals at three consecutive dates.

Finally, we constructed a typology of employment profiles at t1, t2, and t3, based on employment status at each date. Excluding younger women still at school and older women who had retired, we distinguished between four statuses: full-time work; part-time work; unemployment; and being out of the labour force for a panel of N = 10,850 women. The combination of three dates and four statuses gives 64 possible patterns, which were subsequently grouped into a smaller number of dominant employment profiles as shown in Table 6.6.

To date, there has been no national French panel study of employment-related issues. The only relevant data-set is the Career Survey, a supplement to the 1989 LFS which provides limited retrospective information for five points in time (March of 1960, 1967, 1974, 1981, and 1989). Unfortunately, questions on part-time employment were only asked for the first and last job in this survey. Hence we decided to create a panel data-set from three successive years of the LFS, 1990–2, as described in Box 1. This research design provided good information on the employment profiles of women over a three-year period, identifying movement between full-time and part-time employment, into and out of the labour force. Within a representative national sample of 10,850 women of working age, working full-time is the most frequent status (49 per cent) followed by keeping house (27 per cent); part-time work is only the third most common status (14 per cent).

TABLE 6.6. *Distribution of employment profiles over the three years 1990, 1991, and 1992*

Employment status	Stable in all 3 years		Main status (2 out of 3 years)		Total	
	N	%	N	%	N	%
Working full-time	4463	83	906	17	5369	100
Working part-time	886	58	639	42	1525	100
Unemployed	251	35	466	65	717	100
Not in labour force	2404	82	545	18	2949	100
Unstable profile					290	100
Total	8004	74	2556	24	10850	100

We classified as 'stable' those women who retained the same status for three successive years. Working full-time and being out of the labour force have the greatest stability: over 80 per cent of women remain in the same position three years in a row (Table 6.6). We classified women as 'mainly' in a status when they were in the same position at two points in time. Table 6.7 presents an analysis of this group of 2,556 women who were mainly (but not exclusively) full-time, part-time, unemployed, or out of the labour force, showing the third status, which could have occurred in any of the three years 1990, 1991, or 1992. Table 6.7 provides some indication of links between employment statuses, although it does not indicate the direction (or timing) of movements. The link between full-time and part-time work appears to be the strongest, and the link between unemployment and full-time work is stronger than the link between unemployment and part-time work. Within our sample, among the women who were looking for work in 1992, 13 per cent said that they only wanted a part-time job, and 10 per

TABLE 6.7. *Analysis of third employment status for the group with one main status*

Main status (2 out of 3 years)	Number	Percentage	Origins or destinations
Full-time work (N=906)	444	49	Part-time work
	289	32	Unemployment
	173	19	Out of labour force
Part-time work (N=639)	368	58	Full-time work
	109	17	Unemployment
	162	25	Out of labour force
Unemployment (N=466)	198	43	Full-time work
	118	25	Part-time work
	150	32	Out of labour force
Out of the labour force (N=545)	143	26	Full-time work
	184	34	Part-time work
	218	40	Unemployment

cent said they preferred part-time work. Among the women in employment but looking for another job, 20 per cent wished to work longer hours. Thus among active job-seekers, part-time work is not a major preference in France as it is in some other European countries.

We identified five main employment profiles within our sample in terms of the employment status that occurred twice in the three years covered by the data-set:

• women who were mainly (or exclusively) working full-time;
• women who were mainly (or exclusively) working part-time;
• women who were mainly (or exclusively) unemployed;
• women who were mainly (or exclusively) out of the labour force;
• women with 'unstable' profiles, with a different status in each of the three years.

More detail is given in Tables 6.8 to 6.10. Our first aim was to test whether women working mainly part-time were different from those working mainly full-time on the one hand, and from those who were mainly out of the labour force on the other. This was achieved by constructing binomial logit models. Three different models were elaborated: Model 1 analyses women mainly working part-time versus women mainly working full-time (Table 6.11); Model 2 analyses women working part-time versus women out of the labour force (Table 6.12); Model 3 focuses on mobility patterns to explain movement between part-time and full-time work on the one hand versus movement between part-time work and inactivity, regardless of the direction of this movement (Table 6.13). This latter typology allows

us to compare women with a strong labour-force attachment to women with a weak labour-force attachment.

The variables included in the analysis are listed in Box 2. Within the sample, the main contrast is between women who are in the labour force and those who are full-time housewives. Women out of the labour force are older, have a lower level of educational attainment, are most commonly married or cohabiting, and have more children. Women in the labour force are on average younger, more often single, with a higher level of educational attainment, and fewer or no children (Tables 6.8 to 6.10). However, there are also differences between women working full-time or part-time in terms of marital status, and the number and ages of children present in the household. Full-time workers are more likely to be single (22 per cent), without (or no longer with) a dependent child under 18 (50 per cent), or to have only one child older than 6 (30 per cent). Women employed part-time are less frequently single (11 per cent), they typically have at least one dependent child under 18 (60 per cent), and 34 per cent have more than two children.

Women's educational attainment is a strong indictor of their employment profile: human capital theory fits amazingly well with our results. Women with few or no educational qualifications are much more likely to be keeping house; university graduates are more likely to be in the labour force. For the former, resorting occasionally to part-time work is a necessity, for the latter it is a luxury.

At first glance, women working part-time do not appear very different from the mean population: their age distribution is average. So is their educational attainment. Women working predominantly full-time are more distinctive: they are younger, better trained, and live more frequently on their own than the rest of the population; women who have earned a qualification higher than the Baccalauréat are 1.5 times more likely to work full-time than part-time. Women with no qualifications at all are 1.6 times more likely to work part-time than full-time.

Paradoxically, all other things being equal, women who hold a college degree or no qualifications at all are somewhat more likely to work part-time rather than full-time compared to women who hold a vocational degree (Table 6.11—Model 1). This apparent contradiction is resolved when we compare the likelihood of working part-time to that of being out of the labour force: holding a university degree strongly increases (+29) the likelihood of working part-time rather than keeping house (Table 6.12—Model 2). Limited educational attainment increases the likelihood of being out of the labour force as opposed to working part-time (+13).

Thus, the ambivalent meaning of part-time work is clearly revealed in the contrasts between the subgroup of women who switch between full-time and part-time work and the subgroup of women who switch between

Box 2. *Coding of variables used in regression analyses*

Age groups in 1991:
 16–29 years in 1991
 30–9
 40–9
 50–9.
Educational attainment:
 Postgraduate university degree, including 'grandes écoles' degree
 Undergraduate university degree (Baccalauréat plus two years)
 Baccalauréat (high-school graduate, A-level)
 CAP-BEP (vocational secondary school certificate)
 BEPC, completion of junior high school (O-level)
 CEP, primary school certificate, or no qualifications.
Number of children under 18 present in the household:
 none
 1
 2
 3 or more.
Woman's occupation:
 10: Agriculteurs exploitants: self-employed farmers;
 20: Artisans, commerçants et chefs d'entreprise: non-farm small proprietors, own-account craftsmen, corporate owners with more than ten employees;
 30: Cadres et professions intellectuelles supérieures: corporate managers, professionals, including self-employed professionals;
 43: Professions intermédiaires de la santé et du travail social: associate professional and technical occupations in health and social work;
 45: Professions intermédiaires administratives de la fonction publique: associate professional and technical occupations in the public sector;
 46: Professions intermédiaires administratives et commerciales des entreprises: associate professional and technical occupations in the private sector;
 40: Other white-collar occupations;
 52: Employés civils et agents de service de la fonction publique: administrative and clerical employees in the public sector;
 54: Employés administratifs d'entreprise: administrative and clerical employees in the private sector;
 55: Employés de commerce: salesworkers;
 56: Personnels des services directs aux particuliers: personal service occupations;
 60: Ouvriers: salaried skilled and unskilled manual workers in manufacturing industry and agriculture.
Spouse's occupation: as above for women's occupations.
Father's occupation: as above for women's occupations.
Marital status:
 living as a couple
 all others
Citizenship:
 French by birth
 acquired French citizenship
 foreigner.

TABLE 6.8. *Female employment profiles by educational attainment, 1990–1992*

	Main status					Total	
	Full-time	Part-time	Unemployed	Out of labour force	Unstable profile	%	N
University higher grades	8	6	2	2	1	6	607
University lower grades	13	7	2	4	6	9	928
Bac. (A-level)	13	11	7	6	12	11	1150
CAP-BEP, vocational certif.	26	24	27	17	36	23	2551
BEPC	9	10	7	7	9	8	921
CEP, or no diploma	31	42	55	64	36	43	4668
All women 16–59 years	100	100	100	100	100	100	
Base N	5369	1525	717	2949	290		10850

TABLE 6.9. *Female employment profiles by occupation, 1990–1992*

	Main status					Total	
	Full-time	Part-time	Unemployed	Out of labour force	Unstable profile	%	N
Self-employed farmers	4	5	1	*	6	3	314
Corporate owners, artisans	7	4	1	*	4	5	509
Corporate managers, professionals	10	6	1	1	2	6	657
Semi-professional							
other	7	2	2	*	2	4	437
health	5	5	2	*	3	4	404
public sector	2	2	*	0	*	2	176
private sector	6	3	5	*	4	4	465
Non-manual employees							
public	14	17	6	1	7	10	1107
private	19	15	21	2	19	14	1486
Salesworkers	5	8	11	1	10	5	497
Service personnel	6	18	14	2	9	7	768
Manual workers	13	13	28	3	18	11	1239
Out of labour force	1	2	8	90	16	25	2791
All women 16–59 years	100	100	100	100	100	100	
Base N	5369	1525	717	2949	290		10850

TABLE 6.10. *Employment profiles among women aged 16–59 by number of children, 1990–1992*

Number of children	Main status					Total	
	Full-time	Part-time	Unemployed	Out of labour force	Unstable profile	%	N
None	50	40	44	42	32	46	4940
1	27	24	26	18	30	24	2608
2	19	28	21	19	23	20	2188
3 or more	4	8	9	22	15	10	1114
All women 16–59	100	100	100	100	100	100	
Base N	5369	1525	717	2949	290		10850

Note: Children are defined as dependent children under 18 years and living in the same household.

TABLE 6.11. *Logistic regression Model 1: female part-time as opposed to full-time employment*

Independent variables	Coefficient	Statistical test	Likelihood	Marginal effect (%)
Reference category	-1.11		24.83	
Educational attainment				
Graduate university degree	0.40	p <.03	33.09	8.26
Undergraduate university degree	-0.11	ns		
High-school graduate/Baccalauréat	0.24	p <.03	29.67	4.84
Vocational certificate	reference category			
O-level	0.28	p <0.01	30.45	5.62
Primary school certificate	0.29	p <0.0009	30.61	5.77
Occupation				
Self-employed farmer	-0.25	ns		
Proprietor, artisan, corporate owner	-0.70	p <0.0001	14.12	-10.71
Manager, professional, self-employed	-0.59	p <0.0009	15.51	-9.33
Semi-professional worker	-0.83	p <0.0001	12.59	-12.24
Semi-professional in health and social work	0.13	ns		
Semi-professional, public sector	-0.03	ns		
Semi-professional, private sector	-0.51	p <0.004	16.54	-8.29
Employee in public sector	0.40	p <0.0004	32.93	8.10
Corporate employee	reference category			
Sales worker	0.80	p <0.0001	42.33	17.50
Service personnel	1.36	p <0.0001	56.25	31.41
Blue-collar worker	0.12	ns		
Age in 1991				
16–29				
30–9	-0.10	ns		
40–9	-0.26	p <0.001	20.24	-4.60
50–9	reference category			
	0.48	p <0.0001	34.91	10.08

Number of children under 18 in household				
1	−0.56	p <0.0001	15.86	−8.97
2	reference category			
3 or more	0.10	ns		
None	−0.93	p <0.0001	11.53	−13.30
Spouse's occupation				
Self-employed farmer	0.51	p <0.008	35.50	10.67
Proprietor, artisan	0.25	p <0.05	29.85	5.02
Manager, professional, self-employed	0.52	p <0.0001	35.71	10.88
Semi-professional	0.04	ns		
Corporate employee	−0.18	ns		
Blue-collar worker	reference category			
Retired or not stated	0.10	ns		
Not married	0.21	ns		
Father's occupation				
Self-employed farmer	0.21	p <0.02	29.03	4.20
Proprietor, artisan	0.22	p <0.03	29.07	4.23
Manager, professional, self-employed	0.05	ns		
Semi-professional	−0.08	ns		
Corporate employee	0.06	ns		
Blue-collar worker	reference category			
Retired or not stated	−0.03	ns		
Marital status				
Married or cohabiting	reference category			
Single	−0.81	ns		

Sample size: 6799 total; 1495 part-time; 5304 full-time.

Note: All other things being equal, women with a university degree are more likely to work part-time than women with a vocational certificate because the parameter is positive (0.4035). The marginal effect, 8.26 points (Vallet et Caille, 1995) is the difference between the likelihood of this situation (women with a university degree) and the reference category (women with a vocational degree, corporate employed, between 40 and 49 years old, with two children, whose husband is a blue-collar worker and whose father is also a blue-collar worker).

being out of the labour force and part-time work (regardless of the direction of the movement). The marginal effect of having a university degree on shifting from part-time to full-time work is +20. The opposite marginal effect of having no qualifications on moving from part-time work to quitting the labour market is +22. Labour-force attachment is closely linked to educational resources. Educational resources are thus the first crossroads in strategies for private lives and for employment careers.

Results by a woman's own occupational status are in line with the features of part-time work noted earlier, with a higher likelihood of part-time work among public-sector employees and in saleswork, and a very low likelihood among managers and other senior occupations. Self-employed women are less likely to work part-time. Women of foreign origin are more likely to be out of the labour force than to work part-time.

Part-Time Work over the Life-Course

Not surprisingly, women who are out of the labour force in two out of three years are most likely to be married or cohabiting: 92 per cent of women out of the labour force are part of a couple, as opposed to 89 per cent of women working part-time and 78 per cent of women working full-time. Women working part-time are more likely to have at least one child (younger than 18) living in the household: 40 per cent of part-timers have no children living with them compared to 50 per cent among full-timers. Considering only women with children present in the household, the likelihood of a mother of one working full-time rather than part-time is 1.7. Conversely, among mothers of two or three children, the likelihood of working part-time rather than full-time is approximately 1.5. If there is a correlation (not necessarily a causal link) to be found between the number of children living in the household and the part-time employment status of mothers, the age of the youngest child does not affect the propensity to work full-time rather than part-time. The age of the youngest child does have an impact among women who decide to be full-time homemakers for a few years. Having one child under 6, or under 3, increases the likelihood of being out of the labour force rather than working part-time (Table 6.12—Model 2: +12 and +23). The LFS does not record the total number of children raised by women during their lifetime. Other sources, such as the INSEE Career Survey, may shed some light on the effect of total fertility on female employment patterns.

As regards social class of origin, there are no sharp differences between women working part-time and others. They are more likely to come from a rural or self-employed background, and a fair proportion are married to middle-ranking professionals. Women out of the labour force are more likely to be living with a blue-collar worker. Women living with a self-

TABLE 6.12. *Logistic regression Model 2: female part-time employment as opposed to inactivity*

Model variables	Coefficient	Statistical test	Likelihood	Marginal effect (%)
Reference category	−0.38		40.67	
Educational attainment				
Graduate university degree	1.22	p <0.0001	69.83	29.15
Undergraduate university degree	0.62	p <0.0002	51.35	10.68
High-school graduate/Baccalauréat	0.43	p <0.001		
Vocational certificate	reference			
O-Level	0.11	ns	43.44	2.77
Primary school certificate or no qualif.	−0.60	p <0.0001	27.30	−13.38
Age in 1991				
16–29	0.68	p <0.0001	57.40	16.73
30–9	0.30	p <0.001	48.02	7.35
40–9	reference			
50–9	−0.33	p <0.001	33.03	−7.64
Age of youngest child in the household				
6–7 years	reference			
3–5 years	−0.53	p <0.0001	28.78	−11.89
less than 3 years	−1.16	p <0.0001	17.65	−23.02
None	0.13	ns	43.85	3.18
Spouse's occupation				
Self-employed farmer	0.62	p <0.004	55.99	15.32
Proprietor, artisan	0.12	ns		
Manager, professional	−0.41	p <0.001	31.19	−9.48
Semi-professional worker	0.06	ns		
Corporate employee	0.07	ns		
Blue-collar worker	reference			
Retired or not stated	−0.64	0.0001	26.60	−14.07
Not married	1.06	0.07	66.34	25.67

cont./

TABLE 6.12. *cont.*

Model variables	Coefficient	Statistical test	Likelihood	Marginal effect (%)
Father's occupation				
Self-employed farmer	0.44	p <0.0001	51.65	10.98
Proprietor, artisan	0.17	p <0.0001	44.80	4.13
Manager, professional	-0.39	ns		
Semi-professional worker	0.08	p <0.01	42.70	2.03
Corporate employee	0.17	ns		
Blue-collar worker	reference			
Retired or not stated	-0.20	ns	36.04	-4.63
Nationality				
French by birth	reference			
Foreigner	-0.89	p <0.0001	22.00	-18.67

Sample size: 4474 total; 1525 part-time workers; 2949 full-time workers.

Note: All other things being equal, women with a university degree are more likely to work part-time than women with a vocational certificate, because the parameter is positive (1.2166). The marginal effect (29.15 points) is the difference between the likelihood of this situation and the reference category.

employed partner or a farmer are unlikely to work full-time and are often out of the labour force (Tables 6.11 and 6.12—Models 1 and 2). Many of them are family workers.

A weaker labour-force attachment is found among women married to or living with corporate managers or professionals: other things being equal, they are more likely to work part-time than full-time (+11 as shown in Table 6.11—Model 1) and more likely to be out of the labour force than working part-time (+9.5 as shown in Table 6.12—Model 2). When they are mobile, they are less likely to switch between full-time and part-time work (–18 as shown in Table 6.13—Model 3). Working part-time or not at all is an option for these women, who can afford it because of their spouse's occupational status and earnings.

Women whose spouse is a blue-collar worker are more likely to be out of the labour force than working part-time (an odds ratio of 1.19) and more likely to work part-time than full-time (an odds ratio of 1.29) if they work at all. One-third of this group is unemployed. Mobile women with a blue-collar social background are more likely to have a weak labour-force attachment than a strong one (the odds ratio is 1.69). The same trend is noticeable, to a lesser degree, among mobile women whose partners are managers or professionals (an odds ratio of 1.28), although the meaning of part-time work is very different in each case.

Conclusions

Salaried employment by women is a recent but fragile conquest. Women are more dependent than men on family events and their occupational paths are rarely steady. They move about between different types of employment or unemployment depending on their family duties at a given time; most of them switch back to full-time when their children are older. These findings shed a new light on the debate over 'work-sharing'. Part-time work has grown considerably during the employment crisis, at the very time when women's involvement in paid work was being radically upset. The crisis hit this movement head-on. The increase in part-time jobs due to employers' initiatives is one of the devices used to increase employment flexibility and is well suited to a population with a weak labour-force attachment. The increase in part-time work can be understood by taking both these factors into account: women's dependence on the supply of jobs (labour demand) and their difficult fight to free themselves from their traditional role as a homekeeper.

TABLE 6.13. *Logistic Regression Model 3: changes between full-time and part-time work as opposed to changes between part-time work and inactivity*

Model variables	Coefficient	Statistical test	Likelihood	Marginal effect (%)
Reference category	0.82	69.49		
Educational attainment				
Graduate university degree	1.36	p <.01	89.89	20.40
Undergraduate university degree	0.39	ns		
High-school graduate/Baccalauréat	0.31	ns		
Vocational certificate	reference category			
O-level	0.43	ns		
Primary school certificate, no qualif.	−0.93	p <0.0005	47.23	−22.26
Age in 1991				
16–29	−0.10	ns		
30–9	0.09	ns		
40–9	reference category			
50–9	−0.43	ns		
Number of children under 18 in household				
1	0.50	p <0.09	78.92	9.43
2	reference category			
3 or more	−1.12	p <0.0006	42.75	−26.74
None	0.93	p <0.0038	85.20	15.71
Spouse's occupation				
Self-employed farmer	0.40	ns		
Proprietor, artisan	0.52	ns		
Manager, professional	−0.76	0.04	51.47	−18.01

	Coefficient	Significance	χ²
Semi-professional	0.02	ns	
Corporate employee	-0.17	ns	27.29
Blue-collar worker	reference category		
Retired or not stated	-0.02	ns	
Single	2.58	0.02	96.78
Father's occupation			
Self-employed farmer	-0.15	ns	
Proprietor, artisan	-0.15	ns	
Manager, professional	-0.50	ns	
Semi-professional	0.39	ns	
Corporate employee	0.04	ns	
Blue-collar worker	reference category		
Retired or not stated	0.05	ns	
Citizenship			
French by birth	reference category		
Foreigner	-0.37	ns	
Marital status			
Married or cohabiting	reference category		
Other	-0.98	ns	

Sample size: 628 total: 444 working part-time/full-time and 184 working part-time and/or inactive.

Note: All other things being equal, women with three children are less likely to work part-time than women with two because the parameter is negative (−1.1150). The marginal effect (−26.74 points) is the difference between the likelihood of this situation (a woman with three children) and the reference category (a woman with a vocational degree, aged 40 to 49 years, whose husband is a blue-collar worker and whose father was also a blue-collar worker).

REFERENCES

Barrère-Maurisson, A. M. (1984), 'Le cycle de vie familiale' ('The Family Life Cycle'), in *Le Sexe du Travail* (Grenoble: Presses Universitaires de Grenoble), pp. 23–49.

Belloc, B. (1986), 'De plus en plus de salariés à temps partiel' ('Increasing Numbers of Part-Time Employees'), *Economie et Statistique*, 193–4: 43–50.

Bordes, M. and Guillemot, D. (1994), *Marché du Travail, Séries Longues* ('The Labour Market: Long Series'), Resultats, 62–3 (Paris: INSEE).

Bouffartigue, P., de Coninck, F., and Pendariès, J. R. (1992), 'Le nouvel âge de l'emploi à temps partiel' ('The New Age of Part-Tme Work'), *Sociologie du Travail*, 4: 403–28.

Bouillaguet, P. and Germe, J. F. (1981), 'Salarisation et travail féminin en France' ('Female Employment in France'), *Critique de l'Economie Politique*, 17: 83–117.

—— et al. (1986), 'Le partage du travail, une politique asexuée?' ('Worksharing: A Unisex Policy?'), *Nouvelles Questions Féministes*, 14–15: 31–51.

Charraud, A, (1978), 'Activité féminine et famille: aspects socio-économiques' ('Female Employment and the Family: Socio-Economic Patterns'), *Données Sociales*, Resultats, 62–3 (Paris: INSEE), 331–56.

Chenu, A. (1990), *L'Archipel des Employés* ('The Archipelago of Employees'), (Paris: INSEE).

Collectif L'Emploi des Femmes (1993), 'Actes de la Journée du 4 mars 1993' ('Proceedings of the 4 March 1993 Meeting'), Paris: La Documentation Française.

de Coninck, F. and Godard, F. (1992), 'Itinéraires familiaux, itinéraires professionnels: vers de nouvelles biographies féminines' ('Family Careers and Professional Careers: Towards New Female Biographies'), *Sociologie du Travail*, 1: 65–80.

Coutrot, L. and Dubar, C. (ed.) (1992), *Cheminements professionnels et mobilités sociales* ('Work Histories and Social Mobility') (Paris: La Documentation Française, CEREQ-IRESCO).

Goux, D. and Maurin, E. (1993), 'Dynamique des professions et adaptation du système productif' ('Occupational Change and Developments in the Productive System'), *Economie et Statistiques*, 261: 55–65.

Hay des Nétumières, F. (1994), *L'Arrêt de Travail des Femmes: Mariage et Maternité* ('Women Who Give Up Work: Marriage and Motherhood'), Mémoire de DEA de Sciences Sociales (Paris, Université René Descartes).

INSEE (1975), *Données Statistiques sur les Familles*, Collections de l'INSEE, ser. M, no. 48 (Paris: INSEE).

—— (1991), *Les Femmes* ('Women'), (Paris: 'Contours et Caractères' Collection).

Kempeneers, M. and Lelièvre, E. (1991), 'Analyse biographique du travail féminin' ('Life-Cycle Patterns in Female Employment'), *European Journal of Population*, 7: 377–400.

Kergoat, D. (1984), *Les Femmes et le Travail à Temps Partiel* ('Women and Part-Time Employment') (Paris : Documentation Française).

Léry, A. and Deville, J. C. (1978), 'Activité féminine et famille, aspects démo-

graphiques' ('Female Employment and the Family: Demographic Profiles'), *Données Sociales* (Paris : INSEE), pp. 331–56.

Marchand, O. and Thélot, C. (1991), *Deux Siècles de Travail en France* ('Two Centuries of Employment in France'), (Paris: INSEE).

Marimbert, J. (1992), *Situation et Perspective du Travail à Temps Partiel* ('The Current Situation and Outlook for Part-Time Employment'), Rapport au Ministre du Travail, de l'Emploi et de la Formation Professionnelle (Paris: Journaux Officiels).

Marry, C., Fournier-Mearelli, I., and Kieffer, A. (1995), 'Activité des jeunes femmes: héritages et transmissions ('Young Women's Employment: Change and Renewal'), *Economie et Statistique*, 283–4: 67–79.

Maruani, M. (1994), 'Féminisation et discrimination: évolutions de l'activité féminine en France' ('Feminization of the Workforce and Sex Discrimination: New Developments in Female Employment in France'), *L'Orientation Scolaire et Professionnelle*, 3: 243–56.

—— (ed.) (1994), 'Temps, emploi, revenus: anciens clivages, nouveaux partages' ('Time, Jobs, Earnings: Old Cleavages and New Distributions'), Colloque Familles et Recherches Institut de documentation et détudes feminines.

—— and Nicole, C. (1989), *La Flexibilité à Temps Partiel—Conditions d'Emploi dans le Commerce* ('Part-Time Flexibility—Employment Conditions in the Retail Industry'), (Paris: Documentation Française).

—— and Nicole-Drancourt, C. (1989), *Au Labeur des Dames: Métiers Masculins Emplois Féminins* ('Women's Work: Male Crafts and Female Jobs') (Paris: Syros Alternatives).

Maurin, E. and Torelli, C. (1992), 'La montée du temps partiel' ('The Rise of Part-Time Work'), *Institut national de la statisque et des étdes économiques-Première*, 237.

Michal, G. F. (1973), 'Les femmes jeunes travaillent de plus en plus fréquemment' ('Young Women are Working More Often'), *Economie et Statistique*, 51: 33–8.

Salais, R. (1973), 'L'évolution de l'emploi dans les pays du Marché Commun de 1958 à 1970' ('Employment Trends in Common Market Countries, 1958–1970'), *Economie et Statistique*, 51: 3–16.

Thélot, C. (1986), 'Le sous-emploi a doublé en quatre ans' ('Under-employment has Doubled in Four Years'), *Economie et Statistiques*, 64: 192–3.

Tollet, J. Y. and Gavini, C. (1994), 'La durée du travail: construction et déconstruction d'une norme' ('Working Time: Construction and Deconstruction of Norms'), *Droit Social*, 4: 365–70.

Tomasini, M. (1994), 'Hommes et femmes sur le marché du travail: 1973–1993' ('Men and Women in the Labour Market, 1973–1993'), *Institut national de la statisque et des étdes économiques-Première*, 324.

Villeneuve-Gokalp, C. (1985), 'Incidences des charges familiales sur l'organisation du travail professionnel des femmes' ('The Impact of *Charges Familiales* Taxes on the Utilization of Female Employment'), *Population*, Mar.-Apr.

Part-Time Work in West Germany

HANS-PETER BLOSSFELD AND GÖTZ ROHWER

Introduction

In this chapter, we study the long-term development of women's employment and its relationship to the family cycle in Germany. We describe the changes from 1925 until the end of the Second World War for Germany as a whole and then concentrate on changes in West Germany specifically. Changes in women's employment in East Germany after the Second World War are not analysed here because they follow broadly the same patterns and processes that are discussed more generally for socialist countries in Central and Eastern Europe by Drobnič in Chapter 3. As in all these regimes, the policies of the government in the German Democratic Republic (GDR) were aimed at abolishing class and gender inequalities (Nickel, 1992). They supported the dual full-time earner family with full-time re-employment of women after childbirth. Part-time work was done by specific groups, such as disabled persons and pensioners (Schupp, 1991) and was not a phenomenon specifically related to motherhood. The employment patterns of women and men over the life-course were therefore very similar (Huinink, Mayer, and Trappe, 1995: 109). Immediately after German unification in 1989, the part-time employment rate in East Germany at first dropped, because huge numbers of older workers took early retirement and received what were (compared to former GDR standards) very generous pensions that were based on the West German pension system. The rate of part-time work is now rising again in East Germany and, as in West Germany, it is now mainly done by women. However, there is a significant difference between female part-timers in West and East Germany. Whereas West German women typically work part-time on a voluntary basis (and a large proportion of women full-time workers with children would also prefer part-time work), East German women almost invariably work part-time involuntarily. This shows that 40 years of socialist gender policies have changed the attitudes of women towards work dramatically (Deutsches Institut für Wirtschaftsforschung, 1995).

In the remainder of this chapter we focus on West Germany. Using Census and Microcensus data from 1925 to 1990, we first trace the origins of current structures of West German women's part-time work and separate long-term structural shifts from short-term periodic fluctuations. Using event-history data on German women born between 1918 to 1968 from the West German Socioeconomic Panel Study, we then link women's part-time and full-time work to the different phases of the family cycle.

Long-Term Trends in West German Women's Economic Activity Rate

Female activity rates have risen slowly, from a relatively high 49 per cent among women aged 16–60 in 1925.[1] This rate remained stable up to the late 1970s, and was only briefly interrupted by the unusually high unemployment rate immediately after the end of the Second World War (cf. also Müller, Willms, and Handl, 1983; Willms, 1985).[2] Thus, just as in many of the other Northern European countries (see the respective country reports in this book), the notion of a 'rise' in women's overall economic activity rates could only apply to the last decade or so. Beginning with the late 1970s, it rose slowly from 50 per cent to 60 per cent in the 1990s (Table 7.1a).

However, changes in the overall economic activity rate of women aged 16–60 summarizes several structural developments that run in opposite directions and nearly cancel each other out. Women's extending school enrolment shifts women's labour-market entry towards higher ages and reduces the economic activity rates of younger women, whereas the economic activity rate of married women has risen dramatically (Table 7.1a, column 2).[3] From the 1950s until the mid-1970s, it was mainly the economic activity rates of married women that increased (Müller, Willms, Handl, 1983; Willms, 1985), especially married women aged 30–9 and 40–9 (Table 7.1a, columns 5 and 6). Thus, in West Germany, married female workers partly substituted for unmarried female workers in this period.

However, the economic activity rates of married women understate the degree to which these categories of women were working in the market economy, as there was an important decrease in the proportion of 'unpaid family workers' within the overall economic activity rate. In 1950, 15 per cent of married women were 'unpaid family workers' compared with

[1] The economic activity rate was 95% among men in 1925.

[2] This was also true for men until the mid-1960s. Beginning with the late 1960s, men's economic activity rate started to decrease mainly because of educational expansion and early retirement.

[3] Again, this trend was interrupted by the specific conditions of the immediate postwar period.

TABLE 7.1a. *Long-term trends in women's employment in West Germany 1925–1990 (%)*

	Activity rate of women aged 16–60		Proportion of family workers among married women	Activity rate of married women at ages	
	All women	Married women		30–9	40–9
1925	49	29	20	28	31
1933	48	30	20	29	32
1939	50	34	21	36	37
1950	45	26	15	26	27
1960	49	37	13	37	37
1970	50	41	8	40	42
1980	53	48	5	41	49
1990	60	54	2	58	61

Source: Müller, Willms, and Handl (1983: 35 and 53); Brinkmann and Kohler (1989: 474).

around 8 per cent by 1970. This means that the extent to which married women contributed to the economy outside their homes increased significantly from the 1950s to the mid-1970s in West Germany (cf. Müller, Willms, and Handl 1983; Willms, 1985).

Long-Term Trends in West German Women's Part-Time Employment

In this chapter, we rely on two concepts of part-time work. First, in Table 7.1b, part-time employment is defined as any employment arrangement involving normal weekly working hours between 1 and 36 hours. As noted in Chapter 2, this definition is a very broad measure of part-time work.[4] The second measure of part-time work is based on employees' self-classification. In the German Socioeconomic Panel Study, respondents are asked to classify themselves as working part-time if their employment arrangement implies normal weekly working hours below the collectively bargained weekly working time standard in their industry or at their workplace or if, because of highly irregular schedules, no normal weekly working time could be declared. Self-classification as a part-timer is the definition applied throughout this chapter with the exception of Table 7.1.

Brinkmann and Kohler (1989) compared the two measures of part-time work in West Germany in 1988. They found that by the first measure 3.334

[4] In West Germany, collectively bargained weekly working hours declined gradually as follows: 48 hours (until 1956), 45 hours (from October 1956), 44 hours (1959), 42.5 hours (1962), 41.25 hours (1964), 40 hours (1967), 38.5 hours (1985), 37.5 hours (1988), and 37 hours (1989).

TABLE 7.1*b*. *Trends in women's part-time vs. full-time employment in West Germany, 1950–1990 (%)*

	Part-time workers as % of employees			% female among full-time workers
	Male	Female	Total	
1950	1	6	3[a]	—
1960	2	9	4	32
1961	2	10	4	32
1962	2	12	5	31
1963	2	13	5	31
1964	2	15	6	31
1965	2	16	7	30
1966	1	18	7	30
1967	1	19	7	30
1968	1	19	8	30
1969	1	22	8	29
1970	2	24	9	28
1971	2	26	10	28
1972	2	28	11	28
1973	2	29	11	28
1974	2	28	11	30
1975	2	29	12	29
1976	2	29	12	29
1977	2	31	12	29
1978	2	30	12	29
1979	2	30	12	29
1980	1	29	12	30
1981	1	30	12	30
1982	1	30	12	30
1983	2	33	14	29
1984	2	31	13	30
1985	2	31	13	30
1986	2	31	13	31 '
1987	2	31	13	31
1988	2	32	14	31
1990	2	33	14[b]	33

Notes:
[a] Estimated, based on self-assessment of employees; information provided by Hans Kohler (IAB, Nuremberg).
[b] Based on self-assessment of employees; information provided by Hans Kohler (IAB, Nuremberg).

Source: Müller, Willms, and Handl (1983: 35 and 53); Brinkmann and Kohler (1989: 474).

million employees worked part-time, while there were only 3.106 million part-timers by the second measure. The difference of about 200,000 employees is due to the increasingly fuzzy distinction between part-time and full-time work on the boundary line in the first measure.[5]

For West Germany, part-time employment estimates are only available for the year 1950 and from 1960 onwards (Table 7.1*b*). The extent to which women have worked part-time has increased considerably since 1950 and can be divided into two periods. There was a first phase of steep growth between the 1950s and the mid-1970s followed by a second phase of stability with some small fluctuations that started in the late 1970s. It is interesting to note that during the first phase of expansion in women's part-time work rates, the proportion of females among full-time workers actually declined (Table 7.1*b*, column 4). Thus, in the first phase, the rise in the economic activity rates of married women was achieved not only by an increase in the proportion of part-time jobs, but also by a substitution of part-time for full-time jobs. After this expansion phase, the slow increase in the economic activity rates of (married) women was based on a relatively stable rate of women's part-time work and a slightly increasing proportion of women among full-time workers (Table 7.1). In other words, since the late 1970s, women's labour-force participation has slowly been expanding within a relatively stable structure of part-time and full-time employment.

The rapid increase in married women's part-time employment from the 1950s to the mid-1970s can be explained by a unique historical interaction of demand and supply. On the one hand, there was a steep increase in the overall demand for female labour primarily due to the fact that the most rapidly expanding administrative and service occupations during the period of the so-called *Wirtschaftswunder* ('economic miracle') have for some time provided jobs mainly for women in West Germany. On the other hand, there was a decline in the supply of young single women who used to provide the backbone of German female full-time employment. The two major reasons for this decline were women's accelerating educational participation (Blossfeld, 1989; 1990) and a sharply declining age at marriage and first motherhood up to the birth cohort 1944–8 (Blossfeld and Jaenichen, 1992; Blossfeld, 1995). Thus, the increasing employment rates of married women can be interpreted as a supply response to increased job opportunities.[6] The interesting question, however, is why the integration of married women into paid work was based on part-time

[5] Büchtemann (1987) found that if the reference period is changed from one week to one year, about 5.4 million people had some experience of part-time work in 1984.

[6] Other possible solutions to meet rising labour demand, for example by employing men or mechanization, were less practical because there was a general shortage of men beginning in the late 1950s and service work is generally hard to replace by machines.

employment and not on full-time work.[7] Our interpretation is that, given
traditional gender roles in West Germany, with women regarded as being
responsible for the the raising of children,[8] the specific institutional frame-
work (with a general lack of childcare institutions and a school system
where childen come home at lunchtime), as well as a 'conservative' tax pol-
icy that punishes dual full-time earner marriages and rewards women's
non-work or part-time work,[9] the best response by married women to
increased job opportunitites was to offer part-time work. Thus, women
who obviously gave priority to family-centred non-market activities could
best be attracted to paid work by being offered part-time jobs (see Chapter
2 by Hakim). From the employers' side, this was possible due to the far
lower degree of unionization in the growing service industries,[10] and to the
specific nature of women's administrative and service jobs that very often
allow, or even require, organization of work as part-time employment
(Quack, 1993).

But what happened after the mid-1970s when the economic boom was
over? Why do we still observe an increasing economic activity rate for
(married) women, stability in the rate of women's part-time work, and a
slowly increasing rate of women working full-time? Our argument is that
the labour market and the context for employment decisions changed rad-
ically during the previous period of economic boom. With respect to
labour demand, three processes seem to be important. First, beginning with
the oil price shock in the mid-1970s, the German economic miracle and the
expansion of the welfare state came to an end. In the following years, the
West German labour market was less tight and unemployment rates have
been rising step-wise from one economic crisis to the next.[11] Second, the
normative attitudes of employers which discouraged the employment of
married and older women at the beginning of the 1950s had changed as a
result of the boom experiences in the 1960s and 1970s, so that job oppor-
tunities for these women did not decline again. Third, the structure of the

[7] In the USA, for example, married women were increasingly employed in full-time
jobs (see Chapter 12 in this volume).

[8] The incompatibility of work and motherhood is by and large structurally deter-
mined. It is because work and fatherhood are perfectly compatible (Bernhardt, 1993).

[9] The German tax system is based on the so-called *Ehegattensplitting*, which pools
the income of husband and wife and then divides it by two to compute the tax rate of
the employed spouse(s). For example, if one spouse is employed and the other has no
income, then the income on which the employed spouse has to pay taxes is divided by
two.

[10] In West Germany, unions that were almost completely controlled by men were
quite successful in their strategies of reducing all forms of 'non-standard' employment
in certain industries over decades.

[11] A major component of the increasing unemployment rate in Germany is, of
course, married women's rising demand for labour.

job market itself changed during this period. A new type of labour-market segment primarily for part-time workers was established, leading to a specific demand for part-time workers in many administrative and service jobs (Quack, 1993). However, these job categories were far less expansive after the mid-1970s than in the period before, due to the levelling off of the speed of occupational restructuring (Müller, 1983) and employment stagnation in the public sector (Becker and Blossfeld, 1991). Although part-time work itself did not expand for men and women structurally, there has been a continuous change in the composition of part-time work across industries (Table 7.2).

However, there has also been a change with regard to the supply of female labour. Three processes seem to be particularly important. First, the more that women have been working, the more feasible work appears to them in all phases of the family cycle, and the more likely it is that this change will continue across successive generations of women (Oppenheimer, 1970). This change was structurally supported by declining fertility, shortening of the child-bearing years (cf. also Tölke, 1989), and technical innovations in the domestic sphere which dramatically reduced the time that women needed for housework (Müller, Willms, and Handl, 1983: 64). Second, from one cohort to the next, more and more women could not only increase their educational attainment, but also turn it into better job opportunities in the labour market, primarily in the public sector (Blossfeld, 1985; 1989); this, of course, increased the supply of women's labour. Finally, there has also been an official West German policy fostering the integration of married women and women with children into the labour market. This policy has been especially effective in the public sector (Quack, 1993). The result of these demand- and supply-side changes has been a more extensive integration of women into the labour market and a relatively stable rate of part-time work among women since the late 1970s.

The impressive increase in (married) women's labour-force participation during the last thirty years in West Germany has by and large been the result of an expansion of married women's part-time employment. In other words, a wife's role as a supplementary worker has hardly changed (Bernhardt, 1993). Married female part-time workers constitute a qualitatively different type of workforce. There is plenty of evidence showing that these women normally give priority to family-centred non-market activities around which the part-time job must be fitted (see Chapter 2 by Hakim). Since these women keep a foot in the labour market, they are not completely dependent on their husbands or partners in financial terms, but they have by and large suppressed their own (long-term) job opportunities and other interests during the phase when they are raising young children (Bernhardt, 1993).

TABLE 7.2. *Changes in women's part-time employment by industry in West Germany, 1972–1988* (%)

	Agriculture	Primary, manufacturing, and construction	Distributive trades and transport	Banking, insurance, and finance	Other services	Welfare and charitable services	Public administration, professional and scientific services
1972	34	23	34	21	31	41	26
1973	34	24	35	22	31	42	27
1974	31	23	35	23	31	42	26
1975	33	23	36	23	32	45	28
1976	32	23	36	23	32	43	28
1977	35	24	38	25	33	46	28
1978	30	23	36	24	32	43	28
1979	31	24	38	23	32	43	29
1980	33	24	37	22	29	39	28
1981	31	25	39	23	30	41	29
1982	29	24	38	23	31	42	29
1983	34	25	40	23	36	48	30
1984	26	24	37	23	33	47	30
1985	22	24	38	25	32	44	30
1986	25	24	38	24	33	45	30
1987	26	23	38	23	33	46	30
1988	25	24	39	24	34	45	31
Change: 1972–88	−8	+2	+6	+3	+4	+4	+5

Source: Brinkmann and Kohler (1989: 482).

It therefore does not seem appropriate to look at women's overall labour-force participation rates and expect these increases to be a major catalyst for change in women's roles in the labour market and the family (Hakim, 1993a; 1993b). Equally, it would be wrong to evaluate women's part-time work purely in terms of their often 'atypical' employment conditions. First, this perspective neglects the fact that the overwhelming majority of part-time working women in West Germany (83 per cent at the end of the 1980s) are married secondary earners in households where at least one additional family member is working on a full-time basis (Büchtemann and Quack, 1990). In most cases, women's part-time work is a supplement to at least one additional full-time worker in the household. Second, such families normally also provide protection in case of sickness and unemployment as well as social security in old age in West Germany (Büchtemann and Quack, 1990). Third, the atypical work perspective often assumes that part-time work constitutes some kind of an employment buffer against economic downturns and thus involves job insecurity and a relatively high risk of unemployment. However, the available empirical evidence for West Germany shows that this is not the case (Büchtemann and Quack, 1990; Quack, 1993). Finally, the pure fact that almost one-third of employed women work part-time in West Germany, leads us to question the label 'atypical' (cf. Ellingsaeter, 1992). As Table 7.3 shows, most part-time employed women work between 10 and 35 hours a week and many would like to work even shorter hours. This is especially true of full-time working women (Table 7.3).

Although many of the part-time jobs for women in West Germany are low-skilled and poorly paid, there has been a shift from such jobs to higher skilled positions over time. For example, female part-time workers could increasingly be found in skilled clerical and secretarial positions and decreasingly in cleaning work during the 1980s (Quack, 1993: 251). Particularly interesting is the trend in the public sector during the 1980s. Table 7.4 shows that in this period the number of part-time jobs almost doubled from about 245,000 to about 420,000, with particulary large increases in the higher levels of public service. Most of these female part-timers were civil servants with maximum job security, taking up the option of moving from full-time to part-time work and back again without any serious disadvantages. These women could hardly be characterized as a marginal workforce.

Women's Labour-Force Participation and the Family Cycle as Dynamic Processes

So far, our description of part-time work has been based mainly on Census and Microcensus data. However, such cross-sectional data have many

TABLE 7.3. *Actual and desired weekly working hours among employed West German women by family status and age in 1986 (%)*

Weekly hours	Weekly hours worked[a]						Desired weekly working hours[b]					
	Family status					Total	Family status					Total
	Married and aged:			Unmarried	Divorced[c]		Married and aged:			Unmarried	Divorced[c]	
	<29	30–44	45+				<29	30–44	45+			
1–4	—	—	1	—	—	—	6	3	7	4	5	5
5–9	1	1	3	1	1	1	—	1	1	1	1	1
10–14	3	6	6	1	2	4	3	5	6	—	3	4
15–18	3	5	6	—	2	3	3	5	5	—	2	3
19	—	—	—	—	1	—	—	—	—	—	—	—
20–4	10	23	19	4	11	14	27	33	29	14	21	25
25–9	4	6	8	2	6	5	8	9	10	6	6	8
30–4	3	6	7	2	4	5	18	14	13	18	18	16
35–6	3	2	3	4	5	3	12	10	8	17	14	12
37+	72	50	47	86	68	64	23	20	20	38	30	26
Missing	—	—	—	—	—	—	—	1	1	1	1	1
Total	100	100	100	100	100	100	100	100	100	100	100	100

Notes:

[a] Question in the Questionnaire: 'How many hours do you normally work a week?'

[b] Question in the Questionnaire: 'If you consider your family and financial situation and you (as well as your partner) could decide how many hours a week you work, how many hours would you prefer?'

[c] Also including widowed women.

Source: Brinkmann and Kohler (1989: 477).

TABLE 7.4. *Women's part-time employment in the West German economy by occupational group and in the public sector by hierarchical level 1980 and 1989*

Occupational Group/ hierarchical level	1980		1989	
	N[a]	%	N[a]	%
Overall Economy				
Agricultural worker	233	9	142	4
Manual production worker	355	13	322	10
Clerical and sales workers	1375	50	1687	52
Service workers	773	28	1116	34
Total	2736	100	3267	100
Public Service[b]				
Highest level	17	7	37	9
Higher level	65	26	132	31
Intermediate level	151	62	238	57
Lower level	12	5	13	3
Total	245	100	420	100

Notes:
[a] N in 1000s.
[b] Highest level = Höherer Dienst; Higher level = Gehobener Dienst
Intermediate level = Mittlerer Dienst; Lower level = Einfacher Dienst.
Source: Statistical Office (ed.), ser. 1, vol. 4.1.2.

inferential limitations and are inherently ambiguous with respect to their interpretation at the level of the individual woman (Blossfeld and Rohwer, 1995). In particular, the interaction between the family cycle and women's rising full-time and part-time work cannot meaningfully be studied on the basis of cross-sections. A natural framework for the analysis of such complex employment and family history data is a comprehensive event-history model that incorporates the important micro- and macro-level factors (Tuma and Hannan, 1984; Blossfeld, Hamerle, and Mayer, 1989; Mayer and Tuma, 1990; Blossfeld and Rohwer, 1995).

Our event-history analysis is based on data from the German Socioeconomic Panel Study (GSOEP), a nationally representative longitudinal data-set of persons, households, and families in the Federal Republic of Germany (FRG). The first data collection was carried out in 1984, and there has been a further panel wave in every subsequent year. In 1984, about 6,000 households and 12,245 individuals were surveyed (Deutsches Institut für Wirtschaftsforschung, 1990). From this database, we used information from the years 1984–90. Our analyses utilize retrospective data on the employment and family histories of West German women from the 1918–68 birth cohorts during the period 1950 to 1990. The employment data are based on two kinds of information. First, using retrospec-

tive biographical information collected via the so-called biographical scheme in 1984, we reconstructed the employment histories up to 1984. Then we extended these histories with data on women's employment changes between each panel wave from 1984 to 1990. We distinguished especially the following four states in a woman's employment history:

(1) full-time employment,
(2) part-time employment,
(3) being a full-time housewife, and
(4) being otherwise not employed, that is, unemployed, in school, or retired.

Here, we only report transitions between the first three states.

To study a change in women's employment history, we specify as the dependent variable the rate of transition between the states (1) to (3) as follows:

$$r_{jk}(t) = \lim_{\Delta t \to 0} \Pr(t \le T < t + \Delta t, \text{Des} = k \mid T \ge t, \text{Org} = j) / \Delta t,$$

where Pr (.) is the probability of moving from the origin state j ($j = 1, 2, 3$) to the destination state k ($k = 1, 2, 3$; $j \ne k$), at t, provided that such a transition has not occurred before (Blossfeld and Rohwer, 1995). Using exponential and piecewise constant exponential models, we specified the rates r_{jk} as a function of time-constant (\mathbf{x}) and time-dependent ($\mathbf{z}(t)$) vectors of covariates (Blossfeld and Rohwer, 1995):

$$r_{jk}(t) = \exp(\alpha'_{jk} \mathbf{x} + \beta'_{jk} \mathbf{z}(t)).$$

Observation begins at the time when females leave school and enter into one of the three origin states (full-time employed, part-time employed, or being a housewife) and ends with a transition to one of the possible destinations states or at the time where the episode was right-censored.

To introduce time-dependent measures $\mathbf{z}(t)$ into the rate equations, we used the method of episode-splitting, described in detail by Blossfeld and Rohwer (1995). In our application of this approach, a separate data-record was created for sub-episodes at a maximum of one year. For each of these sub-episodes four different pieces of information were provided:

(1) time at the beginning and end of the sub-episode;
(2) the values of the time-dependent covariates at the beginning of these sub-episodes;
(3) whether the interval ended with an event or not; and
(4) the values of the other covariates relevant for the analysis.

Rate function coefficients (α'_{jk}, β'_{jk}) and their t-ratios are helpful in ascertaining how variables influence movement between the states, in what

direction, and at what level of significance. The substantive meaning of the effects and their significance are, however, more easily assessed by examining the percentage change in transition rates, given an increase in the respective covariate. We therefore mainly report the percentage change in transition rates on the basis of the estimated models in our tables.

The explanatory variables include measures of age, period, cohort, women's educational attainment, and their family history. We used a combination of two time-dependent variables (age and age*age at the time of each yearly sub-episode) to model the well-known non-monotonic age dependence of the different transitions. To study the influence of historical periods, we used a set of time-dependent dummy variables that indicates whether the respective sub-episode has started in one of the following historical periods: 1950–4, 1955–8, 1959–62, 1963–6, 1967–70, 1971–4, 1975–8, 1979–82, 1983–6, and 1987–90). The period 1950–4 was used as the reference category. To study cohort effects, we used a set of dummy variables, each representing five-year birth groups from 1918–23 through to 1964–8, with the 1919–23 cohort used as the reference group.

We also included information about women's educational attainment. This variable combines the highest level of general education and vocational training and is measured by the average number of years required to obtain them (Blossfeld, 1985): lower school qualification without vocational training (9 years); lower secondary school qualification with vocational training (11 years); intermediate school qualification without vocational training (10 years); intermediate school qualification with vocational training (12 years); upper secondary school qualification (*Abitur*) without vocational training (13 years); upper secondary school qualification (*Abitur*) with vocational training (15 years); professional college qualification (17 years) and university degree (19 years).

We reconstructed complete marital histories (marriages, divorces) and detailed child-bearing histories, both collected in the second wave of the SOEP in 1985 and updated in the waves 1986–90. The marital history and the history of the children were treated as independent processes. For marital status, we distinguished three states: single,[12] married without a child, and married with at least one child. The 'single' state is the reference category of this time-dependent covariate. With regard to motherhood, we distinguished four states: child of pre-school age, child of school age, youngest child older than 18 years (acting as a proxy for the child leaving home), and no child. For this time-dependent covariate, the 'no child' state was used as the reference category. If there were children at different ages in a family, then the statuses of the respective children were used simulanteously, giving younger children precedence. Thus, in a two-child family,

[12] Which includes both, being not married and being divorced.

one aged 10 and the other aged 2, the time-dependent covariate 'child of pre-school age' was assigned the value '1'.

Our event-history analysis studies the following six transitions in a woman's employment career:

(1) from full-time to part-time work;
(2) from full-time work to housewife status;
(3) from housewife status to full-time work;
(4) from housewife status to part-time work;
(5) from part-time work to full-time work; and
(6) from part-time work to housewife status.

We start with a simple model and then introduce complexity step-by-step.

Age, Cohort, and Period Effects

Important changes in women's transition rates between full-time work, part-time work, and housewife status are expected to occur over age, across cohorts, and in different historical periods. We first include age and cohort variables. We do not interpret age effects here, as they are strongly affected by family events which we will study later. However, the cohort variables give us the opportunity to study whether the transformation of women's employment structure was brought about by cohort differentiation.

Let us look at the transitions from full-time to part-time work again. Table 7.5a clearly shows that there has been a dramatic increase in the movement from full-time to part-time work beginning with the birth cohort 1934–8. During the early 1960s, women born between 1934 and 1938 were in their late 20s, the life phase when entry into marriage and motherhood was particularly strong. This is, however, also the historical period in which the *Wirtschaftswunder* and the expansion of the welfare state combined with other shifts on the supply side of unmarried women, created a considerable rise in the demand of married women. Thus, it seems that this cohort made a historically specific experience in a particular life phase, making it different from the preceding cohorts. This cohort started a change that quickly transformed women's employment structure for each younger cohort. The increase in the transition to part-time work finds its peak for the cohort of 1949–53, a cohort that was in its early 20s when the *Wirtschaftswunder* came to an end and the expansion of the welfare state levelled off. After this birth cohort, movement from full-time to part-time work declined again, but it was still more than twice as high as for the birth cohorts 1918–33. Thus, this specific historical situation in the early 1960s initiated a change in the transition of women from full-time to

TABLE 7.5. *Changes in transition rates by birth cohort*

a. Transition from full-time to part-time work; and from full-time work to housewife status

Birth cohort	Percentage change in transition rates	
	FTW → PTW	FTW → HWS
1918–28	baseline	baseline
1929–33	n.s.	n.s.
1934–8	+ 60	n.s.
1939–43	+ 190	n.s.
1944–8	+ 268	n.s.
1949–53	+ 354	− 24
1954–8	+ 226	− 29
1959–63	+ 205	− 40
1964–8	+ 228	− 68

b. Transition from housewife status to full-time work; and from housewife status to part-time work

Birth cohort	Percentage change in transition rates	
	HWS → FTW	HWS → PTW
1918–28	baseline	baseline
1929–33	n.s.	n.s.
1934–8	n.s.	+ 96
1939–43	n.s.	+ 141
1944–8	n.s.	+ 213
1949–53	n.s.	+ 306
1954–8	n.s.	+ 280
1959–63	n.s.	+ 489
1964–8	n.s.	+ 566

c. Transition from part-time work to full-time work; and from part-time work to housewife status

Birth cohort	Percentage change in transition rates	
	PTW → FTW	PTW → HWS
1918–28	baseline	baseline
1929–33	n.s.	n.s.
1934–8	− 38	− 52
1939–43	− 34	n.s.
1944–8	− 33	n.s.
1949–53	− 50	n.s.
1954–8	− 65	n.s.
1959–63	n.s.	n.s.
1964–8	n.s.	n.s.

Source: German Socioeconomic Panel 1984–90.

part-time work across cohorts that persisted even when the expansion period was over.

It is interesting to note that the transition from full-time work to housewife status did not change until the birth cohort 1949–53 (Table 7.5*a*). Thus, it was not until the peak of the transition from part-time to full-time work was reached across cohorts that the movement from full-time work to housewife status declined. But after that, it declined with increasing rapidity for each younger cohort. In sum, it was the cohort of 1934–8 that began to change the transition pattern from full-time to part-time work, and the cohort of 1949–53 started to change the transition from full-time work to housewife status.[13]

Let us now look at these cohort changes from the perspective of the housewives (Table 7.5*b*). Here we see no cohort trend at all for the transition from housewife status to full-time work. Thus, younger West German houswives did not re-enter full-time work more than their mothers or even their grandmothers. Rising re-entry of housewives into the labour market in West Germany only means rising re-entry into part-time work—again starting with the birth cohort 1934–8. But this change is dramatic across cohorts. Housewives born between 1964–8 are almost six times more likely to re-enter part-time work than women born between 1918 and 1933. This evidence supports the view that part-time and full-time work must be distinguished; it speaks against the studies that only look at the re-entry of housewives into paid work, as they most certainly overstate the 'equalizing' trends of this process on the gender structure (cf. Tölke, 1989; Lauterbach, 1993). However, one could argue that part-time work serves as a bridge from housewife status to full-time employment across cohorts. Thus, let us look at the transition from part-time to full-time work across cohorts.

Table 7.5*c* shows that there is no such trend across cohorts. In fact, for a certain number of birth cohorts the opposite was even the case. Between the 1934 and 1958 cohorts, there was a declining tendency to move from part-time to full-time employment. For the cohorts born after 1959, the pattern is not different from that of the women born during 1918–33. We therefore conclude that part-time work does not serve as a bridge facilitating the transition from housewife status to full-time work. In addition, Table 7.5*c* shows that the character of part-time employment has not changed with regard to housewife status across cohorts. With the exception of cohort 1934–8, which is a special case in this respect, the basic transition intensity did not change across cohorts.

Finally, let us look at the importance of period effects which we now add to the transition models. Since a model using age, cohort, and period

[13] Again, this trend was interrupted by the specific conditions of the immediate postwar period.

effects in terms of 'age = year of period – year of birth' causes an identification problem, we used the proportion of part-timers among employed women in each year (Table 7.1*b*, column 2). For the period between 1950 and 1960, we interpolated linearly to estimate the proportion of female part-timers. This period measure increases monotonically from 5.5 per cent in 1950 to around 30 per cent in the early 1970s and is then relatively stable with some minor fluctuations. The effect of this measure tells us whether the changing conditions in the labour market increase or decrease the transition rates for all women in each year of the historical period under consideration.

TABLE 7.6. *Changes of period effects on transition rates*

Transition from	→ to	Percentage change in transition rates
Full-time	→ Part-time	n.s.
Full-time	→ Housewife status	– 33
Part-time	→ Full-time	n.s.
Part-time	→ Housewife status	– 51
Housewife status	→ Full-time	+ 109
Housewife status	→ Part-time	n.s.

Source: German Socioeconomic Panel 1984–90.

Since the most important changes in female part-time work occurred between 1960 and the mid-1970s, we report the effect of these changes on our six transitions in Table 7.6. At first glance, the results are quite surprising. Contrary to our initial expectations, the period measure only affects part-time transitions. There is a period effect on the transition from part-time work to housewife status. Thus, the change in the level of female part-time work from about 9 per cent to about 30 per cent of employee jobs reduced the transition rate for part-time working women to become housewives by about 51 per cent. However, it has no effect on the transition from housewife status to part-time work and from full-time to part-time work. Instead, it decreases the rate of moving from full-time work to housewife status by one-third, and increases the rate of moving from housewife status to full-time work by about 110 per cent. How can this pattern be explained?

Our interpretation is that our period measure captures increasing demand for women's labour during the 1960s and early 1970s. Given the increasingly tight labour market in this period, there was an increasing demand for women's labour that affected all women and specific women. The main period effect was to increase the full-time work rate of all women. It pulled housewives out of their homes into full-time work and increasingly prevented women from moving back to housewife status. To

some extent, it also kept them from leaving part-time employment. However, since the cohort effects discussed above did not significantly change after the inclusion of the period measure, the cohort interpretation given above remains correct. In other words, the expansion of part-time work was not brought about by period changes; it was basically a cohort phenomenon. It did not affect all women to the same extent, but affected each successive cohort to an increasing extent. The question we ask now is whether this is because women are increasingly better qualified across generations, or because a combination of work and family appears to be more feasible for women of each younger cohort.

TABLE 7.7. *Effects of educational attainment on transition rates*

Transition from → to	Effect of women's educational attainment (%)			
	One additional school year	Comparisions for selected educational attainment groups[a]		
		MMB vs. HOB	UNI vs. MMB	UNI vs. HOB
FTW → HWS	no effect	no effect	no effect	no effect
HWS → FTW	+ 4.4	+ 14	+ 29	+ 47
FTW → PTW	no effect	no effect	no effect	no effect
PTW → FTW	+ 8.7	+ 22	+ 65	+ 112
HWS → PTW	+ 5.6	+ 18	+ 39	+ 64
PTW → HWS	no effect	no effect	no effect	no effect

Note:
[a] HOB: Lower-secondary-school qualification without vocational training (= 9 years);
 MMB: Intermediate-school qualification with vocational training (= 12 years);
 UNI: Professional College qualification or University degree (= 18 years).
Source: German Socioeconomic Panel 1984–90.

Let us therefore study the effect of educational expansion on the six transitions. Table 7.7 describes this effect in two ways. First, it describes how each additional school year affects these transitions and, secondly, it shows the changes in the transition rates if different levels of qualification are compared. According to human capital theory and the economic theory of the family (Becker, 1981), women's educational investments increase the value of women's time which, in turn, increases the incentive to work. The results in Table 7.7 show that women's rising educational attainment affects the transitions in that way. It not only increases the likelihood of moving from housewife status to full-time and part-time work, but it also increases the likelihood of moving from part-time to full-time work. In other words, educational expansion fosters the part-time and full-time work of women. But it increases full-time work via two

routes: on the one hand directly; on the other hand, via part-time work. Part-time work seems to be a bridge between housewife status and full-time employment, mainly for more highly qualified women. Thus, with increasing educational expansion, we must expect women's part-time work to be increasingly transformed into women's full-time work. But educational expansion cannot completely account for the changes across cohorts. After controlling for women's educational attainment, cohort effects in Table 7.5 become weaker, but the basic cohort pattern, as described above, remains.

We therefore have two forces working across cohorts: each better qualified generation of women is working more and each younger cohort of women seems to increasingly prefer the combination of part-time work and family (Stephan, 1995). The effect of the *Wirtschaftswunder* in West Germany was that part-time work was created for married women (with children). Each new generation of women was then increasingly integrated into the labour market on the basis of a combination strategy of work and family based on part-time employment. The effect of educational expansion is that part-time work has also increasingly been transformed into full-time work. The slightly rising proportion of full-time working women during the second half of the 1980s may therefore be a first sign of a new trend towards (married) women's full-time work based on better education.

In studying women's employment patterns, we must also consider that the rate of moving between full-time work, part-time work, and housewife status is dependent on experience of the respective states. According to Mincer (1974), human capital appreciates as women's work experience (time spent in employment) increases. Similarly, it may depreciate as time spent at home increases. If the stock of such experiences affects the transition rates, then such rates should depend on current experiences as measured by the cumulative time spent in certain states (Blossfeld and Rohwer, 1995). We have included these aspects of the employment process in our models by using a piece-wise constant transition rate model. In a piece-wise constant model, duration in a state is divided into intervals, so that the constant term of the rate equation can vary over these periods.

The results of such models are reported in Table 7.8. As far as full-time employment is concerned, we observe the opposite of what one would expect, given human capital theory. The rate of movement to housewife status increases with the time spent in full-time employment. However, this duration pattern completely disappears if we control for the effect of the family cycle in the next step of our analysis. Then, the duration effect in full-time employment shows the expected (if also slight) negative trend over duration in full-time employment. Also in agreement with the human capital theory is the effect of duration on housewife status (women's work experience seems to depreciate as time spent at home increases) and part-

TABLE 7.8. *Duration effects on transition rates*

Transition from → to	Rates of women by duration in origin state (years)						
	0<1	1<3	3<5	5<8	8<12	12 +	
FTW → HWS	0.070	0.122	0.226	0.284	0.304	0.171	
HWS → FTW	0.060	0.056	0.049	0.032	0.032	0.029	
FTW → PTW	0.001	0.001	0.001	0.001	0.001	0.001	
PTW → FTW	no effect	no effect	no effect	no effect	no effect	no effect	
HWS → PTW	0.0001	0.0001	0.0001	0.0001	0.0001	0.0001	
PTW → HWS	0.170	0.147	0.121	0.111	0.093	0.104	

Source: German Socioeconomic Panel 1984–90.

time work (women's job-specific human capital seems to increase). The other duration effects are not significant or do not change over time. Thus, these results support the argument that job-specific human capital is an important factor in women's mobility process.

After having controlled for several important time-related influences, we study the effects of the family cycle on women's changing employment pattern. As discussed above, it is essential that the major family events (marriage, divorce) and the primary events with regard to (multiple) children (birth of the child, child entering school, child leaving parental home) vary independently over time in such an analysis. Table 7.9 presents the results in terms of changes in transition rates for specific phases of the family cycle.

According to these estimates, entry into marriage without having a child increases the transition rate from full-time work (by 250 per cent) and part-time work (by 122 per cent) to housewife status.[14] It also increases the movement from full-time to part-time work (by 145 per cent) and decreases the movement from part-time to full-time work (by 47 per cent). Thus, marriage (independently of motherhood) has an important influence on women's employment behaviour. If we include interaction effects between marriage and cohort membership, then this influence declines across cohorts: for example, for the 1964–8 birth cohort, the transition rate from full-time employment to housewife status increases by only 74 per cent— but it does increase.

If marriage is linked with children, then we must combine the effects for 'married with children' (column 2 in Table 7.9) with the respective effects of the children at different ages ('pre-school age', 'school age', or 'age 18 and over'). Thus, when a woman marries and this is connected with the birth of a child, the transition rate from full-time employment to housewife status increases by about 400 per cent. At the same time, the rate of moving from housewife status to full-time employment is reduced by about 46 per cent. Here again we observe strong interaction effects between cohort membership and the fact that there is a child of pre-school age. For each younger cohort, children become more important for women's employment behaviour. Of course, this is the case because the importance of the events shifted across cohorts in the first family phase from marriage to small children. Young women change their employment behaviour less often at the time of marriage and increasingly at the time when the first baby is born. Both events are increasingly disconnected across cohorts (Blossfeld, 1995): younger women marry later, but they also have their first babies much later. In other words, part of the story of the increase in young married women's full-time work is that age at first birth increased

[14] Around 20% of women aged 40–50 are childless (Höpfinger, 1991).

TABLE 7.9. *Effects of the family cycle on transition rates*

Transition from → to	Percentage change in the transition rates				
	Married		Children at		
	without children	with children	pre-school age	school age	18 and older
FTW → HWS	+ 250	+ 221	+ 222	no effect	no effect
HWS → FTW	no effect	− 46	no effect	+ 110	+ 123
FTW → PTW	+ 145	+ 107	+ 112	no effect	no effect
PTW → FTW	− 47	− 60	− 53	no effect	no effect
HWS → PTW	no effect	no effect	no effect	+ 128	+ 84
PTW → HWS	+ 122	no effect	+ 158	+ 66	no effect

Note: Reference category for 'married' is 'single' and for children at different ages is 'no child'.

Source: German Socioeconomic Panel 1984–90.

and these women continue to work after marriage until they have their first baby.

A mechanism seems to be working with regard to the transitions between full-time and part-time work. Marriage linked with pre-school children leads to more part-time employment and less full-time work. It is interesting that there is no effect for marriage with pre-school children on the transition from housewife status to part-time work. Also the transition rate back to part-time work from housewife status rises only from 122 to 158 per cent if a small child is present in addition. These results may provide evidence that the conflict between part-time work and the first stage of the family cycle, that is, marriage and small children, is much less severe than for full-time work. However, this is not so clear for the later stages in the family cycle. For example, the transition from housewife status to full-time work increases by about 110 per cent if the youngest child is in school and by 123 per cent if the youngest child is older than 18 years. But the transition from housewife status to part-time work only changes by 66 per cent and the fact that the youngest child is older than 18 years seems to have no impact on part-time work at all. Finally, we should note that transitions from full-time to part-time work and back are not affected by the later phases of the family cycle.

Conclusions

The purpose of this chapter has been to assess empirically the importance of rising levels of female part-time work for the gender structure in West Germany. We have tried to show that both a full-time and an atypical perspective on women's work limit our understanding of the changes in (married) women's labour-force participation in general and in women's part-time work in particular. On the one hand, the full-time work perspective overstates the 'equalizing' effects of women's part-time work and provides a far too simplistic picture of the change in the sex-specific inequality structure in West Germany; on the other, the atypical work perspective exaggerates the 'marginalizing' features of married women's part-time work and develops a much too pessimistic scenario. It seems that because changes are so much more rapid now than they were, say, 30 years ago, many people are misled into believing that they must have been caused by something that happened recently. In sociology, changes are often compared with a mythical golden past (Mayer, 1987; Mayer and Blossfeld, 1990).

The truth of the matter is that the increase in women's part-time employment started in the late 1950s in West Germany. It is basically a cohort phenomenon and did not affect all women to the same extent, but affected

each successive cohort to an increasing extent. This change has been quite dramatic across cohorts. Housewives born during 1964–8 are six times more likely to re-enter part-time work than housewives born during 1918–33. This evidence supports the view that part-time and full-time work must be distinguished. Part-time work has not been an intermediary status that helped to bridge the transition from housewife status to full-time work across cohorts. The character of part-time employment has also not changed with regard to housewife status across cohorts.

It is also important to note that the transition from full-time work to housewife status did not change until the birth cohort of 1949–53. Thus, it was not until the peak of the transition from part-time to full-time work was reached that the movement from full-time work to housewife status started to decline. But thereafter, it declined more rapidly for each younger cohort. Thus, it was the cohort of 1934–8 that began to change the transition pattern from full-time to part-time work, and it was the cohort of 1949–53 that started to change the transition from full-time work to housewife status.

Women's part-time and full-time work increase with educational expansion, which increases full-time work via two routes: on the one hand, directly and on the other, via part-time work. Part-time employment seems to be a bridge between housewife status and full-time employment mainly for better qualified women. Thus, educational expansion has increasingly transformed women's part-time employment into full-time work. However, educational expansion cannot completely account for the changes across cohorts. After controlling for women's educational attainment, cohort effects become weaker, but the basic cohort pattern continues to operate. Thus, we must anticipate that part-time work will continue to increase in future from one cohort to the next in West Germany.

As far as the impact of the family cycle on women's employment is concerned, we stressed that younger women change their employment behaviour decreasingly at the time of marriage and increasingly at the time when the first baby is born. Both events are also increasingly disconnected across cohorts (Blossfeld, 1995). Younger women marry later, but they have their first children even later. Thus, part of the explanation for the increase in young married women's full-time labour-force participation is that the age at first birth has increased and that women increasingly continue to work after marriage until the birth of the first child. We also showed that the conflict between part-time work and the first stage of the family cycle (involving marriage, and small children) is much less severe than for full-time work. This does not, however, seem to be true for the later stages of this cycle.

REFERENCES

Becker, G. S. (1981), *A Treatise on the Family* (Cambridge, Mass.: Harvard University Press).

Becker, R. and Blossfeld, H.-P. (1991), 'Cohort-Specific Effects of the Expansion of the Welfare State on Job Opportunities: A Longitudinal Analysis of Three Birth Cohorts in the Federal Republic of Germany', *Sociologische Gids* (1991-4), 261-84.

Bernhardt, E. M. (1993), 'Fertility and Employment', *European Sociological Review*, 9: 25-42.

Blossfeld, H.-P. (1985), *Bildungsexpansion und Berufschancen* ('Educational Expansion and Job Opportunities'), (Frankfurt a. M. and New York: Campus Verlag).

—— (1989), *Kohortendifferenzierung und Karriereprozeß—Eine Längsschnittanalyse über die Veränderung der Bildungs- und Berufschancen im Lebenslauf* ('Cohort Differentiation and Career Process: A Longitudinal Analysis of Educational Changes and Job Opportunities over the Life Course'), (Frankfurt a. M. and New York: Campus Verlag).

—— (1990), 'Changes in Educational Careers in the Federal Republic of Germany', *Sociology of Education*, 63: 165-77.

—— (ed.) (1995), *The New Role of Women: Family Formation in Modern Societies* (Boulder, Colo: Westview Press).

—— and Jaenichen, U. (1992), 'Educational Expansion and Changes in Women's Entry into Marriage and Motherhood in the Federal Republic of Germany', *Journal of Marriage and the Family*, 54/5: 302-15.

—— and Rohwer, G. (1995), *Techniques of Event History Modeling: New Approaches to Causal Analysis* (Mahwah, NJ: Lawrence Erlbaum Associates).

—— Hamerle, A., and Mayer, K. U. (1989), *Event History Analysis. Statistical Theory and Application in the Social Sciences* (Hillsdale, NJ: Lawrence Erlbaum Associates).

Brinkmann, C. and Kohler, H. (1989), 'Teilzeitarbeit und Arbeitsvolumen' ('Part-Time Employment and Work Volume'), zum Thema 'Zur Arbeitsmarktentwicklung 1989/90' ('Development of the Labour Market 1989/90'), Arbeitsgemeinschaft bestehend aus H U Bach, C Brinkmann et al, *Mitteilungen aus der Arbeitsmarkt- und Berufsforschung*, Heft 4: 472.

Büchtemann, C. F. (1987), 'Structural Change in the Labor Market and Atypical Emplyoment: The Case of Part-Time Work in the Federal Republic of Germany', paper prepared for the Conference on 'Labor Force Surveys as an Employment Policy Instrument', Fontevraud, France, Sept. 1987.

—— and Quack, S. (1990), 'How Precarious is "Non-Standard" Employment? Evidence for West Germany', *Cambridge Journal of Economics*, 14: 315-29.

Deutsches Institut für Wirtschaftsforschung (ed.) (1990), *Das Sozio-ökonomische Panel* ('The German Socioeconomic Panel'), (GSOEP), version of 4 Oct. 1990 (Berlin: DIW); (translated by All-University Gerontology Center, Syracuse, New York).

—— (1995), 'Aspekte der Arbeitsmarktentwicklung in Ostdeutschland' ('Aspects

Concerning Labour-Market Developments in East Germany'), *DIW Wochenbericht*, 62: 401–6.

Ellingsaeter, A. L. (1992), *Part-Time Work in European Welfare States. Denmark, Germany, Norway and the United Kingdom Compared*, Report 92:10 (Oslo: Institute for Social Research).

Hakim, C. (1993*a*), 'The Myth of Rising Female Employment', *Work, Employment and Society*, 7: 97–120.

—— (1993*b*), 'Segregated and Integrated Occupations: A New Framework for Analysing Social Change', *European Sociological Review*, 9: 289–314.

Höpfinger, F. (1991), 'Neue Kinderlosigkeit—Demographische Trends und gesellschaftliche Spekulationen' ('The New Childlessness: Demographic Trends and Speculations'), in G. Buttler, H.-J. Hoffmann-Nowotny, and G. Schmitt-Rink (eds.) *Acta Demographica* (Heideberg: Physica-Verlag), pp. 81–100.

Huinink, J., Mayer, K. U., and Trappe, H. (1995), 'Staatliche Lenkung und individuelle Karrierechancen: Bildungs- und Berufsverläufe' ('Government Policies and Individual Career Opportunities: Career and Educational Processes'), in J. Huinink, K. U. Mayer, *et al.* (eds.), *Kollektiv und Eigensinn. Lebensverhältnisse in der DDR und danach* (Berlin: Akademie Verlag), pp. 89–142.

Lauterbach, W. (1993), 'Erwerbsverläufe von Frauen' ('The Career Course of Women'), (Ph.D. thesis, Berlin: Free University).

Mayer, K. U. (1987), 'Zum Verhältnis von Theorie und empirischer Forschung zur sozialen Ungleichheit' ('The Relationship between Theoretical and Empirical Research with Respect to Social Inequality'), in B. Giesen and H. Haferkamp (eds.), *Soziologie der sozialen Ungleichheit* (Opladen: Westdeutscher Verlag), pp. 370–92.

—— and Blossfeld, H.-P. (1990), 'Die gesellschaftliche Konstruktion sozialer Ungleichheit', ('The Construction of Social Inequality'), in P. A. Berger and S. Hradil (eds.), *Lebenslagen, Lebensläufe, Lebensstile*, Sonderband 7, Sozialen Welt (Göttingen: Verlag Otto Schwerz & Co.), pp. 297–318.

—— and Tuma, N. B. (1990), Life-Course Research and Event History Analysis: An Overview', in K. U. Mayer and N. B. Tuma (eds.), *Event History Analysis in Life-Course Research* (Madison, Wis.: Wisconsin University Press), pp. 3–20.

Müller, W. (1983), 'Wege und Grenzen der Tertiarisierung: Wandel der Berufsstruktur in der Bundesrepublik Deutschland 1950–1980' ('The Direction and Limits of Tertiarization: Changes in the Occupational Structure of Germany, 1950–1980'), in J. Matthes (ed.), *Krise der Arbeitsgesellschaft?* (Frankfurt a. M. and New York: Campus Verlag), pp. 142–60.

—— Willms, A., and Handl, J. (1983), *Strukturwandel der Frauenerwerbstätigkeit 1880–1980* ('Structural Changes in Women's Gainful Employment 1880–1980'), (Frankfurt a. M. and New York: Campus Verlag).

Nickel, H. M. (1992), 'Frauenarbeit im Beruf und in der Familie—Geschlechterpolarisierung in der DDR' ('Women's Work in Career and Family: Gender Polarization in the GDR), in A. Joester and I. Schöningh (eds.), *So nah beieinander und doch so fern Frauenleben in Ost und West* ('So Close Together, Yet so Far Apart: Women in East and West'), (Pfaffenweiler: Centaurus), pp. 11–23.

Oppenheimer, V. K. (1970), *The Female Labor Force in the United States: Demographic and Economic Factors Governing its Growth and Changing*

Composition, Population Monograph Series (Berkeley, Calif: University of California, Department of Demography.

Quack, S. (1993), *Dynamik der Teilzeitarbeit* ('Dynamics of Part-Time Work'), (Berlin: Edition Sigma).

Schupp, J. (1991), 'Teilzeitarbeit in der DDR und in der Bundesrepublik Deutschland' ('Part-Time Work in the GDR and in the Federal Republic of Germany'), in Projektgruppe 'Das Sozioökonomische Panel' (ed.), *Lebenslagen im Wandel: Basisdaten und -analysen zur Entwicklung in den Neuen Bundesländern* ('Changing Life Situations: Basic Data and Analysis Concerning Developments in the New German States'), (Frankfurt a. M. and New York: Campus Verlag), p. 268.

Stephan, G. (1995), *Zur Dynamik des Arbeitsangebotes von Frauen. Vollzeit-, Teilzeit- und Nichterwerbstätigkeit* ('The Dynamics of Job Opportunities for Women: Full-Time, Part-Time, and Non-Employment') (Frankfurt a. M. and New York: Campus Verlag).

Tölke, A. (1989), *Lebensverläufe von Frauen* ('The Life Course of Women') (Munich: Juventa Verlag).

Tuma, N. B. and Hannan, M. T. (1984), *Social Dynamics* (Orlando, Ga.: Academic Press).

Willms, A. (1985), *Frauenarbeit: Zur Integration der Frauen in den Arbeitsmarkt* ('Women's Work: Integration of Women in the Labour Market') (Frankfurt a. M. and New York: Campus Verlag.).

8

Female Labour-Market Participation in the Netherlands: Developments in the Relationship between Family Cycle and Employment

PAUL DE GRAAF AND HEDWIG VERMEULEN

The Rise of Part-Time Work

In the Netherlands, female labour-market participation increased enormously between 1960 and 1990. Until the 1960s, only one out of five women between the ages of 15 and 64 was active in the labour market; this proportion increased to one in two by the early 1990s. To a large extent, this increase has been the result of married women entering the labour market in the 1970s and 1980s. Until the 1960s, only women who were not (yet) married or who were active in their husband's firm went to work. This marks a trend similar to changes in the countries neighbouring the Netherlands, and can be explained on the basis of the usual cultural and economic issues, such as modernization, secularization, individualization, and the increasing demand for labour in the service sector. Norms against the participation of women in the labour market have been softened, and it is nowadays a widely accepted fact that married women also work. Educational expansion has increased women's labour-market opportunities, both from the demand side of the labour market due to occupational restructuring and labour shortages, and also from the supply side, as higher educated women are more strongly motivated to participate in the labour market.

Although the direction of the trend of women's labour-market participation in the Netherlands is the same as in neighbouring countries, the timing has been different in the Netherlands. The relatively late increase in the labour-market participation of married women in the Netherlands can be explained by two specific developments. The first is the religious composition of the Netherlands and the persistent effects of religion on fertility and married women's labour-market participation. The second is the way the Dutch labour market has developed (Mol, Van Ours, and Theeuwes, 1988; Hooghiemstra and Niphuis-Nell, 1993; Plantenga, 1993).

The first specific development is in the Netherlands' unparalleled system of pillarization (Lijphart, 1975). This system reached its summmum in the period after the Second World War and resulted from the religious composition of the population. The members of the Roman Catholic church and several Protestant denominations did not collaborate in the educational system, in political parties, or in any other organization. The social-democratic party formed a pillar of its own. The 'front mentality' of the religious and political leaders facilitated value systems strongly tied to religion. In this climate, the wife's role remained confined within the family (Van Heek, 1954) and she was not expected to be active in paid labour outside the home. An important consequence of religious rigidity in the Netherlands is a high fertility rate until the late 1960s, whereas fertility in neighbouring countries like Germany, the UK, Belgium, and France had started to drop years before. Most religious pillars were against any form of birth control, and in the Netherlands they could impose their norms on the faithful longer than in these less pillarized countries.

Since the 1970s, the modernization process has been powerful in the Netherlands, and the trend towards secularization has been strong, as indicated by the abrupt decline in the religious proportion of the population. In 1960, the proportion of the population recorded as religious in official (municipal) records was 82 per cent; by 1990, it had fallen to 62 per cent (Becker and Vink, 1994: 46). In the Netherlands, municipal records used to underestimate the number of non-religious persons, as they automatically assumed that children have the same religion as their parents. Interviews show that the proportion of the population that considers itself religious has decreased much faster than is shown by municipal records. In 1994, about half of the population responded negatively to the question of whether they could be considered religious, whereas in 1960 the proportion was over 70 per cent (Peters, 1993; Becker and Vink, 1994). The pillars lost their power and could no longer prevent people from using contraceptives. This process led to both decreasing fertility and to a more tolerant general attitude towards the participation of married women in the labour market (Sociaal en Cultureel Planbureau, 1994: 543).

The second specific development in the Netherlands that explains the relatively late appearance of married women's paid work has been the restructuring of the labour market. The labour market developed somewhat differently in the Netherlands than in its neighbouring countries. After the Second World War, the industrial sector did not develop as strongly as in Germany or Britain. Until 1960, married women were not needed in the labour market, and although the economic boom of the 1960s put the labour market under pressure, they were still not allowed to participate in the labour market. The shortage of unskilled manual workers was solved by engaging migrant workers instead, and jobs in the growing tertiary sec-

tor were taken by Dutch men. However, after 1970, increased labour demand for employment in the service and welfare-state sectors influenced female labour-market participation to a large degree. By this time, the religious system had loosened its grip on society, and married women became available for service-sector work. Educational expansion and the diminishing power of the ideological pillars gave way to an emancipation of women in the Netherlands, and their occupational aspirations increased.

The availability of part-time employment is strongly related to this process. Until the 1960s, part-time employment was barely available in the Netherlands, and it did not become an important phenomenon until the 1970s. In the 1970s, the proportion of women working in part-time jobs increased enormously, and in the 1990s three out of five working women in the Netherlands have a part-time job. Among married women, the proportion is more than four out of five. Eurostat statistics show that the Netherlands has the highest proportion of women working in part-time jobs in the European Community (OECD, 1991). It is hard to explain this exceptional situation. Women work part-time in all sectors of the labour market, so the absence of women in manufacturing and construction cannot be the main reason. It is possible that the remnants of the value system of the pillarization period are still at work. These are present not only in the norms that people hold with respect to the role of married women in the family, but have also been crystallized in institutions, for example the lack of childcare services and the tax system. It is uncertain whether these institutional barriers do indeed depress female labour-market participation, or whether both low participation and the lack of favourable conditions are jointly caused by a generally negative attitude towards full-time work by married women. It is significant that the large proportion of women working in part-time jobs is not the result of the unavailability of full-time jobs. On the contrary, in the Netherlands 35 per cent of women working full-time would like to work part-time, whereas only 8 per cent of women working part-time would prefer full-time jobs (Kunnen *et al.*, 1995). Many women seem to accept full-time jobs only because part-time jobs are not available to them. This fact does not remove our uncertainty over whether the lack of childcare services is the cause of the small proportion in full-time jobs, or whether the demand for it is low.

Table 8.1 illustrates developments in the labour-market participation of women and men in the Netherlands between 1960 and 1994. All data come from nationally representative data-sets, starting with the Censuses of 1960 and 1971, which were the last Censuses in the Netherlands, and proceeding with the labour-market surveys collected by the Netherlands Central Bureau of Statistics. Although strict comparability is problematic due to changes in the definition of employment, it is clear that there has been a very strong overall upward trend in female employment. In 1960, only 23

TABLE 8.1. *Trends in employment rates in the Netherlands, 1960–1994 (%)*

	Women aged 15–64			Men aged 15–64		
	No job	Full-time: >35 hours	Part-time: 1–34 hours	No job	Full-time: >35 hours	Part-time: 1–34 hours
1960	77	21	2	11	—	—
1971	70	24	6	15	—	—
1973	69	22	9	17	—	—
1975	68	23	9	18	—	—
1977	67	19	14	20	76	4
1981	61	21	18	22	73	7
1985	58	20	22	23	71	6
1987	57	18	25	27	63	11
1988	55	18	27	26	63	11
1989	55	18	28	25	64	11
1990	52	19	29	25	64	11
1991	50	19	30	24	64	12
1992	49	19	32	24	66	10
1993	48	19	33	25	65	10
1994	47	19	34	25	64	11

Sources: Census 1960, Census 1971, Labour Force Surveys (AKT and EBB) 1973–94; own computations and as cited by Mol, Van Ours, and Theeuwes (1988) and Hooghiemstra and Niphuis-Nell (1993).

per cent of all Dutch women between 15 and 64 had a job; by 1994, this proportion had increased to 53 per cent. Developments in the availability of part-time employment completely explain this trend. In 1960, part-time work was virtually non-existent: only 2 per cent of all Dutch women worked in part-time jobs; by 1994, this had increased to 34 per cent. Today, about 60 per cent of all working women have a part-time job. It is striking that the proportion of Dutch women working full-time was stable during this period. In 1960, only one in five women was employed in a full-time job and this proportion did not change over 35 years.

The increase in part-time employment can be observed for men as well, but among men, part-time work is mainly limited to the first part of the occupational career, especially in times of high unemployment, when there are limited opportunities for finding full-time work. It is also more prevalent near the end of a career, when early retirement programmes offer reduced working hours. Only a small proportion of men choose to work part-time (Kunnen *et al.*, 1995) and the apparent increase is generally a result of changes in the labour market.

The strong increase in female labour-market participation is often seen as an indicator of growing equality between men and women, and specifically as an indicator of a reduction in the dependency of wives upon their husbands, as the number of dual-earner couples has grown. However, these developments must be seen from a life-course perspective. Although a growing number of married women have paid jobs, most women are still financially dependent on their husbands during substantial periods in their lives, especially when they are taking care of young children. Table 8.2 illustrates this point, using cross-sectional data from the 1991 Labour Market Survey, as collected by the Central Bureau of Statistics (Enquête Beroepsbevolking). Although cross-sectional data are not appropriate for the demonstration of historical or individual developments in female labour-market participation, this large-scale data-set (N=83,996) gives a reliable picture of the present situation in the Netherlands. The table shows the relationship between family formation and employment in 1991.

Among the unmarried population without children only small differences in the labour supply of men and women can be observed, regardless of age. About 87 per cent and 73 per cent of the age groups between 18 and 40 years and between 41 and 54, respectively, are economically active, which holds for both men and women. However, about 10 to 15 per cent more unmarried women than unmarried men are working in part-time jobs. When people in the Netherlands get married, the differences between men and women grow, even when there are no children at home. Whereas married men without children have a slightly higher rate of labour-market participation than unmarried men without children, married women without children have a much lower labour-market participation than their

TABLE 8.2. *Employment rate related to family status in 1991 (%)*

	Women			Men		
	No job	Full-time: >35 hours	Part-time: 1–34 hours	No job	Full-time: >35 hours	Part-time: 1–34 hours
Unmarried, no children, aged 18–40	12	67	21	13	75	11
Unmarried, no children, aged 41–54	27	48	26	26	62	12
Married, no children, aged 18–40	13	53	33	6	87	7
Youngest child 0–3 years	60	5	35	7	83	9
Youngest child 4–17 years	48	11	41	7	83	10
Married, no children, aged 41–54	55	12	33	16	74	10

Note: Base = population aged 18–54, not in education or military service.

Source: Labour Force Survey (EBB) 1991, own computations.

unmarried counterparts. Whereas 67 per cent of unmarried women without children between 18 and 40 have a full-time job, only 53 per cent of married women without children in this age group work full-time. The difference can be explained by an increase in part-time work. If this cross-sectional data could be interpreted as offering a life-history perspective (which of course it cannot, due to the conflation of life-cycle and cohort effects), we could claim that about 15 per cent of women entering marriage leave their full-time jobs for part-time work.

In the Netherlands, more than 50 per cent of women seem to leave the labour market completely or partially as soon as they have children. Of course, we must again recognize that this interpretation of cross-sectional evidence is not completely warranted. Only 5 per cent of all women with a child of pre-school age have a full-time job; 35 per cent have a part-time job; and 60 per cent have no job at all. When children go to school, more but not many more, mothers return to the labour market: the proportion rises from 40 per cent to 52 per cent. It is notable that married women aged 41 to 54 who do not have childcare responsibilities have the same labour-market participation as women who take care of children between the ages of 4 and 17. The return to the labour market seems to be either undesired or not feasible.

Educational attainment is strongly associated with the labour-market participation of women at all phases of the life-cycle, as is shown in Table 8.3. Whereas only 41 per cent of all less well educated married women without children have full-time jobs, 63 per cent of their highly educated counterparts work full-time. The combination of working full-time and having a child younger than 4 years of age does not seem to be an option for any woman, regardless of her level of schooling. However, the proportion of mothers of young children who work part-time is strongly related to educational attainment: 19 per cent of the less educated and 57 per cent of the highly educated mothers of pre-school-aged children have part-time jobs. As the children get older, the differences between the two groups become somewhat smaller, but they are still considerable. Whereas 58 per cent of all less well educated mothers with a youngest child between the ages of 4 and 17 have no job, only 28 per cent of highly educated mothers remain out of the labour market. The strong relationship between schooling and employment might be an explanation for the increasing labour-market participation of married women in the Netherlands.

Historical Changes in Labour-Market Participation from a Life-Course Perspective

It is tempting to interpret employment differences between family statuses from a life-course perspective. However, doing so can lead to false

TABLE 8.3. *Female employment rate related to family status and level of schooling in 1991 (%)*

	No job	Full-time: >35 hours	Part-time: 1–34 hours
Unmarried, no children, aged 18–40			
Education: low	20	61	19
middle	9	71	20
high	10	67	24
Married, no children, aged 18–40			
Education: low	25	41	35
middle	9	57	34
high	7	63	31
Youngest child 0–3 years			
Education: low	77	4	19
middle	55	5	40
high	35	8	57
Youngest child 4–17 years			
Education: low	58	8	34
middle	40	14	46
high	28	15	58
Married, no children younger than 18, aged 41–54			
Education: low	62	8	30
middle	45	17	38
high	34	27	39
Unmarried, no children, aged 41–54			
Education: low	47	35	18
middle	14	58	28
high	15	53	31

Notes:
Base = female population aged 18–54, not in education.
Education low: primary and lower secondary (LO, LBO, MAVO).
Education middle: higher secondary (MBO, HAVO, VWO).
Education high: tertiary (HBO, WO).

Source: Labour Force Survey (EBB) 1991, own computations.

interpretations and prevent us from gaining insight into historical developments. Women in the later stages of family formation are from older birth cohorts and may in general have lower attachment to the labour market. To gain a better insight into women's position in the labour market over the life-course, we present the results from an analysis that maps out the complete employment careers of birth cohorts born between 1925 and 1974, using data from a recent life-history study which enables us to analyse the relationship between family formation and labour-market participation over time. First, we look at the labour-market participation of successive birth cohorts over the life-course to find out how patterns have changed over half a century. Second, we analyse the covariates of female

labour-market participation, linking it to the process of family formation and the husband's career.

The life-course data-set is the Family Survey of the Dutch Populations 1992–3 (Ultee and Ganzeboom, 1993). This survey is representative of the Dutch population and provides information on the life histories of 1,000 primary respondents and their spouses (or partners in cohabiting couples). A retrospective research design was used to map all life events: educational and occupational careers, family formation, fertility, migration, and health. Spouses were asked exactly the same questions, providing information on another 800 individuals. We thus have information for 890 women.

The analysis examines labour-market transitions and their dependence on phases in the family cycle. It is not self-evident which definition of part-time and full-time employment should be chosen, but we decided to use the same definition as the Netherlands Bureau of Statistics. The three key statuses are:

1. No job (housewife, unemployed, disabled, etc.);
2. Part-time job (less than 35 hours a week);
3. Full-time job (35 hours or more a week).

Transitions between these states will be the units of analysis. The 890 women are categorized into five birth cohorts:

1. Born between 1925 and 1934 N=85;
2. Born between 1935 and 1944 N=172;
3. Born between 1945 and 1954 N=252;
4. Born between 1955 and 1964 N=274;
5. Born between 1965 and 1974 N=107.

Although the sample sizes of these cohorts are not very large, we will show that they allow us to establish clear and significant historical patterns. Finally, we distinguish five phases in the family cycle:

1. Not married or living together;
2. Married/living together, no children;
3. Married/living together, youngest child younger than 4 years;
4. Married/living together, youngest child between 4 and 18 years old;
5. Married/living together, youngest child older than 18 years old.

In contrast to the statistics presented above, we can now present longitudinal information. We can see how a cohort of women has gone through the several phases of family formation and how these women have participated in the labour market. First, we distinguish women before and after marriage (grouping together marriage and consensual unions). When the youngest child in the family is younger than three years, free daycare is not available. When the youngest child is four years old, he or she goes to pri-

mary school (or kindergarten). We assume that when the youngest child becomes 18 years of age, the family ceases to have childcare responsibilities.

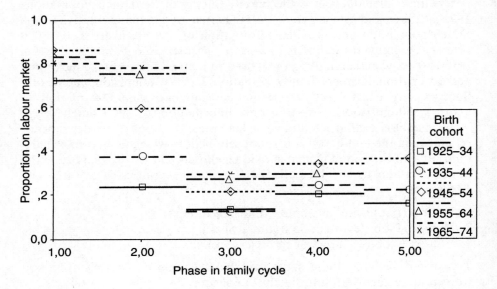

FIG. 8.1. Labour-market participation of cohorts of married women in the Netherlands, according to family cycle

Note: 1. before marriage; 2. married, without children; 3. married, youngest child younger than 4 years old; 4. married, youngest child between 4 and 18 years old; 5. married, youngest child 18 years or older.

Cohort Analysis of Full-Time and Part-Time Work

Fig. 8.1 presents changes in the relationship between female economic activity and the family cycle in the Netherlands. It displays the proportion of married women in work at each stage of family formation, grouping together full-time and part-time work. The overall relationship between family status and female labour-market participation found in cross-sectional data is replicated in this longitudinal analysis. Before marriage, employment rates are high. Employment decreases after marriage, and after the first child is born, rates are low in all cohorts. When children grow up, there is a slight increase in work rates.

In each successive cohort, employment rates rise in each phase of the life-cycle. Before marriage, the increase in labour-market participation is limited, rising from about 70 per cent to about 90 per cent. Between marriage and the birth of the first child (phase 2), the change is spectacular: almost all women born before 1945 stopped working as soon as they married, but

the pattern changed completely for the post-war cohorts. In the youngest cohorts, marriage has little impact on participation in the labour market. After children are born (phase 3), most married women refrain from participation in the labour market even in post-war cohorts, but, a firm trend towards greater economic activity can be observed even for those women who have a young child. The proportion of working women with a child of pre-school age has increased from about 15 per cent in the oldest cohort to 30 per cent in the cohort born around 1970. When the children reach school-age and leave the household (phase 5), labour-market participation of married women is far below 50 per cent, even for the youngest cohort reaching this phase in the family cycle (born around 1950). An upward trend can also be observed here: for married women who no longer have childcare responsibilities, the proportion employed has increased from about 20 to 40 per cent.

Fig. 8.2 also displays the development of female labour-market participation over time, but it only examines full-time jobs. The results are striking: an increase in full-time employment is only visible before children enter the family. Younger cohorts of women continue to work full-time until they have their first child. In all further phases, full-time employment is scarce and there is not much of a change. Hardly any woman born

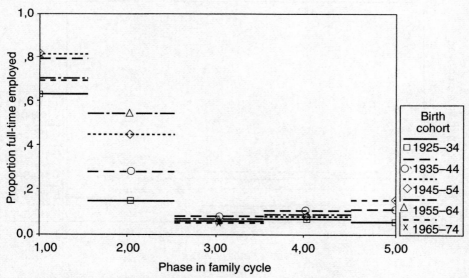

FIG. 8.2. Full-time labour-market participation of cohorts of married women in the Netherlands, according to family cycle

Note: 1. before marriage; 2. married, without children; 3. married, youngest child younger than 4 years old; 4. married, youngest child between 4 and 18 years old; 5. married, youngest child 18 years or older.

before 1975 kept her full-time job after having her first child. Only women who did not yet have children worked full-time, and for women with children it was apparently not feasible to be in full-time employment.

Fig. 8.3 is complementary to Fig. 8.2, showing that the trends in female employment are totally due to changing rates in part-time employment. These trends are not only apparent in the phases where we expect them (when married women are preoccupied with taking care of children). Even in preceding and succeeding phases, the proportion of part-time working women has increased. Apparently, for many women (and their husbands), part-time employment is indeed an acceptable way to be active in the labour market and also continue working in the household.

Event-History Analysis: Labour-Market Transitions

In this section, we investigate the determinants of transitions between the three states 'full-time job', 'part-time job', and 'no job', by following the occupational career from month to month. For each woman, we constructed a separate data record for every month on which information is

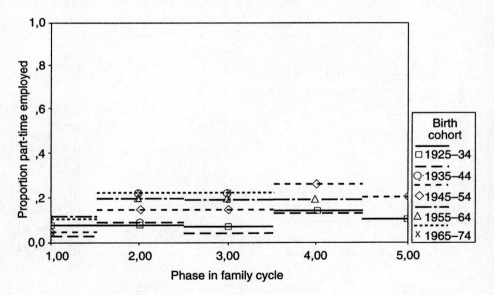

FIG. 8.3. Part-time labour-market participation of cohorts of married women in the Netherlands, according to birth cohort and family cycle

Note: 1. before marriage; 2. married, without children; 3. married, youngest child younger than 4 years old; 4. married, youngest child between 4 and 18 years old; 5. married, youngest child 18 years or older.

available (each record is called a month-person record). The first month of the data record is the month exactly one year before she marries or starts a consensual union. This enables us to investigate how women's employment careers are structured over the life-course, from the phase before marriage until (if applicable) the phase in which the children leave their parents' household. Table 8.4 displays a cross-tabulation of all month-person records, in which the employment status on the first day of a given month is compared with the employment status one month earlier. This transition table shows, for example, that married women exited the labour market 781 times from a full-time job and 349 times from a part-time job. A transition from the state of no job ('housewife') to a part-time job occurred 506 times, and to a full-time job 871 times. To estimate the effects of covariates on transitions, we used event-history analysis (Allison, 1984). We used a 'discrete time analysis' with a logistic response model, in which the transition was the dependent variable. The logistic response model is:

$$\log (p \setminus 1 - p) = \beta\ X$$

in which p is the probability of a transition occurring and $\log (p \setminus 1 - p)$ is the logit of this probability, which is the dependent variable in the analysis. X is the collection of predictor variables and β represents the effects of the predictor variables on the logit which must be estimated. In the regression equations that we present below, β is displayed in exponential form, which enables us to interpret the effects as multiplicative partial effects on the odds $(p / 1 - p)$. Because the transition probability in a given month is very low (due to the large number of immobile women in each month, $p \setminus 1 - p$ is almost equal to p, and we can interpret the transformed effects as multiplicative effects on the monthly transition probability itself.

We analyse only three transitions:

TABLE 8.4. *Transitions in labour-market careers of married (or cohabitating) women in the Netherlands*

Month n+1	Month n			
	No job	Part-time: 1–34 hours	Full-time: 35+ hours	All
No job	155 448	349	781	156 578
Part-time job (1–34 hours)	506	37 731	164	38 401
Full-time job (35+ hours)	871	73	75 827	76 771
All	156 825	38153	76 772	271 750

Source: Family-Survey Dutch Population 1992/93 (Ultee and Ganzeboom, 1993).

- a transition from the labour market to no job (exit);
- a transition from no job to any job (re-entrance), without differentiating between part-time and full-time work—generally, entrance to the labour market will be re-entry in this data-set given the sample used, and we have not distinguished between first entries and re-entries,
- (re-)entrance to the labour market with a full-time job.

The predictor variables employed in the analysis are:

- The phase in the family cycle and the birth cohorts, as defined above, and their interaction terms. The interaction effects of family cycle and cohort indicate whether changes have occurred in the labour-market transitions of the successive birth cohorts.
- Educational attainment, measured on a scale from 1 to 10 (from primary school to post-university education). This scale takes into account that the Dutch educational system has different tracks within secondary and tertiary education, although they have the same duration. Types of education are scaled according to their value in the labour market.
- Educational status, indicating whether a woman is still at school.
- Occupational prestige, coded according to the prestige scale of Sixma and Ultee (1983).
- Experience/duration, which is measured as the time a woman has been in the labour market (in the analysis of the determinants of employment exit) or as the time a woman has been out of the labour market (in the analysis of the determinants of employment entry). Both the linear and the quadratic terms of these indicators of duration are included in the analysis.
- Educational attainment of the husband.
- Occupational prestige of the husband.

The inclusion of the educational and occupational position of the husband needs some additional explanation. We test two hypotheses which argue that the employment history of women is affected by their husbands (cf. Bernasco, 1994). The first hypothesis stems from the household production theory (Becker, 1981); it argues that the occupational success of a husband has a negative impact on the wife's incentive to be active in the labour market. The second hypothesis stems from the 'social capital' theory. It argues that women can profit from the knowledge and social resources of their husbands. De Graaf and Ultee (1991) have shown that spouse effects are mainly positive. Spouse's employment status affects transitions from unemployment to employment positively and transitions from employment to unemployment negatively. This helps to explain why employment and unemployment come in couples (Ultee, Dessens, and Jansen, 1988). Bernasco (1994) argues that in a multivariate model, husband's occupa-

tional position should have negative effects, and husband's educational status should have positive effects on women's employment entry. For employment exits, the effects should be the other way around. Since these hypotheses are supported by our data, we gain additional corroboration for our idea that women's labour-market participation must be seen from a household perspective.

Table 8.5 gives the estimates of the logistic regression equations. The first equation deals with the determinants of employment exit. The probability of a woman leaving the labour market is affected by the family cycle, and this relationship has changed over the century. For the older cohorts, the probability of employment exit is relatively high in the phase between marriage and the first child, but for the youngest cohort this is no longer the case. For the oldest cohort of women, born between 1935 and 1944, the odds of leaving employment are 18.9 higher in the phase after marriage than in the phase before. This factor of 18.9 decreases at a factor of 0.5 for every next cohort and from the second to the fifth cohort, it reaches the low values of 9.7, 5.0, 2.6, and 1.3. Therefore, the youngest cohort of women are no longer inclined to leave the labour force when they marry. In the other phases of the family cycle, we do not observe a change over cohorts, as can be seen from the non-significant interaction terms in the equation. The inclination to become a full-time housewife is larger if there are young children to take care of, and the impact of this relationship has not changed in 40 years. It seems that the attachment of married women to the labour market, as indicated by the quality of their job, is directly related to the probability of employment exit. Occupational prestige has a negative effect on employment exit. Educational attainment and spouse's characteristics do not have any effect at all.

The second regression equation analyses employment re-entry. We observe that in all phases of the family cycle, younger cohorts re-enter the labour market at higher probabilities, but least so in the phase when there are children younger than 4 years of age in the family. In general, the probability of employment entry is very low for all cohorts. In the phase when the youngest child is between 4 and 18, the (conditional) odds ratio has increased—from 0.04 for the oldest cohort to 0.22 for the youngest cohort. It is very likely that the option of part-time employment has facilitated this increase.

The third regression equation only looks at entries into full-time jobs. The hypothesis that cohort developments in employment rates of married women are facilitated by the emergence of part-time work is strongly supported, as can be seen from the disappearance of the interaction effects of cohort and family cycle. Apparently, re-entry into full-time employment is not a satisfactory alternative for married women.

Furthermore, we observe that women with higher educational attain-

TABLE 8.5. *The effects of family cycle on entry into and exit from the labour market of married (or cohabitating) women in the Netherlands*

	Exit	Entry	Entry to full-time job
Before marriage (reference)	1	1	1
Cohort	1.121	1.211*	1.177*
Married, no children	18.902*	0.111*	0.103
* cohort	0.513*	1.399*	1.244
Married, youngest child 0–3	3.640*	0.035*	0.016*
* cohort	1.098	1.167	1.037
Married, youngest child 4–17	2.329*	0.036*	0.013*
* cohort	0.753	1.577*	1.491
Married, youngest child 18+	0.982	0.002*	0.004*
* cohort	1.080	6.618*	1.666*
Experience/duration	0.939*	1.006	0.948
Experience/duration squared	0.999	0.999	0.999
Educational attainment	0.967	1.156*	1.168*
In education	—	0.107*	0.079*
Occupational prestige	0.993*	—	—
Education husband	1.028	1.064*	1.048*
Occupation husband	0.998	0.993*	0.989*
Number of events	702	774	492
Number at risk	68 127	108 081	108 081

Notes: The number of cases is considerably lower than in Table 8.4 due to missing values. The models are logistic response models.
* denotes p significant at 0.05 level.

Source: Family-Survey Dutch Population 1992/93 (Ultee and Ganzeboom, 1993).

ment are more likely to re-enter the labour market, and that women who are in education have a very low probability of re-entering the labour market. Less trivial are the effects of husband's educational and occupational status. As predicted, the spouse's occupational position affects the employment entry of women negatively. A lack of financial incentives must explain this (Bernasco, 1994). In contrast, husband's educational attainment is positively related to employment entry, which indicates that at the time of marriage, a woman who has a well-educated husband benefits from his occupational career. These effects only emerge, when both education and occupation (or income) are taken into account at the same time, as otherwise they cancel each other out.

Conclusions

Female employment has increased in the Netherlands since the 1960s and especially in the 1980s, as in most other European countries. The conclusions that we draw from our life-history data-set are in line with the cross-sectional evidence, so this can now be placed in historical perspective. Our results show that the increase in female employment arises from two developments.

The first is married women's increased participation in full-time work after marriage and before motherhood. Only one in five women in the labour market has a full-time job, and they are to be found among unmarried women, and, increasingly, among married women without children. Because the period between the completion of educational attainment and marriage (or living together) has decreased as a result of longer years in full-time education, and because at the same time the period between marriage and the first birth has increased, the total proportion of women working full-time has not changed. Seen from a life-course perspective, this implies that women from younger cohorts do not work more years in full-time employment than women from older cohorts.

The second important development is the availability of part-time work. Increasing proportions of women are active in the labour market after they have their first child, but only on a part-time basis. Therefore, the significance of increasing female economic activity for gender stratification can be over-estimated. Most of the work done by married women with children is part-time work, which brings fewer financial rewards than full-time employment, and if married women keep on working significantly fewer hours than their husbands, decreasing dependency does not follow. In 1989, only 30 per cent of all women between the ages of 18 and 64, which is 70 per cent of all working women, could be considered to be financially independent in the Netherlands (Hooghiemstra and Niphuis-Nell, 1993: 168). They had an income above the social minimum, which was about DFL 1100 (Dutch guilders) in 1994. Most women are, of course, financially independent before they have children, but since the majority of young women plan to have children, they anticipate a period of economic dependency. This influences their work orientations even in the period before they become dependent.

This does not mean that the increase in part-time work is a negative development. Married women's part-time attachment to the labour market will increase their status within the household to some extent. It may also facilitate a return to full-time work after the children are older. In the Netherlands, hourly wages are only slightly lower for part-time than for full-time workers, and job security for part-time work is as good as for

full-time work (Delsen, 1988). Moreover, most part-time employment takes place in the service sector of the labour market, which is not very sensitive to economic conditions. It seems that in the Netherlands, part-time work is the rational way for married women to contribute to the family income, as it does not depart from prevailing norms that married women should give priority to their domestic work.

REFERENCES

Allison, P. D. (1984), *Event History Analysis: Regression for Longitudinal Event Data* (Beverly Hills, Calif.: Sage).

Becker, G. S. (1981), *A Treatise on the Family* (Cambridge, Mass.: Harvard University Press).

Becker, J. W. and Vink, R. (1994), *Secularisatie in Nederland 1966–1991* ('Secularization in the Netherlands 1966–1991'), (Rijswijk: Sociaal en Cultureel Planbureau).

Bernasco, W. (1994), *Coupled Careers* (Amsterdam: Thesis).

Delsen, L. (1988), 'Deeltijdarbeid en informele economie' ('Part-Time Work and the Informal Economy'), *Tijdschrift voor Arbeidsvraagstukken*, 4: 37–46.

Graaf, P. M. de and Ultee, W. C. (1991), 'Labor Force Mobility and Partner Effects', *Netherlands Journal of Social Sciences*, 27: 43–59.

Van Heek, F. (1954), *Het Geboorteniveau der Nederlandse Rooms-Katholieken: Een Demografisch-Sociologische Studie van een Geëmancipeerde Minderheidsgroep* ('The Birth Rate of Roman Catholics in the Netherlands') (Leiden: Stenfert Kroese).

Hooghiemstra, B. T. J. and Niphuis-Nell, M. (1993), *Sociale Atlas van de Vrouw, ii. Arbeid, Inkomen en Faciliteiten om Werken en de Zorg voor Kinderen te Combineren* ('Social Atlas of Women') (Rijswijk: Sociaal en Cultureel Planbureau).

Kunnen, R., Praat, W. C. M., Smulders, H. R. M., de Voogd-Hamelink, A. M., Vosse, J. P. M., and van Werkhooven, J. M. (1995), *Trendrapport Aanbod van Arbeid 1995* ('Report on Trends in Labour Supply') (The Hague: OSA).

Lijphart, A. (1975), *The Politics of Accommodation: Pluralism and Democracy in the Netherlands* (Berkeley, Calif.: University of California Press).

Mol, P. W., Van Ours, J. C., and Theeuwes, J. J. M. (1988), *Honderd Jaar Gehuwde Vrouwen op de Arbeidsmarkt (OSA-Werkdocument W48)* ('A Hundred Years of Married Women's Involvement in the Labour Market') ('s-Gravenhage: Organisatie voor Strategisch Arbeidsmarktonderzoek).

OECD (1991), *Employment Outlook 1991* (Paris: OECD).

Peters, J. (1993), *Individualisering en Secularisering in Nederland in de Jaren Tachtig* ('Individualization and Secularization in the Netherlands in the 1980s') (Nijmegen: ITS).

Plantenga, J. (1993), *Een Afwijkend Patroon; Honderd Jaar Vrouwenarbeid in Nederland en (West-)Duitsland* ('A Deviating Example: One Hundred Years of Women's Work in the Netherlands and (West) Germany') (Amsterdam: Sua).

Sixma, H. and Ultee, W. (1983), 'Een beroepsprestige voor Nederland in de jaren tachtig' ('Job Prestige in the Netherlands in the 1980s'), *Mens en Maatschappij*, 58: 360–82.

Sociaal en Cultureel Planbureau (1994), *Sociaal en Cultureel Rapport 1994* ('1994 Social and Cultural Report') (Rijswijk: SCP).

Ultee, W. C., Dessens, J., and Jansen, W. (1988), 'Why does Unemployment come in Couples? An Analysis of (Un)employment and (Non)employment Homogamy Tables for Canada, the Netherlands and the United States in the 1980's', *European Sociological Review*, 4: 111–22.

—— and Ganzeboom, H. B. G. (1993), *Familie-Enquête Nederlandse Bevolking 1992/93* ('Netherlands Family Survey 1992/93') [machine readable data-set]. (Nijmegen, Department of Sociology Nijmegen University).

9

Part-Time Work among British Women

BRENDAN J. BURCHELL, ANGELA DALE,
AND HEATHER JOSHI

Introduction

Part-time working in Britain is unusually high by comparison with North America and most countries of the European Community. Only the Netherlands, Denmark, and the Scandinavian countries have higher levels. In Britain, part-time jobs occupy a distinctive location in the labour market: they are highly sex-segregated, and there are very strong associations between the presence of children and part-time work. This chapter begins by providing a background to women's part-time work in Britain. It locates part-time working in a historical context; examines the current situation of part-time workers; highlights some of the consequences of part-time working; and looks at the likely directions for the future. We then present new evidence on the dynamics of part-time employment experiences.

Historical Context

Although women have always engaged in paid work, there have been fluctuations in the overall level and the type of work. During the first half of this century women were highly restricted in the kinds of occupation that they could enter and in many non-manual occupations women were compelled to resign from their jobs on marriage. The marriage bar was particularly widely used during the depression of the 1930s and stayed in force in the Civil Service until 1946 and in the Post Office until 1963 (Walby, 1986).

In both the 1914–18 and the 1939–45 world wars, restrictions on women's employment were removed. British women were urged to take on work traditionally done by men—for example, in ship-building, munitions factories, public transport, and agriculture. Day nurseries were rapidly set up to take care of women workers' children. In the Second World War in particular, part-time working was introduced as an alternative means of

enabling women with children to take part in the 'war effort'. However, the trade unions had opposed women's entry to men's jobs during the war and only agreed on the condition that women left them as soon as the war was over. At the end of the wars, nurseries closed and women returned to their homes or to 'women's' work—although this phenomenon was less marked in 1945 than in 1918.

The Rise of Part-Time Working

The post-war economy of the 1950s needed more workers. There were three main reasons: first, economic growth and reconstruction; second, the growth of services associated with the welfare state; and third, an increase in the 'dependent population' through a higher birth-rate and greater numbers of elderly people. Labour shortage was exacerbated by a decline in the number of single women available for work as the sex ratio of the adult population became more balanced (Dale, 1991). During the 1950s and early 1960s, demand had been partly met by recruitment of immigrants from the Commonwealth. However, during the mid-1960s, Britain restricted further immigration, and leaders of industry identified an alternative source of labour: the 'reserve army' of married women (CBI, 1967; Fabian Society, 1966). They proposed an increase in part-time jobs that would fit in with what was seen as women's primary responsibility—home and children. At the same time there was a growing number of women keen to find a way of combining employment with childcare. This was a notably different solution than that adopted by some other European countries (e.g. France and Belgium) where the provision of daycare and after-school facilities enabled women to work full-time and (e.g. France and Germany) where immigrant workers formed a much more important solution to the labour shortage.

Employers were, at first reluctantly, persuaded to meet their labour shortages by introducing part-time jobs for women. Jobs were set up in a context in which married women were seen as 'a necessary expedient to tide over a period of labour shortage' (Klein, 1961: 39) and on the assumption that their primary responsibilities lay at home. Thus, part-time work was explicitly designed to be undemanding and lacking in promotion prospects and responsibility. Invariably, part-time jobs were also low-paid and segregated from the work of men. The ramifications of this are still being experienced by women today and are discussed in more detail below.

The British post-war ideology of married women as homemakers, economically dependent on their husbands, was also entrenched in the framework for the welfare state, contained in the 1942 Beveridge Report. This view informed the 1946 Royal Commission on Equal Pay, which opposed equal pay for women, except for some categories of civil servants. It was

not until 1955 that women in professional branches of teaching, local government, and the civil service were given equal pay (Holdsworth, 1988). The presumption of wives' dependency and of mothers' primary commitment to childcare can still, today, be traced in social security legislation and underlies the high levels of part-time work amongst women with children.

Part-Time Work in the Post-War Era

By 1991 about 26 per cent of the British workforce was part-time; this represented about 45 per cent of women and 6 per cent of men who were in the workforce (Employment Department figures). As shown in Fig. 9.1, part-time working has been responsible for most of the growth in women's

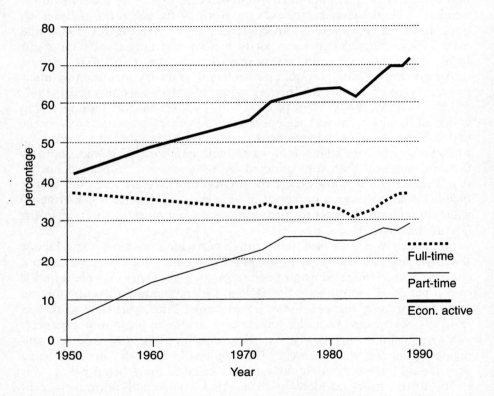

FIG. 9.1. Economic activity rates of women aged under 60 in Britain, 1951–1989
Note: For 1951–71 the lower age-limit is 15; for 1973–89 it is 16.
Source: Figures for 1951 and 1961 from Joshi (1990*a*) based on the Census of Population 1971–89 from the General Household Survey published reports

employment since 1951. It is only since the mid-1980s that there has been any indication of growth in the level of full-time working amongst women (Joshi, 1990*a*; Dale and Joshi, 1992; Hakim, 1992). This rise in part-time working was largely the result of the entry (or re-entry) of married women with children into paid employment. The relationship between part-time work and child-rearing will be discussed in greater detail later.

It has already been suggested that there were strong demand factors which resulted in the construction of part-time jobs for women with family responsibilities. However, the growth in the availability of part-time jobs was also accompanied by a demand, particularly amongst women with children, to work part-time. This coincided with the greater availability of labour-saving domestic appliances, as well as the greater availability of family planning methods which gave women more control over their fertility than in earlier decades.

The re-structuring of British industry in the late 1970s and early 1980s resulted in an expansion of the service sector and a resulting expansion of jobs which were already being done by women on a part-time basis (e.g. shop work, catering, and cleaning). It was not until around 1986 that there was evidence of an increase in women's full-time employment. The recession of the late 1980s and the early 1990s has, again, impacted most heavily on full-time employment and has left the level (if not the terms) of part-time employment largely unaffected.

Work Hours

In Britain there is considerable variation in the number of hours worked by part-timers. Whilst there is a formal definition of 30 hours or less, women themselves do not apply such definitions. Recent qualitative work by the Employment Department (Watson and Fothergill, 1993) suggest that women's own definitions may include anything from 2 to 37 hours a week. Fig. 9.2, from the 1992 Labour Force Survey, shows the hours worked by women who defined themselves as part-time. Although there is a peak at 20 hours, there is considerable variation on either side and a median point which is well below 20 hours. The hours of part-timers also show considerable variability, with 44 per cent of part-timers reporting variation from week to week (Watson and Fothergill, 1993).

The Occupational Distribution of Part-Time Jobs

Women who work part-time are known to be highly concentrated in a limited number of occupations. The 1992 LFS (Watson and Fothergill, 1993) showed that nearly 80 per cent of part-timers were in four major groups of

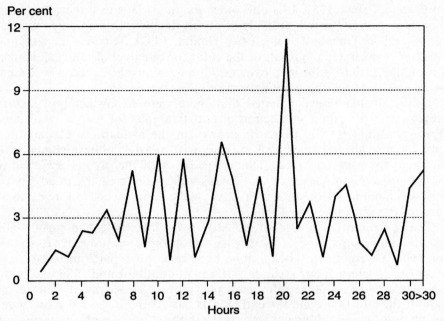

Fig. 9.2. Distribution of total usual weekly hours of part-timers
Source: Watson and Fothergill, 1993, based on spring 1992 LFS estimates.

the Standard Occupational Classification (SOC). One-third were classified in SOC 7, sales occupations; 19 per cent were in SOC 4, clerical and secretarial occupations; 18 per cent in SOC 7, personal and protective services; and 9 per cent in SOC 2, professional occupations. With the exception of the last category, these are also highly feminized tasks, seldom performed by men.

Table 9.1 compares the occupational distribution of women working full- and part-time (defined by the number of hours worked) using the classification of occupations devised for the Women and Employment Survey (Martin and Roberts, 1984). It is evident that by comparison with fulltimers, women working part-time are more likely to be in sales jobs, in semi-skilled domestic work, and in unskilled work.

Occupational Segregation

It is well established that women who work part-time are more likely to work only with other women than women who work full-time (Martin and Roberts, 1984: 28). There are a number of different measures of occupational segregation by sex and there has been considerable debate over the

TABLE 9.1. *Occupational distribution of full-time and part-time working women*

	Women		Men	
	FT	PT	FT	PT
Professional	3	1	8	6
Teachers	7	4	3	5
Nursing	9	8	2	2
Other intermediate	19	6	26	15
Clerical and secretarial	32	22	5	8
Sales and shop assistant	6	17	3	13
Skilled manual	9	6	35	19
Semi-skilled factory	7	3	7	3
Semi-skilled domestic	5	15	1	7
Other semi-skilled	2	3	6	11
Unskilled	2	15	4	12
Total	100.0	100.0	100.0	100.0
Total numbers	(61 610)	(39 834)	(121 697)	(5588)
	39	61	96	4

Sources: Samples of Anonymized Records from 1991 Census (GB); Crown copyright; categorization of occupations based on Martin and Roberts, 1984.

most appropriate (Hakim, 1979; Siltanen, 1990; Hakim, 1992; Blackburn, Jarman, and Siltanen, 1993). However, it seems widely accepted that, in recent years, there has been little overall change in levels of occupational segregation; this is mainly because women have gained greater access to professional jobs, whilst clerical and service sector work has become increasingly feminized (Rubery and Fagan, 1993; 1995). Thus, decreases in occupational segregation amongst full-timers are likely to be offset by increases amongst part-timers.

From Table 9.1 it is evident that a great deal of part-time work is confined to occupations such as childcare, domestic work, and personal service jobs in the public and private sectors. These all tend to be highly sex-segregated. Whilst there are some moves towards opening up management jobs on a part-time basis (Sidaway and Wareing, 1993) these are still embryonic. Table 9.1 shows that women working part-time are still much less likely to be in 'other intermediate' occupations, which include managers, and civil servants in central and local government. Job-sharing is one way in which a full-time job may be divided between two people, each working part-time. However, in 1990 there were only just over 1 per cent of women and a negligible percentage of men who were job-sharing (Wareing, 1992). Organizational obstacles to part-timers supervising others accentuate their vertical segregation. Evidence presented later on illustrates the interaction of continuity in part-time jobs and their sex segregation.

Part-timers in less feminized occupations have been more likely to re-enter full-time jobs, and are presumably less likely to experience long episodes of part-time employment.

Full and Part-Time Pay Differentials

Women's full-time hourly earnings are substantially below those of men—despite the 1970 Equal Pay Act that came into force in 1975. Data from the New Earnings Survey shows that, while women's full-time average earnings (exclusive of overtime) as a proportion of men's, rose from 63.1 per cent in 1970 to 75.5 per cent in 1977, they fell again so that, by 1988, they were still only 75.1 per cent—0.4 per cent lower than the 1977 peak. Since 1988, women's hourly earnings have risen steadily to 77.8 per cent those of men in April 1991—the highest ever.

It is difficult to obtain reliable earnings information for part-time workers. The New Earnings Survey excludes most of those whose earnings fall below the tax threshold—in 1993 this was £66.50 a week. Generally, average gross hourly earnings of women working part-time who are represented in the NES are less than 60 per cent of male full-time employee earnings. This has changed little with time: in 1979, the percentage was 59.3 per cent; in 1988, 56.6 per cent and 58.2 per cent in 1991. It is likely that, were all part-timers to be included, this percentage would be considerably lower.

The pay gap between full-time and part-time women has widened during the 1980s. Female part-time workers have been identified as the only group who did not increase their skills level during the 1980s (Gallie, 1991). Horrell, Rubery, and Burchell (1990) suggest a polarization within the female workforce between those women with higher educational qualifications who are working full-time and the increasing number of part-timers whose jobs are less skilled (see also Scott, 1994 and Rubery, Horrell, and Burchell, 1994).

Women Working Part-Time: Reasons and Consequences

In Britain, part-time working is a largely female phenomenon and strongly related to marital status and child-rearing. Of all those working part-time, 85 per cent are female (1992 Labour Force Survey figures quoted by Watson and Fothergill, 1993). Of the 15 per cent of part-timers who are men, 31 per cent are aged 16–19 and 43 per cent are 50 or over. Therefore, for men, part-time working is strongly related to age and to having an alternative status—usually that of student or early retired. By contrast, part-time working amongst women begins to expand in the mid-20s, as a

response to marriage and motherhood, and continues into the post-child-rearing phase, with highest levels amongst 35- to 49-year-olds.

The Labour Force Surveys attempt to assess the extent of voluntary or involuntary part-time working. In 1992, 83 per cent of women in part-time work were recorded as not wanting a full-time job, and only 9 per cent as working part-time because they could not find full-time work. By comparison, 22 per cent of men working part-time were recorded as unable to find a full-time job, whilst 34 per cent were students (Watson and Fothergill, 1993). However, whilst the LFS attempts to distinguish voluntary from involuntary part-time work, it does not enquire into why someone might state a preference for part-time: whether this was a forced choice or their own preference. An NOP omnibus survey (Watson and Fothergill, 1993) throws a little further light on this by finding that 14 per cent of women part-timers would like full-time work but were prevented from seeking it by domestic commitments, whilst 31 per cent preferred part-time work because it allowed time for their children. Alwin *et al.* (1992) highlight the extent to which part-time work is seen as an appropriate option for women with school-age children in Britain; by comparison, West Germans were more likely to favour women with school-age children not working outside the home, whilst American men and women were the most likely to favour full-time work for mothers of school-age children—around a third of both men and women supported this option. Although a majority of British women working part-time appear to be content to work part-time, it is none the less evident that the lack of childcare available imposes considerable problems over working during school holidays (Watson and Fothergill, 1993) and that a significant proportion of women would be prepared to increase their hours if better childcare facilities were available. This will be discussed in more detail later.

Part-time working has been identified as the main route through which women's labour-market participation has increased since the 1950s. It is therefore important to consider some of the effects of part-time working on women's lives.

Part-time working restricts women's earning ability. It is poorly paid even on an hourly basis. Using data collected in 1980, Ermisch and Wright found it was on average paid 8 per cent less per hour than full-time employment for otherwise identical employees (Ermisch and Wright, 1993) and gave poorer returns for accumulating qualifications or experience. This picture was confirmed in Waldfogel's analysis of a cohort of young women in 1991, where she estimated that a switch from full-time to part-time work would result in a pay penalty of 12–17 per cent (Waldfogel, 1995). Using the 1986 Social Change and Economic Life data-set, Sloane (1994) estimated that, after controlling for gender, qualifications, gender segregation, and other variables in a standard human-capital model, part-time

employment was rewarded with 15 per cent less pay than full-time employment. Women who earn less than the Lower Earnings Limit do not have to pay National Insurance (NI) contributions—and neither do their employers. This represents a saving to employers of about 7 per cent (currently) of the gross wage and therefore provides them with an incentive to keep the hours of part-timers below this earnings threshold. The threshold has been much higher in Britain than, for example, in Germany (Schoer, 1987), providing a greater incentive for British employers to use part-time labour.

For the years in which women have no NI contributions they are not building up contributions towards Unemployment Benefit, Statutory Maternity Pay, or Sickness Benefit, and, under some circumstances, they do not receive any credit for their retirement pension. About 29 per cent of all women who work part-time fall below this National Insurance limit (Schoer, 1987). Until 1995, women who worked less than 16 hours a week also had fewer statutory employment rights than full-timers. Maternity pay, the right to return to one's job after maternity leave, redundancy pay and the ability to claim unfair dismissal, were only available to full-time workers (16+ hours) after 2 years continuous service with their employer. For women working more than 8 but less than 16 hours, these benefits were not available until 5 years of continuous employment with the same employer. Since 1995, the legal rights of part-timers have been extended so that they now have the same service qualifications as full-timers for a range of statutory rights which include unfair dismissal, redundancy pay, and higher levels of maternity leave. The cut-off points of 16 and 8 hours discussed above are no longer applicable (Labour Research Department, 1995).

Maternity Rights Legislation

Maternity rights legislation was introduced with the 1975 Employment Protection Act, which gave a woman 18 weeks Statutory Maternity Pay (SMP) and also the right to return to her job within 29 weeks after childbirth. These rights are linked to the length of continuous service with an employer and women need 2 years of continuous employment to qualify. An amendment in 1980 removed from small employers (fewer than six employees) the obligation to reinstate. Until February 1995, this was also linked to working hours, as discussed previously. In 1988, about 60 per cent of pregnant women qualified for SMP and the right to reinstatement (McRae and Daniel, 1991). Statutory Maternity Pay is paid for 6 weeks at 90 per cent of salary and 12 weeks at a flat rate of £39.25 in 1990/1. The lower flat rate is available for 18 weeks to women with only 6 months continuous employment as long as they have made National Insurance contributions. Contractual maternity pay (an additional payment made by the

employer) is made to about 14 per cent of women, mainly in the public sector (McRae and Daniel, 1991). The effect of maternity legislation on women's return to work will be discussed later.

Women working part-time are unlikely to belong to an employer's pension scheme. In 1991, only 17 per cent of part-time working women belonged to such a scheme, compared with 55 per cent of women working full-time and 61 per cent of full-time working men (Bridgwood and Savage, 1993). Ginn and Arber (1993) have shown that, after controlling for a number of labour-market and family-related variables, part-timers are less likely than full-timers to be in an occupational pension scheme by a factor of about 6 : 1. In September 1994, a European court confirmed the right of part-timers to join pension schemes if their exclusion could be proved to be discriminatory on the grounds of sex. There is evidence that some companies in Britain are changing their pension scheme rules to include part-timers (Labour Research Department, 1995) but how quickly this practice is adopted generally remains to be seen.

Table 9.2, using data for 33-year-olds from the National Child Development Study, shows the extent to which various fringe benefits vary between full- and part-time employees. The receipt of fringe benefits varies with the kind of benefit. Membership of an employer's pension scheme is most frequently reported—67 per cent of men and 62 per cent of women working full-time, and 20 per cent of women working part-time. This difference between female full- and part-time workers is evident in most of the other fringe benefits shown in Table 9.2 and is far greater than the difference in benefit receipt between male and female full-timers. The provision of help with childcare is notable by its absence—only 1 per cent of men and 2 per cent of women, with no difference between full- and part-timers, received this benefit.

There is likely to be a considerable difference between the private and

TABLE 9.2. *Receipt of fringe benefits from employer, self-reported (%)*

	Men	Women	
	FT	FT	PT
Shares in firm	28	20	9
Company car for private use	24	8	2
Private medical insurance	22	15	3
Employer's pension scheme	67	62	20
Help with childcare	1	2	2
	100	100	100
	(4109)	(1843)	(1640)

Source: Ward *et al.* (1993).

the public sector in the kind of benefit available and the range of employees to whom it is extended. Table 9.3 shows the breakdown of employees in the National Child Development Study by type of organization, whilst Table 9.4 provides the level of provision of an occupational pension by type of organization. It is important to remember that these figures refer to a single age cohort—people aged 33 years and working in 1991.

TABLE 9.3. *Type of organization worked in by sex and full-time or part-time working*

	Male	Female	
	FT	FT	PT
Private firm	69	53	56
Nationalized industry	9	6	4
Local authority/LEA	10	19	19
Health Authority/hospital	3	10	12
Central government	6	7	4
Charity	1	2	3
Other	3	3	3
Total	100	100	100
	(4002)	(1817)	(1619)

Source: NCDS, Ward *et al.* (1993).

There are considerable differences in the extent to which different kinds of organizations provide pensions, with private firms being the lowest and central government the highest. Table 9.4 shows that women are more likely than men to work in the public sector and this clearly has advantages for them in terms of pension provision. Generally, part-time female employees do badly in terms of employer pension provision and this is particularly important for the 56 per cent who are working in private firms. Further work is needed to establish the extent to which these differences may be affected by the different occupations of part-timers within each sector.

Part-Time Work and Domestic Responsibilities

In Britain, a majority of women still leave the labour market when they have children and return to paid work, often part-time, after several years of absence. This is due to a number of interrelated factors. The lack of available childcare is discussed below, and the historical exclusion of women from higher paid jobs has already been mentioned. Compounding this is the view, held more widely by men than by women, that women with

TABLE 9.4. *Membership of an employer's pension scheme by type of organization, sex, and full-time or part-time work (%)*

	Male	Female	
	FT	FT	PT
Private firm	62	51	15
Nationalized industry	86	86	39
Local authority/LEA	81	76	23
Health Authority/hospital	86	69	29
Central government	91	88	78
Charity	68	58	16
Other	81	68	10
Total	69	63	21
	(4109)	(1843)	(1640)

Source: NCDS, Ward *et al.* 1993.

pre-school children should not work outside the home (Jowell *et al.*, 1991). Employers are also likely to be men who hold these views. It is not, therefore, surprising that women still take primary responsibility for domestic work and childcare in Britain.

However, the effect of absence from the labour market and, particularly, a return to part-time work, is often occupational downward mobility (Martin and Roberts, 1984; Dex, 1987; Joshi and Newell, 1987). These part-time jobs conform to employers' and families' perceptions of the kind of work suitable for married women with children. This downward mobility is responsible for considerable occupational inequality between men and women. At the stage in the life-course when women are most constrained by domestic and childcare responsibilities, men are consolidating and improving their occupational position, typically by gaining professional qualifications and by moving into managerial and supervisory positions. Thus, in aggregate, men and women show a widening gap in occupational status over the life-course, with married men moving up into managerial positions while married women move down into part-time personal service sector jobs (Dale, 1987; Dale, 1991).

A recent survey on women's return to work after first childbirth (McRae and Daniel, 1991) found that, since 1979, there had been a clear increase in the percentage of women who were returning to full-time work within 9 months of childbirth: from 5 per cent in 1979 to 15 per cent in 1988. There was also an increase in the percentages of women returning to work part-time—30 per cent in 1988 by comparison with 18 per cent in 1979. However, because of the difficulties in sustaining childcare arrangements, many women do not manage to remain at work: thus, in 1992 only 11 per

cent of women with a child under 5 were in full-time work (1992 GHS; reported in Thomas, 1994: see Table 9.5). Of those women working part-time before childbirth, 50 per cent went back to work within 9 months. A high proportion of these women are likely to have already been in part-time work to fit in with an earlier child and therefore continue in this mode of working. McRae (1991) found that those women who returned to work full-time were unlikely to experience downward occupational mobility. Of those returning part-time, women who were managers or administrators, or who were in clerical or secretarial jobs before giving birth, were most likely to move down the occupational structure (29 and 26 per cent respectively). By contrast, only 9 per cent of women in professional occupations who returned to part-time work experienced downward occupational mobility. From this evidence, it would appear that women may have been less likely to experience downward occupational mobility following child-bearing than ten years earlier (Martin and Roberts, 1984) but that, at least for some occupational groups, a return to part-time working still results in a fall in occupational status.

TABLE 9.5. *Economic activity of women aged 16–59 in Great Britain by presence and age of children*

Age of youngest dependent child	Employment status (%)	1973	1992
0–4	Full-time	7	11
	Part-time	18	31
	Not employed	75	58
5–9	Full-time	18	20
	Part-time	42	44
	Not employed	50	36
10+	Full-time	30	31
	Part-time	37	45
	Not employed	33	24
No dependent child	Full-time	52	47
	Part-time	17	24
	Not employed	31	29
100% =		8956	6967

Sources: General Household Survey, 1992; (Thomas *et al.*, 1994).

Simulations for Britain (Joshi, 1990*b*) suggest that a break from employment followed by part-time working leads to a fall in income that is not recovered in later life, even if a return to full-time work is made, and episodes of the lowest paid occupations prove transient. Waldfogel (1993), examining the effects of having children on women's earnings, found that the wage penalty associated with having children was also associated with

part-time work. It was much weakened if the woman took maternity leave and continued in full-time work.

Estimates of the earnings foregone by British mothers, encapsulating the combined effects of motherhood on participation, hours, and pay over a hypothetical lifetime, are presented by Joshi (1990*b*). In the central illustrative example, a woman whose rising earnings profile had reached £6000 per annum at age 24, takes an 8-year break from employment to care for two children born when she is 25 and 28, and afterwards has 12 years more part-time employment than she would have done if she had remained childless. The total earnings foregone amount to £122,000, or 50 per cent of what she would have earned over ages 25–59 had she not had children. This sum foregone is very roughly equally divided between the earnings loss due to the break in employment, the shorter hours, and the lower rates of pay. These arise as a result of lost employment experience and being confined to the part-time sector of the labour market. Other examples can be found for other countries and other educational levels in Joshi and Davies (1992*a*; 1992*b*).

Although the sum of foregone earnings sounds large as a summary of the impact that motherhood has on women's direct contribution to the economy, it would be twice as big if it were not possible for women to make the economic compromises involved in combining paid work with motherhood, e.g. if there were no part-time jobs. Neither is it as large as the sum that would normally be forfeited if fathers took all the time off work needed to rear children, as husbands usually face higher and steeper earnings profiles than their wives.

Part-time earnings are seldom enough to live on. Most women who work part-time have another, full-time, earner in the family. A woman's part-time earnings augment the joint income of the couple and play an important role in keeping the family out of poverty. For the woman herself, some degree of economic independence is gained, although usually part-time working simply lifts her from total to partial economic dependence on her partner (Ward, *et al.*, 1996*a*). In this study of 33-year old wives, it was only full-time employment that was likely to make an equal or major contribution to the couple's budget. The extent to which women move from part-time to full-time jobs, and thereby increase the extent of their economic independence, is examined later.

Childcare in Britain

Britain has very little formal childcare for the under 5s. In 1990, Meltzer (1994) found that 8 per cent of children under 5 in England attended a day nursery and a further 6 per cent were looked after on a regular basis by a child-minder. Nannies or au pairs looked after 3 per cent of children. These are the only kinds of formal childcare available. In 1990, fewer than 10 per

cent of working mothers used any kind of day nursery (Jowell *et al.*, 1991).

The 1990 British Social Attitudes Survey found that two-thirds of mothers (of children under 12) not now in paid work said they would go out to work if childcare arrangements were better. Additionally, one in three mothers who worked part-time said that, with better childcare, they would increase their hours (Jowell *et al.*, 1991). Using a different and speculative econometric method on data from the GHS and FES in 1991–2, Duncan and colleagues (1995) also concluded that there were positive, though modest, labour supply effects of making childcare cheaper for mothers of under 5s. Their model of the joint choice of labour supply and childcare suggested that a 10 per cent fall in the cost of childcare would raise participation by 6 per cent (and also increase the hours of participants).

With a few exceptions, employers have made little attempt to retain the skills and expertise of their female workforce. Although there have been some schemes, particularly by the large banks, for working arrangements that retain women during family formation, this is limited mainly to women with particularly sought-after qualifications at higher grades. At present there are only about 400 workplace nurseries in the UK. Despite being the only form of childcare to receive some tax concessions, there are doubts about the suitability of this form of provision for children who do not live close to their mother's workplace, and these facilities have been vulnerable to economic recession. So, too, are the few embryonic schemes for employers to contribute to the costs of childcare arrangements off-site by means of childcare vouchers. In a 1988 survey of mothers of new babies, McRae (1991) found that only 4 per cent of women who were employed during pregnancy had access to workplace nurseries or received other help with childcare from their employers. The extent of this provision had increased by 1 percentage point in the last decade.

Studies consistently show the extent to which British women make use of informal methods of childcare (Martin and Roberts, 1984; Ward, *et al.*, 1996). Particularly amongst women who work part-time, husbands play an important role in enabling them to work evening and weekend shifts, but this source of childcare usually stops short of allowing full-time employment.

The European Community and Women's Employment

One of the major forces for change in women's employment patterns is through legislation, particularly that stemming from the European Community. The 1984 Equal Value Amendment to the Equal Pay Act provided an opportunity for women to claim wages similar to those of men doing comparable work, although Gregory (1992) highlights the difficulty of achieving a successful outcome under this legislation.

The EU Draft Directive on Parental Leave and Leave for Family Circumstances included provision for a statutory minimum of three months 'parental leave' per worker per child during the first two years of a child's life. It also proposed an entitlement to 'family leave' to cover a child's illness. This would have made full-time work for women with children considerably easier; however, Britain was the only EC country to oppose this and it has therefore not been adopted. Similarly, Britain has opposed two of the three linked Draft Directives on Atypical Working. None the less, there have been recent enhancements in the rights of part-timers, as discussed earlier. Although these have only been accepted with reluctance by the government after legal cases in the European court and the British House of Lords, they pave the way towards greater equality of treatment between full- and part-time workers.

Transitions into and out of Part-Time Jobs

The data for all the analyses in this and the following sections come from the work history component of the Social Change and Economic Life Initiative (SCELI) interviews of 6,000 adults (aged 20–59) living in one of six local labour markets in England and Scotland. Each respondent was asked for details of every job that he or she had held since leaving full-time education, and of every gap between jobs. This information was supplemented by other information on marriages, any children, and family of origin, plus a variety of other information, such as physical and psychological health, political attitudes and values, which has not been used in the analyses presented here. Three main types of analysis are presented, all considering only the female respondents. The first is concerned with the first jobs of all of the women, which thus covers the period from the early 1940s (when the oldest women in the sample would have left school) through to the mid-1980s. A dramatic increase in women entering employment in part-time jobs is revealed; factors associated with it will be explored, first at a bivariate level and then with a multivariate logistic regression.

The next two analyses investigate the transitions between full-time and part-time jobs. This is done by taking, as the unit of analysis, each pair of adjoining jobs, whether or not there was a gap between them. We look first at the way in which the transitions from full-time jobs to part-time jobs differ from the transitions from one full-time job to another; and second, how the quits from part-time employment leading to full-time employment are different from those that are followed by other part-time jobs. For the sake of brevity, this method of looking at pairs of adjoining jobs will not be critically discussed in any detail in this chapter, but detailed consideration of the pros and cons of this approach can be found in Burchell (1993).

Its main advantage is its amenability to simple exploratory analyses without the need for specialist techniques or packages which prevent many researchers from making full use of their longitudinal data. There are of course drawbacks, such as the inability to consider women's trajectories over more than one transition. There are also several shortcomings of the SCELI data-set for these particular analyses. Pay was not recorded for each job in the work histories; only the respondents' subjective estimates of whether each job was better, the same, or worse than the previous job. Unfortunately, as it was not specified whether it was the hourly or weekly pay that should be considered, it is ambiguous when applied to transitions between full- and part-time jobs and has therefore not been used in this set of analyses. Neither did the SCELI work history make provision for the possibility that respondents may hold more than one job simultaneously; with part-time employment this may be a significant issue for a number of respondents. Finally, there are limitations imposed on these analyses by the limited time that has been available for the analyses. For instance, many of the life-history variables, such as partner's activities, marriage, and childbirth, would have been very useful in these analyses but have not been used because of the (not inconsiderable) data management problems involved. However, in many cases there is evidence of women's life-history events that can be taken directly from the work-history file, such as the reason for leaving a job and the length of a period without employment.

One of the problems of using work histories collected from respondents of different ages is the confounding of the age of the respondent and calendar time; for the period just before the survey there are job holders of all ages, but as one goes back in time the maximum age decreases, such that in the 1940s we only have examples of jobs held by teenagers. There are a number of techniques that can be used to overcome this problem, but in this case a very simple solution was used; job transitions were only included in the sample if they occurred after 1966 and when the respondent was less than 40 years old. This eliminates the confounding of age and time, albeit at the loss of some important data, and focuses on transitions in early to middle in the life-cycle. A supplementary analysis takes data from the women's own retrospections of their working lives, when they were asked which of all their jobs they had liked the most.

First Jobs

Before considering the flows of women between full-time and part-time employment, it is important to consider the employment status (part- or full-time) of women when they first entered the labour market. This was done by examining the first activity which each woman undertook after

leaving full-time education. As the women were aged between 20 and 60 years old in 1986, we have labour-market entry data for the period from the early 1940s to the mid-1980s. It was found that 88 per cent of women were recorded as employees in this first activity; other categories were unemployed (4.8 per cent), full-time housewife (3.1 per cent), government schemes (1.6 per cent), and self-employment (0.3 per cent). Of the employees, 97.4 per cent were working full-time; only a tiny proportion, 2.6 per cent, were working part-time in their first job. There was a strong blue-collar/white-collar effect here, with the proportion in white-collar jobs working part-time only 1.9 per cent compared to 3.8 per cent of those starting in blue-collar jobs. The general picture is consistent with the material presented earlier, of part-time employment usually occurring at the family formation stage of the life-cycle. However, within this there was also a very marked increase in the proportion working part-time in their first jobs over the 35-year period, particularly in 1980–5. This can be seen from Fig. 9.3. This increase is particularly marked for the blue-collar jobs, where the rate of part-time employment upon entry goes from a level of 2 to 3 per cent in the period 1940 to 1975, after which it rises rapidly to a level over 18 per cent in the period 1980–5. The corresponding rise amongst white-collar jobs was from below 2 per cent to 7 per cent. (There was a corresponding rise in male entry into part-time work, but from a much lower base: 1.2 per cent of men's first jobs were part-time up to 1970, but this rose to 3.2 per cent after 1970.) One possible explanation is that the early 1980s were years of economic recession. We cannot tell from this evidence whether the trend persisted after 1985 when overall full-time employment rates started to rise, or if any effect of recession is repeating itself in the 1990s. And without corroboration from other data-sets perhaps we should remain slightly sceptical about this finding. An alternative explanation is that it could have been an artefact of incomplete recall—as respondents got older they may have been more likely to forget a part-time first job, particularly if it were of short duration. Another possibility is that it is linked to changing patterns of higher education in the 1980s and the fall, in real terms, of student grants, causing more students to augment their incomes through earnings.

However, there have been many other structural changes in the labour market over this period, some of which may have affected women's part-time working, so a multivariate analysis is needed to untangle these effects.

Bivariate analyses showed that women with qualifications higher than O-level (or equivalent) were more likely than those with O-levels or below to enter the labour market as a part-timer (5.1 per cent), as were non-white ethnic groups (18 per cent). (All the figures in this paragraph can be compared to the population figure of 2.6 per cent). Area (Aberdeen, Coventry, Kirckaldy, Northampton, Rochdale, and Swindon) or whether

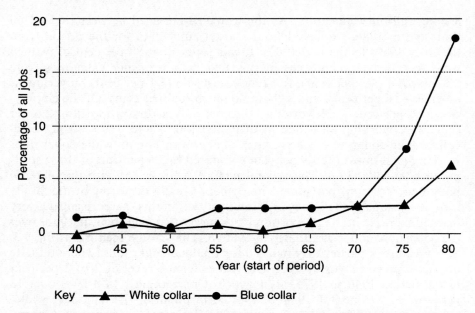

FIG. 9.3. Percentage of women's first jobs on leaving full-time education which were part-time, by five-year period

the respondent's mother worked when the woman was young were not related to prevalence of part-time employment in the first job. Several characteristics of a woman's first job were also related to part-time employment, such as employment in semi-skilled or unskilled manual work (4.1 per cent and 15 per cent respectively); employment in the retail sector (5.3 per cent); and size of workplace—9.6 per cent of those who worked alone in their first job and 4.0 per cent of those at workplaces with less than 25 employees were working part-time. The relationship between part-time work in a first job and both higher qualifications and lower skill is somewhat puzzling, but perhaps indicates that many of these part-time first jobs were seen by the participants as gap-fillers rather than the start of a career. Non-trade-union members were more likely to be part-timers (3.3 per cent), but there was no difference in rates of part-time employment in the first job between the public and private sector.

A forward stepwise multivariate logistic regression entering mother's and father's social class, qualifications, sector (retail vs. rest), age of entry, size of workplace, social class of first job, area, and ethnic origin confirmed that there was still an independent and statistically significant trend over time even after the other effects had been accounted for, although it was

weaker than the effect in the bivariate relationship (see Table 9.6). Period of entry was the first variable entered into a forward stepwise logistic regression. When the Registrar General's Social Class (RG Social Class) of the first job was entered, the effect of period of entry was strengthened due to the trend away from manual work (where part-time employment is more prevalent) over the last forty years. However, the strong trend towards later school-leaving age over this time, the increase in employment in small workplaces, and the effect of higher qualifications all reduced the effect of calendar time. Father's and mother's Registrar General's Social Class, region, and ethnic group were considered but not entered into the model, as they were no longer significantly related to the dependent variable once all of the above variables were entered (all ps > 0.2).

There was also some evidence of a two-way interaction between period of entry into the labour market and rate of part-time working and both qualifications and school-leaving age; the increase in the rate at which women entered the labour market in a part-time capacity was particularly marked amongst more highly qualified women and women who stayed on in education after the age of 17. The increase in part-time jobs among those most recently reported may yet turn out to be a statistical artefact. Many are likely to have been very short term, such as jobs during the vacation following graduation, which remain fresh in the minds of those who did them recently but tend to be omitted in reports from older respondents. The growth of the part-time labour market for women in general may genuinely have made more such jobs available to those leaving education, but much remains to be investigated. For example, how were these part-time labour-market entrants economically supported; by their own low wages or by parents, partners, or the state? While a detailed analysis of these first jobs is beyond the scope of this chapter, one clear difference between the part-time first jobs and the full-time first jobs was in their duration of tenure; the median duration of the part-time jobs up to 1980 was only 9.5 months, compared to 15 months for full-time jobs. There are problems with right-censoring in making similar estimates for more recently started first jobs, but the evidence suggests that in the 1980s the part-time jobs became shorter and the full-time jobs longer in tenure.

The prevalence of jobs (other than the first job) which were part-time, already much higher, has also risen over time, but not to the same extent: 24 per cent of all jobs started in the period 1966–71 (and started when the respondent was less than 40 years old) were part-time, rising to 30 per cent in 1971–6, 31 per cent in 1976–9, 37 per cent in 1979–82, and 44 per cent in 1982–6. The fact that the greatest proportionate changes have taken place in women's first jobs, which are usually taken before the formation of their own families, suggests that it is not simply women's changing domestic situations which have brought about the higher levels of

TABLE 9.6. *Logistic regression predicting rates of part-time employment in women's first jobs*

Variables in the Equation

Variable	B	S.E.	Wald	df	Sig.	R	Exp (B)
QUALS	1.1751	.4268	7.5784	1	.0059	.1081	3.2384
Age leaving full-time education			19.9456	5	.0013	.1443	
AGEFJ(1)	−.2878	.4229	.4632	1	.4961	.0000	.7499
AGEFJ(2)	−.4270	.3803	1.2609	1	.2615	.0000	.6525
AGEFJ(3)	−1.2508	.6697	3.4882	1	.0618	−.0558	.2863
AGEFJ(4)	.5412	.3466	2.4384	1	.1184	.0303	1.7180
AGEFJ(5)	−.6834	.6085	1.2613	1	.2614	.0000	.5049
Size of first workplace			16.7230	4	.0022	.1351	
FJNOEMP(1)	1.6377	.5354	9.3553	1	.0022	.1241	5.1435
FJNOEMP(2)	.6624	.2962	5.0001	1	.0253	.0793	1.9394
FJNOEMP(3)	−1.6740	.6394	6.8557	1	.0088	−.1008	.1875
FJNOEMP(4)	−.0849	.3890	.0477	1	.8272	.0000	.9186
Registrar-General's Social Class			39.5080	5	.0000	.2486	
FJRG80(1)	−4.4724	12.4244	.1296	1	.7189	.0000	.0114
FJRG80(2)	−1.5722	2.5663	.3753	1	.5401	.0000	.2076
FJRG80(3)	.4926	2.5018	.0388	1	.8439	.0000	1.6365
FJRG80(4)	.4027	2.5427	.0251	1	.8742	.0000	1.4959
FJRG80(5)	1.9308	2.5071	.5931	1	.4412	.0000	6.8951
RETAIL	−1.1604	.3938	8.6830	1	.0032	−.1183	.3134
Period of entry into first job			15.4540	4	.0038	.1249	
FJYR10(1)	−1.6251	.7547	4.6373	1	.0313	−.0743	.1969
FJYR10(2)	.0430	.3783	.0129	1	.9096	.0000	1.0439
FJYR10(3)	.5561	.3244	2.9372	1	.0866	.0443	1.7438
FJYR10(4)	1.5275	.3901	15.3356	1	.0001	.1671	4.6067
Constant	−4.5219	2.6907	2.8244	1	.0928		

Definitions of variables

QUALS Qualifications to O level or above
Base Qualifications below O level

Age leaving full-time education
AGEFJ(1) 15 or under
AGEFJ(2) 16
AGEFJ(3) 17
AGEFJ(4) 18–19
AGEFJ(5) 20–1
Base: 22+

Size of workplace
FJNOEMP(1) Works alone
FJNOEMP(2) 2–24 employees
FJNOEMP(3) 25–99 employees
FJNOEMP(4) 100–499 employees
Base: 500+ employees

Social class of first job
FJRG80(1) Professional
FJRG80(2) Intermediate
FJRG80(3) Clerical
FJRG80(4) Skilled manual
FJRG80(5) Semi-skilled manual
Base: Unskilled manual

Industrial sector
RETAIL Distribution inc. retail, wholesale, hotels, catering, etc.
Base: All other sectors

Period
FJYR10(1) 1950–9
FJYR10(2) 1960–9
FJYR10(3) 1970–9
FJYR10(4) 1980–
Base: up to 1949

part-time employment but rather it is also closely linked to changes on the demand side of the labour market.

Transitions between Jobs

The rate of shift between full-time and part-time jobs also needs to be considered to understand the trend in part-time work. In this part of the analysis job transitions were only included in the sample if they occurred after 1966 and when the respondent was less than 40 years old. In the period from 1966 to 1971, 18 per cent of those who left a full-time job to go to another job took a part-time one next. This increased very slowly to 24 per cent in the period 1979–82, and then increased more dramatically to 31 per cent in the period 1982 to 1986 (Fig. 9.4). There was, however, little sustained change in the outflow of part-timers to full-time employment over that period, from a peak just below 40 per cent up to 1979, to around 30 per cent in 1979 to 1986 (Fig. 9.5). The following paragraphs will examine the circumstances under which women transfer from full-time jobs to part-time jobs, and vice versa.

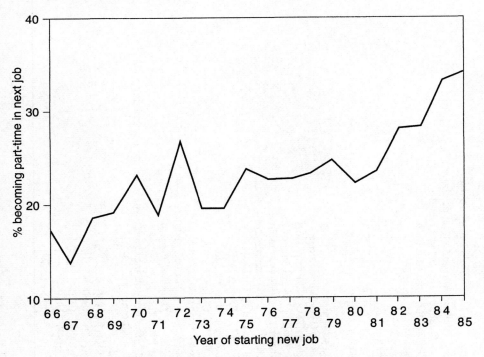

Fig. 9.4. Percentage of quits from women's full-time jobs which resulted in a transfer to part-time employment, by year of start of new job

Flows from Full-Time to Part-Time Jobs

23 per cent of transitions from full-time jobs to other jobs were to part-time jobs. As Fig. 9.4 shows, this figure has increased markedly over the period 1966 to 1986, from 18 per cent in 1966–71 to 30 per cent in 1982–6. Before considering this in more detail, the reasons for this transition will be explored by looking at the effects of type of job, the woman's pre-labour-market characteristics, and her domestic situation on the prevalence of part-time employment in the 'destination' job.

Employment-Related Effects. Generally, the type of job a woman was doing had little predictive power in determining whether her next job would be part-time or full-time. There were a few exceptions to this, but none of the effects were strong. There was a positive relationship between job security and the probability of the next job being part-time: 26 per cent of women leaving jobs they rated as 'very secure' were part-time in their next job, compared to only 15 per cent of those leaving 'very insecure' jobs. There was also a moderate effect of the socio-economic group of the source job, with only 9 per cent of transitions from managerial jobs in large establishments being to part-time jobs (albeit less than 2 per cent of women's employment was in this group) compared to 29 per cent of jobs in unskilled manual work at the other extreme. There was also an effect of the industry that the full-time job was located in: transfers to part-time were particularly rare in construction (12 per cent), energy and water supply (18 per cent), and financial services (18 per cent), but more likely in light manufacturing (29 per cent).

Pre-Labour Market Characteristics. More highly qualified women were less likely to transfer into part-time work: for instance, only 14 per cent of full-time jobs held by women with degrees were followed by part-time jobs, compared to 29 per cent of jobs held by women without any formal qualifications.

Life-Cycle Variables. The number of variables related to women's position in their life-cycle that can be used in this analysis is limited to work-history related variables, but the SCELI data-set would, given adequate time and resources to combine different parts of the data-set, permit more detailed analyses of this area using variables such as marital status, age of children, and partner's employment status. However, it is clear that the position of a woman in relation to child-birth and childcare is of primary importance in determining shifts from full-time to part-time jobs. Fig. 9.5 shows the age effect, with women in the early stages of their labour-market participation having close to no risk of transferring to part-time work, but this rises steadily to peak at around the late 20s, only to fall off slowly after that. Only 8 per cent of jobs taken by women who had never

experienced a period out of the labour market to undertake a period of full-time housework were part-time, compared to 52 per cent of those jobs undertaken after a woman had experienced one or more such spells. Only 4.7 per cent of full-time jobs which were left 'to get a better job' resulted in part-time employment, compared to 51 per cent of jobs left for family or personal reasons, 14 per cent of jobs left involuntarily, and 19 per cent of jobs left for other reasons.

Multivariate Analyses. A multivariate logistic forward stepwise regression of the variables implicated in the transfer from full-time to part-time employment confirmed the pervasive effect of life-cycle-related variables. As Table 9.7 shows, the variables with the most influence in the model are reason for leaving previous job (PWHYLFT), the duration of the break (if any) between the two jobs (DURGAPC2), whether the woman has had time out of the labour market for full-time housework up to the point of taking the next job (HWFLAGC) and age (AGESTC). The only job-related variable to be significant was the job security variable, again indicating that women were a little more likely to leave secure full-time jobs to go into part-time employment than insecure full-time jobs. The only pre-labour-market variable to be entered was level of qualifications, reflecting the increased chance of the movement into part-time employment for less qualified women. But even when all these effects are controlled for, there is still a highly significant linear effect of period, with steadily increasing rates of

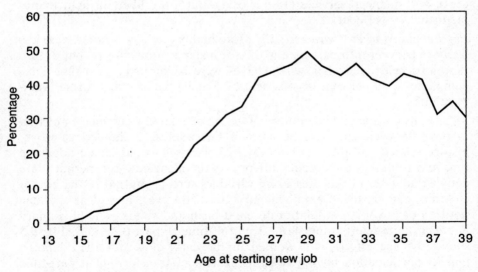

FIG. 9.5. Percentage of quits from women's full-time jobs which resulted in a transfer to part-time employment, by age of women at starting new job

flow to part-time employment over the twenty years. (Socio-economic group and industrial sector were not entered into the model, all ps > 0.07.)

Flows From Part-Time to Full-Time Employment

34 per cent of quits from part-time jobs resulted in full-time employment. This changed little over time, and what changes there were, were not monotonic over the 20-year period from 1966 to 1986; the highest rates of flow from part-time into full-time employment were in 1976–9 at 39 per cent, and the lowest rate, 27 per cent, was in 1979–82 (Fig. 9.6).

Employment-Related Factors. Unlike the case of flows from full-time employment, the nature of the job that a part-time woman was doing was predictive of whether that woman would stay in part-time employment in her next job or would change to full-time employment. The more hours a woman worked a week in her part-time job, the more likely she was to become full-time employed in her next job: only 19 per cent of part-timers working less than 8 hours per week went full-time, compared to 39 per cent who had been working 23 or more hours per week. Only 30 per cent of

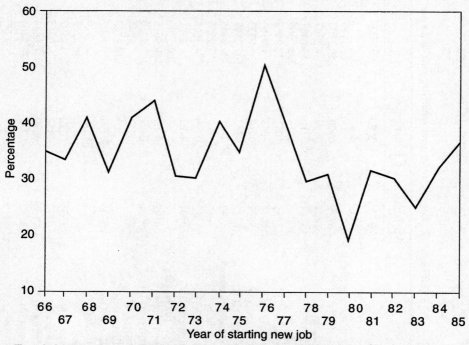

Fig. 9.6. Percentage of quits from women's part-time jobs which resulted in a transfer to full-time employment, by year of start of new job

TABLE 9.7. *Logistic regression predicting entry into part-time employment from full-time employment*

Variable	B	S.E.	Wald	df	Sig.	R	Exp (B)
Variables in the Equation							
Age on starting new job			61.5926	3	.0000	.0907	
AGESTC(1)	-.6379	.0900	50.2700	1	.0000	-.0845	.5284
AGESTC(2)	.1404	.0659	4.5347	1	.0332	.0194	1.1508
AGESTC(3)	.4213	.0716	34.6487	1	.0000	.0695	1.5240
Length of gap			223.7306	4	.0000	.1787	
DURGAPC2(1)	-.5655	.1051	28.9595	1	.0000	-.0632	.5681
DURGAPC2(2)	-.1076	.1068	1.0164	1	.3134	.0000	.8979
DURGAPC2(3)	.5591	.0919	37.0233	1	.0000	.0720	1.7491
DURGAPC2(4)	.8725	.0842	107.2898	1	.0000	.1248	2.3929
Full-time housework	-.4992	.0501	99.2345	1	.0000	-.1200	.6070
Job security			7.9556	2	.0187	.0242	
PJOBSEC2(1)	.1583	.0756	4.3808	1	.0363	.0188	1.1715
PJOBSEC2(2)	-.0701	.0762	.8481	1	.3571	.0000	.9323
Reason for leaving job			200.3700	3	.0000	.1696	
PWHYLFT(1)	.8192	.0669	149.9616	1	.0000	.1480	2.2686
PWHYLFT(2)	-.9081	.0892	103.7155	1	.0000	-.1227	.4033
PWHYLFT(3)	-.0617	.0947	.4244	1	.5148	.0000	.9402
Qualifications			10.9768	2	.0041	.0321	
QUALSC(1)	-.0285	.0790	.1307	1	.7177	.0000	.9719
QUALSC(2)	-.1926	.1272	2.2916	1	.1301	-.0066	.8248
Period			36.5273	4	.0000	-.0650	
PERIOD(1)	-.1335	.0722	3.4192	1	.0644	-.0145	.8750
PERIOD(2)	-.0172	.0842	.0415	1	.8386	.0000	.9830
PERIOD(3)	.1155	.0890	1.6854	1	.1942	.0000	1.1225
PERIOD(4)	.3735	.0776	23.1464	1	.0000	.0559	1.4528
Constant	-1.3114	.0948	191.1656	1	.0000		

Definitions of variables

Age on starting new job

AGESTC(1)	<20
AGESTC(2)	20–5
AGESTC(3)	25–30
Base:	30–40

Length of gap

DURGAPC2(1)	1–6 months
DURGAPC2(2)	7–12 months
DURGAPC2(3)	1–3 years
DURGAPC2(4)	3 years +
Base:	No gap between jobs

Full-time housework

| HWFLAGC | Never having had a spell of FT housework before taking up new job |
| Base: | Having ever had a spell of FT housework before taking up new job |

Job security

PJOBSEC2(1)	A very secure full-time job
PJOBSEC2(2)	A fairly secure or fairly insecure full-time job
Base:	A very insecure full-time job

Reason for leaving job

PWHYLFT(1)	Left previous job for family or domestic reasons
PWHYLFT(2)	Left previous job to get a better job
PWHYLFT(3)	Dismissed or made redundant from previous job
Base:	Other reasons

Qualifications

QUALSC(1)	O level and above (except teaching)
QUALSC(2)	Teaching qualifications
Base:	Below O-level

Period

PERIOD(1)	1971–6
PERIOD(2)	1976–9
PERIOD(3)	1979–82
PERIOD(4)	1982–6
Base:	1966–71

women working in predominantly female workplaces became full-time in their next job, compared to 41 per cent who worked in mixed or predominantly male workplaces. It was also related strongly to occupational segregation: women doing jobs done mainly by men (see Scott and Burchell, 1994, for more details of this measure of occupational segregation) were most likely to transfer to full-time employment (44 per cent), compared to women in jobs done by a fairly equal mix of men and women (39 per cent), and women in jobs done mainly or exclusively by women (32 per cent). The social class of the part-time job was important, with professional and intermediate non-manual jobs (39 per cent) and skilled manual jobs (41 per cent) more likely to be followed by full-time employment than, at the other extreme, unskilled manual jobs (23 per cent).

Pre-Labour-Market Characteristics. Father's social class was related to the flow out of part-time employment, but the relationship was not linear: 46 per cent of episodes in part-time jobs resulted in transfers to full-time jobs where the father had been in the intermediate non-manual RG category, compared to 28 per cent where fathers were in less skilled non-manual work, and 31 per cent where fathers were in the skilled or semi-skilled categories. There was also a linear relationship with the level of women's qualifications, varying from only 30 per cent of those without qualifications to 46 per cent of those with teaching qualifications or degrees.

Life-Cycle Variables. Again the strongest relationships were with variables reflecting the woman's domestic responsibilities and her position in the life-cycle. Where the part-time job was left for family or personal reasons, only 21 per cent were followed by full-time jobs. This rose to 36 per cent where the quit was involuntarily, and 46 per cent where the quit was to get a better job. As Fig. 9.7 shows, there was a strong relationship with age: 60 per cent of those who were less than 20 when they transferred from a part-time job went to a full-time job; this decreased to only 28 per cent for those in the age band 25–30, and rose very slightly to 32 per cent for those in their 30s. There is also an effect of having a gap between jobs: 38 per cent of those who go straight into their next job transfer to full-time work, but as the length of any gap increases, the chance of transferring to full-time employment decreases down to only 20 per cent for those out of employment for more than 3 years.

Multivariate Analysis. The flow from part-time to full-time employment was again analysed with a forward stepwise logistic regression model. Again, the strongest predictors of transition from part-time jobs to full-time jobs were the life-cycle-related variables: the reason for leaving the job (whether for family reasons or to get a better job) and age (with outflow being greater for older and younger women) (see Table 9.8). There were also some pre-labour-market variables which made a modest contribution:

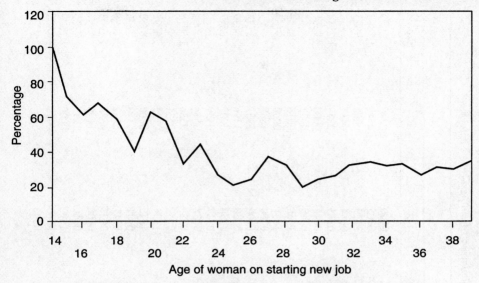

Fig. 9.7. Percentage of quits from women's part-time jobs which resulted in a transfer to full-time employment, by age of women on starting new job

more qualified women and women with intermediate, non-manual fathers were more likely to re-enter full-time employment; daughters of less-skilled, non-manual fathers were particularly likely to stay in part-time work.

However, unlike full-time jobs, there were particular types of jobs which women, once they took those jobs, were less likely to leave. These part-time 'traps' were typically more gendered women's jobs, in more mixed and female workplaces, and were more likely to involve less than 8 hours work per week. Controlling for these factors, there is still a highly significant effect of period, with the rate of outflow being higher in the period 1979–82 than in any of the other periods. Neither the duration of the break after leaving the part-time job nor its social class entered into the forward step-wise model (all ps > 0.16).

Summary of Job Transition Results

In one of the six local labour markets studied, all respondents who had experienced two or more jobs were asked the question '. . . [of] all the jobs you've ever had, which <u>one</u> was the job you liked best?' It was deliberately left open and subjective, but other analyses have shown that this question

TABLE 9.8. Logistic regression predicting entry into full-time employment from part-time employment

Variables in the Equation

Variable	B	S.E.	Wald	df	Sig	R	Exp (B)
Hours of part-time job			24.2018	2	.0000	.0916	
PHOURSC(1)	.6336	.1820	12.1150	1	.0005	.0648	1.8843
PHOURSC(2)	−.1048	.1037	1.0228	1	.3119	.0000	.9005
Workplace segregation			9.5705	2	.0084	.0481	
PMENWOMC(1)	.1918	.0864	4.9246	1	.0265	.0349	1.2114
PMENWOMC(2)	−.0345	.1392	.0612	1	.8045	.0000	.9661
Occupational segregation			6.2093	2	.0448	.0303	
PSEXRATC(1)	−.2124	.1500	2.0053	1	.1568	−.0015	.8086
PSEXRATC(2)	−.0233	.1194	.0382	1	.8451	.0000	.9769
Reason for leaving job			91.8523	3	.0000	.1888	
PWHYLFT(1)	.6509	.0908	51.3835	1	.0000	.1432	1.9173
PWHYLFT(2)	−.5745	.0821	48.9194	1	.0000	−.1396	.5630
PWHYLFT(3)	−.1453	.1067	1.8537	1	.1734	.0000	.8647
Father's social class			8.4434	2	.0147	.0430	
v166J7C(1)	−.3437	.1186	8.3978	1	.0038	−.0516	.7091
v166J7C(2)	.3349	.1568	4.5587	1	.0328	.0326	1.3978
Period			14.7782	4	.0052	.0531	
PERIOD(1)	−.1869	.1233	2.2997	1	.1294	−.0112	.8295
PERIOD(2)	−.1324	.1004	1.7371	1	.1875	.0000	.8760
PERIOD(3)	−.1868	.1133	2.7200	1	.0991	−.0173	.8296
PERIOD(4)	.3706	.1180	9.8635	1	.0017	.0572	1.4486
Qualifications	.1742	.0576	9.1425	1	.0025	.0545	1.1903
Age on starting new job			40.2621	3	.0000	.1193	
AGESTC2(1)	−.8382	.1387	36.5071	1	.0000	−.1197	.4325
AGESTC2(2)	.1509	.1072	1.9820	1	.1592	.0000	1.1629
AGESTC2(3)	.3920	.0962	16.5902	1	.0000	.0779	1.4800
Constant	.4357	.1539	8.0118	1	.0046		

Definitions of variables

Hours of part-time job
PHOURSC(1) less than 8 hrs/wk
PHOURSC(2) 8–22 hrs/wk
Base: 23+ hrs/wk

Workplace segregation
PMENWOMC(1) Mainly female workplace
PMENWOMC(2) Work alone
Base: Mainly male or mixed workplace

Occupational segregation
PSEXRATC(1) OUG group more than 60% male
PSEXRATC(2) OUG group mixed—40% to 60% male
Base: OUG group more than 60% female

Reason for leaving job
PWHYLFT(1) Left previous job for family or domestic reasons
PWHYLFT(2) Left previous job to get a better job
PWHYLFT(3) Dismissed or made redundant from previous job

Father's social class
v16J7C(1) Intermediate non-manual
v16J7C(2) Clerical
Base: All others

Period
PERIOD(1) 1971–6
PERIOD(2) 1976–9
PERIOD(3) 1979–82
PERIOD(4) 1982–6
Base: 1966–71

Qualifications
QUALSC(1) Below O-level
Base: O-level and above (except teaching)

Age on starting new job
AGESTC(1) <20
AGESTC(2) 20–5
AGESTC(3) 25–30
Base: 30–40

was very revealing and predictive of job satisfaction and many other labour-market attitudes and behaviours. It is interesting to note that of the women who answered this question and who had held at least one part-time job and one full-time job, 62 per cent indicated a full-time job that they had held, 34 per cent a part-time job, and 4 per cent a period of self-employment. The total number of full-time jobs held by these women constituted 65 per cent of all jobs, compared to the remaining 35 per cent of jobs which were part-time. Thus, there is no evidence that women preferred the full-time jobs that they had held over the part-time jobs. As many of the analyses of part-time employment in Britain show, any naïve equating of part-time employment with the secondary labour market is over-simplistic.

The sizeable rise in women's part-time employment in Britain over the past two decades has been investigated at three interfaces: the proportion of women entering their first job in part-time employment, the rate of flow of holders of full-time jobs into part-time work, and the rate of flow of part-timers back into full-time work. The most dramatic change over the period in question appears to be an increase in women taking part-time employment in their first jobs on leaving education, which requires some further investigation. The rate at which quitters from a full-time job take part-time employment in their next job has also increased markedly over the period. The indicators of which women will move into part-time employment are almost entirely accounted for by life-cycle-related variables, in particular having to leave full-time employment for domestic reasons: other pre-labour-market or employment variables have little effect. There has been little change in the rate of flow out of part-time employment over the period: the rate peaked in the period 1979–82 (a period of very rapid rise in unemployment) and has declined slightly since. There is some evidence that some types of part-time employment act as 'traps', restricting movement back into full-time work, but again, most of the variance is accounted for by life-cycle-related variables.

Moves into part-time employment are seldom reported as improvements over preceding full-time jobs, although this is often the case for movers in the opposite direction. Yet, on the whole, part-time jobs are as likely as full-time ones to be picked on as the best in a woman's history. Perhaps because of the fit with the rest of her life, part-time work is not always regretted.

It should be remembered that these analyses have several shortcomings. By considering only the supply side of the labour market, no account has been taken of the other main institutional forces which may be acting on these women, such as changes in employer policies, the attitudes of men and women to 'working mothers', or the provision of childcare outside of the family. No investigation of changes in part-time employment over time can be complete with such a limited focus. The novel method of analysis

also has its shortcomings. The flows between full-time and part-time employment have been looked at in detail, but the flows between both types of employment and economic inactivity may also be critical. Over this period, women's participation rates have been increasing markedly, and it may be that the substitution between full-time housework and part-time employment may be more important than the substitution of full-time employment for part-time employment.

Conclusions

Most of the 'advance' of women into the labour market of post-war Britain consisted of an increase in part-time working, which did little to challenge the position of men within the labour market or of women within the home. Because of high levels of segregation and low pay rates, the new entrants to the labour market did not compete with men, either in the labour market or in the provision of a family income. Women simply took on an additional role, whilst still responsible for domestic work and child-care. Along with the 'double burden', the women themselves gained some economic freedom (although only partial) as well as an alternative identity to wife and mother.

However, amongst later cohorts there is evidence of a more fundamental change, at least for some groups of women. Those with higher levels of education (a growing proportion) have been challenging men for entry to the more prestigious occupations. They have also delayed entering into domestic commitments, with the result that they are less constrained in their career advancement. However, there are still informal barriers facing even single women and no easy solution to maintaining a career during family formation. Most women still have children, childcare remains expensive and largely unsubsidized, and there is little sign of an increase in men's willingness to share the responsibility for children.

It is likely that women's occupational and pay differentials are becoming less tightly clustered and, as for men, we may see greater differences between those at the top and those at the bottom of the occupational structure. There is every indication that levels of part-time work will remain high, and this will continue to trap many women into low-paid and low-level occupations.

REFERENCES

Alwin, D., Braun, M., and Scott, J. (1992), 'The Separation of Work and Family: Attitudes towards Women's Labour-Force Participation in Germany, Great Britain and the United States', *European Sociological Review*, 8 (1), 13–38.

Blackburn, R., Jarman, J., and Siltanen, J. (1993), 'The Analysis of Occupational Gender Segregation over Time and Place: Considerations of Measurement and some New Evidence', *Work, Employment and Society*, 7 (3), 335–62.

Bridgwood, A. and Savage, D. (1993), *1991 General Household Survey* (London: HMSO).

Burchell, B. J. (1993), 'A New Way of Analyzing Labour Market Flows using Work History Data', *Work, Employment and Society*, 7: 237–58.

CBI (1967), *Employing Women: The Employers' View* (London: Confederation of British Industry).

Dale, A. (1987), 'Occupational Inequality, Gender and Life-Cycle', *Work Employment and Society*, 1 (3), 326–51.

—— (1991), 'Stratification over the Life-Course: Gender Differences within the Household', in G. Payne and P. Abbott (eds.), *The Social Mobility of Women* (Basingstoke: Falmer), pp. 139–58.

—— and Joshi, H. (1992), 'The Social and Economic Status of Women in Britain', in G. Buttler *et al.* (ed.), *Acta Demographica* (Heidelberg: Physica-Verlag), pp. 27–46.

Dex, S. (1987), *Women's Occupational Mobility* (Basingstoke: Macmillan).

Duncan, A., Giles, C., and Webb, S. (1995), *The Impact of Subsidizing Childcare*, Research Discussion Series, 13 (Manchester: EOC).

Ermisch, J. F. and Wright, R. E. (1993), 'Wage Offers and Full-Time Employment by British Women', *Journal of Human Resources*, 28 (2), 111–33.

Fabian Society (1966), *Womanpower*, Young Fabian Pamphlet No. 11 (London: Fabian Society).

Ferri, E. (ed.) (1993), *Life at 33: Evidence from the National Child Development Study* (London: National Children's Bureau and ESRC).

Gallie, D. (1991), 'Patterns of Skill Change: Upskilling, Deskilling or the Polarization of Skills'? *Work, Employment and Society*, 5 (3), 319–51.

General Household Survey 1986 (London: HMSO).

Ginn, J. and Arber, S. (1993), 'Pension Penalties: The Gendered Division of Occupational Welfare', *Work, Employment and Society*, 7: 47–70.

Gregory, J. (1992), 'Equal Pay for Work of Equal Value', *Work, Employment and Society*, 6 (3), 461–73.

Hakim, C. (1979), *Occupational Segregation*, Department of Employment Research Paper No. 9 (London: Department of Employment).

—— (1992), 'Explaining Trends in Occupational Segregation: The Measurement, Causes and Consequences of the Sexual Division of Labour', *European Sociological Review*, 8 (2), 127–52.

Holdsworth, A. (1988), *Out of the Dolls House* (London: British Broadcasting Corporation).

Horrell, S., Rubery, J., and Burchell, B. (1990), 'Gender and Skills', *Work, Employment and Society*, 4 (2), 189–216.

Joshi, H. E. (1990a), 'Changing Roles of Women in the British Labour Market and the Family', in P. Deane (ed.), *Frontiers of Economic Science* (London: Macmillan), pp. 101–28.

—— (1990b), 'The Cash Opportunity Cost of Childbearing: An Approach to Estimation using British Evidence', *Population Studies*, 44: 41–60.

—— and Davies, H. B. (1992*a*), 'Daycare in Europe and Mothers' Foregone Earnings,' *International Labour Review* 131, 6, 561–79.

—— —— (1992*b*), 'Pensions, Divorce, and Wives' Double Burden', *International Journal of Law and the Family*, 6: 289–320.

—— and Newell, M.-L. (1987), 'Job Downgrading after Childbearing', in M. Uncles (ed.), *London Papers in Regional Science*, 18 (London: Pion).

Jowell, R., Brook, L., and Taylor, B. (1991), *British Social Attitudes: The 8th Report* (Aldershot: Dartmouth).

Klein, V. (1961), *Employed Married Women* (London: Institute of Personnel Management).

Labour Research Department (1995), 'Part-Time Workers' Employment Rights', *Labour Research*, 84 (3), 26.

McRae, S. (1991), 'Occupational Change over Childbirth', *Sociology*, 25 (4), 589–606.

—— and Daniel, W. W. (1991), *Maternity Rights: The Experience of Women and Employers* (London: Policy Studies Institute).

Martin, J. and Roberts, C. (1984), *Women and Employment: A Lifetime Perspective* (London: HMSO).

Meltzer, H. (1994), *Day Care Services for Children*, OPCS (London: HMSO).

Rubery, J. and Fagan, C. (1993), *Occupational Segregation of Women and Men in the European Community* (Brussels: Commission of the Economic Community).

Schoer, K. (1987), 'Part-Time Employment: Britain and West Germany', *Cambridge Journal of Economics*, 11: 83–94.

Scott, A. M. (1994), 'Gender Segregation in the Retail Industry', in A. M. Scott (ed.), *Gender Segregation and the British Labour Market* (Oxford: Oxford University Press), pp. 235–70.

—— and Burchell, B. (1994), 'And Never the Twain Shall Meet? . . . Lifetime Gender Segmentation in Work Histories', in A. M. Scott (ed.), *Gender Segregation and the British Labour Market* (Oxford: Oxford University Press), pp. 121–56.

Sidaway, J. and Wareing, A. (1992), 'Part-Timers with Potential', *Employment Gazette* (Jan.), 19–26.

Siltanen, J. (1990), 'Social Change and the Measurement of Occupational Segregation by Sex: An Assessment of the Sex Ratio Index', *Work, Employment and Society*, 4: 1–29.

Sloane, P. J. (1994), 'The Gender Wage Differential and Discrimination in the Six SCELI Local Labour Markets', in A. M. Scott (ed.), *Gender Segregation and the British Labour Market* (Oxford: Oxford University Press), pp. 157–204.

Thomas, M., Goddard, E., Hickman, M., and Hunter, P. (1994), *The General Household Survey 1992* (London: HMSO).

Walby, S. (1986), *Patriarchy at Work* (Cambridge: Polity Press).

Waldfogel, J. (1995), 'The Price of Motherhood: Family Status and Womens' Pay in a Young British Cohort, *Oxford Economic Papers*, 47: 584–610.

Ward, C., Dale, A., and Joshi, H. (1993), 'Participation in the Labour Market', in E. Ferri (ed.), *Life at 33: Findings from the Fifth Sweep of the National Child Development Study* (London: National Children's Bureau and ESRC).

Ward, C., Joshi, H., and Dale, A. (1996*a*), 'Income Dependency within Couples',

in L. Morris and E. S. Lyon (eds.), *Gender Relations in Public and Private* (Durham: BSA Publications Ltd.), pp. 95–120.

——— ——— ——— (1996*b*), 'Combining Employment with Childcare: An Escape from Dependence?', *Journal of Social Policy,* 25:2, 223–47.

Wareing, A. (1992), 'Working Arrangements and Patterns of Working Hours in Britain', *Employment Gazette* (Mar.), 88–100.

Watson, G. and Fothergill, B. (1993), 'Part-Time Employment and Attitudes to Part-Time Work', *Employment Gazette* (May), 213–20.

10

Women's Employment and Part-Time Work in Denmark

SØREN LETH-SØRENSEN AND GÖTZ ROHWER

Introduction

In Denmark, as in most industrialized Western societies, there have been major changes in the employment structure in the last three decades. First, we have witnessed the trend to a post-industrialized society, characterized by the primary and secondary sector having less significance, while the service sector has expanded. Second, female labour-force participation has grown, especially among married women, and at the same time, the public sector has expanded with almost the same number of employees. Against this background, it is interesting to investigate what kinds of job have been created by these developments—one sceptical argument being that the job structure in post-industrialized society will to a higher degree consist of 'junk' jobs, that is, temporary, part-time jobs with low pay. The other more positive argument is that we will see new upgraded jobs, replacing the hard and unhealthy physical work that is now disappearing.

In this context, our interest is to describe women's labour-force participation in the 1980s, distinguishing between full-time work, part-time work, and unemployment versus being out of the labour force. In particular, we will investigate the relationship between the family life-cycle (consensual unions, marriage, having children) and type of labour market participation. We also take into account conditions of women's education and employment. There are several Danish studies on labour supply (Smith, 1990; Dex and Smith, 1990; Pedersen and Smith, 1991; Smith, Walker, and Westergaard-Nielsen, 1993), but the transitions between different labour market states have not been their main focus.

We start by describing the development of the female labour market since 1960. Then we describe trends in women's education and vocational training. Next we turn to women's family situation. We finally introduce transition rate models describing the shifts between different kinds of participation. Our conclusion identifies some factors at the macro-level which

might explain the more general trend of female labour-market participation in Denmark. Finally, we try to predict future developments in full-time and part-time work.

Women in the Labour Market

For the 1960s, the main source of information on women's labour-market participation are the Population Censuses of 1960, 1965, and 1970. Unfortunately, information on part-time work was only collected in 1970. The Danish Census in 1976 was based on registry data for the first time. This method has been used on an annual basis since 1980 and it provides the most comprehensive data for Denmark since 1980. Another source for this period is the series of Labour Force Surveys, providing data on female part-time work from 1967 onwards for a sample of the population.

We can distinguish between part-time and full-time work using either subjective or objective methods. Using a subjective approach, one might ask a person if he or she works the normal number of hours per week for that type of job; if not, the person is classified as a part-time worker. This principle was used in the Danish Census in 1970 and is widely used in European Labour Force Surveys. The objective method consists of classifying people based on the number of hours worked per week, applying a somewhat arbitrary cut-off point to distinguish part-time workers. Due to the use of registry data, this method was used in the 1976 census and in the subsequent annual censuses since 1980. When looking at the development of part-time work since 1960, we have to take account of different methods used to identify part-time jobs.

In Denmark, as in many other countries, the rise in the proportion of married women participating in the labour market was one of the most profound recent changes: the participation rate increased from 23 per cent in 1960 to 43 per cent in 1970. At the same time, there was a small decline in the participation rate for unmarried (young) women. The earliest information on the proportion of women working part-time is from the 1967 Labour Force Survey, with a percentage of 29. Throughout the 1970s, the participation rate for women continued to increase. It is remarkable that in this period the number of new jobs created corresponded almost exactly with the rise in the number of part-time working women. In consequence, the highest proportion of women working part-time, at 45 per cent, was reached in 1978.

From 1980 to 1990, the participation rate increased for women between 30 and 59 years, in particular among older groups. About 80 to 90 per cent of women aged 20 to 40 were in the labour force. In 1990, for people aged 35 years, the difference between the participation rates of men and women

was less than 3 percentage points (Danmarks Statistik, 1990). In effect, the difference between the male and female participation rate is disappearing in Denmark. At the same time the category of full-time housewives not in paid employment has virtually disappeared (Danmarks Statistik, 1992). Surveys show that even among women with children aged 0–6 years, the percentage of women classified as housewives declined from 43 per cent in 1974 to 3 per cent in 1990 (Nygaard Christoffersen, 1993).

The proportion of women working full-time compared to part-time increased among those aged over 25 years during the 1980s. Here too, the female situation became similar to that for men. However, sex segregation of occupations remains. Industries characterized by a relatively high proportion of women working part-time are cleaning activities, restaurants and hotels, the retail trade, and welfare institutions. Part-time work is concentrated in jobs with relatively low socio-economic ranking among white- and blue-collar employees. But this does not mean that part-time work is looked down upon; on the contrary, it is a very attractive form of employment for many cohabiting women with small children. The rights of part-time employees are in practice almost equivalent to those of full-time workers. In Denmark, there are few disincentives for employees (and for employers) to choose part-time work. On the other hand, it seems reasonable to assume that it is a disadvantage to be working part-time if you want to be upwardly mobile in a given organization.

A Sample from the IDA Database

Our data consist of a random sample of women from the IDA database established by Danmarks Statistik (Danmarks Statistik, 1991). The IDA database is constructed as a panel data-set, but it covers the whole population as well as all enterprises with employees (200,000 local units). Data collection started in 1980 and ended in 1989. The database was constructed by linking data from public registers. In this way, it has been possible to provide information for the whole population as labour-market status at the end of the month of November each year. At the same time each employee can be linked to a certain enterprise (local unit), making it possible to measure different kinds of job mobility (Esping-Andersen *et al.*, 1994; Leth-Sørensen, 1993; see also Table 2.4 in this volume). Our sample consists of women living in Denmark in 1980 and born between 1918 and 1968, who are aged 12–62. All of these women, except for those who left the country or died, were traced up to 1989, giving us ten observation points. The sample size in 1980 was 19,398, and in 1989 we still had a sample of 18,201 women, corresponding to 93.8 per cent of the female sample size in 1980.

Fig. 10.1 shows the age distribution of the women in the sample at the

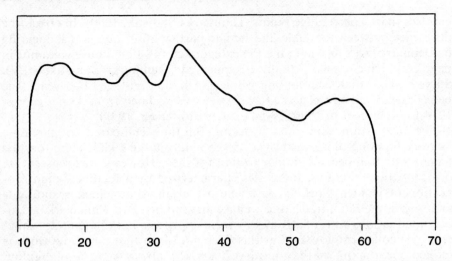

FIG. 10.1. Age distribution for women at the beginning of the observation
period (1980)

Note: Age is given on the abscissa. The distributions are shown as a smoothed density by
using a kernel density estimator with normally distributed kernels.

beginning of the observation period in 1980. The form of the distribution
reflects the development of the fertility rate in Denmark since 1918. This
means that the number of women who are in their early 30s, is the highest
in 1980. This is a consequence of the high fertility rates just after the
Second World War, with a net fertility rate of 1370 in 1946. The number
of women in our sample is lowest for women aged around 50 years, reflect-
ing the very low fertility rate in Denmark in the 1930s during the
Depression. In this period it was at its lowest in 1933, with a net repro-
duction rate under 900, considerably below 1000, which is the required
level if the population is not to decline in the long run. From 1940, the rate
was above 1000 until 1969, when it dropped to under 1000.

Labour-Market Participation

Our analysis of labour-market participation identifies four states:

(1) Full-time employment: working 30 or more hours per week.
(2) Part-time employment: working less than 30 hours per week.
(3) Unemployment.
(4) Out of labour force.

Our definitions follow ILO conventions as a short one-week reference period is used. This means that a woman can be a student and at the same time be classified as working in a part-time job. It is, in fact, quite common in Denmark for students to work part-time. 'Unemployed' means that a person is registered as having no paid work and is searching for a job. 'Out of labour force' means that a person has no paid job and is not (currently) searching for a job. The self-employed and family helpers are considered to be working full-time. Employees are classified as 'full-time working' if they are working at least 30 hours per week, otherwise as 'part-time working'. We note that this does not correspond to the way Eurostat classifies full-time and part-time work in the LFS because Eurostat uses the self-classification subjective method applicable only in personal interview surveys. Because we use registry data, we have to use the more objective method. A comparison with data from the Eurostat Labour Force Survey shows that defining part-timers as those working less than 30 hours a week produces a somewhat lower proportion of people working part-time.

A Cross-Sectional Picture

Fig. 10.2 gives a cross-sectional picture of these four labour-market states for the sample at the beginning of our observation period, that is, in 1980. First of all, the figure shows the very high participation rate for women in Denmark. For women over 40 years old, the figure shows that the proportion of women outside the labour market is rising. However, the reason why the curve increases most sharply for women over 60 years is partly due to a new system of early retirement pay in Denmark. This gives people aged between 60 and the normal pension age of 67, who have been members of the unemployment insurance system, the possibility of early retirement. This system has been successful in that 25 per cent of the women in this age group were receiving this kind of pension in 1990 (Danmarks Statistik, 1992).

Looking at Birth Cohorts

The cross-sectional picture in Fig. 10.2 is not the complete story of trends across the life-cycle. As a first step in this direction, we consider the different birth cohorts in our observation window, 1980–9. In what follows, we use the following definition of birth cohorts:

Cohort 0 Born 1918–23 Cohort 1 Born 1924–8
Cohort 2 Born 1929–33 Cohort 3 Born 1934–8
Cohort 4 Born 1939–43 Cohort 5 Born 1944–8
Cohort 6 Born 1949–53 Cohort 7 Born 1954–8
Cohort 8 Born 1959–63 Cohort 9 Born 1964–8

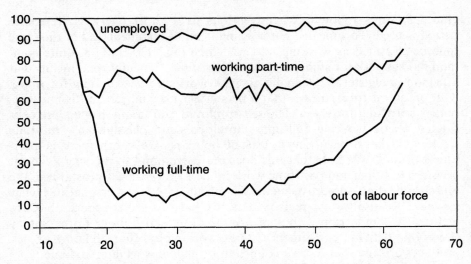

FIG. 10.2. Cross-sectional proportions (%) of women in a specific age who are out of the labour force, working full-time, working part-time, or unemployed, 1980

Note: Age is given on the abscissa.

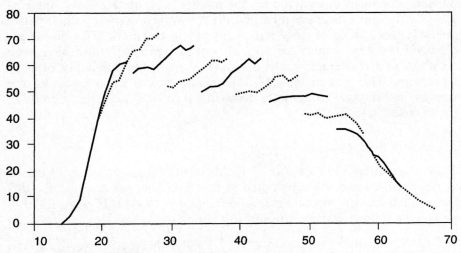

FIG. 10.3. Rate (%) of full-time labour force participation of women by cohort and age, 1980–1989

Note: Age is given on the abscissa; birth cohorts from right (oldest: cohort 0) to left (youngest: cohort 9).

Fig. 10.3 shows the proportion of women in our sample working full-time by age and cohort. The rate for each cohort is given as the middle of the age band for the cohort in 1980, adding one year in each year up to 1989. The figure clearly shows a rising trend in full-time work rates in this period and that this is a general tendency in all age cohorts.

Analogous results for part-time work rates are shown in Fig. 10.4 but the picture is somewhat different. The proportion working part-time is highest in 1980 for women aged 37–41 (born 1939–43). In the following years, 1980–9, the part-time work rate decreased for all cohorts except the very youngest. In 1989, it is still the women born 1939–43 who have the highest part-time participation rate. This is in accordance with what is already known about a decline in part-time participation for women since 1980 (Goul Andersen and Christiansen, 1991). Looking at age cohorts, it is clear that the full-time participation rate has increased regardless of age. If one were to draw conclusions based only on the cross-sectional picture in Fig. 10.2, one would expect that from the age of 20 years or so, the full-time participation rate would decline.

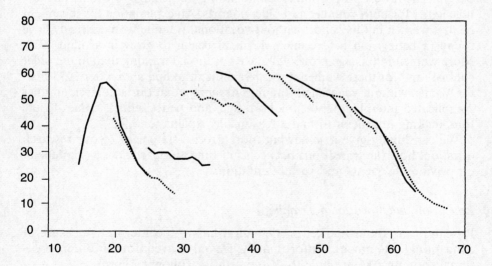

FIG. 10.4. Rate (%) of part-time labour-force participation of women by cohort and age, 1980–1989

Note: Age is given on the abscissa; birth cohorts from right (oldest: cohort 0) to left (youngest: cohort 9).

Explanatory Factors

Sector and Type of Employment

One of the major changes in Denmark since 1960 has been the growth of the public sector as a percentage of those in employment, from 10 per cent in 1960 to 30 per cent in 1990 (Danmarks Statistik, 1992). The public sector is the main source of female employment: about 45 per cent of women in employment. In our sample, employment in the public sector exceeds or is close to 50 per cent for some of the cohorts, and the highest proportion, in 1980, is found for women aged 27 to 31 years. Except for the youngest and oldest cohorts, the proportion employed in the public sector remains more or less constant across cohorts. For women aged 17 to 21 years in 1980, public-sector employment seems to be somewhat lower than among older cohorts. This might be due to the policy operating during the 1980s of curtailing expansion of the public sector, partly by not hiring new personnel and thereby cutting out the younger generations.

We also looked closely at women who are working in unskilled jobs or have only a partial relation to the labour market. We refer to both groups as unskilled. Except for the very young and very old cohorts, the proportion unskilled in each cohort is almost constant during our 10-year observation period. The lowest proportion is found among women aged 27 to 31 in 1980; it is higher for both younger and older cohorts. An explanation for this might be that women in this cohort without vocational training would already have found (a better) job before unemployment began to grow in around 1973. More women in this age group will have vocational training than in the older cohorts, and for these women it was less difficult to find a job after 1973 than for women without vocational training. Assuming that this is correct, another complicated interplay between cohort, age, and period effects comes to the fore, making it difficult to find a reasonable explanation.

We can finally give a somewhat more precise statement to our research question: how the transitions between full-time and part-time work depend on private life events and social conditions.

Education and Vocational Training

Research on labour-market participation has to include some measure of educational attainment. Unfortunately, we only have information on vocational training. We are able to distinguish the following levels:

One Year This means having completed (in a rather new educational system) one year of vocational training, in addition to basic education.

Apprenticeship	This covers completed vocational training at this level. For women, it will mostly be training in connection with an office job.
Short Courses	This is some vocational training, taking one to two years, often while working in the public sector.
Medium Courses	This is vocational training, taking three or four years.
Long Courses	This type of vocational training is, in most cases, at the university level.
No Voct	This means that there has been no vocational training in addition to basic education.

The level of vocational training varies not only with age but also, and more significantly, by birth cohort. Generally, younger cohorts have more vocational training, as shown in Table 10.1. Of course, women in the very youngest age cohorts are not old enough to have completed their vocational training. Consequently, the level of vocational training is highest among women born in 1944–8, who were 32–6 years old in 1980. In addition to information on completed vocational training, we know if a woman is involved in additional education or training, and whether she is currently in employment or not. This is a somewhat mixed category, ranging from attending the normal school system, taking part in short courses for, say, 4 weeks, or being a student at university level.

Fig. 10.5 shows the percentage of women in the educational system by age in 1980 and 1989. Most women have finished education and vocational training by their mid-20s. However, there are at least some women taking part in additional training at a later age. The conventional picture which assumes a definite point in time for leaving the educational system is in many cases no longer appropriate. Furthermore, the percentage for each age group up to at least 30 years is somewhat higher in 1989, indicating a higher level of educational training in 1989 than before.

Consensual Unions, Marriage, and Children

In Denmark, there have been enormous changes in the family formation process traditionally associated with marriage. According to official statistics, the percentage of women born in 1925–6 who had married by the age of 25 was 70 per cent, but for women born in 1966–7, it had only reached 21 per cent by the same age (Danmarks Statistik, 1993). At the same time, a major proportion now live in consensual unions. In 1980, the percentage in our sample of women aged 22–6 years who were cohabiting with another person was 66 per cent, but only slightly over half of these women were married. In the same cohort in 1989, the proportion cohabiting has

TABLE 10.1. *Level of (additional) vocational training for women in 1980, shown by row percentages for different birth cohorts*

Cohort	First year	Apprenticeship	Short courses	Medium courses	Long courses	No Voct	Total
1918–23	0.4	10.5	1.6	0.9	0.4	86.1	1967
1924–8	0.6	18.4	4.9	2.1	1.0	73.1	1671
1929–33	0.6	23.8	5.8	3.4	0.8	65.6	1516
1934–8	0.3	26.1	8.0	4.2	1.9	59.4	1604
1939–43	0.7	32.2	8.7	5.2	1.6	51.7	1931
1944–8	0.5	35.6	8.9	7.2	2.8	44.9	2403
1949–53	4.7	23.9	11.6	7.6	3.6	48.7	2017
1954–8	12.0	20.0	7.7	2.9	1.4	56.0	2020
1959–63	19.9	6.7	0.2	0.1	—	73.2	2098
1964–8	0.1	—	—	—	—	99.9	2171
Total	814	3795	1106	659	267	12757	19398
(%)	4.2	19.6	5.7	3.4	1.4	65.8	100.0

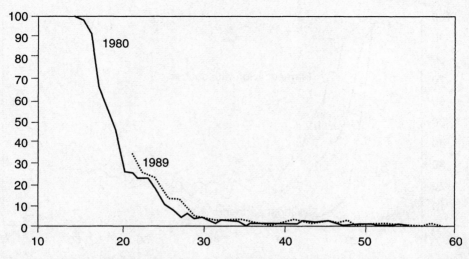

FIG. 10.5. Percentage of women in vocational training by age, 1980 and 1989
Note: Age is given on the abscissa.

increased to 76 per cent, but 80 per cent of these women were married then. An interpretation of this could be that consensual unions are a kind of transitory living arrangement that often leads to marriage.

Given that the legal status of a woman is a poor indicator of her family situation, we use the *de facto* living situation as the basis for our analysis. We distinguish four states, as follows:

Child in a Family	These are young women up to 25 years old living with their parents. One should note that the Danish family definition is based on the principle that a family living together can only consist of two generations. This means that if a woman living at home has a child, she will be classified as having a family of her own.
Without a Partner	This means that a woman lives outside her family of origin without a partner, or else lives with her parents but is older than 25 years.
Consensual Union	This means that a woman lives together with another person but is not married.
Married	This means that the woman is married and is living together with her spouse.

Fig. 10.6 shows a cross-sectional distribution for 1980 for the four categories defined above. The greatest differences by age are—as would be

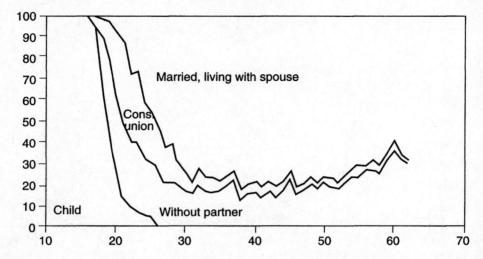

FIG. 10.6. Cross-sectional proportions (%), according to age in 1980, of women living as a child in a family, without a partner, in a consensual union, or married and living together with their spouses

Note: Age is given on the abscissa.

expected—up to the age of 30. Since it is slightly easier to look at the corresponding densities, we portray them in Fig. 10.7.

Looking first at women who live without a partner or in a consensual union, we can see that the distribution by age is the same up to an age of about 30 years. After this age, the proportion of women in consensual unions declines. The proportion living alone is at about the same level, but eventually increases because a substantial number of women become widows. The proportion of married women rises up to the age of 30. In our sample, more than 50 per cent of the 26-year-old women are actually married. Of course, in this case it might be misleading to base conclusions on family formation on such a cross-sectional picture. However, from other Danish sources we know that from 1974 to 1990, there was a prolonged period before a young person started working. At the same time, the age by which half of the women were living in consensual unions or were married went up by 1 year in this period (Nygaard Christoffersen, 1993). Therefore, we show in Fig. 10.8 how the proportion of women living without a partner has developed for each of our cohorts.

It turns out that in our sample the proportion living alone has also increased among the younger cohorts. A possible explanation for this prolonged period of adolescence might be that a greater proportion of young women are now undertaking vocational training (Nygaard Christoffersen, 1993). The IDA database provides information on whether a women has

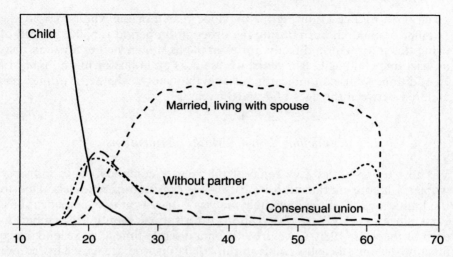

FIG. 10.7. Cross-sectional age distribution for 1980 of women living as a child in a family, without a partner, in a consensual union, or married and living together with their spouses

Note: Age is given on the abscissa. The distributions are shown as smoothed densities using kernel estimators with normally distributed kernels.

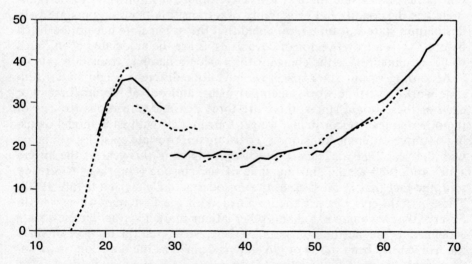

FIG. 10.8. Proportion (%) of women living alone by cohort and age, 1980–1989

Note: Age is given on the abscissa; birth cohorts from left (youngest: cohort 9) to right (oldest: cohort 0).

given birth to a child during the previous year. For the whole sample, the number of children born during the observation period is 5804. Instead of using this information directly, for example to show whether a woman has at least one child aged 0–6 years, we use it as an indicator in our analysis. In addition, we use an indicator variable that shows whether a woman has children between the ages of 7 and 17 years.

Modelling Labour-Market Transitions

We now try to assess how some of the factors described above influence women's labour-market transitions, using transition-rate models. Due to the limitations of our sample, the analysis is based on two simplifications. First, since we only have observations for a specific month (November) in each of the years 1980–9, we proceed on a discrete-time axis. Second, since most of the episodes observable in this 1980–9 period are left-censored, we ignore the question of duration dependence. Based on these simplifications, we use a discrete-time logistic transition-rate model (Allison, 1982).

To formally define the model, let T be the duration of the episode (measured since 1980). Let O and D denote the origin and destinations states, respectively. The model can then be written as:

$$\Pr(t = t, D = k \mid O = k_0, T \geq t) = \exp(\beta_0 + X\beta)/(1 + \exp(\beta_0 + X\beta))$$

On the left-hand side there is a discrete-time transition rate, to be interpreted as the conditional probability of a transition from origin state k_0 to destination state k at time t, provided that the origin state has not been left before t. X is a (row) vector of covariates, β are the associated coefficients to be estimated; β_0 is the constant to provide a baseline transition rate.

According to our state space, we have four different origin states: full-time work, part-time work, unemployment, and out of labour force. For each of these origin states, there are three possible transitions (to one of the other states). Accordingly, we get four models with each model focusing on three different transitions. To set up appropriate episodes, we begin with the year 1980 and define the state occupied in this year as the 'origin state' and 1980 as the starting time of the episode (ignoring, as already said, the fact that in most cases the episodes actually started before 1980). These pseudo-episodes are then defined until the first year when we can observe that a woman has changed her labour-market status. The new state is defined as the 'destination state' of the episode, and the number of years the women has been in the origin state is defined as the duration (in years) of the episode.

Since we are mainly interested in the influence of life-cycle events on labour-market participation, we exclude the very young and the very old

and concentrate on birth cohorts 3–7, that is, women born between 1934 and 1958 (aged 22–46 in 1980). We focus on transitions between full-time and part-time work, partly because we only have information on job characteristics for these women. However, these two states cover the majority of women. We use the same covariates for the four models, as follows:

D82–3 A period dummy taking the value 1 for 1982–3.

D84–5 A period dummy taking the value 1 for 1984–5.

D86–9 A period dummy taking the value 1 for 1986–9. The reference period for these three dummy variables is 1980–1.[1]

COHO4 A dummy variable taking the value 1 for birth cohort 4, born 1939–43.

COHO5 A dummy variable taking the value 1 for birth cohort 5, born 1944–8.

COHO6 A dummy variable taking the value 1 for birth cohort 6, born 1949–53.

COHO7 A dummy variable taking the value 1 for birth cohort 7, born 1954–8. The reference for these four dummy variables is cohort 3, women born between 1934 and 1938.

CH1 A time-varying dummy variable taking the value 1 if a woman has children aged up to 6 years.

CH2 A time-varying dummy variable taking the value 1 if a woman has children 7 to 17 years old.

CH3 A time-varying dummy variable taking the value 1 if a woman has children 18 to 25 years old. The reference for these three dummy variables are women without children, or with children older than 25 years.

CONU A time-varying dummy variable taking the value 1 if a woman lives in a consensual union.

MAR A time-varying dummy variable taking the value 1 if a woman is married and lives with her spouse.

EPART A time-varying dummy variable taking the value 1 if a woman currently participates in education or additional vocational training (lagged by one year).

VOCT A time-varying dummy variable taking the value 1 if a woman has completed vocational training. The reference category is women without vocational training.

PSEC A time-varying dummy variable taking the value 1 if a woman is currently employed in the private sector. The reference category is the public sector.

[1] These period dummy variables are included to provide for some additional flexibility in the models. Of course, since our episodes are left-censored, they capture a mixture of period and duration effects. They will, therefore, not be given a substantive interpretation.

UNSK A time-varying dummy variable taking the value 1 if a woman is currently employed in an unskilled job.

Full-Time Work Episodes

Table 10.2 shows estimation results for episodes in full-time work beginning in 1980.

TABLE 10.2. *Discrete-time transiton-rate model based on episodes for women beginning in 1980 in a state of full-time work*

| | Destination state | | | | | |
| | Part-time | | Unemployed | | Out of labour force | |
	Coeff.	*t*-value	Coeff.	*t*-value	Coeff.	*t*-value
Const.	−3.55	−24.26	−3.50	−25.58	−3.90	−18.57
D82–3	−0.65	−7.19	−0.31	−3.83	−0.41	−2.81
D84–5	−0.87	−8.49	−0.68	−6.93	−0.73	−4.19
D86–9	−1.33	−13.24	−1.12	−11.69	−0.81	−5.37
CH1	0.25	2.97	0.22	2.76	0.15	1.06
CH2	0.16	2.02	0.03	0.40	−0.09	−0.73
CH3	0.08	0.67	−0.23	−1.84	0.15	0.90
CONU	0.03	0.21	−0.09	−0.87	−0.34	−1.69
MAR	0.36	3.60	−0.17	−1.96	−0.15	−1.05
COHO4	−0.07	−0.53	0.10	0.77	−0.04	−0.22
COHO5	−0.08	−0.65	−0.07	−0.53	−0.00	−0.02
COHO6	0.28	2.08	0.21	1.62	−0.29	−1.35
COHO7	0.28	2.02	0.61	4.86	0.18	0.87
EPART	0.54	2.95	−0.49	−1.99	0.47	1.62
VOCT	0.10	1.32	−0.57	−7.51	−0.59	−4.66
PSEC	−0.27	−3.59	0.70	10.25	−0.19	−1.63
UNSK	0.10	1.04	0.76	10.37	0.53	4.16

Log-likelihood: −9912.29

Flows from full-time to part-time work. The model shows a higher propensity for younger birth cohorts to change from full-time to part-time work. There is also a strong influence of small children and being married. Although the rate of transition from full-time to part-time work is quite low in Denmark, these results correspond to a traditionalist situation where a married woman with small children reduces her working hours. But it is not equally easy for all women to have a part-time job, and the transition is more common if a woman is employed in the public sector rather than the private sector. This might be due to different organizational

cultures and to different kinds of jobs. If a woman is undertaking education or (additional) vocational training, then there is, as might be expected, a higher transition rate. However, there seems to be no clear influence of education or whether the woman is working in an unskilled job.

Flows from full-time work to unemployment. Here we find that younger women have a higher risk of becoming unemployed. There is a strong influence of small children (0–6 years old) and a negative effect of being married. In addition, there is a higher transition rate into unemployment in the private sector, as would be expected, and if a woman has no or only low vocational training or is employed in an unskilled job.

Flows from full-time work to being out of labour force. Here we find only two highly significant effects. Vocational training decreases, and unskilled working increases the transition probability.

Part-Time Work Episodes

Table 10.3 shows estimation results for episodes in part-time work beginning in 1980.

TABLE 10.3. *Discrete-time transition-rate model based on episodes for women beginning in 1980 in a state of part-time work*

	Destination state					
	Full-time		Unemployed		Out of labour force	
	Coeff.	*t*-value	Coeff.	*t*-value	Coeff.	*t*-value
Const.	−2.01	−13.25	−3.20	−11.54	−2.79	−11.06
D82–3	−0.39	−4.66	−0.20	−1.41	−0.44	−3.04
D84–5	−0.38	−4.15	−0.68	−3.53	−1.12	−5.21
D86–9	−0.55	−6.24	−0.86	−4.69	−1.03	−5.61
CH1	−0.16	−1.92	0.20	1.26	0.44	2.77
CH2	0.21	2.78	−0.37	−2.72	−0.57	−4.22
CH3	0.10	1.06	0.08	0.43	−0.33	−1.79
CONU	−0.12	−0.79	−0.40	−1.44	−0.53	−2.12
MAR	−0.52	−4.82	−0.65	−3.43	−0.75	−4.37
COHO4	0.13	1.25	−0.10	−0.47	0.06	0.36
COHO5	0.34	3.16	0.34	1.67	−0.53	−2.56
COHO6	0.41	3.43	0.07	0.31	−0.41	−1.89
COHO7	0.53	3.56	0.83	3.34	−0.17	−0.73
EPART	0.61	3.81	−0.54	−1.75	0.67	2.96
VOCT	−0.04	−0.58	−0.37	−2.76	−0.18	−1.32
PSEC	−0.17	−2.67	0.60	4.93	0.09	0.78
UNSK	−0.03	−0.40	0.18	1.32	1.06	7.52

Log-likelihood: −6634.95

Flows from part-time to full-time work. Here we find a strong influence of birth cohorts: younger cohorts have a significantly higher propensity to change from part-time to full-time work. We also find some life-cycle influences. Small children (0–6 years) decrease this transition probability, but once the children are 6 years and over, there is a positive influence on changing to full-time work. Interestingly, this transition seems to be common in the public sector. To interpret the impact of EPART, being in education or additional training, one should note that this time-varying variable is lagged by one year.

Flows from part-time work to unemployment. The estimation results for this transition are very much the same as for the transition from full-time work to unemployment. But, interestingly, being employed in an unskilled job no longer has a highly significant effect.

Flows from part-time work to being out of labour force. The most significant positive impact comes from being employed in an unskilled job, followed by the impact of small children (0–6 years old). When the children become older, the probability of leaving the labour force decreases; the same is the case if a woman is married or lives in a consensual union.

Looking at Selected Transition Probabilities

To help in the interpretation of the modelling results, we now present some selected transition probabilities. The calculation is based on the estimation results of our models. Table 10.4 consists of five parts: (*a*) transition probabilities for 'typical' Danish women (*b*) change in probabilities due to marriage (*c*) change in probabilities due to small children (*d*) change in probabilities due to sector of employment (*e*) change in probabilities due to unemployment. At the same time the table includes different types of transitions, which we have found to be the most interesting: (1) from full-time (FT) to part-time (PT) (2) from part-time to full-time work, and (3) from full-time work to unemployment (UE).

'Typical' Danish women. In this section we have calculated the probabilities for women in 'typical' social conditions, based on their age. First, we have a young unmarried woman without children, who has not completed any vocational training, is not working in an unskilled job, and is employed in the public sector. At the other end of the age spectrum is a middle-aged, married woman with children 7–17 years old, who has not had any vocational training, is not working in an unskilled job, and is employed in the public sector. The table shows a greater probability of transition from full-time to part-time work for women with small children. The transitions from part-time to full-time work and from full-time work

Cohort	Married	Children	Voct	Unskilled	Sector	Transition		
						FT→PT	PT→FT	FT→UE
'Typical' Danish women								
1954–8	no	no	no	no	public	0.037	0.185	0.052
1949–53	yes	0–6	no	no	public	0.065	0.092	0.037
1944–8	yes	0–6	no	no	public	0.046	0.086	0.029
1939–43	yes	7–17	no	no	public	0.043	0.101	
1934–8	yes	7–17	no	no	public	0.046	0.089	
Marriage								
1954–8	yes	no	no	no	public	0.052	0.119	0.045
1949–53	no	0–6	no	no	public	0.046	0.146	0.044
1944–8	no	0–6	no	no	public	0.033	0.137	0.034
1939–43	no	7–17	no	no	public	0.031	0.158	
1934–8	no	7–17	no	no	public	0.033	0.142	
Children 0–6 years								
1954–8	no	no	no	no	public	0.037	0.185	
1954–8	no	0–6	no	no	public	0.046	0.161	
1949–53	yes	no	no	no	public	0.052	0.107	
1949–53	yes	0–6	no	no	public	0.065	0.092	
1944–8	yes	no	no	no	public	0.037	0.100	
1944–8	yes	0–6	no	no	public	0.046	0.086	
Sector of employment								
1954–8	no	no	no	no	private	0.028	0.161	0.100
1949–53	yes	0–6	no	no	private	0.050	0.079	0.073
1944–8	yes	0–6	no	no	private	0.036	0.074	0.056
1939–43	yes	7–17	no	no	private	0.034	0.086	
1934–8	yes	7–17	no	no	private	0.036	0.077	
Unemployment								
1954–8	no	no	no	yes	private			0.192
1954–8	no	0–6	no	yes	private			0.228
1949–53	yes	no	no	no	public			0.030
1949–53	yes	0–6	no	no	public			0.037
1944–8	yes	no	yes	no	public			0.013
1944–8	yes	0–6	yes	no	public			0.016

to unemployment are both higher for young women, showing the expected effect of age.

Marriage. In the next section we concentrate on the effect of marriage on transition rates. As expected, we find that married women have a higher probability of becoming employed part-time. For the part-time to full-time transition, the probability is highest for the women without a husband. This could partly be due to women getting a divorce and wanting to work full-time afterwards.

Children 0–6 Years. The next section includes the differences in probabilities due to having small children in the family. These results show that having small children increases the probability of going to work part-time, and that the absence of small children increases the probability of changing from part-time to full-time employment (Ingerslev, Ploug, and Reib, 1992; Økonomiministeriet, 1991).

Sector of Employment. In this section, the probabilities of transition are based on the coefficients for employment in the private sector. Comparing these probabilities shows that the transition between full-time and part-time participation is lower for those who work in the private sector. The risk of being unemployed is somewhat higher in the private sector, which was also what we expected. Some civil servants have very long terms of notice (up to 3 years); at the same time, the public sector has been characterized by a tradition of not laying off employees on normal contracts.

Unemployment. The last section contains types of women deliberately selected to show the differences in the risk of unemployment. Depending on age, vocational training, type of employment, and sector, it is possible to find groups with very different risks of unemployment. Besides age and sector, the risk of unemployment is high for women without any vocational training and women who are working in an unskilled position. Also, women with small children have a somewhat higher risk of unemployment (Ingerslev, Ploug, and Reib, 1992).

Conclusions

These results on transitions to or from full-time and part-time work indicate that such movements are less frequent among older women. The reason for this is presumably that women find their job more or less acceptable after some years in the labour market. Being married increases the rate of changing from full-time to part-time work and reduces the rate for transitions in the opposite direction. For married women, this indicates a tendency to work part-time, which might be explained by a division of roles in some couples. Women living in consensual unions seem to be more

or less in the same position as single women, as indicated by the fact that transitions do not substantially differ between them. However, having small children increases the probability of transitions to part-time work. For women who do not have small children any longer, there might be some indication that they will return to full-time work. Education seems to have no impact, since having some vocational training does not make any significant difference. This might seem unexpected because one might argue that women without any vocational training would be more inclined to work part-time.

Being in the educational system (lagged by one year) increases the probability of transition from full-time to part-time work. An explanation for this might be that women taking part in educational activities want to reduce the number of hours they work. But the results also show that being in the educational system increases the probability transition from part-time to full-time work. The only explanation for this seems to be that this concerns women who have finished their education this year. But this needs to be studied more carefully using a data-set that provides more information on education.

A further significant factor in explaining the transitions between full-time and part-time work is the sector in which the women work. The transitions in both directions are highest for women working in the public sector. Here we have jobs, in particular in the social and educational area, that can easily be organized as part-time jobs. And it should be noted that there is already a relatively long tradition of accepting part-time work in Denmark's public sector.

For transitions to unemployment, the risk is higher among women who are young, unmarried, without vocational training, and working in the private sector. Except for the last factor, this is what is already known from the unemployment statistics. For transitions from work to being out of the labour force, the results show very few significant factors for women working full-time; only vocational training and being unskilled seem to matter. For women working part-time, there are additional factors that relate to the transition out of the labour force. Maybe this is due to a higher probability of exiting the labour force from part-time work than from a full-time job. Since very few women leave full-time work to leave the labour force altogether, it is difficult to find social factors that explain this transition.

The main conclusion is that transition to and from full-time and part-time work is indeed dependent on social conditions and private life events. However, we would like to add a few remarks about the influences of the 'macro-level' which might also have some influences on increasing the proportion of women working full-time. It seems remarkable that according to Sundström (1993) similar developments can be observed in Sweden,

another Scandinavian welfare state. Therefore, one should look for explanations that could be relevant to both cases. We mention a few factors that we think are most relevant.

Looking first at the supply side, the following points should be mentioned. First, younger women live alone for a longer period, they have a smaller number of children, more women have longer years of education, and higher education should give them access to more attractive jobs. When the labour-market participation of married women began to increase in the 1960s, many of the new jobs did not require much skill and were rather routine jobs; therefore, they were easier to divide into part-time jobs. For the young women of today who have some vocational training, the jobs would be more highly qualified, and it would be more difficult to split these into part-time jobs. Probably, if asked what kind of job they would like, most women would prefer a full-time job. This could be interpreted as an indicator of a shift in the (self-)definition of women, in particular young women. Young women, in particular, prefer having education which includes vocational training, so that they can live an independent way of life, if necessary. The role of being a wife and mother is no longer their most significant expectation.

One demand-side factor that might have some influence is that the number of working hours per week has been reduced since 1987, thereby making part-time employment less likely. One should, of course, also take the general economic situation since 1980 into consideration. In this period, the unemployment rate has been quite high and one would therefore expect employers' preferences to be dominant in the labour market. One might suggest that they prefer full-time workers; however, this question is still open. An additional point concerning the economic situation is that the inflation rate has been falling to a very low level since the beginning of the 1980s. Consequently, the expectations of the families who borrowed money to buy a house or flat were quite different at the time they obtained the loan from the situation that prevailed later. This might have the consequence that some women cannot afford to stop working full-time. At least it seems reasonable to believe that the economic situation has enhanced the importance of full-time employment.

Among the institutional factors, the impact of the tax system is noted by Sundström, among others. In Denmark, separate taxation of wage income for husband and wife has been in operation since the end of the 1960s. As a consequence, there has been no tax incentive for wives to stay at home or work fewer hours. Furthermore, the unemployment insurance system in Denmark is often accused of pulling women into the labour market. If a woman subsequently becomes unemployed, her family has a paid housewife. It is likely that the very high unemployment rate in Denmark during most of the 1980s kept a minor part of the labour force in unemployment

which would otherwise have been outside the labour force. During the 1980s, trade unions had policies of insisting that employees have full-time jobs. They were reluctant to accept proposals for job-splitting or to otherwise create an easier labour market for those who would otherwise have great difficulty in finding a job.

For an explanation of the Danish experience since 1960 with respect to women's relation to the labour market, it also seems reasonable to note the theory of Oppenheimer (1970). The period from 1960 to 1970 was characterized by the expansion of the public sector. This created many jobs that were traditionally occupied by women. At the same time it was becoming more common to be in the educational system for a longer period. For example, the percentage passing a secondary school exam grew from 7 per cent in 1960 to 14 per cent in 1970 (Danmarks Statistik, 1992: Table 6.3). While the demand for female employees was growing, more young women were in the educational system during this period. The consequence was a demand for labour which resulted in an increase in the participation rate for married women. Even foreign workers came to Denmark in greater numbers.

In this context, it also seems reasonable to turn to Esping-Andersen's (1990) description of the influence of the Scandinavian welfare states on the labour market. According to Esping-Andersen, the Scandinavian welfare states encourage employment by providing childcare and care for the elderly. One consequence of the welfare state is a reduction of traditional female work in the family, making it possible for the women to have a job. At the same time the welfare state has created a huge labour market, especially in the field of social services and the health service, where women can find employment.

Although the proportion of women working part-time is now declining, a substantial number of women still work part-time. Since women who work part-time have specific characteristics, the full-time perspective on women's part-time employment, which only differentiates between housewives and employed women, is not correct. The social situation of women working part-time is not equal to that of other women. On the other hand the 'typical work perspective', which mainly looks at employment status in the labour market, is also incorrect because the status of a part-time employee is a clear consequence of the woman's family situation.

In Denmark, it is generally believed that the labour-market participation rate of women will rise still more in the near future. There is only a small difference between the participation rate for men and women born after 1950, and as these cohorts grow older, employment rates might even become higher for women than for men. In the short term, new legislation in 1994 making it easier to take leave from employment for up to one year on minimum pay might delay this trend. It is reasonable to assume that

this opportunity will be used first and foremost by the female part of the labour market, since married women often have a lower income than their husbands. The consequence of this legislation, especially for women, remains to be seen.

Future developments in women's part-time work are difficult to ascertain, since there are factors pointing to an increase as well as to a decline. We have shown that the proportion of women working part-time has fallen in Denmark since 1980. From other sources we know that the proportion of women working part-time was at it highest by the end of the 1970s. New jobs in the service sector could increase the number of part-time jobs in coming years. A presumed weakening of the labour unions might also point to the possibility of the creation of more 'atypical' jobs. But it should also be noted that principles of rationalization, standardization, and fordism could be used in a new context and this could lead to the creation of new 'junk' jobs.

Our analysis of transitions between different types of participation showed that marriage and small children are indeed significant determinants of the transitions between full-time and part-time participation. Both make a transition to part-time work more likely and reduce the probability of a transition from part-time to full-time work. Among younger women with higher levels of education, there is a tendency to live alone for a longer period before entering a consensual union or marriage. Also, the fertility of younger birth cohorts is low. These factors suggest that the proportion of women working part-time will stay low or decline.

New Danish legislation permitting paid leave from employment for a longer period might stimulate still other types of labour-market participation. One could think of periods of full-time work broken up by shorter periods of leave. This model has the advantage of only stopping a person's career for a shorter period, as compared with having a part-time job on a more permanent basis. This might also give men an opportunity to withdraw temporarily from the labour market. This could be a model for future developments, at least for a country that builds on the Scandinavian welfare model.

REFERENCES

Allison, P. D. (1982), 'Discrete-Time Methods for the Analysis of Event Histories' in S. Leinhardt (ed.), *Sociological Methodology* (San Francisco: Jossey-Bass), pp. 61–98.

Danmarks Statistik (1990), 'Arbejdsmarked 1992: Registerbaseret arbejdsstyrkestatistik ultimo november 1990' ('Labour Market 1992: Labour Force Statistics Based on Register Data, November 1990'), No. 15, Statistiske Efterretninger (Copenhagen: Danmarks Statistik).

—— (1991), 'IDA—en integreret database for arbejdsmarkedsforskning' ('IDA: An Integrated Database for Labour-Market Research'), (Copenhagen: Danmarks Statistik).

—— (1992), 'Levevilkår i Danmark: Statistisk oversigt 1992' ('Living Conditions in Denmark in 1992: A Statistical Review'), (Copenhagen: Danmarks Statistik Socialforskningsinstituttet).

—— (1993), 'Befolkningens bevægelser 1991' ('Population Statistics 1991'), (Copenhagen: Danmarks Statistik).

Dex, S. and Smith, N. (1990), 'The Labour Force Behaviour of Married Women in Denmark and Britain: A Comparative Study', Working Paper 90–8 (Aarhus: Aarhus School of Economics and Business Administration).

Esping-Andersen, G. (1990), *The Three Worlds of Welfare Capitalism* (Cambridge: Polity Press).

—— Rohwer, G., and Leth-Sørensen, S. (1994), 'Institutions and Occupational Class Mobility: Scaling the Skill-Barrier in the Danish Labor Market', *European Sociological Review*, 10(2), 119–34.

Goul Andersen, J. and Christiansen, J. M. (1991), *Skatter uden velfærd* ('Taxes without Welfare'), (Copenhagen: Jurist og økonomforbundets Forlag).

Ingerslev, O., Ploug, N., and Reib, J. (1992), *Forløbsanalyser af de 25–59 årige i 1980'erne* ('Longitudinal Analysis of Persons 25–9-Year-Olds in the 1980s'), (Copenhagen: Socialkommissionens Sekretariat).

Leth-Sørensen, S. (1993), 'Jobmobilitet belyst ved hjælp af IDA-databasen' ('Job Mobility Analysis based on the IDA Databases'), *Dansk Sociologi* , 2: 62–80.

Økonomiministeriet (1991), *Lovmodel 1991* ('The Danish Law Model System 1991'), (Copenhagen: Økonomiministeriet).

Nygaard Christoffersen, M. (1993), *Familiens ændring* ('Changes in the Family Structure'), Copenhagen: Socialforskningsinstituttet.

Oppenheimer, V. K. (1970), *The Female Labour Force in the United States: Demographic and Economic Factors Governing its Growth and Changing Composition*, Population Monograph Series, Department of Demography, University of California, Berkeley.

Pedersen, P. J. and Smith, N. (1991), 'Early Exit in the Danish Labour Market— A Time-Series Approach', *Studies in Labor Market Dynamics*, Working Paper 91–2 (Aarhus: Aarhus School of Economics and Business Administration).

Smith, N. (1990), 'Household Labour Supply and Taxes in Denmark', *Studies in Labor Market Dynamics*, Working Paper 90–2 (Aarhus: Aarhus School of Economics and Business Administration).

Smith, N., Walker, I., and Westergaard-Nielsen, N. (1993), 'The Labour Market Behaviour of Danish Lone Mothers', *Studies in Labor Market Dynamics*, Working Paper 93–2 (Aarhus: Aarhus School of Economics and Business Administration).

Sundström, M. (1993), 'The Growth in Full-Time Work among Swedish Women in the 1980s', *Acta Sociologica*, 36(2), 139–50.

11

Managing Work and Children: Part-Time Work and the Family Cycle of Swedish Women

MARIANNE SUNDSTRÖM

Introduction

Sweden is famous for its high rate of female labour-force participation and fertility, as well as for its relatively high degree of gender equality as compared to other industrialized countries. Contrary to popular belief, the high labour-market activity of married women in Sweden is a fairly recent phenomenon. Census data show that never-married women constituted the majority of the female labour force even in the 1950s, and it was not until 1965 that the proportion of married women exceeded 50 per cent (Table 11.1). However, in contrast to most other European countries, Sweden has long had a high proportion of part-time workers among employed women, about 34 per cent already by 1965 (Table 11.2).[1] This may seem contradictory: with this relatively high degree of gender equality, why do so many Swedish women work part time? By demonstrating how Swedish women use part-time work over the family cycle, I will argue in this chapter that for Swedish women, part-time work has been a prerequisite for their high rate of paid work and fertility. It has also contributed to increased gender equality.

The chapter surveys and draws on previous Swedish research, compiled on the basis of panel data from the Swedish Labour Force Surveys and on other relevant data. The chapter is organized as follows: the next section identifies the key features of part-time work in Sweden. I then present trends in female part-time work in Sweden and discuss explanations for the shift, before describing how Swedish women shift into and out of part-time work over the family cycle—first, in connection with childbirth, and then as the children grow up.

I am grateful to Eva Bernhardt and Britta Hoem for their valuable comments on earlier versions of this chapter. I also want to thank Britta Hoem for letting me have the data for Tables 11.9 and 11.10.

[1] In this chapter, a part-time worker is defined as a person who ordinarily works 1–34 hours per week and 'longer' part-time as 20–34 hours per week. The data source is the Swedish Labour Force Surveys, if not stated otherwise.

TABLE 11.1. *Swedish women in the labour force, 1920–1990*

	Employed women 000s	% women of the labour force	% married of the female labour force	LFPR all women (%)	LFPR married[a] women (%)	LFPR never married[b] women (%)
1920	775	30	5	27	4	52
1930	898	31	10	31	8	57
1940	810	27	16	29	9	58
1950	819	26	29	30	14	62
1960	966	30	44	32	23	54
1965	1160	34	51	35	30	51
1970	1207	35	58	38	38	44
1975	1373	39	56	46	43	51
1980	1604	43	69	53	55[a]	37[b]
1985	2022	47	68	59	68[a]	45[b]
1990	2158	48	66	61	71[a]	47[b]

[a] For 1980–90, data refer to all cohabiting women.
[b] For 1980–90, data refer to non-cohabiting women.

Note: LFPR = Labour force participation rate. Data for 1920–65 include all persons 15 years or over and for 1970–90 persons 16 years or over. Female family workers in agriculture are excluded in 1920–65. Persons working less than 20 hours/week are only included in 1985–90. In 1985, a new definition was introduced which overstates employment compared to the old method.

Source: The Population Censuses.

TABLE 11.2. *Labour-force participation rates and the proportion employed part-time among Swedish women and men aged 16–64 years, 1965–1993*

	LFPR (%)		% employed part-time		Weekly hours worked[a]	% of female part-timers working 20–34 hours p.w.
	Female	Male	Women	Men		
1965	55	89	34[b]	4[b]	36	41
1970	59	87	38	3	33	63
1975	68	88	41	3	32	72
1980	75	88	46	6	31	78
1982	77	86	47	6	31	80
1985	79	86	44	6	32	84
1990[c]	82	86	42	7	34	86
1993[c]	77	81	41	9	33	85

[a] Average hours worked by women at work.
[b] Persons aged 16–74 years.
[c] Data have been adjusted to the 1993 change in LFS method and are not quite comparable to earlier years.

Source: The Labour Force Surveys, Statistics Sweden, yearly averages.

Characteristics of Part-Time Work in Sweden

As in most countries, part-time work in Sweden is a predominantly female phenomenon. However, the proportion of employed men working part-time is non-neglible and increasing (Table 11.2). In Sweden, women's part-time work implies rather long weekly hours: 30 hours per week is not uncommon. This is one of the features of part-time work in Sweden which gives it a non-marginal character, distinguishing it from the other countries in this study. Furthermore, Swedish part-time workers are (and have been for some time) entitled to full social benefits, with income-related benefits proportional to earnings, paid vacation, and job security (Sundström, 1992). Third, part-time work in Sweden, especially among mothers of pre-school children, often takes the form of reduced hours, that is, persons employed full-time take a partial leave of absence with the right to go back to full-time work, a system described further later. Fourth, as will be shown later, part-time work among Swedish women predominantly takes the form of continuous employment; part-time work alternating with periods of non-employment is more rare. Fifth, in Sweden, part-time work is not restricted to unqualified, low-level, and low-paid jobs: a considerable proportion of women with higher education also work part-time.

In this chapter, I define part-time workers as persons who ordinarily work less than 35 hours per week and this definition is applied over the whole period analysed. Since the standard work week is 40 hours (and has been since 1973), a small proportion of part-time workers will fall outside this category (e.g. those who work 37 hours per week). The reverse case of full-time workers being classified as part-timers will be even less frequent, as shift-workers and other groups that have shorter weekly hours in accordance with collective bargaining agreements normally work 36–8 hours per week. Consequently, my definition produces higher percentages of part-time workers than definitions using lower hours thresholds in other countries. However, the main difference between Sweden and other countries is that large groups of Swedish part-time workers have working conditions that differ very little from those of full-time workers.

Trends in Part-Time Work among Swedish Women 1970–1993

Along with the steep rise in female labour-force participation during the 1970s, the share of part-timers among employed women also grew rapidly, especially in the late 1970s, to reach its peak at about 47 per cent in 1982 (Table 11.2). This increase in female employment was to a large extent intended by policy-makers and created through policy measures aimed at increasing female labour supply, since Sweden had long had a shortage of

labour. One significant factor in encouraging the gainful employment especially of married women was the introduction of separate taxation of spouses from 1970 (Gustafsson, 1992). This tax reform was important because in the highly progressive Swedish tax system, the earnings of a married woman were formerly taxed on top of her husband's, which implied low net earnings, even if the husband earned an average wage.[2] A second factor was the rapid expansion of public daycare facilities for pre-school children and young schoolchildren (Gustafsson and Stafford, 1992). Third, the introduction of six months' paid parental leave in 1974, later extended and supplemented with other leave options, stimulated labour-market activity among young women, since benefits received are based on prior earnings and non-employed women receive only a very low flat-rate payment (Sundström and Stafford, 1992).[3] Fourth, the rise in female real wage rates relative to those of men in the 1970s exerted a strong positive influence on women's paid work (Gustafsson and Jacobsson, 1985; Sundström, 1987). In fact, the joint effect of separate taxation and rising marginal tax rates, plus the narrowed male–female wage gap, was to favour a re-allocation of time in the household, so that women increased their time spent on market work and decreased that spent in housework and vice versa for men (Sundström, 1987; Axelsson, 1992).

Why did the proportion of part-time workers among employed women rise in the late 1970s? As I have shown in previous work, the main explanation was that labour-force participation increased most rapidly among groups of women that had an above average propensity to work part-time if they were employed at all, such as married women and mothers of pre-school children (Sundström 1987; 1991). In addition, the proportion employed part-time rose among all groups of employed women after the mid-1970s. One factor which increased the relative attractiveness of part-time over full-time work in this period was the growth of marginal tax rates.[4] Another factor was the fact that women did not lose their social benefits by working part-time. A third factor was a series of reforms that broadened employees' opportunities for reduced hours and part-time

[2] In the 1960s, Swedish feminists campaigned actively in favour of mandatory separate taxation of spouses, since they realized its importance for women's labour-market activity and thereby for gender equality (Lyttkens, 1992).

[3] Since 1974, employed parents of newborn children have the right to a leave of absence with benefits equal to 90% of earnings. Initially, benefits covered only six months' leave but, since then, benefits have been extended stepwise to 15 months' leave from 1989 onwards, of which the final three are replaced by a flat rate of SEK 60 per day for everyone (Sundström and Stafford, 1992). Since 1995 earnings have been reimbursed at 80%.

[4] For a full-time worker with an average blue-collar wage, marginal tax rates reached an all time high of 64% in 1976, while those of half-time workers remained constant at about 32% throughout the decade (Tegle, 1985: 77).

work, sometimes with compensation for loss of income. Examples of such reforms are the partial pension[5] (from 1976), parental leave which could be used on a part-time basis (from 1974), and the (unpaid) right of parents of pre-school children to reduce their working hours to 75 per cent of full-time hours with the right to go back to full-time work again (from 1979). The result of these changes in public policies and net wages was to produce rates of female labour-force participation and part-time work that were high by international standards. After 1982, the proportion working part-time fell among all groups of employed women and average weekly hours worked rose by about two hours per woman. In Sundström (1993), I suggested that a major explanation for this new development was the 1983 Swedish tax reform, carried out in a period of high demand for labour: marginal tax rates for full-time workers were reduced stepwise, whereas those of part-time workers were raised. Also contributing to the change was the expansion of after-school care for young schoolchildren and a lower replacement rate in the partial pension in 1982–7 (see n. 5). These changes increased the relative profitability of full-time work over part-time employment in the years following 1983. In the economic downturn of the early 1990s, trends were again reversed. The decline in the proportion of women working part-time halted, as did the growth in weekly hours worked; the proportion of part-time workers working longer hours diminished, and female labour-force participation rates fell after three decades of continuous growth.

Part-Time Work and the Family Cycle

In Sweden, part-time work has been most frequent among women of child-bearing age and older women. The latter fact is mainly explained by the availability of partial pensions. That is, employed persons aged 60–5 years who reduce their working hours can get a 65 per cent compensation for loss of income (see n. 5). However, many of the women in the oldest age cohorts work part-time without having a partial pension, since they re-entered the labour market with a part-time job when their children had grown up.

Hoem (1989) has shown that it has been a long time since Swedish women interrupted work or reduced their working hours at marriage. Among non-pregnant women born in 1936–40, who entered their first

[5] Since 1976, employed persons aged 60–5 years with ten years of pensionable income after the age of 45 have been entitled to partial pensions. They must reduce their weekly hours by at least five and, after the reduction, work at least 17 and at most 35 hours per week. The pension replaces 65% of gross earnings lost by the reduction in hours. In the period 1982–7, the compensation rate was 50%.

union (marriage or cohabitation) in the late 1950s or early 1960s, 14 per cent were full-time homemakers shortly after union initiation. (Among pregnant women the proportion was of course higher.) By contrast, this proportion was only 3 per cent among women born ten years later (1946–50), and among the youngest women (born 1956–60), such behaviour could not be seen at all.[6]

While for a long time entry into a union has not been a cause for Swedish women to change their employment status, child-bearing is and has increasingly become a reason for doing so over the past two decades. That is, there are distinct period effects in part-time work. Thus, Bernhardt (1988) found such effects strong when she analysed the choice of part-time work among women who had their first birth either before 1967, in 1968–74, or in 1975–80, and who had taken up employment—the 'risk' of choosing part-time work increased over time.[7] Examining more recent data (from 1976–91), we see that there also seems to be a cohort effect, that is, a declining propensity to work part-time over cohorts among women aged 40 and over, when child-bearing is normally completed and children are in school (Fig. 11.1). For women of child-bearing age, period and cohort effects seem to be intertwined; the rising average age at first birth in these cohorts has also contributed to confounding the pattern.[8] We now turn to the movement into and out of part-time work among first-time mothers and among women having births of higher parity.

Part-Time Work around Childbirth

From panels of Swedish Labour Force Surveys (LFS), one can observe changes in employment status, including changes for women who gave birth during the time they were in the survey (Sundström, 1987; 1993). Fifteen panels of female respondents were specially compiled for the period 1970/2–1988/90.[9] Each panel contained observations for a survey week in

[6] Using the Swedish Fertility Survey of 1981, Hoem (1989) analysed among other things the employment situation of 1600 childless and non-pregnant women two months after marriage or the start of a consensual union.

[7] Using the Swedish Fertility Survey of 1981, Bernhardt (1988) analysed the choice of part-time work among married and cohabiting one-child mothers who had taken up employment within one year of the first birth.

[8] Average age at first birth rose from 24.4 in 1974 to 25.5 in 1980 and to 26.3 years in 1990.

[9] The Labour Force Survey is carried out monthly with a sample of (from 1988) 18,000 individuals, representative of the Swedish population aged 16–64 years. The panels referred to here are based on interviews with 8,000–10,000 women (see Statistics Sweden, 1989; 1990). As discussed by Sundström (1993), there are two problems in making the data from the 1986–90 panels comparable to the earlier data. First, in 1986, the LFS introduced a new method for data collection, tending to underestimate

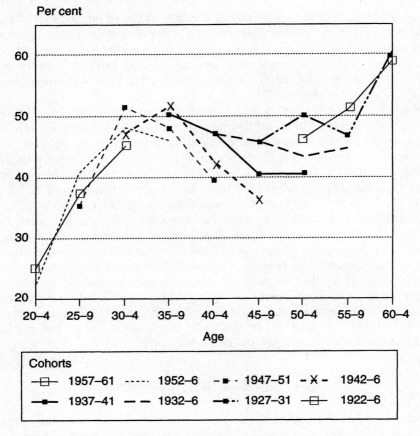

Per cent

FIG. 11.1. Proportion (%) of employed Swedish women working part-time by
age and cohort

Note: Synthetic five-year cohorts.

Source: The Labour Force Surveys 1976–91.

each of eight months three months apart. Information in each survey
round included the respondent's employment status as well as presence and
age of children. On this basis, women were classified into thirteen cate-
gories according to their pattern of employment continuity and shifts
between full-time employment, part-time employment and non-

full-time employment and overestimate part-time employment. Second, the new opera-
tional definition of part-time employment used to classify the thirteen categories differs
from the one used before 1986. To facilitate comparisons over time, I have reanalysed
the 1979–80 panel using the new algorithm and this is used for the tables in this chap-
ter.

employment (see the Appendix to this chapter). The results show that to an increasing extent Swedish women work full-time up to and after the birth of their first child (Table 11.3), and thus remain classified as full-time employed while on parental leave.[10] The implication of this is clear from Table 11.4: almost 90 per cent of employed mothers of infants were absent from work in an average week in 1992. Childcare or parental leave were the dominant reasons for absence among women of child-bearing age (Table 11.5).

TABLE 11.3. *Percentages continuously full-time employed, part-time employed, and non-employed among child-bearing women in 1970–1990*

	Full-time	Part-time	Non-employed
Women giving birth to their first child			
1970–2	25	2	8
1979–81	32	7	7
1986–8	41	8	1
1988–90	48	8	2
Women having higher-order births			
1970–2	8	9	31
1979–81	10	24	18
1986–8	19	30	8
1988–90	20	26	6

Source: The panel of the Labour Force Surveys: see Sundström (1987; 1993).

With this classification, the proportion of first-time mothers who were recorded in full-time work for eight quarters in a row up to, including, and after childbirth rose from 25 per cent in 1970/2 to 48 per cent in 1988/90 (Table 11.4). This steep rise reflects a combination of parental leave policy and the definitions used: first, the parental leave scheme gives women who plan to have children a strong incentive to work full-time prior to childbirth in order to increase subsequent benefits. Second, since women on parental leave from a full-time job are classified as employed full-time, extensions of the leave period will increase the proportion recorded as full-time employed. We also see that virtually no first-time mothers are continuously non-employed.

Among women having higher-order births, the proportion working continuously full-time almost tripled over the twenty years studied. The rise was particularly steep in the late 1980s. We also see that among these

[10] By international convention, all persons who have a job and are absent from work during a survey week, whether it is because they are sick, on vacation, or on leave, are classified as employed in the Labour Force Surveys.

TABLE 11.4. *Proportion of employed women absent from work according to age of youngest child (%)*

Age of youngest child	1983	1986	1990	1992
0 years	87.0	87.3
1–2 years	35.7	31.7
0–2 years	46.0	48.1	49.8	50.8
3–6 years	16.5	15.4	24.0	15.6
7–10 years	17.7	14.4

.. = Not available.
Source: The Labour Force Surveys.

TABLE 11.5. *Percentage absent from work due to childcare or parental leave among women and men absent from work in 1992*

Women aged	
16–19 years	1.7
20–4 years	39.6
25–34 years	57.8
35–44 years	20.8
All women	28.1
Women with children under 7 years	68.8
Men with children under 7 years	15.1
All men	3.4

Source: The Labour Force Surveys.

women, the proportion continuously working part-time quadrupled from 1970/2 to 1984/5, after which it fell. Evidently, the strong growth of continuous part-time employment among this group of mothers has occurred at the expense of continuous non-employment, which has fallen drastically.

After parental leave, an increasing share of first-time mothers shifted from full-time to part-time work in the 1970s: 24 per cent of all first-time mothers did so in 1979/81, compared to 12 per cent in 1970/2 (Table 11.6). The proportion recorded as changing to part-time work fell during the 1980s, particularly after 1988. We believe that this was essentially due to the longer duration of leave benefits (15 months from 1989); the return to the labour market was progressively more likely to fall outside the eight-quarter observation period. Instead, we observe an increase over time in the proportion shifting from part-time to full-time work among women with one pre-schooler (see Appendix). Moreover, the extended leave period, the possibility of combining part-time benefits with part-time work, and the statutory option to reduce weekly working hours must all have contributed to substantially reducing the outflow of women from full-time

TABLE 11.6. *Proportion shifting between part-time and full-time work among child-bearing women in 1970–1990*

	Percentage changing	
	From full-time to part-time	From part-time to full-time
Women giving birth to their first child		
1970–2	11.5	1.0
1979–81	20.4	1.5
1986–8	12.7	3.9
1988–90	6.9	2.9
Women having higher-order births		
1970–2	3.3	0.7
1979–81	5.7	2.5
1986–8	8.2	6.0
1988–90	9.0	5.0

Source: The panel of the Labour Force Surveys: see Sundström (1987; 1993).

work to non-employment at first birth from 18 per cent in 1970/2 to less than 5 per cent in 1988/90 (see Appendix).

Part-Time Work while Children are Growing up

Women with pre-school children (children under the age of 7 years) work part-time to a greater extent than other groups of Swedish women (disregarding those aged over 60). Table 11.7 displays the sharp increase in the proportion continuously employed part-time in the 1970s and early 1980s, parallel to the fall in the proportion non-employed. In the late 1980s, part-time work declined and full-time work increased in this group also. However, the steepest rise in continuous full-time employment occurred only among women with schoolchildren.

How often do mothers change from part-time work when children are young to full-time work when they are in school? We see in Table 11.8 that although among mothers of pre-schoolers the proportion shifting to part-time work exceeds the proportion changing to full-time work, the situation is reversed and increasingly so among mothers of schoolchildren, which is consistent with the rise over cohorts in the proportion of women over 40 working full-time (see Fig. 11.1 above).

When it comes to women's employment in the next phase of the family cycle, the 'empty nest' phase, when children move away from home and start living on their own, our knowledge is more limited. However, the

TABLE 11.7. *Proportions continuously full-time employed, part-time employed, and non-employed among women with pre-school children and schoolchildren in 1970–1990 (%)*

	Full-time	Part-time	Non-employed
Women with children under 7 years			
1970–2	11.1	13.0	28.3
1979–81	10.8	22.8	14.3
1986–8	15.4	34.1	6.8
1988–90	16.6	30.4	4.6
Women with youngest child 7–16 years			
1970–2	20.8	19.7	17.7
1979–81	24.8	22.2	9.0
1986–8	32.5	29.9	4.3
1988–90	37.1	26.3	2.9

Source: The panel of the Labour Force Surveys: see Sundström (1987; 1993).

TABLE 11.8. *Fractions shifting between part-time and full-time work among women with pre-school children and schoolchildren in 1970–1990*

	Percentage changing	
	From full-time to part-time	From part-time to full-time
Women with children under 7 years		
1970–2	2.0	2.5
1979–81	4.9	5.0
1986–8	8.0	6.8
1988–90	8.9	6.7
Women with youngest child 7–16 years		
1970–2	1.8	4.2
1979–81	3.0	3.9
1986–8	3.0	8.3
1988–90	3.6	8.9

Source: The panel of the Labour Force Surveys: see Sundström (1987; 1993).

curves in Fig. 11.1 and other data suggest that women with grown up children continue to work full-time to an increasing extent, but they might reduce their hours after the age of 60.

Part-Time Work, Cohort, Family, and the Role of Education

Who are the mothers who change to part-time work, and which mothers continue to work full-time? Analysing women who had their first birth

before 1981, Bernhardt (1988) found that, after controlling for birth cohort, education in interaction with work experience had a significant effect on the choice of part-time work (see n. 8). Higher education reduced the probability of choosing part-time work among mothers with less than five years of work experience but increased that 'risk' among those with longer work experience. The latter effect was stronger, however, among women with a low level of education. Martial status and social background had no significant impact on the choice of part-time work. On the effect of marital status, there is a supplementary result from the analysis of part-time work among one-child mothers in Hoem (1989): single women were significantly less prone to work part-time than married or cohabitating women, as might be expected.

The role of education in women's choice of part-time work can also be seen from census data. Table 11.9 shows that for the cohorts of employed women born in 1940–4 to 1965–9, the proportion of women working part-time was higher for those who were of child-bearing age in 1990, but decreased substantially with the level of education. Table 11.10 shows that the proportion of employed women working part-time increased with the number of children ever born; even among women with higher education, more than half of those in the 1955/9 cohort that had given birth to two children worked part-time in 1990. It is also interesting to observe that the number of children ever born influenced the extent of part-time work among women of the 1940/4 cohort even in 1990, although they were less likely to have young children by that time.

TABLE 11.9. *Proportion of part-time workers among cohorts of employed Swedish women in 1990 according to level of completed education (%)*

Educational level	Cohort					
	1940–4	1945–9	1950–4	1955–9	1960–4	1965–9
Primary education	45.2	45.2	50.0	55.0	52.9	41.0
1–2 year gymnasium	40.7	44.2	52.5	57.4	50.8	36.1
3–4 year gymnasium	32.0	38.9	49.9	51.5	38.5	30.1
Short post-gymnasium	32.1	39.9	52.0	53.9	36.5	22.8
Long post-gymnasium	25.8	33.6	42.5	42.1	24.5	24.0
Post-graduates	13.1	17.6	24.9	27.6	18.0	0.0

Note: Part-time workers are those who ordinarily work 1–34 hours/week by percentages of all employed with reported working hours.

Source: The Population Census 1990.

Conclusions

We have seen in this chapter that for women in Sweden, the availability of reduced hours and part-time work has served to facilitate the combination of work and children. Most probably female labour-force participation rates would have been considerably lower if the opportunities for working part-time had been more limited and the terms had been less favourable; and the fertility rate would have been lower in the absence of these opportunities (all else equal). This is because if public policy is such that women can have, or are even encouraged to have, substantial paid work during the child-bearing years, the cost of having children will be lower than if women have to abstain from work when they have children. Further, the availability of part-time jobs has contributed to increased gender equality in a number of ways.[11] First, part-time work has replaced time out of the labour force, especially among women who have children, and thereby increased the continuity of women's labour-market attachment. The latter is a necessary, if not sufficient, means of achieving greater gender equality in the labour market and in society as a whole, since work interruptions have adverse effects on women's earnings and career progression (Corcoran and Duncan, 1979; Mincer and Ofek, 1982). Second, the growth in women's part-time work in Sweden has taken the form of permanent employment and relatively long hours, rather than of part-time work interrupted by periods of non-employment and short hours, as is common in other European Union countries and the USA. Third, the growth in part-time work has not been followed by increasing difficulties for women working part-time to switch back to full-time work. Indeed, the proportion of women who increase their hours from part-time to full-time has risen over time, despite the recession.

[11] What I discuss here is a move towards greater equality. Those who believe that Sweden has already achieved complete gender equality are recommended to read Persson (1990) or Hoem (1992).

TABLE 11.10. *Proportion of part-time workers among two cohorts of Swedish women according to number of children ever born and level of education completed (%)*

Level of education	Childless in cohort		One child in cohort		Two children in cohort	
	1940–4	1955–9	1940–4	1955–9	1940–4	1955–9
Primary education	34.6	26.4	41.8	46.1	46.5	60.8
1–2 year gymnasium	31.1	22.2	37.0	45.8	41.7	67.0
3–4 year gymnasium	22.3	17.9	29.3	39.4	33.6	65.9
Short post-gymnasium	23.8	15.9	28.2	39.5	32.0	67.9
Long post-gymnasium	21.2	13.7	20.1	30.6	25.1	57.0
Post-graduates	13.7	8.2	22.8	23.2	12.1	48.1

Note: Part-time workers are those who ordinarily work 1–34 hours/week by percentages of all employed with reported working hours.

Source: The Population Census 1990.

APPENDIX: *Work patterns among subgroups of women in 1979–81 and 1988–90, by percentage of all women in the group*

A. 1979–81

	Continuously			One change from						Several changes between				
	FT	PT	NE	FT→PT	NE→PT	PT→FT	PT→NE	NE→FT	FT→NE	FT and PT	PT and NE	FT PT and NE	FT and NE	Total
Childless women														
All ages	30.2	11.3	18.7	3.9	1.2	1.9	2.3	2.2	2.1	10.5	3.5	8.2	3.9	100
16–24 years	30.0	2.2	4.9	3.3	2.4	1.8	0.8	6.5	3.4	7.9	5.4	20.6	11.1	100
25–44 years	55.1	7.2	5.7	5.9	0.6	2.7	1.4	1.1	1.1	12.3	2.2	3.7	1.5	100
45–64 years	21.9	16.6	30.5	3.6	0.8	1.6	3.6	0.3	1.7	11.3	3.0	3.2	0.9	100
Women with children														
under 7 years	10.8	22.8	14.3	4.9	3.5	5.0	2.5	0.3	0.6	18.4	6.6	8.1	1.2	100
one child	16.9	14.6	4.7	9.6	2.7	6.2	0.9	1.0	0.8	25.8	3.9	10.1	1.5	100
two or more	8.9	25.2	17.1	3.4	3.8	4.7	3.0	1.6	0.3	16.2	7.3	7.5	1.1	100
7–16 years	24.8	22.2	9.0	3.0	2.9	3.9	0.8	1.4	0.8	19.3	4.9	5.8	1.3	100
First-time mothers	31.5	6.5	6.1	20.4	0.3	1.5	0.0	1.1	3.8	15.5	3.1	8.9	1.4	100
Higher-order births	10.0	23.6	17.9	5.7	1.3	2.5	3.4	1.4	0.6	18.3	4.7	9.2	1.6	100
All with children	17.6	22.5	11.7	4.7	3.2	4.4	1.7	1.4	0.7	18.9	5.7	7.0	1.2	100
All women	24.7	16.1	15.6	4.0	2.1	3.0	2.1	1.9	1.5	14.1	4.5	7.7	2.7	100

B. 1988–90

Childless women														
All ages	36.4	14.3	12.3	2.9	1.6	3.4	2.1	2.4	1.6	8.6	2.5	8.4	3.2	100
16–24 years	27.3	3.0	6.3	2.1	3.9	4.8	1.4	6.5	2.4	8.3	5.2	21.4	7.8	100
25–44 years	58.1	8.9	3.8	4.1	0.5	3.9	0.8	1.0	0.9	9.2	1.2	3.6	2.6	100
45–64 years	32.8	24.7	20.4	2.8	0.6	2.2	3.4	0.1	1.5	8.5	1.2	1.6	0.4	100
Women with children														
under 7 years	16.6	30.4	4.6	8.9	3.4	6.7	1.0	0.9	0.6	17.0	3.2	6.0	0.7	100
one child	20.8	21.9	4.0	12.2	4.5	6.9	0.2	2.0	0.2	16.0	2.7	8.2	0.2	100
two or more	15.6	32.7	4.8	8.0	3.0	6.6	1.2	0.6	0.7	17.2	3.4	5.4	0.8	100
7–16 years	37.1	26.3	2.9	3.6	1.1	8.9	0.6	0.7	0.6	13.2	0.9	3.4	0.8	100
First-time mothers	47.8	8.4	1.9	6.9	1.0	2.9	2.1	1.8	4.8	9.0	1.8	8.2	3.0	100
Higher-order births	19.9	25.6	5.9	9.0	2.1	5.0	2.9	0.7	1.5	16.7	5.2	3.9	1.7	100
All with children	26.3	28.5	3.8	6.3	2.3	7.8	0.8	0.8	0.6	15.2	2.1	4.8	0.7	100
All women	33.8	18.2	9.3	4.2	1.8	5.1	1.6	1.8	1.3	11.1	2.3	7.0	2.3	100

Note: The same operational definitions have been used in the two panels; FT = full-time employed, PT = part-time employed, and NE = non-employed.

Source: The panel of the Swedish Labour Force Surveys (LFS): See Sundström (1987; 1993).

REFERENCES

Axelsson, C. (1992), *Hemmafrun som försvann* ('The Housewife who Disappeared') (Stockholm: Institute for Social Research).

Bernhardt, E. M. (1988), 'The Choice of Part-time Work Among Swedish One-Child Mothers', *European Journal of Population*, 4: 117–44.

Corcoran, M. and Duncan, G. J. (1979), 'Work History, Labour Force Attachment, and Earnings Differences Between the Races and the Sexes', *Journal of Human Resources*, 14: 3–20.

Gustafsson, S. (1992), 'Separate Taxation and Married Women's Labour Supply', *Journal of Population Economics*, 5: 61–85.

—— and Jacobsson, R. (1985), 'Trends in Female Labor Force Participation in Sweden', *Journal of Labour Economics*, 3: S256–74.

—— and Stafford, F. P. (1992), 'Childcare Subsidies and Labour Supply in Sweden', *Journal of Human Resources*, 27: 204–30.

Hoem, B. (1989), 'Sysselsättningen under familjebildningsfasen bland svenska kvinnor födda 1936–50' ('Employment in the Family Formation Phase amongst Swedish Women Born during 1936–50'), *Stockholm Research Reports in Demography*, 58 (Stockholm University).

—— (1992), 'The Way to the Gender-Segregated Swedish Labour Market', *Stockholm Research Reports in Demography*, 68 (Stockholm University).

Lyttkens, S. (1992), 'Införande av särbeskattning i Sverige' ('The Introduction of Separate Taxation in Sweden'), in A. Baude (ed.), *Visionen om jämställdhet* ('The Vision of Gender Equality') (Stockholm: SNS).

Mincer, J. and Ofek, H. (1982), 'Interrupted Work Careers: Depreciation and Restoration of Human Capital', *Journal of Human Resources*, 17: 3–24.

Persson, I. (1990), 'The Third Dimension—Equal Status Between Swedish Women and Men', in I. Persson (ed.), *Generating Equality in the Welfare State* (Oslo: Norwegian University Press).

Statistics Sweden (1989), *Revision of Contents and Definitions in the Swedish Labour Force Surveys*, iii (Stockholm: Statistics Sweden).

—— (1990), *The Swedish Labour Force Surveys*, iii (Stockholm: Statistics Sweden).

—— (1991), 'Barnomsorgsundersökningen 1990' ('The Childcare Survey') (Stockholm: Statistics Sweden).

Sundström, M. (1987), *A Study in the Growth of Part-time Work in Sweden* (Stockholm: Arbetslivscentrum and Almqvist & Wiksell International).

—— (1991), 'Part-Time Work in Sweden: Trends and Equality Effects', *Journal of Economic Issues*, 25: 167–78.

—— (1992), 'Part-Time Work in Sweden and Its Implications for Gender Equality', in N. Folbre *et al.* (eds.), *Issues in Contemporary Economics, iv. Women's Work in the World Economy* (London: Macmillan).

—— (1993), 'The Growth in Full-Time Work among Swedish Women in the 1980s', *Acta Sociologica*, 36: 139–50.

—— and Stafford, F. P. (1992), 'Female Labour Force Participation, Fertility and Public Policy in Sweden', *European Journal of Population*, 8: 199–215.

Tegle, S. (1985), *Part-Time Employment*, Lund Economic Studies No. 35 (Lund: Studentlitteratur).

12

Part-Time Work in the United States of America

SONJA DROBNIČ AND IMMO WITTIG

Introduction

It is commonly assumed that women pursue part-time jobs because they are relatively easy to combine with household responsibilities. At various stages of family formation, part-time work may offer the flexibility required to meet family obligations, and at the same time allow women to maintain ties to paid employment. Therefore, part-time work is often seen as a means of integrating women into the labour market. Indeed, in a number of Western European countries, part-time work has been responsible for most of the growth in women's employment, and the increase in part-time work represents one of the most striking changes in the structure of the labour market since the 1950s. This increase has been especially dramatic during the 1960s and 1970s, with some variations between countries, as illustrated by developments in Great Britain (Beechey and Perkins, 1987; Hakim, 1993), Sweden (Sundström, 1991), and West Germany (Quack, 1993).

In the USA, labour-force participation among women is very high, but part-time work is less common among American women than among women in many other developed industrialized countries.[1] One in four American women are employed part-time at any given time. Part-time work has received only moderate attention in professional and political circles. There is little public debate on part-time work similar to that in

[1] OECD data on part-time employment in 1990/1 set the picture for American women in international context: 62.2% of employed women in the Netherlands work part-time, 47.6% in Norway, 43.2% in UK, 40.5% in Sweden, 38.4% in Denmark, 34.3% in Japan, 33.8% in Germany, 25.6% in the USA, 23.5% in France, 20.2% in Austria, 11.2% in Spain, and 9.6% in Italy. Thus, the proportion of part-time working women in the USA is moderate. Part-time work among men, however, is more common in the USA than in most other countries: 16.7% in the Netherlands, 10.5% in the USA, 10.4% in Denmark, 10.1% in Japan, 9.1% in Norway, 7.5% in Sweden, 5.3% in the UK, 3.4% in France, 2.6% in Germany, 2.4% in Italy, 1.6% in Austria, and 1.5% in Spain.

Germany in the mid-1990s, where part-time work has been conceived as a means to combat unemployment through a more equal distribution of available jobs among the population. However, the rapidly increasing labour-market participation of American women has raised concerns about role strains experienced by dual-earner families. It is suggested that the work–family cross-pressure would be eased by flexible institutional arrangements of working hours: 'permanent' part-time employment and flexibility in voluntary reduced work time should develop as standard practice in response to changing family obligations (Moen and Dempster-McClain, 1987).

This chapter examines the dynamic relationship between the family cycle and women's employment patterns over time. It points to the need to perform longitudinal analysis on individual-level data to investigate to what extent participation in the labour market and the work schedule reflect fluctuating family responsibilities of individual women, and to what extent part-time employment accomplishes the task of reconciling domestic and employment roles. In particular, we will examine whether flows out of the labour market following an increase in family demands are different for women holding part-time and full-time jobs, and whether the return to work is facilitated through part-time work arrangements. If this is the case, proposals about more part-time work opportunities for women and parents in general are well grounded, and creating more part-time jobs may potentially represent an important institutional support for reconciling family responsibilities with paid work outside the home in the USA. However, if evidence indicates that part-time employment is not a viable response to changes in family obligations, such proposals—grounded on experience in other countries—may be premature and overly optimistic in its expected consequences.

Women's Paid Employment

Before focusing on part-time employment, we address women's labour-force participation in the USA more generally. Unlike some European countries, where the notion of steadily rising female employment has been seriously questioned (Hakim, 1993), the USA has in fact had a steady and accelerating growth in female employment throughout the twentieth century and in particular since the 1940s (Fig. 12.1). Women's labour-force participation increased very slowly until the early 1940s; prior to 1940, the typical woman worker was young, poor, single, and only worked before marriage and children. Few wives worked outside their homes: it is estimated that among the four million working girls and women counted by the 1890 census, only half a million were married women (Hesse, 1979).

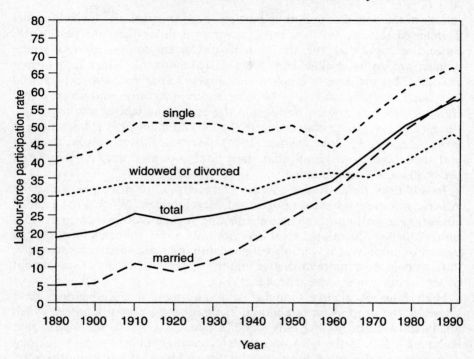

FIG. 12.1. Long-term female labour-force participation rate by marital status

Note: Persons aged 14 and over until 1960; from 1961 onwards persons aged 16 and over. *Sources*: 1890–1930: Wandersee (1981), derived from Table 4.1; 1940–92: *Statistical Abstract of the United States*, varius issues.

The practice of 'marriage bars'—explicit rules against hiring married women or retaining women in their jobs after marriage—was widespread and such rules were in effect for large classes of typical female occupations until the 1950s. The Second World War brought a tremendous change in the working status of American women. Women from all social backgrounds went to work during the period 1940–5, raising the number of women in the labour force in just a few years by 5.5 million workers. At the war's end, when men returned to civilian life, there was enormous pressure on women to return to their former positions (Hesse, 1979), and the number of employed women dropped considerably. However, the rising trend of female labour-market participation was soon resumed and has not been reversed since.

The impetus for women to enter the labour force came from the demand side of the labour market. Oppenheimer (1973) showed how the interplay between the demographic factors and the general rise in the demand for

labour in the post-war period, in particular the expansion of typical female-dominated sectors, led to a rapid integration of women into paid work. Since the supply of the traditionally preferred unmarried and young women was on the decline, employers started employing older and married women. This increase in employment opportunities was also experienced by young mothers who—due to their higher education and more recent training—were in a good position in the expanding labour market. Thus, the mothers of young children were the next to enter paid employment in large numbers. As Oppenheimer (1974) observed, this was also a result of early marriage, which meant that many young couples could not subsist on the husband's earnings alone.

In addition, there were a number of social and demographic trends in American society which supported this development. Women's expanded education is an important factor affecting female labour-force participation. A higher educational level may not only affect women's intrinsic valuation of employment, but also significantly increase their market wages, making paid work more attractive and the opportunity costs of staying out of the labour force higher (Becker, 1981).

High rates of divorce, coupled with non-marital child-bearing, have increased the proportion of children living in single-parent families, which are in most cases mother-only families (Bumpass, 1990; Da Vanzo and Rahman, 1993). In the USA, marriage increasingly fails to provide lifelong economic security either for women or for children for whom mothers are becoming primary providers.[2] Young women may increasingly recognize that they must be able to support themselves, so they invest more in activities which make them economically independent. In addition, low fertility, which became the norm in all Western industrial societies, also reduced the time spent in childcare by married women. Together with technological advancements in household production, it permitted them to reduce the time spent on domestic tasks and increase their time in the labour force.

Part-Time Employment

The increase in the labour-force participation of American women has been striking. Whereas in several European countries, a substitution of part-time for full-time jobs occurred in the post-war period (Hakim, 1993), in the USA, both part-time and full-time employment of women have been increasing simultaneously. Growth in female part-time employment was observed particularly in the 1950s. According to the decennial censuses of

[2] In 1988, 31.1% of families were headed by women, and only 40% of women with children under age 21 whose father was absent received child maintenance support (Veum, 1992).

1950 and 1960, the percentage of part-time workers among total female employment increased from 19 to 28 per cent (Goldin, 1990: Table 6.5). The number of part-time working women almost doubled in ten years (from a low starting-point, however), whereas the increase in full-time employment was much more modest in this decade—about 27 per cent. This development coincides with a substantial decrease of part-time employment in agriculture and food producing, and an increase in service-producing industries, particularly in the wholesale and retail trades. Growth in female full-time employment in this period was most pronounced in professional and related services (Leon and Bednarzik, 1978). After the 1950s, the growth rates of full-time and part-time employment have been balanced, so that the proportion of part-time working women among all women at work remained remarkably stable. In the 1980s, full-time female employment started growing faster than part-time employment.

About 20 million people in the US non-agricultural sectors are part-time employees, with part-time work defined as less than 35 hours a week. Part-timers currently comprise about 17 per cent of the workforce (Table 12.1). Part-time employment grew fastest in less skilled white-collar occupations, particularly clerical, sales, and service occupations (Tilly, 1991). Women are more likely than men to work on a part-time basis, although men's part-time work has been gaining in importance. In the early 1990s, every fourth employed woman worked part-time, as did one in ten men. By 1992, women constituted 46 per cent of the labour force; 41 per cent of full-time workers and two-thirds of part-timers were women (Table 12.1; Fig. 12.2).

It should be noted that Table 12.1 presents cross-sectional data; additional important differences between men's and women's employment patterns may exist without being detected by this type of data. Working full-time does not necessarily mean year-round employment, and part-timers may work the whole year or just some fraction of the year. However, in the USA, women have had an impressive growth in year-round work and are becoming less and less likely to leave the workforce for part of the year or on a seasonal basis (Mellor and Parks, 1988). Also part-timers tend to work on a continuous basis more often than in the past. Only for about one-fifth of working women does the attachment to the labour market remain sporadic: they work part-time and only intermittently.[3]

[3] It is intriguing, however, that Moen and Smith (1986) found that these women demonstrate the highest levels of subjective work commitment, measured as the readiness to continue working even if it were financially unnecessary. It might be that these women are already in the position to successfully combine family and work roles; therefore, they do not want to work continuously or more hours and can afford not to. These results challenge Hakim (1991), who considers part-time employment status of women in the UK as a proxy for lower work commitment.

TABLE 12.1. Employed workers, by work schedules, 1968–1992

Year	Part-time as % of all employed workers	Men		Women		Full-time employed women as % of all FT workers	Part-time employed women as % of all PT workers
		Total (in 000s)	PT as % of total	Total (in 000s)	PT as % of total		
1968	14.0	48 114	7.8	27 807	24.9	32.0	65.0
1969	14.5	48 818	8.2	29 084	25.1	32.7	64.6
1970	15.2	48 990	8.5	29 688	26.1	32.9	65.1
1971	15.6	49 390	8.8	29 976	26.8	32.6	64.8
1972	15.7	50 896	8.9	31 257	26.9	33.0	65.0
1973	15.6	52 349	8.6	32 715	26.8	33.4	66.0
1974	15.8	53 024	8.8	33 769	26.8	33.8	66.1
1975	16.6	51 858	9.4	33 989	27.6	34.4	65.9
1976	16.6	53 138	9.4	35 613	27.5	34.9	66.3
1977	16.7	54 729	9.5	37 289	27.4	35.3	66.4
1978	16.5	56 479	9.2	39 569	26.9	36.1	67.2
1979	16.4	57 607	9.0	41 217	26.7	36.6	68.0
1980	16.8	57 186	9.6	42 117	26.8	37.4	67.3
1981	17.1	57 397	9.6	43 000	27.1	37.6	68.0
1982	18.2	56 271	10.6	43 256	28.1	38.2	67.2
1983	18.4	56 787	10.8	44 047	28.1	38.5	66.8
1984	17.6	59 091	10.2	45 915	27.1	38.7	67.4
1985	17.3	59 891	10.1	47 259	26.6	39.2	67.6
1986	17.4	60 892	10.2	48 706	26.4	39.6	67.4
1987	17.4	62 107	10.2	50 334	26.1	40.0	67.4
1988	17.3	63 273	10.2	51 696	25.7	40.3	67.3
1989	17.0	64 315	10.0	53 028	25.5	40.6	67.8
1990	16.9	64 434	10.0	53 479	25.2	40.8	67.6
1991	17.4	63 593	10.5	53 283	25.6	41.0	67.2
1992	17.5	63 804	10.8	53 793	25.4	41.4	66.4

Sources: Years 1968–88: derived from ILO 1989 report Conditions of Work Digest, 8(1), Table 19, based on Labour Force Survey results; years 1989–92: Statistical Abstract of the United States.

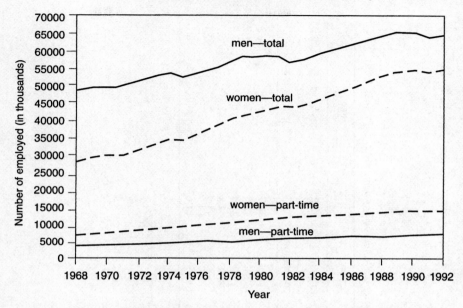

Fig. 12.2. Employed male and female workers by work schedule

Sources: 1968–88: derived from ILO report, *Conditions of Work Digest*, 8(1), Table 19, based on Labour Force Survey results; 1989–92: *Statistical Abstract of the United States*, various issues.

Working part-time is most common for both sexes among young people at the beginning of their career and among older workers as they exit from the labour force. Table 12.2 shows that in the period 1969–89, most of the growth of part-time employment was due to increases in the rate of part-time work among older persons (age 65 and over), young people (ages 16–21), but also prime-age men (ages 22–64). Women in the main child-rearing years increased their participation in the labour market significantly, but their proportion in part-time employment remained essentially unchanged over this period.

There seems to be no single powerful causal factor explaining national variations and differences in the status of part-time work (Ellingsæter, 1992); instead, complex relations between the market, the state, and the family, as well as individual characteristics, may influence the probability of a woman holding a part-time job. On the demand side, the labour-market structure and regulations are undoubtedly of importance. Labour-market segmentation and demand for part-time workers in specific sectors and occupations may play a decisive role in the composition of the labour force. Particularly well-developed service industries and a large public

TABLE 12.2. *Age and sex composition of the labour force and rate of part-time employment, 1969, 1979, and 1989*

Age and sex	1969		1979		1989	
	as % of at-work population	% PT	as % of at-work population	% PT	as % of at-work population	% PT
All persons aged 16–21	12.8	40.6	14.0	41.7	10.3	46.3
Women aged 22–44	17.3	22.7	23.1	22.5	27.7	21.9
Women aged 45–64	13.2	22.5	11.3	24.4	11.6	23.8
Men aged 22–64	53.2	3.7	48.9	4.8	47.8	6.7
All persons 65 and over	3.5	41.1	2.7	52.9	2.6	52.4
Total	100.0	15.5	100.0	17.6	100.0	18.1

Note: Labour force includes only non-agricultural workers at work.

Source: Tilly (1991: 11). Estimates were computed from the BLS publication *Employment and Earnings*.

sector have been associated with the growth of part-time employment (Ellingsæter, 1992; Rosenfeld and Birkelund, 1995).

Women are better able to combine their labour-market activities with family demands in countries where part-time employment is not heavily penalized in terms of benefits, income, and job security (Kalleberg and Rosenfeld, 1990). Other factors, such as the availability of jobs in the labour market, governmental policies, family transfers, tax regulations, daycare facilities,[4] and corporate initiatives may be important for explaining variations in female labour-force participation and the extent of part-time work.

Characteristics of Part-Time Jobs

There has been much discussion of the characteristics of part-time jobs. Part-time jobs are not inherently bad. One category of part-time jobs, the so-called retention jobs are 'good' part-time jobs, created to retain (or in some cases attract) valued employees whose life circumstances prevent them from working full-time (Tilly, 1989; 1991). Retention part-time arrangements tend to be in relatively skilled jobs. They involve high compensation, high productivity, and low turnover—all characteristics of a primary labour market. However, retention part-time jobs are an exception rather than the rule. Most of the part-time jobs in the USA are poor in terms of low pay, lack of advancement opportunities, and high turnover.

Tilly (1989; 1991) convincingly showed that since the end of the 1960s, part-time jobs have expanded in the USA primarily because more employers view them as a means of cutting labour costs, and not because of the growth in demand for working part-time among employees. First, the industrial composition of employment has shifted away from manufacturing and towards industries such as trade and services that traditionally employ large numbers of part-timers. Next, many firms within these industries have created a low-wage, low-skill, high-turnover labour market, built in many cases around secondary part-time employment. For example, a full 36 per cent of retail workers were part-time in the mid-1980s; in grocery stores the rate was 41 per cent, and a huge 60 per cent of supermarket employees were part-timers (Tilly, 1989).

Wages in part-time jobs are low: in 1991, the median part-time worker earned only 58 per cent of the hourly wage of the median full-time worker

[4] The availability and costs of childcare services, and their effect on mother's employment have recently been investigated in a number of studies on kin and institutionalized childcare (Folk and Beller, 1993; Parish, Hao, and Hogan, 1991; Blau and Robins, 1988, 1991; Cattan, 1991; Maume, 1991; Presser and Baldwin, 1980; Michalopoulos, Robins, and Garfinkel, 1992; Hofferth and Phillips, 1987).

(Tilly, 1991). Compared to full-timers, part-time workers also are much less likely to receive most major fringe benefits. In particular, part-time work rarely gives benefits such as access to group health insurance (Kalleberg and Rosenfeld 1990; Harris 1993). The lack of health-care benefits for part-timers is especially important in the context of the USA health care system.

Thus, the costs of part-time working are severe. Part-time work not only brings about the loss of income, but also an erosion of wages, non-monetary benefits, promotion possibilities, job training, and job security. The effects of part-time jobs on women's wages are nearly identical to the effects of time spent out of the labour force (Corcoran, Duncan, and Ponza, 1984). In view of these findings, part-time work is hardly an ideal strategy for a rewarding employment career. If part-time jobs are not attractive in terms of pay and other benefits, it is assumed that they must be attractive to women for other reasons—presumably due to greater compatibility with the family in periods of high household and childcare responsibilities. In the remainder of this chapter, we shall analyse the relationship between family life stages and part-time work over the life-course, using data on employment and family histories of individual women. We decompose aggregate changes in the participation rate into flows into the labour market and flows out of the labour force, and the impact of background characteristics on labour-market flows are analysed.

Data and Methods

The National Survey of Families and Households (NSFH),[5] based on a nationally representative sample of households interviewed in 1987–8, collected detailed retrospective data on family events and changes in household structure, as well as employment histories for a random sample of the non-institutional US population aged 19 and older. This data-set enables us to analyse the process of labour-force exit separately from that of labour-force entry. Our analysis is limited to data for white women who were primary respondents in the NSFH because the employment patterns of black women differed considerably from those of white women.[6]

[5] The National Survey of Families and Households was funded by a grant (HD21009) from the Center for Population Research of the National Institute of Child Health and Human Development. The survey was designed and carried out at the Center for Demography and Ecology at the University of Wisconsin-Madison under the direction of Larry Bumpass and James Sweet. The fieldwork was done by the Institute for Survey Research at Temple University.

[6] Particularly in the 1950s and 1960s, labour-force participation of black women was significantly higher than that of white women. Since then, the gap has narrowed and in 1991, the civilian labour-force participation rate of white women surpassed the black

Employment career in the NSFH is depicted as a sequence of periods in the labour force and 'out-of-work' states, starting when the person began work in a job that lasted at least 6 months. A new employment spell starts when the person re-enters the labour market and lasts until he or she exits the labour market, for whatever reason. The length of employment and out-of-work spells is coded in months. For every at-work spell, we knew whether the respondent worked mainly full-time or part-time. Part-time work is defined as less than 30 hours per week. Employment histories were reconstructed for 4120 white female respondents in the NSFH data. They consist of continuous records of women's in-work and non-employment experiences from their first job until 1987–8. Only about 4 per cent of women were excluded from the analysis because they were never in paid employment or had never worked at a job which lasted at least 6 months.

The main disadvantage of this data-set for our analysis is that changes of jobs and employment statuses within an employment spell are not coded. Therefore, we cannot study transitions between full-time and part-time jobs if such a transition occurs without an intermediate non-employment spell. This probably does not matter very much, however. Moen and Smith (1986: 469), who studied the employment behaviour of women in two successive years, found that the odds of continuously employed full-time workers switching to part-time work are extremely low. If their work status changes, they are more likely to drop out of the labour force than to move into part-time jobs. Likewise, part-timers are more likely to move out of the labour force than into full-time work. Blank (1989) also confirmed the stability of women's labour-market involvement and low mobility between the part-time and full-time segments of the labour market.

Event history analysis was used to analyse transition rates. This type of analysis is described in detail elsewhere (Blossfeld and Rohwer, 1995; Blossfeld, Hamerle, and Mayer, 1989; Tuma and Hannan, 1984; Allison,

women's participation rate for the first time (Economic Report of the President, 1992). Employment projections for the next ten years predict that labour-force participation of white women will continue to be higher than the participation rate of black women. Because our data are retrospective, we cannot ignore these different developments in employment patterns in the past. Differences are also visible over the individual's life-course. Among whites, young women in the 16–19 age group had a higher participation rate than older women until the end of the 1980s; black teenagers, however, have had considerably lower participation rates than older black women and also lower ones than their white counterparts. These differences in age patterns have been persistent over time. In 1991, the civilian labour-force participation rate of white females, aged 16–19, was 54.3%, and of those 20 years and over, 57.7%. Among black women, the 16–19 group had a participation rate of only 33.5%, and that of black women 20 years and over, 59.3% (Economic Report of the President, 1992; see also Mellor and Parks, 1988).

1984; Kalbfleisch and Prentice, 1980). To estimate transition rates, we used an exponential and piece-wise constant model allowing the baseline hazard rate to vary without having to specify the exact hazard-rate path. This method of modelling time-dependent hazard rates divides the duration of spells into separate periods, and also estimates—in addition to the effects of covariates on hazard rates—the β coefficients which can vary from period to period.

We estimated the following labour-market transition rates: from full-time employment to non-employment (FT-NE), from part-time employment to non-employment (PT-NE), from non-employment to full-time employment (NE-FT), and from non-employment to part-time employment (NE-PT). The independent variables included in the analysis are age, birth cohort, historical period, education, and family history. To be able to assess the effects of time-dependent family events upon the risk of in-work/out-of-work change, we split the observed employment spells into subspells of a maximum duration of one year. With this spell-splitting method (see Blossfeld, Hamerle, and Mayer, 1989), we obtained 93,960 subspells, which were the basis of our analysis.

Family-Cycle Variables

To assess the effect of family events on transitions between employment spells, we used the concept of the family life-cycle, based on the classical model developed by Glick (1977), but with some important modifications. We did not limit vital events, such as marriage and birth of children, to a single linear progression through the stages in a predetermined order. In our analysis, the birth of a child can precede the status 'married'. Or, if the spacing between children's births is of a longer duration than six years, the stage 'school child present' precedes for some period of time the 'pre-school child present' stage. We also did not assume a classical stable nuclear family. Several marriages may occur, and children may be born to different spouses or out-of-wedlock. No distinctions are made between the classical ideal model of conventional family life-cycle events and 'non-conventional' family patterns. Every stage can be repeated several times in various orders and is assumed to have the same effect on the likelihood of employment transitions.

Child-rearing history distinguishes four states:

- *pre-school child*: at least one young child up to 6 years of age in household;
- *school child*: no child younger than 6 years but at least one child under 18 years of age;

- *grown-up children*: no children younger than 18 years in the family;
- *no children*, which is the reference category.

When more than one child was present in a family, precedence was given to the youngest child, in this way recognizing the greater demands of young children on their mothers' parental responsibilities.

Marital status entails three possible states:

- *married without children*;
- *married with children*;
- *not married*, used as a reference category.

When a woman marries, but has no children yet, the dummy variable 'marriage without children' is coded 1 and 'marriage with children' 0. The birth of a child reverses the coding of these two variables, and the variable 'pre-school child' gets a code 1. By distinguishing two types of 'marriage', the effects of children on married and unmarried mothers can be assessed. For example, the coefficient 'pre-school child' indicates the difference in a transition rate between a single woman without children, and a non-married mother of a young child. If we want to assess the effect of a pre-school child on a married woman, the coefficient 'marriage with children' has to be added to the parameter estimate for the 'pre-school child'.

Findings[7]

We start our analysis by studying the effects of three time-related factors on transition rates between full-time or part-time employment and non-employment: age, cohort, and historical period effects. Although problems inherent in distinguishing age, cohort, and period effects are not negligible (Ryder, 1985; Hobcraft, Menken, and Preston, 1982; Burt, 1991; Riley, 1987), it is necessary to distinguish between these factors to disentangle individual variations in employment behaviour during women's life-course, those effects which are experienced by an aggregate of women within the same time interval, and the historical constellations which affect all women in a similar way during a certain historical time.

Fig. 12.3 shows the effects of age on employment transition rates, estimated with an exponential model. Transition rates across the life-course are in most cases non-monotonic. Those from employment to non-employment first decrease, and then slightly increase at an older age. If a woman has a job in the first place, it is less and less likely that she will leave the labour force. Only after the ages of 44 and 52 for full-time and

[7] Models were estimated using Götz Rohwer's TDA (Transition Data Analysis) program. We would like to thank Götz Rohwer for his help with managing the data-set.

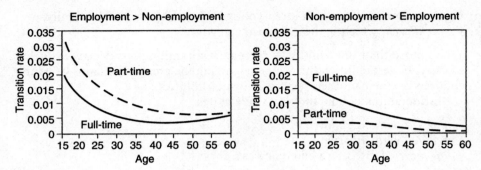

FIG. 12.3. Transition rates between various employment statuses over the life-course of American women

part-time employment, respectively, does the probability of moving to non-employment status somewhat increase. This is a fairly unexpected result, showing that women do not move out of the labour market at their prime child-bearing and child-rearing ages.

Transitions in the opposite direction display different patterns. The rate of movement from non-employment to full-time employment decreases monotonically. As non-employed women grow older, they are less and less likely to enter full-time employment. For example, a 20-year old non-employed woman is four times more likely to enter full-time employment than a 50-year-old woman. The rate of change from non-employment to part-time employment is low and again non-monotonic: it rises slightly until age 23 and then declines. This pattern suggests that entering part-time employment is primarily a characteristic of very young women at the beginning of their employment career; entries to part-time employment fall with age.

Next, we looked at cohort information. Goldin (1990) demonstrated that over the twentieth century the pattern of women's labour-market participation across cohorts was entirely different from that indicated by cross-sectional evidence. At any given age, each successive cohort had a higher participation rate than the one before. Dummy variables representing birth cohorts in four-year intervals have been included in the model (Table 12.3). Controlling for the effect of age, the risk of dropping out of the labour force—from full-time as well as part-time jobs—is basically independent of birth cohorts. This aspect of women's employment patterns is concealed in cross-sectional data. Therefore, when looking at the cross-sectional evidence, some researchers conclude that the level and shape of women's labour-force participation are changing rapidly and will soon approach those of men (Masnick and Bane, 1980). Our results challenge this proposition. Although the aggregate-level data in the past two decades show

a very different shape of labour-force participation for women between 25 and 45 than in the previous time-period, younger cohorts of women also interrupt their employment spells. To reconcile this apparent inconsistency with the cross-sectional evidence, we assume that women in younger cohorts re-enter the labour market sooner and on a more massive scale.

TABLE 12.3. *Cohort effects on the estimated rates of transition from full-time work (FT) to non-employment (NE), from part-time work (PT) to non-employment (NE), and vice versa*

	FT→NE	PT→NE	NE→FT	NE→PT
Cohort 1 (1924–8)	−0.1618	−0.1258	−0.3448*	0.5342*
	(0.0958)	(0.1819)	(0.1506)	(0.2612)
Cohort 2 (1929–33)	−0.0619	−0.4067	−0.2595	0.5388*
	(0.0967)	(0.2180)	(0.1403)	(0.2717)
Cohort 3 (1934–8)	−0.0512	−0.3540	−0.2522	0.9630**
	(0.0932)	(0.1881)	(0.1342)	(0.2592)
Cohort 4 (1939–43)	−0.1518	−0.2213	0.0066	1.3067**
	(0.0948)	(0.1890)	(0.1344)	(0.2648)
Cohort 5 (1944–8)	0.0081	−0.3914*	0.1539	1.6350**
	(0.0931)	(0.1919)	(0.1339)	(0.2657)
Cohort 6 (1949–53)	−0.0635	−0.2005	0.3353*	1.9390**
	(0.0932)	(0.1889)	(0.1345)	(0.2681)
Cohort 7 (1954–8)	−0.1350	−0.1818	0.3264*	2.4408**
	(0.0975)	(0.1961)	(0.1413)	(0.2731)
Cohort 8 (1959–63)	−0.1776	−0.3197	0.5206**	2.6092**
	(0.1049)	(0.2109)	(0.1530)	(0.2912)
Cohort 9 (1964–9)	0.0729	−0.1355	0.7189**	3.0112**
	(0.1275)	(0.2263)	(0.1862)	(0.3349)

Notes: ** significant at the 99%-level.
 * significant at the 95%-level.
 Reference category for birth cohorts is < 1924.
 The model is exponential; age is controlled.
 Standard errors are given in parentheses.

Indeed, this assumption is supported when the transition into the labour market is examined. Here, younger birth cohorts exhibit greater likelihood of entering full-time and in particular part-time employment than older cohorts. In the case of part-time work entry, a robust and consistent trend appears: the younger the birth cohort the higher the propensity to change non-employment for part-time employment. This trend is accelerating over time.

Our findings on cohort effects are consistent with Goldin's (1990) findings. She maintains that until recently most women stopped working at marriage; in our analysis also, exiting the labour force is basically independent of birth cohorts. According to Goldin, the bulk of the increase

in female employment did not originate from a change in that pattern, but from higher rates of re-entry across successive cohorts, which has been confirmed by our results. However, in the continuation of our analysis we will refine Goldin's arguments on cohorts as vehicles of changes in female employment. After including the period effect, education, and family covariates, it will become clear that (1) some of the effects that she attributed to cohorts as such are due to differences in fertility and education among cohorts, and (2) the distinction between full-time and part-time jobs must be made in order to understand the patterns in detail. When we distinguish between full-time and part-time work, it becomes evident that re-entry to full-time work is in essence a period phenomenon, while part-time employment is predominantly a cohort phenomenon.

The range of opportunities in the labour market—such as the unemployment level, the availability of part-time jobs, or normative expectations about married women's employment—can to a large extent influence the employment patterns of women of different ages and in different life-cycle situations. This kind of structural influence is generally called a period effect. At the next stage, we included the period dummy variables in exponential models together with age and cohorts. Results are presented in Table 12.4. The historical period is important for the transition from non-employment to full-time employment. After 1968, the probability of women moving from non-employment to full-time employment increased

TABLE 12.4. *Period effects on the estimated rates of transition from full-time work (FT) to non-employment (NE), from part-time work (PT) to non-employment (NE), and vice versa*

	FT→NE	PT→NE	NE→FT	NE→PT
Period 1958–62	−0.1305	−0.1225	−0.0348	0.1798
	(0.1015)	(0.2274)	(0.1636)	(0.3973)
Period 1963–7	−0.2070	−0.5146*	0.2781	0.3677
	(0.1143)	(0.2498)	(0.1770)	(0.3998)
Period 1968–72	−0.1216	−0.2303	0.4728*	0.1319
	(0.1305)	(0.2746)	(0.2064)	(0.4358)
Period 1973–7	−0.1528	−0.3638	0.6584**	0.1372
	(0.1535)	(0.3224)	(0.2409)	(0.4792)
Period 1978–82	−0.0432	−0.3933	0.7977**	0.1702
	(0.1787)	(0.3726)	(0.2812)	(0.5335)
Period 1983–8	0.1127	−0.2956	0.8309**	0.5219
	(0.2059)	(0.4260)	(0.3218)	(0.5900)

Notes: ** significant at the 99%-level.
 * significant at the 95%-level.
 Reference category for time periods is < 1958.
 The model is exponential; age and cohorts are controlled.
 Standard errors are given in parentheses.

considerably in comparison to previous times, regardless of the individual's age and birth cohort. This means that since the mid-1960s, women of all generations have increasingly entered the full-time segment of the labour market.

Effects of Education and Family Cycle

We then studied the effects of education and the family cycle on women's employment patterns. The question is how—in addition to age, cohort, and period—education, family-related factors, and previous history affect the length of time spent in a particular state. It is important to control for previous history because the time spent in a particular state may have significant consequences for future employment behaviour. Most women demonstrate considerable stability in their labour-market involvement (Blank, 1989; Moen and Smith, 1986). Women who are employed and stay in employment for a longer period of time, accumulate work experience and other resources which increase their career prospects, strengthen their labour-market attachment, and increase the opportunity costs of leaving their jobs. Women who stay out of the labour force gradually lose their marketable skills and their prospects of getting a 'good' job may decline. Both arguments lead to the supposition that the effects of certain covariates over the duration spent in a particular state are not constant.

To assess the duration dependence, we introduced a piece-wise constant model. Results are presented in Table 12.5 and indicate a declining hazard over the duration for all four transitions.[8] The educational attainment of younger birth cohorts of women has risen considerably over time. Within the economic approach to the family, this trend indicates an increased affinity to invest in market-specific human capital, which changes the opportunity cost of working or withdrawing from the labour force. Thus, higher education—which is characteristic of younger birth cohorts— reflects the job reward potential of a woman; it can increase women's labour-market participation and can also reduce the job-leaving rate. Education has an important effect on women's labour-market behaviour (Table 12.5). It considerably decreases the propensity of leaving full-time jobs but it has no statistically significant effect on the probability of leaving part-time jobs. When transitions from non-employment to employment are considered, education has a statistically significant positive effect on re-entering both full-time and part-time employment.

[8] For example, women in their first year of full-time employment are twice as likely to leave their job as those who have worked for 12 years, since exp(−1.0327)=0.3560 and exp(−1.7575)=0.1725. Taking a ratio of these effects yields a two-fold decrease in the rate of leaving a full-time job.

TABLE 12.5. *Education and family-related effects on the estimated rates of transition from full-time work (FT) to non-employment (NE), from part-time work (PT) to non-employment (NE), and vice versa*

	FT→NE	PT→NE	NE→FT	NE→PT
Duration				
≤12 months	−1.0327**	−1.5027*	−4.9672**	−9.7267**
	(0.3079)	(0.6431)	(0.4790)	(0.8352)
>12–36 months	−1.0034**	−1.5142*	−4.8699**	−9.7013**
	(0.3099)	(0.6436)	(0.4798)	(0.8351)
>36–60 months	−1.1734**	−1.9441**	−5.3107**	−10.0555**
	(0.3148)	(0.6534)	(0.4850)	(0.8417)
>60–96 months	−1.3716**	−2.2642**	−5.5785**	−10.1311**
	(0.3188)	(0.6593)	(0.4897)	(0.8486)
>96–144 months	−1.5939**	−2.5299**	−5.7136**	−10.0092**
	(0.3231)	(0.6688)	(0.4930)	(0.8519)
>144 months	−1.7575**	−2.3901**	−6.0386**	−10.3008**
	(0.3203)	(0.6628)	(0.4934)	(0.8536)
Education	−0.0409**	−0.0290	0.0456**	0.0879**
	(0.0078)	(0.0169)	(0.0101)	(0.0169)
Marriage				
without children	1.1650**	0.4745**	−0.5469**	−0.0014
	(0.0508)	(0.1234)	(0.0884)	(0.1787)
with children	0.2063**	−0.0069	−0.5900**	0.1128
	(0.0547)	(0.1155)	(0.0637)	(0.1168)
Children				
Pre-school	0.6133**	0.4631**	−0.3298**	0.0003
	(0.0698)	(0.1458)	(0.0873)	(0.1759)
School-age	0.3507**	0.3802*	0.3131**	0.3428
	(0.0830)	(0.1802)	(0.1004)	(0.1949)
Grown-up	0.4161**	0.4866*	0.0841	−0.1031
	(0.1055)	(0.2479)	(0.1614)	(0.2723)

Notes: ** significant at the 99%-level.
 * significant at the 95%-level.
 The modelling uses a piece-wise constant model; age, cohorts, and periods are controlled.
 Standard errors are in parentheses.

Marital and family status have a strong effect on women's labour-market behaviour. Marriage and the presence of children increase the likelihood of leaving the labour force, when the transition rates are compared to those of unmarried women without children. Entry into marriage before having a child increases the transition rate from full-time employment to non-employment by 221 per cent. Surprisingly, this is more than the combined effect of 'marriage with children' and the presence of a pre-school child. Thus, marriage has an important influence on American women's

employment behaviour, even if it is not coupled with motherhood.[9] One could speculate that marriage is a triggering event for some groups of women oriented towards more traditional roles, who use this opportunity to move to the status of a housekeeper. In addition, there are other possible explanations for the significant effect of marriage. Marriage is often associated with geographical moves for at least one partner. If such a move occurs, the person has to interrupt his or her employment career at least temporarily before finding a new job at the new location.

The presence of children of any age has a dampening effect on full-time employment, but the effect is much weaker than for marriage alone. The possibility of distinguishing marital status with or without children gives us the opportunity of examining the effects of children of various ages for married and unmarried mothers. The presence of a pre-school child increases the risk of leaving a job by 127 per cent for married mothers and 85 per cent for unmarried mothers of pre-schoolers. With a child of school age, the risk increases by 75 per cent and 42 per cent for married and unmarried women, respectively, and with a child older than 18 years by 86 and 52 per cent. Our findings demonstrate that the propensity to leave full-time work when children are present, is somewhat stronger for married than for unmarried women.

Transitions between part-time employment and non-employment exhibit similar patterns, but also some differences in comparison to full-time employment. The state dependence remains important: staying in part-time jobs for a longer period of time decreases the probability of dropping out of the labour force. Family events remain important, with two deviations. Marriage before children also encourages part-time working women to stay at home, but considerably less than full-timers. The presence of children has similar effects; however, this effect is independent of women's marital status. In other words, married full-time employed mothers are more likely to leave the labour force than non-married (single, divorced, widowed) mothers. However, marital status does not play any role in this respect for mothers employed part-time.

The next two columns in Table 12.5 display the results for the transitions from non-employment to full-time and part-time jobs. As before, state dependence plays an important role in the probability of re-entering the labour force. Other things being equal, women who have not been in paid work for longer periods of time are less and less likely to return to the labour market.

Striking differences are found in the effects of family-related covariates which are important for re-entering full-time but not part-time employment.

[9] Model specifications with an interaction between marriage and cohorts show a much stronger effect of marriage for older cohorts than for younger ones (estimates not shown).

Controlling for other factors, marriage before the birth of a child decreases the probability of entering a full-time job by about 40 per cent. The presence of a pre-school child has an inhibiting effect on entering full-time employment, particularly for married mothers. A school-age child has a positive effect, although a schoolchild in combination with marriage still results in a decreased transition rate. Thus, when children enter school, non-married mothers in particular are inclined to enter full-time employment. Older children have no effect on the transition from non-employment to full-time work; still, married women with grown-up children are less likely to enter full-time employment than unmarried women with or without children. Again, period effects play the most important role in this transition, and the positive effects of recent periods surpass the inhibiting effects that the family situation may impose on women. Marriage and children have no effects on the probability of entering part-time employment. There is some indication that the likelihood of working part-time increases when children are of school age, but the coefficient is not statistically significant. Family obligations do not inhibit women from entering part-time employment, nor do they promote this move.

Discussion

Women employed full-time continue to exhibit 'traditional' behaviour when their marital and family situation changes. Marriage provides an impetus to leave the labour market. Also children, regardless of their age, promote mothers' transition from full-time work to non-employment; this effect is stronger for married women. It is remarkable that this pattern of stopping work at the time of marriage is displayed for all birth cohorts and all historic periods. The growth in female employment in the USA seems to depend on a differential tendency to re-enter the labour market and not on leaving the labour market in the first place.

The length of spells out of the labour market is critical for the likelihood of returning to a full-time job. The longer a woman stays out, the less likely she is to re-enter. However, there have been some tremendous changes across time. Since the mid-1960s, women have increasingly re-entered the labour market, regardless of their age, family status, and other characteristics. This dramatic change did not occur gradually through birth cohorts; instead, it swept across all generations of American women and re-integrated them into the workforce.

Parallel to this period effect, the family life-cycle continues to exhibit consistent effects. Marriage and the presence of young children inhibit women from (re-)entering full-time employment. The inhibiting effect of a pre-school child, however, is considerably weaker for non-married moth-

ers. When children enter school, the likelihood of mothers starting work full-time increases, consistent with the assumption that household and child-rearing obligations are most severe when children are small; when children reach school age, paid employment is easier to combine with family responsibilities.

The move from part-time employment into non-employment seems to be driven by similar factors as in the case of full-time work. Women's individual age and family cycle affect the transition out of part-time work. Birth cohort, historical period, and education have no statistically significant impact on leaving part-time jobs. The effect of marriage is weaker for part-time work, which would indicate somewhat less conflict between part-time work and household responsibilities. However, the effects of the presence of children are at a similar level as for full-time work, refuting the hypothesis of greater compatibility between child-rearing and reduced working hours. Such effects of children on the transition to non-employment are observed for married and unmarried women.

Transition from non-employment to part-time employment exhibits particularly interesting patterns, since the determinants of non-employment spells that end in part-time work are different from those that end in full-time work. Contrary to common belief, family life-cycle has no significant effect on women's chance of re-entering the part-time segment of the labour market. What affects the risk of entering part-time work are individual age, education, and particularly the birth cohort. Re-entry to the part-time segment of the labour market has been occurring through differential participation of birth cohorts. Starting with the cohort born in the mid-1930s, each successive cohort of women has had a higher part-time participation rate than the one before.

Conclusions

This study advances our understanding of women's paid employment in two different ways. First, it challenges a simple view of straightforward growth in female employment and shows how the much-echoed but not well-explained increase in participation was accomplished. This process can only be understood if flows both into and out of the workforce are considered, and full-time and part-time employment are distinguished.

As already demonstrated by Goldin (1990) in an influential study on the evolution of the American female labour force, cross-sectional data are not very informative and are in some cases openly misleading. In terms of leaving the labour market, American women continue to exhibit rather traditional behaviour. However, their propensity to re-enter the labour market shows new non-traditional patterns. Goldin displayed the benefits of the

cohort approach and provided a new view on the evolution of the female labour force. However, since she used aggregate census data for the most part, individual level life-cycle progression and the effects of particular events remained obscured in her analysis. For example, our analysis of full-time employment shows that what appears to be cohort expansion in flows of return to the labour market is in effect traceable to attributes which vary across cohorts, such as educational level, timing of marriage, and fertility patterns. However, cohorts and historic periods remain important in addition to the family-related changes and educational expansion. Since the mid-1960s, women have increasingly (re-)entered the full-time segment of the labour market. This increase in full-time employment over historical time, which incorporated women across all generations, has been accompanied by cohort-specific part-time employment. Starting with the 1934–8 birth cohort, participation in part-time work has grown across cohorts. Unfortunately, we were not able to explore whether younger cohorts of women use part-time work as a bridge to full-time employment. Other studies show that this is generally not the case (Blank, 1989; VandenHeuvel, 1991).

The second aspect specifically refers to part-time work and carries important policy implications. While a weaker coefficient for marriage on leaving part-time jobs indicates somewhat less conflict between part-time work and household responsibilities, the effects of the presence of children are at a similar level as for full-time work. This refutes the assumption of greater compatibility between child-rearing and reduced working hours. Also, entering part-time employment is independent of the family stage, which casts serious doubts on the role of part-time work as a solution to the work–family conflict in the USA. Rather, part-time employment seems to represent a kind of stop-gap solution in women's employment careers.

Why is it that part-time employment does not play such a significant role in the family life-cycle of American women as in some other Western industrialized countries?[10] We believe that the main reasons are in the characteristics of labour markets and part-time jobs in particular. Part-time work as an employment form which is compatible with certain stages in the family life-cycle seems to have expanded in countries where the state as one of the major employers provided relatively 'good' part-time jobs which do not marginalize the incumbents, and/or where a supportive income 'cushion' is available in case of less than full-time participation. This income backing is based either on welfare provisions or a partner's full-time earnings.

[10] In Germany, for example, it has been argued that part-time work is the most important form of re-employment upon the termination of the 'family break' (Pfau-Effinger, 1994; Schupp, 1991).

In the USA, a large majority of part-time jobs are in the 'secondary' labour market, where jobs are characterized by low skill requirements, low pay and fringe benefits, low productivity, high turnover, and little opportunity for advancement. A whole set of industries, particularly in trade and services, have shifted their employment strategy towards the secondary labour market to cut labour costs and enhance staffing flexibility (Tilly, 1991). This development has brought about high employment creation rates and high dynamics in the labour market, as well as low average unemployment spells, compared to the rigid labour arrangements and rampant long-term unemployment in Europe.[11] However, it has also worsened the situation for broad segments of employed workers, and resulted in more involuntary part-time work. Over a quarter of the part-time workers in the USA work part-time involuntarily—mostly because they are unable to find a full-time job (Tilly, 1989).[12] Thus, most part-time jobs offer sporadic employment opportunities rather than prospects for a meaningful long-term career. Our data also show that part-time spells are of considerably shorter duration than full-time spells and seem to be a qualitatively different work arrangement.[13]

Next, part-time employees receive far fewer fringe benefits than full-timers. The probability of having sick leave, paid vacation, pension, health, dental, and life insurance decreases sharply with the number of hours worked. In particular, employer-based health care is of critical importance for workers in the USA. Even taking account of the fact that some part-timers gain health-care insurance through their spouses, it has been estimated that 42 per cent of part-timers have no employer-provided health-care coverage at all (Chollett, cited in Tilly, 1989: 32). Harris (1993) maintains that welfare eligibility with Medicaid benefits is a critical consideration for poor mothers and their children. Poor unmarried women can simply not afford to work part-time and risk losing Medicaid benefits, even if, in terms of cash benefits, the part-time wage would exceed the amount received for welfare assistance. Therefore, they either stay on welfare and out of the labour force, or they must find a full-time job with sufficient

[11] The United States generated 28 million new jobs between 1973 and 1987, a period during which employment growth in Europe was essentially zero. However, it has been argued that this employment growth has been fuelled by low-paid, dead-end jobs. Among newly created jobs with low annual wages, the vast majority were part-time or part-year jobs (cf. Tilly, 1989).

[12] On the other hand, there are queues for retention part-time jobs. Retention part-time jobs are found in the primary labour market, and involve high compensation, high productivity, and low turnover. These jobs are in high demand, so that in general, firms with retention part-timers tend to have some involuntary full-timers (Tilly, 1989: 17).

[13] Over 30% of part-time work spells last 12 months or less; half of all spells are terminated at 26 months. For full-time work spells, only 16% have a duration of one year or less, and the median is 53 months, over four years.

wages and social benefits to pull them and their children out of poverty, a choice that enhances polarization of female employment.

At present, part-time work in the USA does not offer a suitable long-term alternative to full-time work as a means of reconciling work and family. This goal does not seem to be viable without restructuring part-time employment.

REFERENCES

Allison, P. D. (1984), *Event History Analysis: Regression for Longitudinal Event Data* (SAGE series: Quantitative Applications in the Social Sciences).

Becker, G. S. (1981), *A Treatise on the Family* (Cambridge, Mass.: Harvard University Press).

Beechey, V. and Perkins, T. (1987), *A Matter of Hours: Women, Part-time Work and the Labour Market* (Minneapolis: University of Minnesota Press).

Blank, R. M. (1989), 'The Role of Part-Time Work in Women's Labor Market Choices over Time', *American Economic Review*, 79: 295–9.

Blau, D. M. and Robins, P. K. (1988), 'Child-Care Costs and Family Labor Supply', *Review of Economics and Statistics*, 70: 374–81.

—— —— (1991), 'Child Care Demand and Labor Supply of Young Mothers over Time', *Demography*, 28: 333–51.

Blossfeld, H.-P., Hamerle, A., and Mayer, K. U. (1989), *Event History Analysis: Statistical Theory and Application in the Social Sciences* (Hillsdale, NJ: Lawrence Erlbaum Associates).

—— and Rohwer, G. (1995), *Techniques of Event History Modeling: New Approaches to Causal Analysis* (Hillsdale, NJ: Lawrence Erlbaum Associates).

Bumpass, L. L. (1990), 'What's Happening to the Family? Interactions between Demographic and Institutional Change', *Demography*, 27: 483–98.

Burt, R. S. (1991), 'Measuring Age as a Structural Concept', *Social Networks*, 13: 1–34.

Cattan, P. (1991), 'Child-Care Problems: An Obstacle to Work', *Monthly Labor Review*, 114 (10), 3–9.

Corcoran, M., Duncan, G. J., and Ponza, M. (1984), 'Work Experience, Job Segregation, and Wages', in B. F. Reskin (ed.), *Sex Segregation in the Workplace: Trends, Explanations, Remedies* (Washington, DC: National Academy), pp. 171–91.

Da Vanzo, J. and Rahman, M. O. (1993), 'American Families: Trends and Correlates', *Population Index*, 59: 350–86.

Economic Report of the President (1992), (Washington: United States Government Printing Office).

Ellingsæter, A. L. (1992), *Part-Time Work in European Welfare States: Denmark, Germany, Norway and the United Kingdom Compared* (Oslo: ISF).

Folk, K. F. and Beller, A. H. (1993), 'Part-Time Work and Child Care Choices for Mothers of Preschool Children', *Journal of Marriage and the Family*, 55: 146–57.

Glick, P. C. (1977), 'Updating the Life Cycle of the Family', *Journal of Marriage and the Family*, 39: 513.

Goldin, C. (1990), *Understanding the Gender Gap: An Economic History of American Women* (New York and Oxford: Oxford University Press).

Hakim, C. (1991), 'Grateful Slaves and Self-Made Women: Fact and Fantasy in Women's Work Orientations', *European Sociological Review*, 7: 101–21.

—— (1993), 'The Myth of Rising Female Employment', *Work, Employment and Society*, 7: 97–120.

Harris, K. M. (1993), 'Work and Welfare among Single Mothers', *American Journal of Sociology*, 99: 317–52.

Hesse, S. J. (1979), 'Women Working: Historical Trends', in K. W. Feinstein (ed.), *Working Women and Families* (Beverly Hills and London: Sage Publications), pp. 35–62.

Hobcraft, J., Menken, J., and Preston, S. (1982), 'Age, Period, and Cohort Effects in Demography: A Review', *Population Index*, 48: 4–43.

Hofferth, S. L. and Phillips, D. A. (1987), 'Child Care in the United States, 1970 to 1995', *Journal of Marriage and the Family*, 49: 559–71.

ILO (1989), *Conditions of Work Digest*, 8 (1) (Geneva: ILO).

Kalbfleisch, J. D. and Prentice, R. L. (1980), *The Statistical Analysis of Failure Time Data* (New York: Wiley).

Kalleberg, A. L. and Rosenfeld, R. A. (1990), 'Work in the Family and in the Labor Market: A Cross-National, Reciprocal Analysis', *Journal of Marriage and the Family*, 52: 331–46.

Leon, C. and Bednarzik, R. W. (1978), 'A Profile of Women on Part-Time Schedules', *Monthly Labor Review*, 101 (10), 3–12.

Masnick, G. and Bane, M. J. (1980), *The Nation's Families: 1960–1990* (Boston: Auburn House).

Maume Jr., D. J. (1991), 'Child-Care Expenditures and Women's Employment Turnover', *Social Forces*, 70: 495–508.

Mellor, E. F. and Parks II, W. (1988), 'A Year's Work: Labor Force Activity from a Different Perspective', *Monthly Labor Review*, 111 (9), 13–18.

Michalopoulos, C., Robins, P. K., and Garfinkel, I. (1992), 'A Structural Model of Labor Supply and Child Care Demand', *Journal of Human Resources*, 28: 166–203.

Moen, P. and Dempster-McClain, D. I. (1987), 'Employed Parents: Role Strain, Work Time, and Preferences for Working Less', *Journal of Marriage and the Family*, 49: 579–90.

—— and Smith, K. R. (1986), 'Women at Work: Commitment and Behavior over the Life Course', *Sociological Forum*, 1: 450–75.

Oppenheimer, V. K. (1973), 'Demographic Influence on Female Employment and the Status of Women', *American Journal of Sociology*, 78: 946–61.

—— (1974), 'The Life-Cycle Squeeze: The Interaction of Men's Occupational and Family Life Cycles', *Demography*, 11: 227–45.

Parish, W. L., Hao, L., and Hogan, D. P. (1991), 'Family Support Networks, Welfare, and Work among Young Mothers', *Journal of Marriage and the Family*, 53: 203–15.

Pfau-Effinger, B. (1994), 'Erwerbspartnerin oder berufstätige Ehefrau. Sozio-

kulturelle Arrangements der Erwerbstätigkeit von Frauen im Vergleich' ('Career Woman or Working Wife?'), *Soziale Welt*, 45: 322–37.

Presser, H. B. and Baldwin, W. (1980), 'Child Care as a Constraint on Employment: Prevalence, Correlates, and Bearing on the Work and Fertility Nexus', *American Journal of Sociology*, 85: 1202–13.

Quack, S. (1993), *Dynamik der Teilzeitarbeit: Implikationen für die soziale Sicherung von Frauen* ('Dynamics of Part-Time Work') (Berlin: Ed. Sigma).

Riley, M. W. (1987), 'On the Significance of Age in Sociology', *American Sociological Review*, 52: 1–14.

Rosenfeld, R. A. and Birkelund, G. E. (1995), 'Women's Part-Time Work: A Cross-National Comparison', *European Sociological Review*, 11: 111–34.

Ryder, N. B. (1985) [1965], 'The Cohort as a Concept in the Study of Social Change', in W. M. Mason and S. E. Fienberg (eds.), *Cohort Analysis in Social Research* (New York, Berlin, Heidelberg, Tokyo: Springer-Verlag), pp. 9–44.

Schupp, J. (1991), 'Teilzeitarbeit als Möglichkeit der beruflichen (Re-)Integration. Empirische Analysen auf der Basis aktueller Längsschnittdaten' ('Part-Time Work as an Opportunity for (Re-)Integrating Women into the Labour Market'), in K. U. Mayer, J. Allmendinger, and J. Huinik (eds.), *Vom Regen in die Traufe: Frauen zwischen Beruf und Familie* (Frankfurt and New York: Campus), pp. 207–32.

Statistical Abstract of the United States, various issues.

Sundström, M. (1991), 'Part-Time Work in Sweden: Trends and Equality Effects', *Journal of Economic Issues*, 25: 167–78.

Tilly, C. (1989), 'Half a Job. How U.S. Firms Use Part-time Employment' (Ph.D. thesis, Departments of Economics and Urban Studies and Planning, Massachusetts Institute of Technology, Cambridge, Mass.).

—— (1991), 'Reasons for the Continuing Growth of Part-Time Employment', *Monthly Labor Review*, 114 (3), 10–18.

Tuma, N. B. and Hannan, M. T. (1984), *Social Dynamics: Models and Methods* (New York: Academic Press).

VandenHeuvel, A. (1991), 'Juggling Employment and Family Demands: Part-Time Employment during Young Parenthood', paper presented at PAAS, Washington, DC.

Veum, J. R. (1992), 'Interrelation of Child Support, Visitation, and Hours of Work', *Monthly Labor Review*, 115 (6), 40–7.

Wandersee, W. D. (1981), *Women's Work and Family Values 1920–1940* (Cambridge, Mass. and London: Harvard University Press).

13

Women's Part-Time Employment and the Family Cycle: A Cross-National Comparison

HANS-PETER BLOSSFELD

Introduction

This chapter presents the culmination of our investigation of the rise in women's (part-time) employment in modern societies. It summarizes the major findings of the country reports from a cross-national comparative perspective, and it tries to illuminate the time-related interplay of the most important mechanisms that have been working in different countries and have generated the great variety of part-time work in modern societies. It also attempts to disentangle the common thread of the place of part-time work within women's life-course. I first recapitulate the main hypotheses which have guided our long-term cross-national comparative case-study approach and then synthesize the findings and draw some major conclusions.

Hypotheses

In the introductory chapter, we suggested the following three overlapping and related groups of potential mechanisms that could be important for an explanation of the complex patterns of change in women's (part-time) work:

1. Demand-side mechanisms

- 'Reserve army' thesis: steep economic growth (decline) increases (decreases) married women's part-time and full-time employment;
- 'Labour flexibility' thesis: unemployment or too much labour relative to jobs increases deregulation and the incidence of precarious forms of part-time employment for all kinds of workers; married women with small children are then, however, no special group;

- 'Post-industrial society' thesis: the shift towards post-industrial occupational structure creates jobs which can or must be provided by part-time workers;
- 'Sexual segregation' thesis: part-time work has been the result and has resulted in increasing levels of occupational segregation;
- 'Public sector' thesis: the public sector provides a particularly attractive and skilled labour market for female part-timers.

2. Supply-side mechanisms

- 'Increasing educational investment' thesis: educational expansion increases the supply of female (full-time and part-time) labour in all phases of the family cycle across cohorts;
- 'Extended educational participation' thesis: extended educational participation decreases the supply of young female full-time workers and increases the proportion of part-time working students;
- 'Declining importance of family cycle' thesis: fundamental changes in the family system and the role of women increase the supply of women's part-time and full-time work in all phases of the family cycle across cohorts;
- 'Increasing pensioners' hypothesis: growing early/partial retirement across cohorts increases the supply of elderly men's and women's part-time work.

3. Country-context mechanisms

- Social democratic welfare-state regimes support women's paid work, and encourage wives' and mothers's full-time emplyoment against part-time employment, and part-time employment against non-employment; part-time work in these regimes is unlikely to be a marginal form of employment;
- 'Liberal' welfare-state regimes create a comparatively high proportion of low-grade, semi-skilled, and unskilled (part-time) jobs; policies of the welfare state do not particularly stimulate wives' and mothers' employment;
- Conservative welfare states favour wives' economic dependence on their husbands and stimulate mother's choices of non-employment against part-time work, and part-time work against full-time employment; the quality of part-time work is mixed, there are highly protected part-time jobs mainly in the public sector as well as marginalized part-time jobs in the private economy;
- Pro-natalist policies in France encourage mother's full-time work as a norm against part-time work, and lead French women to prefer part-

time work against non-employment; part-time employment is mixed: there is a high proportion of protected jobs mainly in the public sector, but also a greater proportion of fairly precarious employment forms;

- 'North-South lag' hypothesis: the transformation of the traditional family system and the agricultural/industrial labour-market structure is delayed, encouraging more conventional forms of women's employment over the life-course (paid full-time work of young women, part-time work mainly of 'unpaid family members' and non-work mothers); there has only been a moderate expansion of the welfare state workforce and paid part-time work is to a large degree precarious; policies only reluctantly support mother's integration into the labour market;
- Socialistic transformation hypothesis: socialist regimes supported the two full-time earner family model, and full-time re-employment of women after childbirth; part-time work was not considered to be a typical female phenomenon; after the breakdown of socialist economies in Central and Eastern Europe, which has led to a deregulation of the state, all kinds of precarious, less-protected, or even non-protected forms of employment have been on the increase.

Syntheses of Results

Using data for long stretches of time (typically the whole post-war period), each of the country reports described in detail the development of a particular trajectory of women's (part-time) employment. We now try to synthesize these results from a cross-societal perspective in order to evaluate the suggested mechanisms. The main task here is to combine the hypotheses in a time-related way so that the commonalities and differences in the development of women's part-time work among modern societies can be better understood. The selection of countries in this book gives us broad contrasts of country-specific contexts and experiences of structural shifts over time.

First, in the former socialist countries of Central and Eastern Europe, part-time work was fairly rare (see Table 1.1). In contrast to capitalist countries in Northern Europe part-time work was not specifically a female phenomenon. Integrating women into paid full-time work was considered a vital strategy to achieve gender equality in the socialist development. The objective of expanding access to full-time work for (married) women (with children) (the 'socialistic transformation' thesis) was compatible with the objective of meeting the manpower goals dictated by central planning ('modified reserve army' thesis). These strategies were reflected in a very high female full-time labour-force participation rate, the re-entry of mothers into full-time work after childbirth, and in the main function of

part-time work to further integrate pensioners, disabled persons, and workers with a second job into the labour market. While socialist reforms do not seem to have generally altered sexual segregation of paid labour and women's primary familiy responsibilies at home, they have contributed to increasing sexual equality in educational attainment (Shavit and Blossfeld, 1993) and presumably to more equal job opportunities for women over time (Sørensen and Trappe, 1995). After the breakdown of socialism in Central and Eastern Europe, institutional and structural contexts have changed radically and fast. 'Liberal' market policy has been adopted, leading to a swift change in the occupational and industrial structure, preserved by former central socialist planning, with an expanding service sector (the 'post-industrial' society thesis), unprecedented high unemployment rates among men and women of all ages, and high rates of early retirement of older, obsolete workers with low pensions. Today, in these countries the proportion of unemployed and early retired men and women easily exceeds 20 per cent, strongly reducing employment as a percentage of the working age population (see Table 1.1). Too much labour relative to jobs and extreme deregulation have been slowly increasing the incidence of precarious part-time employment of all types and for all workers, making married women (with small children) not a particularly specific category (the 'labour flexibility' thesis). However, it is of theoretical interest that socialist gender policies over several decades obviously have changed the attitude of women towards being a full-time homemaker. For example, between 1990 and 1994, the proportion of full-time homemakers among East German women aged 16–59 has not only been extremely low (around 6 per cent in comparison to around 35 per cent in West Germany), but has also not changed within a structure that has become more 'West German' (Deutsches Institut für Wirtschaftsforschung, 1995).

Second, part-time work of married women with children is particularly characteristic of Northern European capitalist societies (see Table 1.1). Since part-time work is nowadays so much more common than some years ago, many social scientists are misled into thinking that this growth must have been caused by something that happened recently. However, the country reports demonstrate that women's part-time employment in most Northern European capitalist societies rose fastest from the late 1950s to the mid-1970s, with the Netherlands and France as the exceptions. During this historical period, an unprecedented economic growth in the overall demand for labour (the 'reserve army' thesis), accompanied by a fast structural shift towards administrative and service jobs in general (the 'post-industrial society' thesis), and skilled and highly skilled jobs in the welfare-state sector in particular (the 'public sector' thesis), have produced a marked rise in demand for female (part-time) labour (the 'sexual segregation' thesis). During the same period, there has been a declining supply

of young unmarried women due to educational expansion (the 'extended educational participation' thesis) and a fall in first marriage/motherhood age (Blossfeld, 1995), making women who used to provide the backbone of the female labour force in the immediate post-war period—the unmarried and the young—a stationary or declining population group (Oppenheimer, 1970). As a consequence, a rising demand for labour required an increasing integration of married women into the labour-market. As several country reports have shown, this integration occurred via a cohort process. It did not affect all women in the population to the same extent, but gradually changed the labour-market behaviour of each successive younger cohort of married women (with children) to an increasing extent.

Third, the integration of married women into the labour market was not uniform across the countries in Northern Europe and the USA. The demand- and supply-side changes in the labour market interacted with different country contexts and produced different levels and various tempos of change in the proportion of women's part-time work between the mid-1950s and late 1970s. The following differentiation of broader ideological and political country contexts seem to be important:

1. The Scandinavian model in Denmark and Sweden pro-actively tried to integrate married women (with children) into the labour force. Its proponents introduced employment policy, fiscal policy, and social policy measures promoting the combination of family and market work (e.g. proportional earnings, full social benefits, expansion of public childcare) and encouraged women to choose paid (full-time and part-time) work rather than the role of a full-time housewife and mother. One particularly significant factor was the introduction of separate taxation of spouses and the growth of marginal tax rates that increased the relative attractiveness of part-time over full-time work for Swedish women in this period. However, most part-time work in Denmark and Sweden is not very different from full-time work in terms of working hours (see Fig. 2.1), skill level, and protection.

2. The 'liberal' welfare-state regimes in Great Britain and the USA did little to stimulate (married) mothers' labour supply in particular. National policies have been dominated by means-tested assistance, modest universal transfers, and modest social-insurance plans. In the 1960s, British married women were seen as a 'reserve army' to tide over a period of labour shortage, and part-time work was explicitly designed by employers for married women to be undemanding, lacking promotional prospects and responsibility. Provision of daycare and after-school facilities enabling mothers to work full-time have generally been lacking. Thus, the relatively unregulated market forces in Britain increasingly integrated married women (with children) into part-time work, even at the expense of full-time jobs (Hakim,

1993). This development, however, is in sharp contrast to the process in the USA. In the USA, which also belongs to the cluster of 'liberal' welfare-state regimes, the unregulated American market forces integrated married women (with children) not only into undemanding part-time jobs with low pay, and low levels of social security, but also into (female) full-time jobs. The growth rates of full-time and part-time employment have been fairly balanced for decades. In the 1980s, full-time employment started growing faster than part-time employment. This leaves us with an unsettling problem. Why is it that two 'liberal' welfare states produce such different patterns of women's full-time employment? Given the descriptive nature of our approach, we can only speculate as to the mechanisms that might be at work here. Drobnič and Wittig demonstrate in Chapter 12 that while there is no significant change across cohorts with regard to the rate at which American women leave the labour market when a child is born, re-entry into part-time work has increased dramatically across cohorts, starting with the birth cohort 1934–8. This pattern is completely in accordance with the one observed in the other Northern European capitalistic countries, including Britain. However, Drobnič and Wittig find in addition an interesting development which can only be seen for the USA: since the mid-1960s, there has been an additional continuously rising period effect increasing all women's entry into full-time employment. There must be something more general stimulating American women's full-time work; something that is not particularly connected with the family cycle. One possible explanation could be that in the USA most employers pay for health insurance for full-time workers, but only few provide insurance for part-time employees (Dex and Shaw, 1986). Given the increasing costs of health care in modern societies, this might constitute an increasingly important motivation for women to work full-time. Although this may be part of the explanation, one also suspects that it is not the entire story. Further research is needed to explain the surprising period effect that produces this important rise in American women's full-time work. From a theoretical perspective, it is important to note here that part-time and full-time employment of married women have been growing in 'liberal' regimes, even without particularly active measures through welfare-state policies.

3. In France, policy-makers pro-actively adopted measures to increase fertility at the end of the 1960s and 1970s. However, rather than trying to dissuade women from joining the labour force, the French solution has been to reduce the obstacles to fertility for full-time working women (through maternity leave schemes, systems of crèches, daycare institutions, and after-school facilities). As a consequence, marriage lost its importance for women's labour-force participation and increasingly fewer mothers have been leaving the labour market after the birth of a child. Thus, in France, active welfare-state policy measures might explain the higher level

of full-time employed mothers and the comparatively low proportion of part-time work.

4. In the conservative welfare states of the Netherlands and West Germany, public policy has been committed to the traditional type of family life. Social policy measures have encouraged motherhood, and family services, such as daycare, have been underdeveloped in both countries. In West Germany, the tax system still punishes the dual full-time earner marriage and rewards wives' non-work or part-time work. Therefore, it is not surprising that in West Germany, married women with children either did not re-enter the labour market after childbirth or if they did, they increasingly entered part-time work across cohorts. The Netherlands followed the West German pattern with a delay of about a decade. De Graaf and Vermeulen explain this lag by an ideological public discourse among various religious and political groups in the 1950s and 1960s, resulting in an enforcement of more traditional family roles with high levels of fertility. But since the early 1970s, secularization in the Netherlands opened the way for more tolerant general attitudes towards part-time working wives and mothers. The Netherlands has now become the part-time champion of Europe (see Table 1.1). From a theoretical perspective, it is important to stress that the relatively high proportions of part-time working women in West Germany and the Netherlands were produced by an institutional-structural framework commited to the traditional family model. Part-time work in conservative welfare regimes is mixed in terms of demands, pay, and levels of social security. However, because of a large public-sector workforce and at least compared to 'liberal' welfare regimes, the more regulated labour market in conservative states creates a great proportion of part-time jobs which cannot be considered as marginal.

Our fourth important conclusion is that after the oil price shock in the 1970s in Western Europe and the USA, the labour markets in many of these countries started to change considerably again with respect to rising unemployment rates. However, our longitudinal analyses show that the integration of married women (with children) into the labour market has continued across cohorts. This evidence speaks against a rigid version of the 'reserve army' thesis. Athough unemployment has increased, wives have not been sent back (or were not willing to go back) to their homes and children in the 1980s and 1990s, as was the case after the First and Second World Wars in many European countries. Instead, it seems that in the 1960s and 1970s a different labour market was created for part-time working (married) women (with children), and normative attitudes of employers and women have changed based on experiences during the economic boom. It seems that the change in norms is frequency dependent over time: the more married women (with children) who are working, the more feasible work appears to women in all phases of the family cycle, and

the more likely it is that this increase will continue across successive generations of women. This trend has, of course, been supported by increasing educational attainment of women across cohorts and a declining importance of family-cycle events over time.

Fifth, for our theoretical argument it is important to demonstrate that those countries that missed the excessive economic boom in the 1960s and 1970s, have followed quite a different trajectory with regard to (married) women's integration into the labour market. Thus, Southern European societies serve as a kind of 'control group' in our cross-national case-study approach. And indeed, these countries did not transform their labour markets and family systems to a similar extent in the 1960s and 1970s. This helps to explain why the level of women's labour-force participation and female part-time work did not increase in Italy and Spain. Female labour supply did not start to rise in the Southern European countries until the late 1970s with a lag of about 15 to 20 years. However, women's work in Southern Europe still means full-time work (to about 90 per cent). Women's part-time work is underdeveloped and it is only loosely connected with the family cycle. Part-time work seems to be important in the more traditional sectors of the economy (e.g. female unpaid family workers in agriculture and small businesses), related to specific groups constituting a qualitatively different workforce (such as students or pensioners), and it shows strong signs of precariousness. Portugal remains a unique case in Southern Europe, with the highest full-time work rate in Western Europe that has changed little for decades.

Sixth, across all countries we found that women's increasing educational investments stimulated both (married) women's part-time and full-time work. To the extent that longitudinal analyses could be done, they showed that educational expansion increased married women's full-time work via two routes: directly and through part-time work. Particularly for higher qualified women, part-time jobs seem to act as a bridge between housekeeping and full-time employment in several European countries. Thus, educational expansion increasingly transforms—intended or not—women's part-time work into full-time employment across cohorts. This is particularly true for the Netherlands, West Germany, and Britain. However, educational expansion alone cannot completely account for the changes across cohorts. After controlling for women's educational attainment, cohort effects on re-entry into part-time and full-time work become weaker, although the basic cohort pattern remains unchanged. This pattern suggests a continuous normative change in the role of women in modern societies, leading to their engaging in more part-time and full-time work over the life-course.

Seventh, as far as the impact of the family cycle on women's employment is concerned, we found that in Britain, West Germany, and the

Netherlands the event that leads to women's employment interruption shifted from marriage to the birth of the first child across cohorts. The time of marriage and the time of first childbirth have increasingly been disconnected over time. Younger women delay marriage because of extended educational participation over the life-course (Blossfeld, 1995) and delay the first birth of a child even more. Part of the increase in young married women's full-time labour-force participation across cohorts is therefore simply due to the increasing gap between these two life-course events. Young women continue to work after marriage until their first child is born. All longitudinal analyses show that the conflict between part-time work and the first stage of the family cycle (marriage, small children) is much less severe than for full-time work.

Conclusions

What are the consequences of this trend for gender equality and what does it mean for the evaluation of the equalization and marginalization hypotheses, discussed in the introduction of this book? It seems to me that the results in this book demonstrate that both the equalizing and marginalizing perspectives are misleading for our understanding of the fundamental changes in women's labour-force participation in general and in married women's part-time work in particular. On the one hand, the equalizing perspective, which does not take into account the number of hours that women work, overstates the 'liberating' effects of women's increasing labour-force participation, because in many countries (the USA is an exception) only married women's part-time work has expanded. Thus, looking only at women's overall labour-force participation provides a far too simplistic portrayal of the changes in the sex-specific inequality structure in Europe. On the other hand, the marginalization perspective is also misleading, because it exaggerates the negative aspects of married women's part-time work in most modern countries and develops a much too pessimistic scenario. This perspective overlooks the fact that the welfare of most part-time workers, and of married female part-time workers in particular, is not solely determind by their own occupational status and earnings. 'The majority of part-timers regard breadwinning as the *primary* (but not exclusive) responsibility of men, and see women as secondary earners whose *primary* (but not exclusive) responsibility is domestic work and homemaking' (Hakim, 1996: 181). Thus, both perspectives seem to miss the central point in women's increasing part-time employment in modern societies: part-time working women (and others with non-standard contracts) must be set *within the context of the family and the sexual division of labour in the family*. If one does that, then part-time jobs and other low-paid or

non-career jobs can not merely be tolerated, but can even be enthusiastically appreciated by dependent wives and other secondary earners.

REFERENCES

Bernhardt, E. M. (1993), 'Fertility and Employment', *European Sociological Review*, 9: 25–42.

Blossfeld, H.-P. (1995), *The New Role of Women: Family Formation in Modern Societies* (Boulder, Colo: Westview Press).

Deutsches Institut für Wirtschaftsforschung (1995), 'Aspekte der Arbeitsmarktentwicklung in Ostdeutschland' ('Aspects of Labour-Market Development in East Germany'), *DIW Wochenbericht*, 23: 401–10.

Dex, S. and Shaw, L. B. (1986), *British and American Women at Work: Do Equal Opportunities Policies Matter?* (London: Macmillan).

Hakim, C. (1993), 'The Myth of Rising Female Employment', *Work, Employment and Society*, 7: 97–120.

—— (1996), 'The Sexual Division of Labour and Women's Heterogeneity', *British Journal of Sociology*, 47: 178–88.

Oppenheimer, V. K. (1970), *The Female Labor Force in the United States: Demographic and Economic Factors Governing Its Growth and Changing Composition* (Berkeley, Calif: Population Monograph Series, Department of Demography).

Shavit, Y. and Blossfeld, H.-P. (1993), *Persistent Inequality: Changing Educational Attainment in Thirteen Countries* (Boulder, Colo: Westview Press).

Sørensen, A. and Trappe, H. (1995), 'Frauen und Männer: Gleichberechtigung—Gleichstellung—Gleichheit'? ('Women and Men: Equal Rights, Equal Opportunities, and Equality'), in J. Huinink and K. U. Mayer (eds.), *Kollektiv und Eigensinn. Lebensverläufe in der DDR und danach* (Berlin: Akademie Verlag), pp. 189–222.

NAME INDEX

SUBJECT INDEX

The Subject Index should be treated as a complement to the detailed chapter contents listing. Topics which are identified there, and which the book as a whole covers, such as women's employment or part-time work, are not repeated here.